(08.04.83)

DUTCH AND FLEMISH PAINTING

Pierre Courthion

CHARTWELL
BOOKS, INC.

© Éditions Fernand Nathan 1983
© Heraclio Fournier, S.A.

Reprinted with permission by W.S. Konecky Associates, Inc.

ISBN: 0-89009-906-5

Published by
CHARTWELL BOOKS, INC.
A Division of BOOK SALES, INC.
110 Enterprise Avenue
Secaucus, New Jersey 07094

Printed and bound in Spain

PREFACE

My fundamental intention — and perhaps it will become a hallmark of this book — has been to examine works of art outside their respective historical contexts. Art is individual and the artist is always exceptional. This does not mean that an artist's birthplace and his era are not contributing factors to a certain extent. Although there is no native land for art itself, individual artists do have native lands. On the other hand, the significance of their creations increases in relation to emancipation from local influences and the quest for universality.

It is possible to agree with Herman Teirlinck's affirmation that "the identity of Flanders is defined by the basin of the Escaut and Wallonia's by the basin of the Meuse, whereas Holland's identity emerges at the confluence of these two rivers." In simplified terms, it can be said that Flemish painters were primarily influenced by Medieval and Gothic art, whereas Dutch painters tended to reflect the influence of the Renaissance.

One of the primary aims of this book has been to delineate the qualities of these paintings so that they may awaken interest among contemporary audiences, independently of any extra-pictorial criteria. What impressions do the artists' creations convey? What are their distinct contributions? What do we know about them?

Within this framework it is essential to refrain from excessive admiration for what we may regard as masterpieces. This perspective explains our lack of interest in Antonio Moro, who was born in Utrecht, or the Pourbus brothers from Bruges, because these artists, notwithstanding the success and renown granted to them during their lifetimes, merely reflected the conventional preferences of their eras.

Changes in taste are unforeseeable and it is therefore possible for the unexpected to emerge from one fifty year period to another. Recognition can now be granted to artists whom Fromentin barely mentioned, apart from his admirable pages concerning Rubens, Hals and certain others. In fact, around 1876, it was necessary to study significant works at their respective locations, whereas our era provides the opportunity to gain access to most reproductions of these works in our own countries.

Western Shadows

In examining Flemish and Dutch artists, we confine ourselves to a region of Europe that became the source of so many bountiful perceptions and visions transposed onto canvas or wooden panels during a period when cities such as Ghent, Haarlem, Bruges and especially Antwerp were emerging as centers of trade and artisanry in northern Europe. These are the cities where enamellers, wood-carvers, inlayers, and metalworkers, whom Fierens-Gevaert called the *aurifabri,* pursued their labors

and where painting gained an especially prominent role during the fourteenth century, even to the point of rivaling the Italian's creations.

Flemish art remained predominantly linear from Van Eyck to Quentin Metsys. It was internalized and expressive but not ostentatious. Admirably precise draftsmanship is nearly always combined with shadows that, instead of creating *chiaroscuro* effects, constitute "the unreal shadows rediscovered by Leonardo and Rembrandt: the Western shadows" (Malraux). It is possible to encounter color schemes with clearly defined and bold tones but without excessive affectation. The Flemish painters paid a great deal of attention to details such as bouquets and the vast array of objects that enrich the settings created in their painting.

In this region, brotherhoods — or guilds — of painters and sculptors proliferated to such an extent that, by the fifteenth century, Flemish influence was predominant in Western painting, except in Italy. Groups of artists in various nations often worked anonymously in *ateliers* headed by Flemish painters. These groups traveled to many lands to complete works commissioned by churches, monasteries and individual patrons. Thus, Flemish craftsmanship was represented by the "Master of the Aix Annunciation," the "Master of Moulins," the triptych of Ternant (Nièvre), the "Master of the Carnation" in Switzerland, and as far away as Poland and Moravia. To a certain extent, the tradition of collective creation was continued by Rubens, whose studio was filled with assistants and apprentices.

Another distinctive feature of Flemish painting was the development of motifs with a slanting (or overhead) perspective. This technique is observable in the Master of Flémalle's *Mystic Lamb* altarpiece and in his *Annunciation* panel. It can also be recognized in the structure of Thierry Bouts' *Last Supper* triptych in Louvain and in the center panel of Van der Goes' *Portinari altarpiece* in Florence. Adoption of a slanting perspective ultimately attained a culmination in Bruegel's *Seasons*.

Flanders and Holland: An Imprecise Boundary

Paintings produced in Flanders and in Holland are sometimes interrelated and appear to merit the designation "Flemish-Dutch," or *vice versa*. This explains why certain art historians, in works pertaining solely to painting from Van Eyck to Bruegel, have considered "early Dutch painting" an acceptable designation. The "Flemish" categorization would thus appear to be limited to the confines of Flanders. However, these painters from the "Low Countries" of yore were called *fiamminghi* in Italy or *flamencos* in Spain. We have adopted the designation that is more consistent with tradition than with history or geography.

Furthermore, Dutch painters pursued their careers with far more independence from rulers and the Church, and Amsterdam contained fewer patrons than Antwerp. Hence, the art of the Netherlands did not develop with the continuity that can be recognized from the Limbourg brothers and Van Eyck to Quentin Metsys, between Bosch and Bruegel, and between Rubens and other artists influenced by the Antwerp School. Among the Dutch painters, there are isolated figures who stand apart from one another (Frans Hals, Rembrandt, Pieter Claesz, Van Ruysdael, Vermeer...)

In this book, we have "highlighted" passages about the masters from the works of Carel Van Mander, Fierens-Gevaert, and especially Eugène Fromentin, who was the first author subsequent to Vasari to describe and analyze painting techniques so knowledgeably.

At the same time, one should not forget that the creator of *Dominique* was also an esteemed painter, that he had participated in the Salon's exhibitions, and that his paintings were of an extremely ordinary quality. But while it is true that he confessed to abandoning "ambitious hopes" as a critic, he displayed an undeniable tendency to defend his own works through eloquent descriptions of the masters' creations.

Fromentin described paintings by Rembrandt that were familiar to a vast public: the famous *Night Watch,* the *Syndics,* and the first *Anatomy Lesson* given by Doctor Tulp. Throughout Fromentin's text one senses that the author is somewhat intimidated by Rembrandt's rigorous and imaginative craftsmanship. Indeed, he wrote that Rembrandt had "a dexterous hand without great skill." In the final pages of his book, Fromentin almost begrudgingly — so it seems — offers his conclusions about the great visionary: "This self-styled earthly man, this *vulgar* and *unseemly* (Fromentin's emphasis) man was a pure *spiritualist.*"

Although we do not fully share Eugène Fromentin's views with respect to Flemish and Dutch painters, our descendants will very likely have a different attitude toward qualities that captivate us today. This depends upon how the eye is trained and upon absorption of the ideas and influences of one's own century at a given time.

These considerations belong to the domain of mutability of taste and esthetic phenomenology. All innovations are discordant in relation to our optical habits. A true innovation overturns images and transforms the process which we will call "reading," in other words our way of observing, absorbing, and interpreting a work of art. Every innovator conveys a hitherto unknown vision or, in more precise terms, a vision that seemed unexpected when we encountered it. This occurrence inevitably collides with the precepts we previously learned. Our eyes are unaccustomed to a certain color scheme, or our minds are not trained to observe and think in a particular way. When we are confronted by a new physical or spiritual perspective, we tend to be both astonished and reticent. Then we gradually discover the elements that link the innovative artist to tradition. He may be perceived by many as an iconoclast, whereas he actually has no doubts about the secret thread binding him to the past, even if he regards himself as a revolutionary. In turn, when one encounters new creations, the past itself undergoes recurrent transformations, allowing us to discover previously unobserved qualities in works of tradition.

On the other hand, insofar as a work of art has a sufficient number of appealing aspects in order to match all of the changes in our way of seeing and thinking, it then becomes capable of permanently captivating us and even of acquiring a timeless importance that will ensure its triumph over the reserve of our responses.

An extended Visual Adventure

We will undertake a long journey among the various portrayals of the visible or invisible world created by these painters. We will encounter the expression of profound religious belief and fantastic bursts of imagination that produced incredible sorcery in the form of comical and poignant scenes.

After watching motionless objects, we will be able to glance upon a vast expanse of earth and space and distinguish trees, bushes and a windswept sky. From the intimacy of rooms with lacemakers at work, we will travel to the mythological domain in which we will find a procession of Venuses opulently portrayed as women in love and as young mothers. Then, on a more earthly plane, we will uncover the haunts of tipplers and carousers. Lastly, as a final belated remininscence of the *Mystic Lamb,* we will witness Christ's entry into Brussels.

We will journey from the steadiness of skilled hands to the most unrestrained and audacious brushstrokes, from the most strikingly obvious revelations to nocturnal visions and spiritual contemplation, from the most charming effects of paint in depicting female bodies to the most unruly and frenzied disorder. This is a beautiful journey, a long journey of the mind's eye among Flemish and Dutch painters who belong to the ceaseless visual exploration that has occurred and will continue to occur so long as our planet is inhabited by human beings who live and paint.

In considering Flemish art, one must begin with the first contribution and proceed to the depiction of landscapes by the Limbourg brothers (active around 1402) — Jean, Hermant, and Pol who was the leader of their *atelier*. Born in Nijmegen (they may have been nephews of Jean Malouel), these brothers, who became inhabitants of Brabant, painted before Fouquet and entered the Duke of Burgundy's service in 1402. After several years of apprenticeship in Paris, they worked for Jean, the Duke of Berri, who was the most ostentatious, most avid, and most zealous art collector of his era. The illuminated manuscript which the Limbourg brothers prepared for the Duke in *Les Très Riches Heures* (Chantilly, Musée Condé) earned them a predominant position in Flemish Gothic art. With the bright greens surrounding the gleaners and mowers in the *Month of June* or the sowers in the *Month of October,* they anticipated Bruegel's *Seasons* and Claude Lorrain's *Hours of the Day*. Flemish art is indebted to them for having introduced landscapes, space, and buildings in painting, in contrast to gilded backgrounds such as the one in *The Martyrdom of Saint Denis* (Louvre). The latter painting, which was begun by Jean Malouel and completed by Henri Bellechose, was the altarpiece commissioned by the Carthusians of Champmol, a monastery established by Philip the Bold near Dijon as a burial site for the Dukes of Burgundy. During the same period, Melchior Broederlam (born in Ypres and documented between 1385 and 1400) painted the side panels for this same cloister, including the *Flight into Egypt* (Musée de Dijon). In this painting the Virgin dressed in blue and holding her child is riding gracefully upon an ass, while Joseph is shown drinking from an uplifted flask amid plants and boulders. Champmol is also the location where the sculptors who created *Moses' Well* worked under the supervision of Claus Sluter. There, one encounters the deeply religious attitude which subsequently permeated the works of Jan Van Eyck.

FLEMISH ART

VAN EYCK AND HIS DISCIPLES

Jan Van Eyck

1385–1441

At the beginning of the fifteenth century, Jan Van Eyck was the great master of northern European painting. He was the inventor of specific techniques for painting with oil. As a prodigious draftsman, he promoted a linear art whose influence became observable everywhere.

In the first place, he was a prodigy, one of those rare manifestations of human genius whose presence inspires bewilderment, not only because we are incapable of hoping to attain such grandeur, but because we are reassured by the heights to which a painter's creations can soar.

The world contains many wonders and this is especially true of Italy. In northern Europe, however, it is necessary to mention the *Mystic Lamb*.

There remains a degree of uncertainty with respect to the artists who created this masterpiece, because, in addition to Jan Van Eyck, there was a Hubert Van Eyck who appears to have begun this extensive project (it is unknown whether Hubert was Jan Van Eyck's brother). On the other hand, Hubert's brief life and the perfection of other paintings by Jan Van Eyck suggest the wisdom of abandoning futile disputes and of regarding Jan Van Eyck as the principal creator of the *Mystic Lamb,* the altarpiece in the Cathedral of Saint Bavo in Ghent. This altarpiece was begun on May 6, 1432.

The Triumph of the Lamb

The principal panel displays a throng of figures surrounding the Lamb amid a vast landscape. This is a visual representation of the Apocalypse foretelling the victory of the Paschal Lamb and the triumph of the Church, whereupon the Earth and the Heavens render homage. "Then there appeared before my eyes an immense and countless multitude from every nation, race, people, and tongue, standing before the throne of God, in the presence of the Lamb." Fourteen angels are shown kneeling before the altar. Four of them are carrying the instruments of the Crucifixion, eight are kneeling with their hands clasped and two are wielding censers.

Fierens-Gevaert, in his *History of Flemish Painting* wrote: "These faces, this lavishness, these processions, these daisies and

Adoration of the Mystic Lamb, 1432 →
Church of Saint Bavo, Ghent
The "Adoration" scene, in the center panel, is enhanced by an admirable landscape derived from the Biblical source. As the lamb stands on an altar, its blood is flowing into a chalice while angels, prophets, apostles, bishops, priests, patriarchs, and martyrs have gathered to express their veneration.

Saint Barbara, 1437
(31 x 18 cm.), Musée Royal des Beaux-Arts, Antwerp
This is one of the most beautiful examples of a linear style.

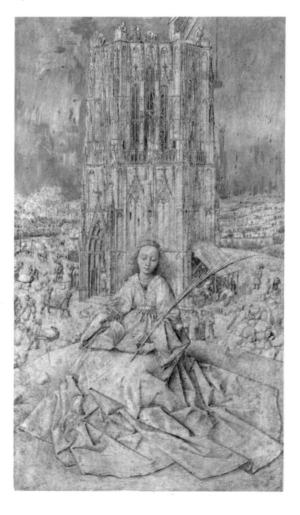

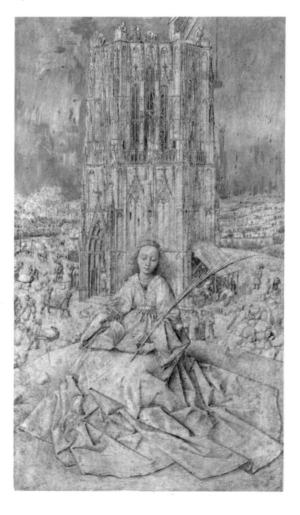

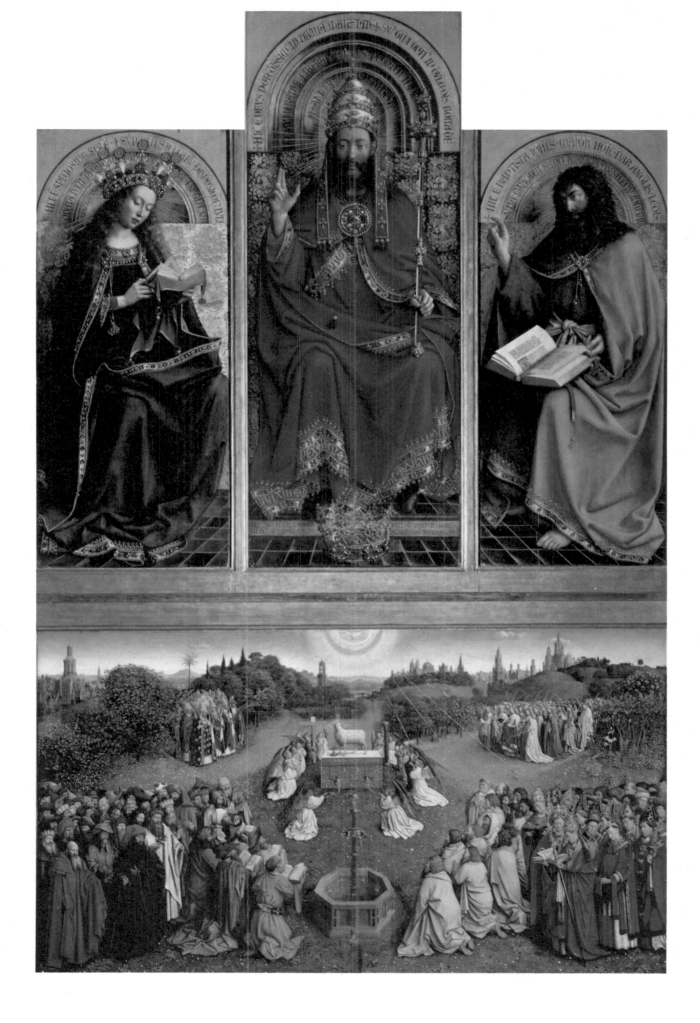

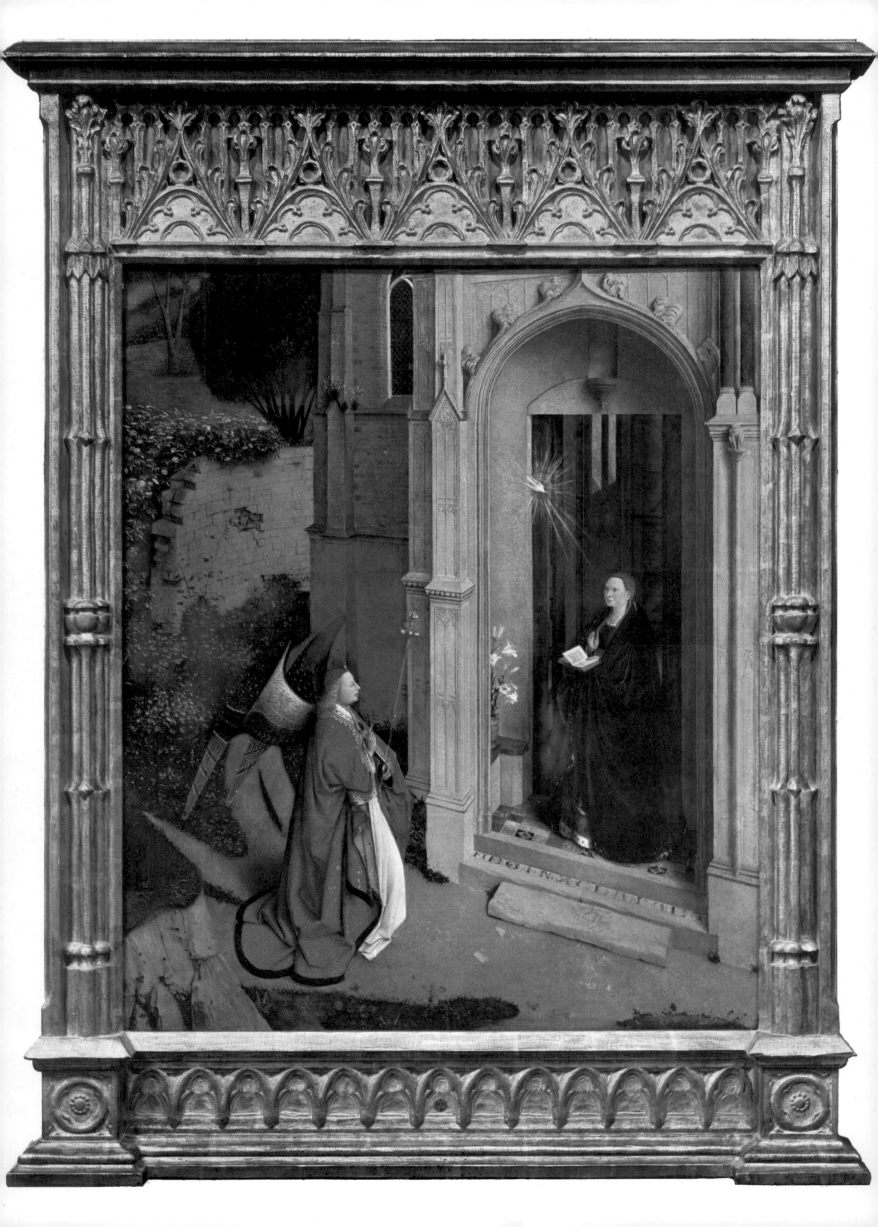

lilies, with this pale blue and this Faith — that is Flanders, an ideal Flanders that cannot be disguised by cypresses, date-palms and orange trees. Love, illusion and superhuman energy atain an unsurpassable height." Here, the Belgian author alluded to Italian art and, undoubtedly, to Masaccio, who only a few years earlier introduced a new mode of painting at the Carmine in Florence, namely, a less linear style with dramatic *chiaroscuro* effects. Van Eyck's polyptych also includes a musical panel, depicting an organ-player beside God, the Virgin, and Saint John, and the nude figures of Adam and Eve, evoking human suffering, appear at opposite ends of the uppermost panel.

An Ill-Fated Altarpiece

Van Eyck's altarpiece has a history of its own, a veritable mystery novel, with countless vicissitudes since the first restoration in 1530. When a fire destroyed the roof of the Cathedral of Saint Bavo, the altarpiece was relocated to a safe place and then returned to its original location. The figures of Adam and Eve were cleaned, but their sordid nudity produced a scandal. In 1974, an order from a bishop prevented the dismantling of the six detachable panels of the polyptych. These panels were subsequently removed by French officials, and were replaced in 1815. The following year an Englishman purchased the panels and gave them to the King of Prussia. Then there was another fire. The center portion was saved but it was damaged in moving. The entire altarpiece was restored on two separate occasions. When World War I broke out, the restored altarpiece was concealed to avoid confiscation by the Germans but thefts and restorations have continued until our own era.

Today, as a result of the efforts of the *Laboratoire de Bruxelles,* the *Mystic Lamb* has been restored to a condition relatively close to its original state, as if it were a seriously disabled veteran who had managed to survive both the beneficial and harmful forms of treatment inflicted upon him.

Because it is difficult to reproduce the entire polyptych, only the lower center portion has been reproduced. This portion presents the fundamental theme of veneration of the Mystic Lamb by the prophets and saints of the Old and New Testaments amid a majestic and vast landscape.

Jan Van Eyck's Life

There is hardly any information about Van Eyck's youth subsequent to his birth in approximately 1385. From 1422 to 1424 he lived in the Hague in the court of the Count of Holland. After the Count's death, he became a *valet* and painter in the court of Philip the Good, the Duke of Burgundy. It is known that he was sent on diplomatic missions to Aragon and later to Portugal. On October 18, 1427, he was lavishly honored by the magistrates of Tournai. Three years later, he settled in Bruges where he purchased a house and was visited by princely patrons. Van Eyck was married in April, 1434 and died on July 9, 1441 when he was fifty-six years old, having won fame and widespread admiration.

The Madonna at the Fount, 1439
(19 x 12 cm.). Musée Royal des Beaux-Arts, Antwerp
The Virgin has visionary brilliancy as she stands in front of a tapestry supported by two angels and extending onto a floor with floral decoration.

The Annunciation, c. 1434
(78 x 65 cm.). Metropolitan Museum of Art, New York
The contemplative quality of this painting and its delicate colors produce a profound silence.

At this point it is appropriate to consider other paintings by Jan Van Eyck.

At New York's Metropolitan Museum we were astonished by the Virgin's expression in the *Annunciation.* She seems to be both surprised and reassured by the angel's presence. There is a delightful contrast between the crumbling wall and the Gothic elements of the cathedral, whereby emphasis is given to humble origins and predestined glory. What a palette! The colors vary from the dark blue of the Madonna's clothing to the scarlet garb of the heavenly messenger.

The colors of the small *Virgin at the Fountain of Life* (1439) are even more dazzling. The damascene red of a tapestry held-up by two angels is balanced by the Virgin's dark blue mantle.

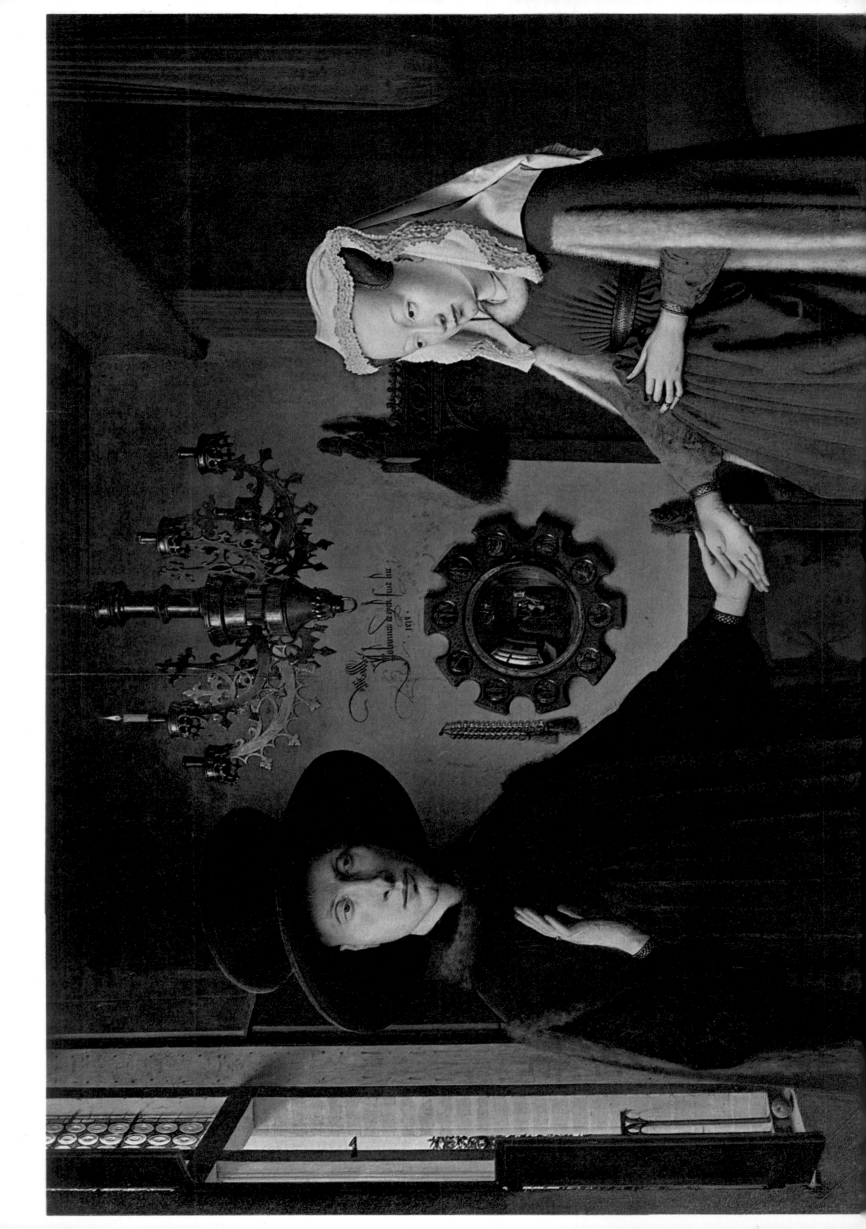

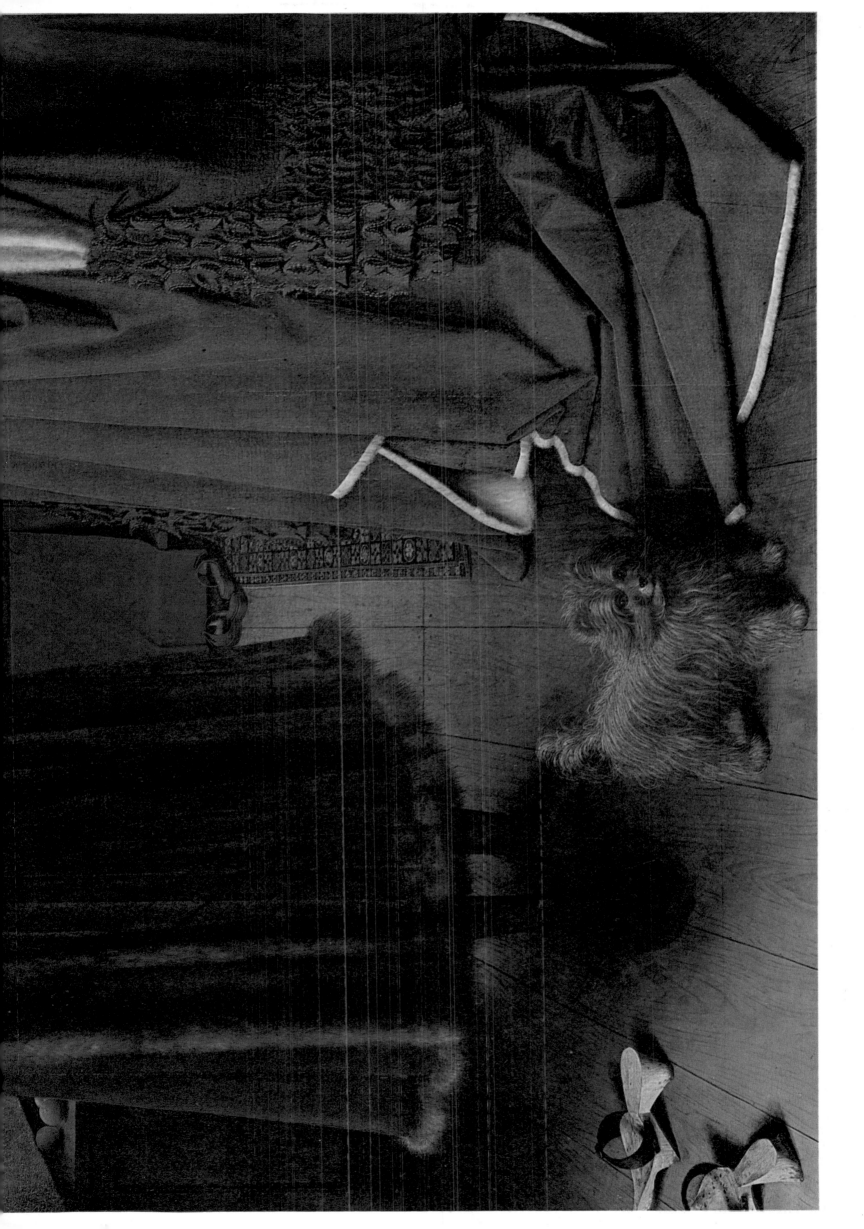

As for the techniques of this painter, it is possible to envision his methods by examining Antwerp's Musée Royal des Beaux-Arts faintly colored sketch of *Saint Barbara* (1437), traced on an oak panel. This is possibly one of the most beautiful sketches ever created by a painter. It is truly astonishing that so many marvelous things could have been evoked within a space of 35 x 18 centimeters. Our eyes travel from the saint wrapped in a mantle with prominent folds to the towering Gothic cathedral. We rarely see such precision, except in the works of Leonardo da Vinci, a consummate delineator of the human body. What an admirable contrast between the saint immersed in contemplation and the minuscule movements of the laborers busily hauling blocks of stone.

A Window Revealing a Landscape

The Virgin and Child with Chancellor Rolin (1431-1436) provides an unexpected surprise: a view of an infinitely vast landscape between the columns. In this painting at the Louvre, the Chancellor with his hands placed together over a book of hours seriously contemplates the Christ Child, whose hand holds a golden crucifix, while an angel dressed in blue is placing a crown upon the Virgin. One striking element in this painting is provided by two persons in the background who seem entirely indifferent to the event and have apparently turned their backs.

Jan Van Eyck's techniques and methods have been discussed frequently, along with the secrets of his craftmanship that ensured the durability of his creations. It has been claimed that Van Eyck mixed eggs with his paint although scientific analysis has indicated that he used a drying oil mixed with natural resins instead of eggs. Van Eyck also displayed an exceptional talent "for recreating the world, filling space with air and light, and surrounding forms with atmosphere" (Fierens-Gevaert).

Van Eyck's Principal Masterpiece

Apart from the *Mystic Lamb*, the *Portrait of Giovanni Arnolfini and His Wife Giovanna Cenami* (1434) is perhaps Jan Van Eyck's greatest masterpiece. This painting is both precise and enigmatic. Arnolfini and his spouse are standing hand in hand beneath a large copper chandelier, while a spaniel symbolizing fidelity is at their feet and a pair of clogs lies forgotten on the floor.

Arnolfini was a wealthy merchant from Lucca who had lived in Bruges since 1420 (he died on September 11, 1472). Attired in a habit with slits on both sides and a fur trim, Arnolfini is wearing an enormous felt hat. His wife, whose gown is bordered with ermine, is wearing a white silk coif adorned with frills, a headdress known as a *huve*. Although she would appear to be pregnant, it was fashionable during this era for women to wear gowns that accentuated their abdomens.

Preceding page.
Portrait of Giovanni Arnolfini and His Wife, Giovanna Cenani, 1434
(85 x 63 cm.). National Gallery, London
This ornate image of the couple is reflected within a mirror in the background.

6. p. 14 (to the right)
Preceding page
The Virgin and Child with Chancellor → *Rolin*, 1431-1436
(66 x 62 cm.), The Louvre, Paris.
Beneath the arches, this painting opens onto an admirable landscape in the distance, offering a contrast to the intimate scene in the foreground.

The Virgin and Child with Chancellor Rollin, detail.

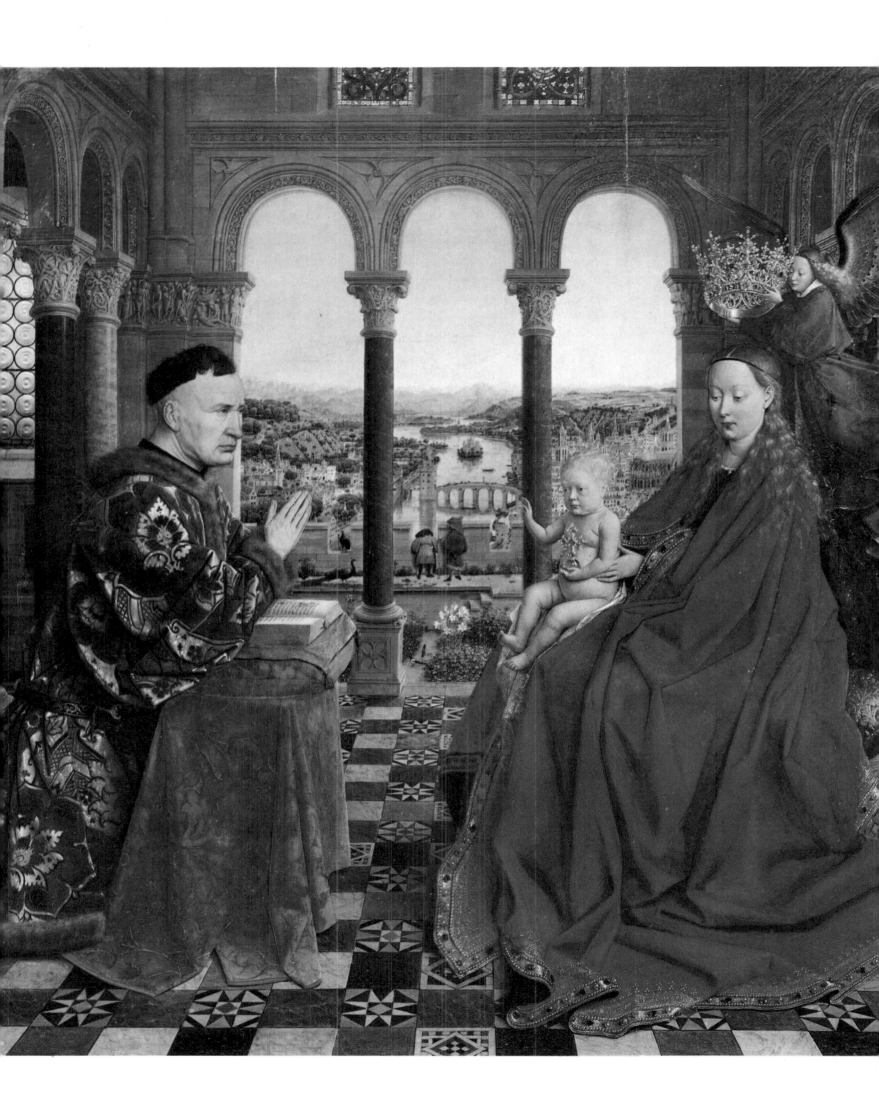

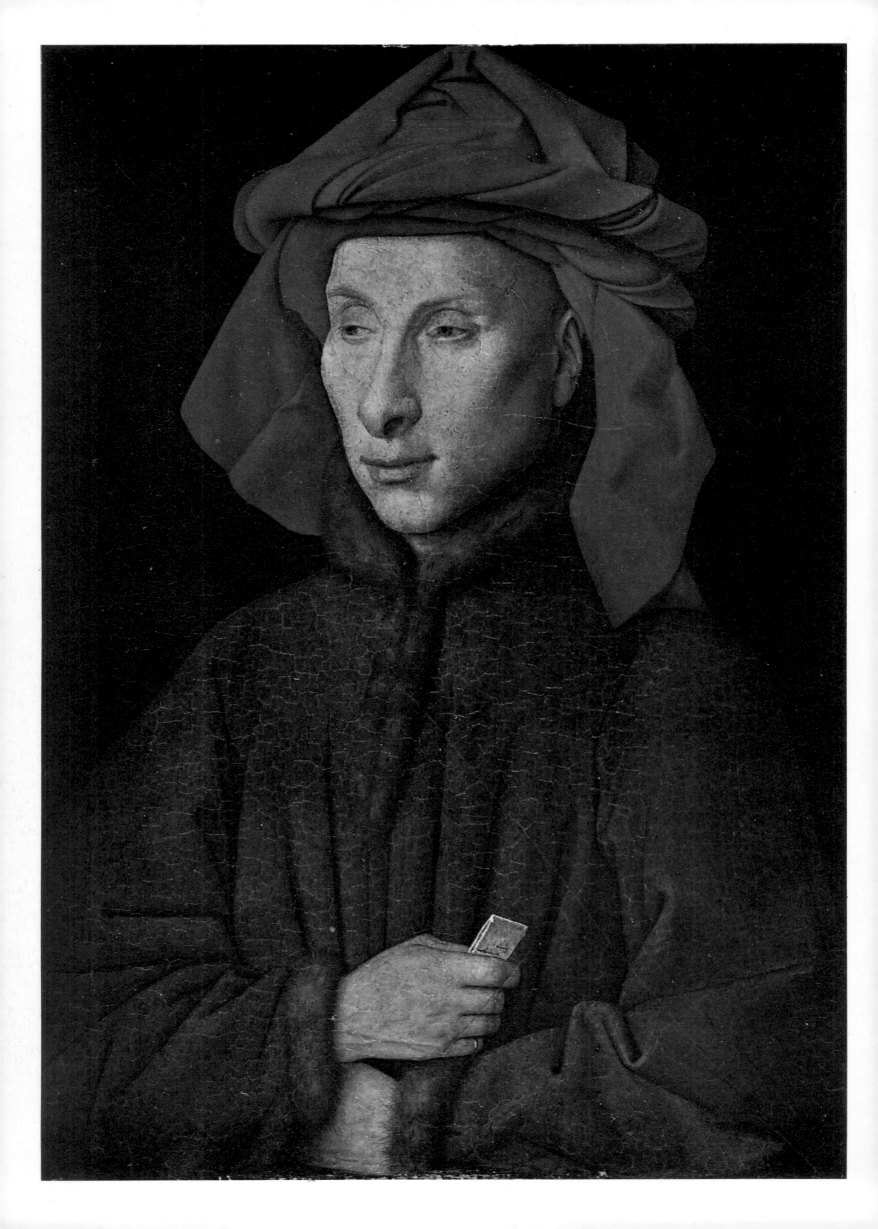

The Master of Flemalle

Robert Campin, 1380–1444.

As the creator of monumental art and as a painter whose religious scenes are distinguished by their intimacy, the "Master of Flémalle" was a title whose anonymity concealed the name of Robert Campin and perhaps of Jacques Daret.

The originality of this painting arises from the mirror reflecting the two figures (the crenellated frame around the mirror contains scenes from the life of Christ within circular pictures mounted between the indentations. Reflections within the mirror endow the painting with a certain mysteriousness. It is like a secret or a small window revealing the intimacy of a couple whom some authors have occasionally regarded as a portrait of Van Eyck and his wife, who were married in 1434 (the date inscribed upon the painting). The important aspect is the intimate atmosphere evoked by the artist, its sacramental quality and the ingenious interplay of two vertical arrangements, the straight downward pattern of the man's garments and the rounded folds of the woman's gown. In turn, the colors in this painting flow gently downward amid dusky light.

A portrait of Van Eyck's friend that belongs to the Galerie Dahlem in Berlin was undoubtedly completed at a later point, subsequent to 1434. Here, Giovanni Arnolfini's face is set off by a red headdress with a flap. With its curled lips, this cautious and mistrustful face belongs to a man who served as an advisor to Philip the Good.

It is also appropriate to cite *The Three Marys at the Empty Grave of Christ* (Museum Boymans van-Beuningen, Rotterdam), where an impressive landscape comprises the background. The three holy women are shown in the presence of an angel seated upon the empty grave, whereas the guards continue to sleep soundly. The entire painting is distinguised by an admirable array of colors and by unbelievably flawless delineation.

The Father of Flemish Painting

It is probable that Jan Van Eyck was a man who was responsive to everything that transcended external reality. Indeed, he appears to have been a profound artist who refrained from the salaciousness that emerged in the religious works of Italian painters and in Rubens' most exuberent creations. Van Eyck is the father of Flemish painting in the same way that Giotto was the originator of Florentine painting. The heirs of this northern Jesse included all of the subsequent painters of the former Low Countries: the Master of Flémalle, Rogier van der Weyden, Thierry Bouts, Memling, Van der Goes, Petrus Christus, and even Patenier, all of whom represented this vital tradition prior to the emergence of Bosch and Bruegel.

It is not our intention to become embroiled in the endless disputes among art historians with respect to a painter who is still referred to as the "Master of Flémalle," according to the name of an abbey known as Flémalle-lez-Liège that never actually existed. In our opinion this is a collective title that may refer to Robert Campin, whose wife, Isabel de Stockhem, was born in a village of the same name, not far from Maestricht, the birthplace of Jan Van Eyck.

Whereas some referred to the artist as "the Master of Flémalle" and others knew him as Robert Campin and "the Master of Mérode," the first title endured. Some authors even confused him

Madonna Nursing the Christ Child,
early fifteenth century.
(Diameter: 19.5 cm.). Museo del Arte de Cataluña, Barcelona.
The theme of the Madonna nursing her child — which was already popular among the artists of Siena — appeared frequently in Flemish paintings during this period.

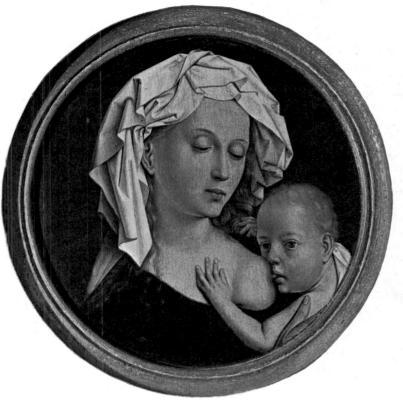

with Hans Witz, the father of Conrad Witz, and with Jacques Daret when the name Campin began to be accepted. In fact, the dispute has not ended...

Flémalle-Campin, who was born in Valenciennes around 1380, was registered as a master in Tournai in 1406 and as one of the city's burghers in 1410. He was commissioned to provide decorations for the city and was a member of the Communal Councils from 1425 to 1427, although he was prosecuted for having joined the rebels in social struggles and leading a dissolute life. Initially condemned to banishment, he was finally ordered to pay a small fine as a result of the protection offered by Margaret of Burgundy, the Countess of Hainault. Campin died on April 26, 1444.

Figures Executed with Simple Realism

The *Annunciation* at the Brussels Museum has a monumental quality that inspires indescribable emotions. Our eyes are fully drawn into the scene as if we were isolating its intimacy by peering through an overhead window. In the background, closed windows endow this mysterious scene with even greater secrecy. The colors vary from the milky white hue of the angel to the Virgin's purple mantle with a carefully calculated brightness.

In order to be convinced of Robert Campin's identity as the "Master of Flémalle," one has to compare this *Annunciation* with the scene portrayed in the triptych at the Metropolitan Museum in New York. It is possible to recognize the same hand in the poses of the angel and the Virgin. There is also the same round

THE MASTER OF FLÉMALLE

A delightful story-teller who remained loyal to traditional methods, he sometimes pursued exquisite digressions as did other painters during the early sixteenth century. The famous Annunciation *in the Mérode Collection, which is surrounded by all of the works presumed to represent his works or those of his school, imparts to us all of the secrets of his spirit. He was somewhat unresponsive to the external beauty of human beings and particularly the beauty of the feminine form, while his plastic techniques often yielded cumbersome shapes. The "Flémallian" style was not associated with the milieu of Tournai, where the manneristic elegance of fourteenth century French art held sway. Instead, it suggests the ambiance of Dijon around 1400, when the first indications of distinctly realistic art in northern Europe began to emerge.*

Fierens-Gevaert
La Peinture flamande, Volume II

Annunciation Scene, with Saint Joseph and the Donors, c. 1420
Center panel: 64 x 63 cm.)
(Side panels: 65 x 28 cm.)
Metropolitan Museum of Art, New York.
This painting in which the artist adopted a descending perspective has an appealing intimacy. The donors appear in the left panel and Saint Joseph is shown working as a carpenter in the right panel.

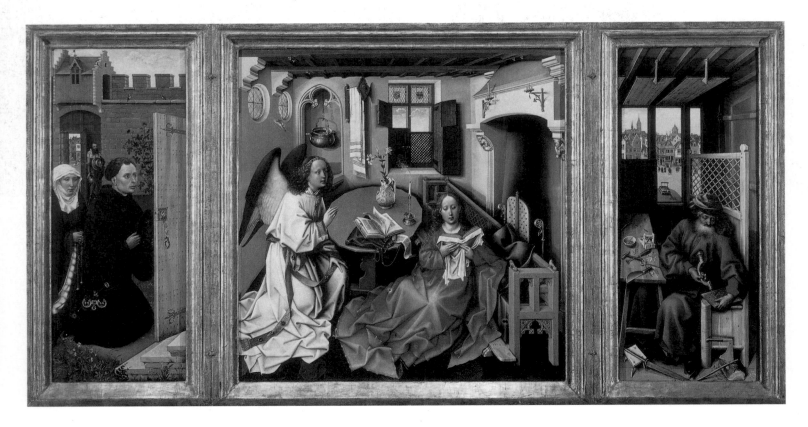

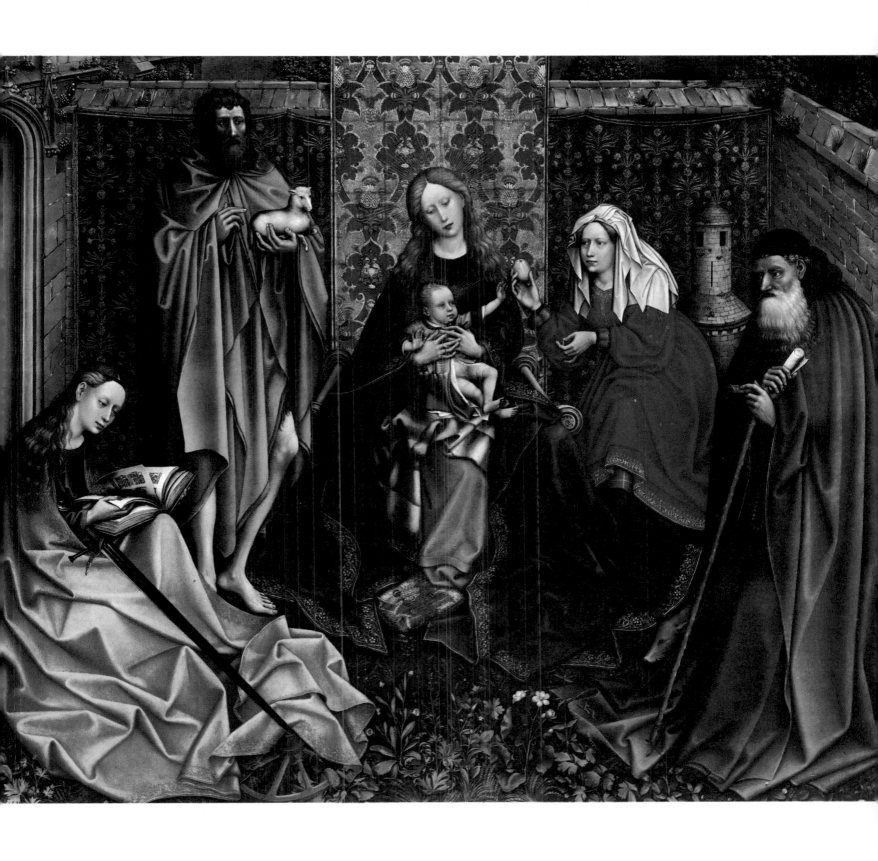

The Virgin with Saint Catherine, Saint John, Saint Barbara, and Saint Anthony, early fifteenth century.
(120 x 149 cm.). National Gallery of Art, Washington, D.C.
This Madonna surrounded by saints is situated within a geometrically harmonious context.

19

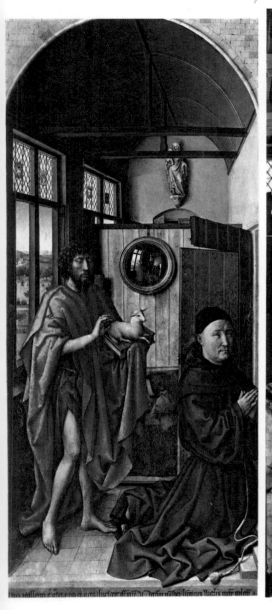

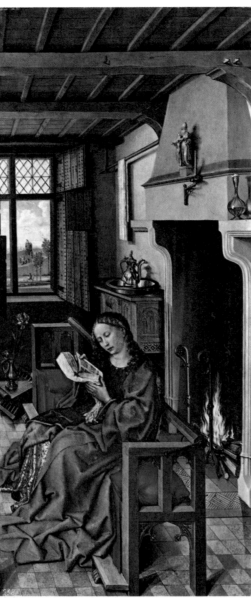

Saint John the Baptist and a Clergyman Praying, 1438.
(101 x 47 cm.). Museo del Prado, Madrid. Saint John the Baptist with the Lamb on his arm is reflected in the mirror in a way that is reminiscent of Jan Van Eyck. The praying clergyman is Friar Henri de Werl, whose name appears on the panel.

Saint Barbara, 1438
(101 x 47 cm.). Museo del Prado, Madrid. This is the second panel from a triptych that also included the preceding painting. There is no information concerning the center panel.

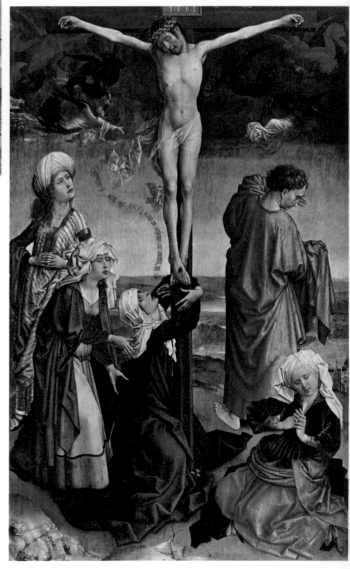

table painted from an overhead perspective and adorned with a vase containing lilies. Moreover, the open book, the candlestick, the wood of the long Gothic bench, and the hearth are the same. What a style! What simple realism in these figures!

What tranquility! It appears to be a continuation of Van Eyck. The wood of the same bench reappears in the *Saint Barbara* at the Prado. This painting encompasses all of the elements of early Flemish art with its unadorned style and its windows opening onto urban or bucolic landscapes.

Subsequent to an unforgettable painting in Siena by Ambrogio Lorenzetti but prior to a painting by Fouquet (Musée Royal des Beaux-Arts, Antwerp), the theme of "the Virgin Nursing Her Child" became popular during this era. Campin's *Virgin* (his painting has often been attributed to an unknown artist) is distinguished by exceptional serenity beneath her white coif with large folds. This particular painting is also distinguished by very precise draftsmanship and by an "Arnolfini" mirror that reappears in his *Saint John the Baptist and a Praying Clergyman* at the Prado (The room is filled with an abundance of objects).

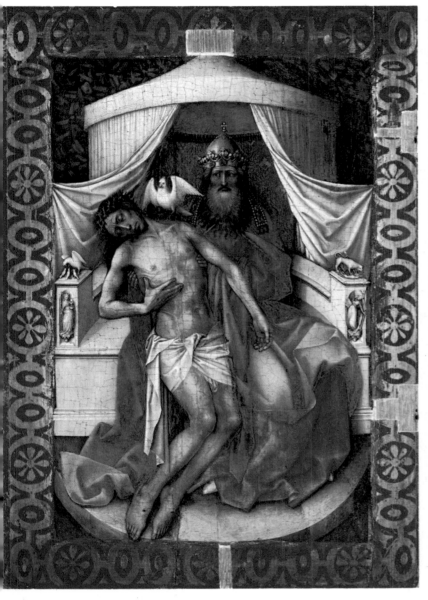

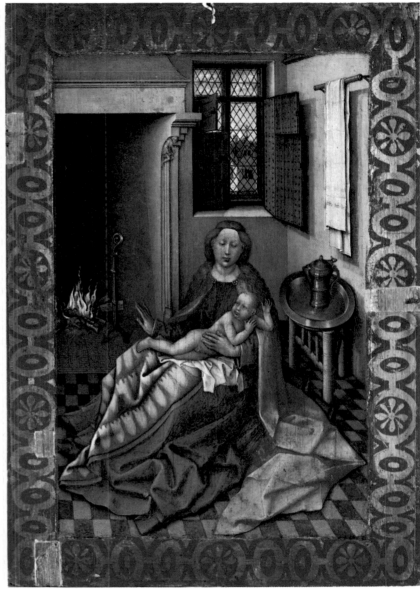

The Trinity, the Virgin, and the Child,
early fifteenth century.
(34.3 x 24.5 cm.). The Hermitage
Museum, Leningrad.
This is the most complete painting where
this particular theme appeared. There are
other versions in Frankfurt and at the
Musée Communal in Louvain.

← *Crucifixion,* c. 1440.
(77 x 47 cm.). Galerie Dahlem, Berlin.
The landscape, the sky, and the angels
were added shortly after completion of
this painting.

In a large panel at the National Gallery of Art, Washington,
D.C., where the Virgin is placed between Saint Barbara and Saint
Anthony (Saint Anthony appears to have been skillfully re-
touched), the triangular arrangement appears to serve as an
appropriate specimen for a course in geometric layout.

Nearly all works from this period reflect a style possessing an
astonishing degree of unity. Hence, the "Master of Flémalle"
sometimes displays close similarities to the "Master of Moulins."

The "Master of Flémalle," who probably trained Rogier Van
der Weyden, a younger artist, displayed a unique familiarity with
landscapes, as it is possible to observe in his *Adoration of the
Magi* at the Musée de Dijon.

He was fascinated with details and consistently chose to pre-
sent them within a vast framework. "The Master of Flémalle" was
undoubtedly influenced by the sculptors of Hainault, from whom
he may have derived a robust precision of form. To an even
greater degree than Van Eyck, he may represent the source of the
teeming scenes created by Conrad Witz and by the "Master of
the Aix Annunciation."

Rogier Van der Weyden

Rogier de la Pasture, around 1400–1464.

As a master of considerable breadth, this artist created not only the Last Judgment of Beaune *but a triptych revealing extensive knowledge of the craft of painting. In recreating the sacramental scenes of Christianity, he journeyed far from the boundaries of realism.*

As in the case of earlier painters, it is difficult to formulate a precise concept of the works of Rogier Van der Weyden, who was known as "Rogier de *le* Pasture" in Flanders (Jules Destrée corrected the reference to "Rogier de *la* Pasture"). There are no works bearing his signature and there is little available documentation. The great aritists of this era were exceptionally modest. Consequently, it is not possible to accept many of the attributions that have been proposed. Let us therefore open our eyes and observe!

As a whole, this is a mode of art impregnated with deeply religious and sometimes profoundly touching sentiments.

Rogier Van der Weyden painted triptychs and highly dramatic scenes within strict Gothic architectural contexts. His deepest compassion was reserved for the image of the Virgin. He also created portraits dominated by a serious tone. The sacraments of the Church are placed amid God, the Virgin, and the saints. Van der Weyden was the most liturgical painter of his era and nature is merely an accessory element. His paintings are sometimes without trees or hints of greenery; instead, one encounters gold and dark backgrounds, or ogival architecture. In Van der Weyden's creations, everything is framed between the birth and death of Christ or between baptism and the final rites preceding the *Final Judgment* portrayed in the Hôtel–Dieu of Beaune.

Rogier Van der Weyden was the first early Flemish painter to rely on shifts in perspective as a means of intensifying the impact of his style. He was also the first to combine linear and pictorial elements with diversity. His work is characterized by an unmistakeable legibility as a result of his talent for creating complex but well-balanced evocations.

Rogier Van der Weyden was the son of a cutler. Born in Tournai around 1400, he married a native of Brussels when he was in his twenties. In 1427, he was working under the tutelage

Crucifixion Triptych, c. 1440.
(Center panel: 101 x 70 cm.)
(Side panels: 101 x 35 cm.).
Kunstshistorisches Museum, Vienna.
"The Crucifixion" is placed between panels depicting *Mary Magdalen* and *Saint Veronica*.

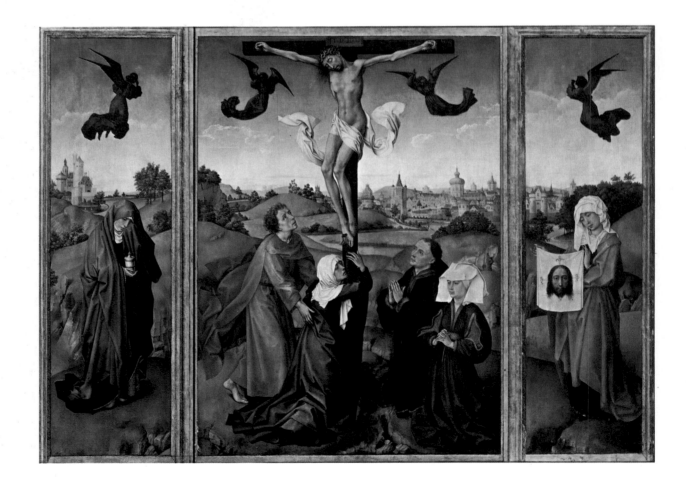

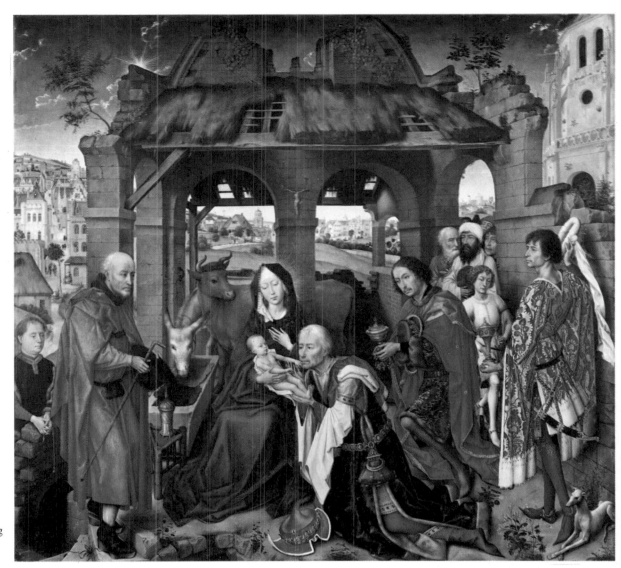

Adoration of the Magi,
1455–1460
(138 x 153 cm.)
Alte Pinakotek,
Munich.
The importance
allotted to the land-
scape in this painting
constitutes a signifi-
cant innovation.

*Pietà with a Donor
and Saints*,
early fifteenth
century.
(34 x 45 cm.). Na-
tional Gallery,
London.
The subjects por-
trayed by Rogier Van
der Weyden in-
fluenced other
painters for more
than a century.
Rogier Van der
Weyden was especial-
ly creative in adapt-
ing themes. His
works inspired a far-
reaching renovation
of Christian
iconography.

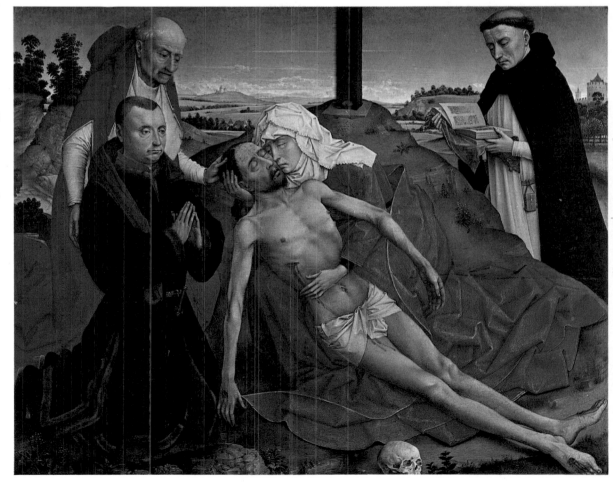

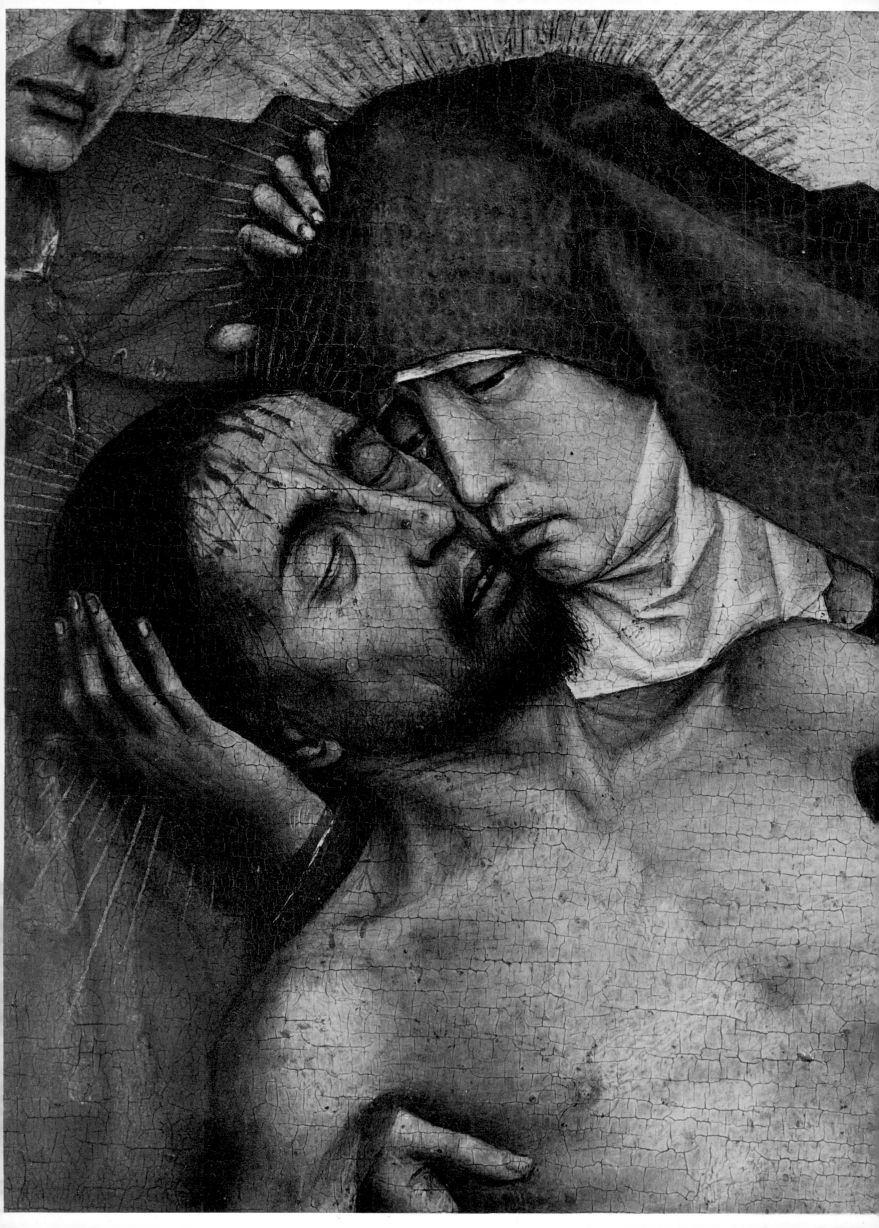

of the "Master of Flémalle" and, five years later he became a free master in the guild of Tournai. After being appointed as the official painter for the city of Brussels in 1435, he was usually known by the name Rogier Van der Weyden. In 1450, he travelled to Rome in honor of the Holy Year Jubilee, and had a chance to observe the works of Gentile da Fabriano who had died in Rome more than twenty years earlier. Upon returning to Flanders, Van der Weyden prospered as an artist until his death in Brussels on June 18, 1464.

His dramatic genius is clearly demonstrated by the *Pietà,* in which he painted a Virgin with a uniquely touching face. The entire world's grief for the death of Christ is concentrated in her countenance.

The *Crucifixion Triptych* is regarded as a painting of the artist's mature years. In spite of retouching in the center portion, this is a painting in which the color scheme has been ingeniously developed from reds and blues. In the left panel, Mary Magdalen is holding a jar containing ointments while Saint Veronica appears in the right panel with the shroud bearing the Divine Image. Dark angels are shown mournfully fluttering above the cross.

In order to complete his large tableau in Beaune, Van der Weyden relied on assistants. This painting is strictly orthodox from a scriptural viewpoint and it was originally placed in the chapel of the town hospice. Albert Vandal imagined the terrifying vision that must have confronted the sick when they observed this final drama of Christianity during times when the chapel was fully illuminated.

ROGIER VAN DER WEYDEN

The escutcheons of the bishopric of Tournai and of Jean Chevrot each appear three times upon the triptych. There cannot be any doubts concerning its origin. This triptych traveled far and undoubtedly underwent substantial damage before Van Ertborn purchased it in Dijon in 1826 from the heirs of Pirard, the last "Presiding Speaker" of the Parliament of Burgundy. Some of the figures appear to have been retouched (especially in the baptismal scene) and their fluid forms and brownish hues clash with the precise delineation and tranparent coloring of the accompanying faces. The original quality of its colors was generally preserved, however, and is identical to what we encounter in the Last Judgment *in Beaune. The reds, blues, violets, and whites of cloaks and robes blend against a silvery backdrop. Burger regarded the* Seven Sacraments *as Van der Weyden's masterpiece.*

Fierens-Gevaert
La Peinture flamande, Volume II

Pietà, early fifteenth century.
(32 x 47 cm.). Musées Royaux, Brussels.
This painting presents the same theme as the *Pietà with a Donor and Saints*, although it conveys greater depth of emotion. In both paintings, the Christ figure was depicted in the same slanting pose. Intense sadness is expressed by the sorrowful face of the Virgin leaning toward her son.

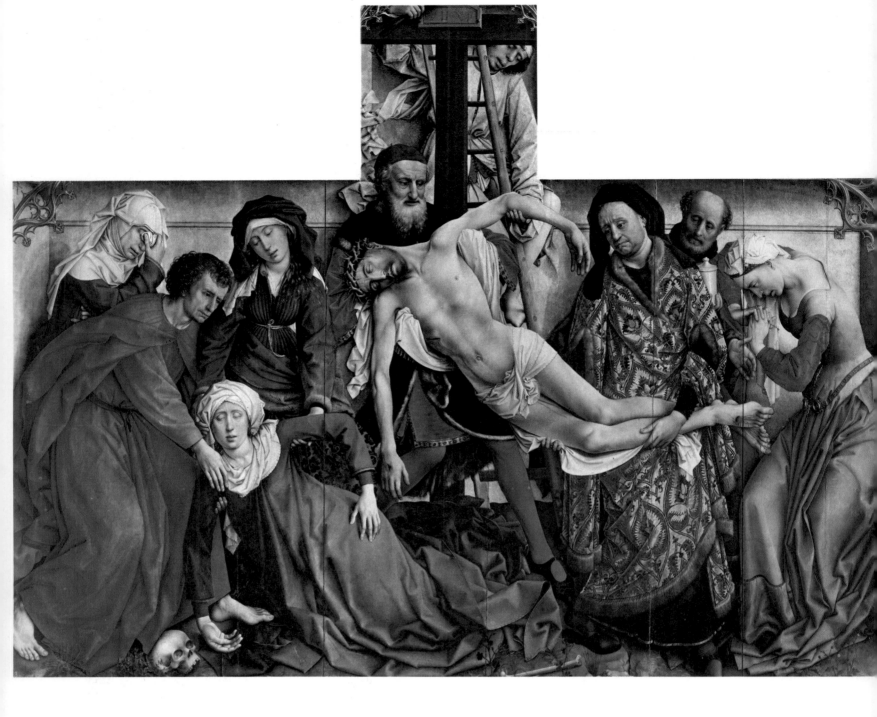

Descent from the Cross, c. 1435.
(220 x 262 cm.). Museo del Prado,
Madrid.
In this portrayal of the descent from the
cross, Christ's body appears in an oblique
position once again.

In the *Descent from the Cross* at the Prado, Van der Weyden
made use of a gold background for greater intensity. His Christ
supported by the mourners forms a grief-inspiring diagonal. This
panel (it has an unusual history) was initially hung in the Church
of Notre-Dame-hors-les Murs in Louvain. Subsequently, it was
acquired by Mary of Hungary. At a later point, a ship transport-
ing Van der Weyden's masterpiece to the King of Spain sank but
the panel floated because it was made of wood. So, it was saved.

The scene, accompanied by a gold background, is reminiscent
of a bas-relief. A weeping woman, with a handkerchief placed
over her eyes, appears beside Saint John. There is a full view of
the Virgin's face beneath her white coif; she is extremely pallid
because she has fainted. In turn, Mary Magdalen's body was
painted with admirable suppleness, whereas Christ's body is
characterized by a rigid and lifeless pose.

The *Triptych of the Seven Sacraments* offers marvelous scenes
beneath a Gothic nave. Ceremonies from baptism to the last rites
unfold beneath a Christ figure placed in the uppermost register,
where he is nailed to an exceptionally long cross extending
between the curved portions of the nave above the Eucharist. This
is a monumental creation with a profoundly expressive structure,
where figures are often separated by columns and where angels
attired in red, white, and yellow hover above the baptismal scene,
in contrast to the angels in dark blue robes placed above the
sacraments associated with maturity and death.

Portrayal of the Virgin

In comparing these scenes depicting the sacraments, Rogier
Van der Weyden's portrayals of the Virgin are distinguished by
an unexpected gracefulness, compassion and refinement. The

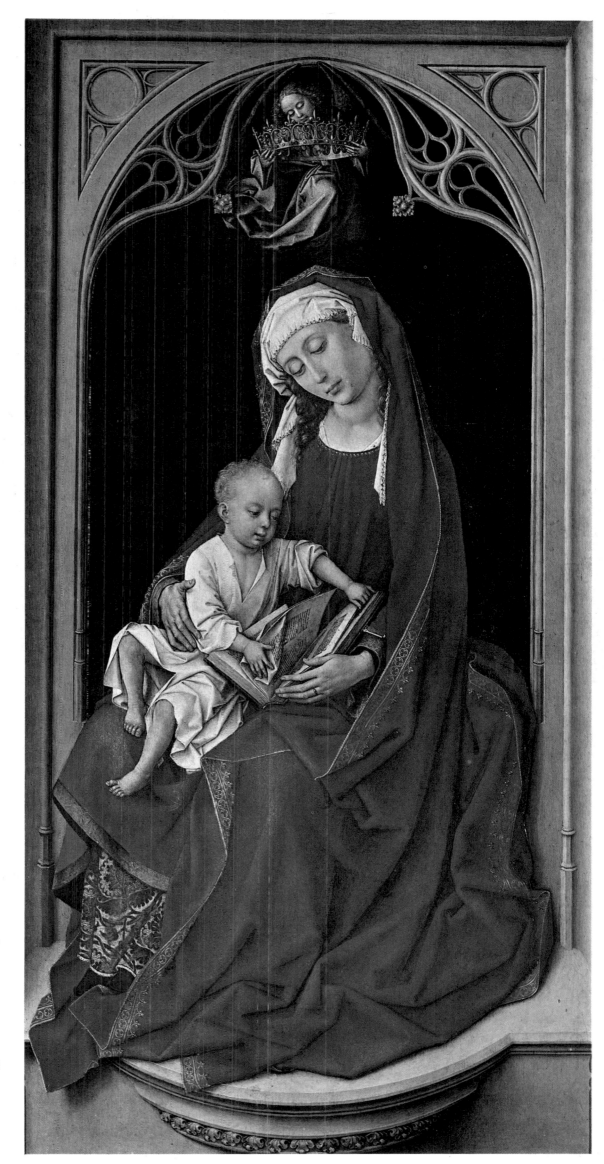

The Madonna Crowned by an Angel, early fifteenth century. (100 x 52 cm.). Museo del Prado, Madrid. This painting is impressive on account of its warm colors. The Virgin's cloak is purplish-red, in contrast to the Christ Child's white garment.

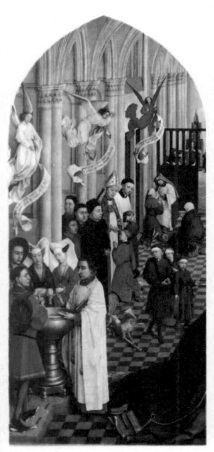

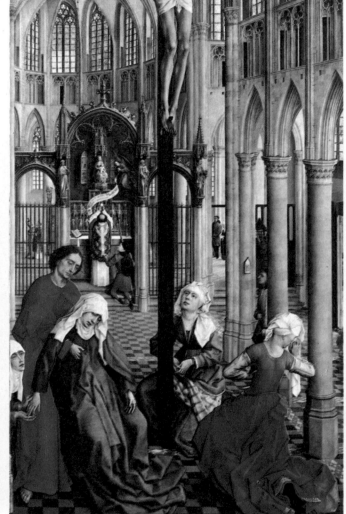

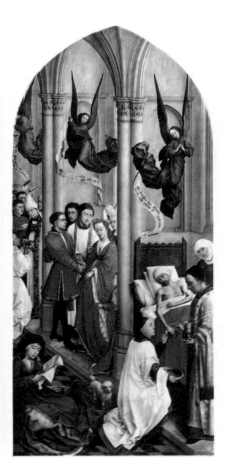

Triptych of the Seven Sacraments, c. 1450.
(Center panel: 200 x 97 cm.)
(Side panels: 119 x 63 cm.).
Musée Royal des Beaux-Arts, Antwerp.
This synoptic composition furnishes evidence of the painter's devoutness and of his inventive quest for innovative ways of presenting scenes inspired by Christian liturgy. This is one of Rogier Van der Weyden's masterpieces.

Virgin Crowned by an Angel sits beneath a portico adorned with Gothic interlacing. The Mother of Christ is wearing a red mantle, while her child sits her knees turning the pages of a book with his tiny hands. This image, set against a black background, has a delicate sinuousness and exceptional tenderness. The same qualities are observable in the *Virgin Nursing The Child* at the Art Institute of Chicago — a deeply moving painting in spite of alterations that produced rigidity in certain locations and damaged the Christ Child's left hand.

Van der Weyden's portraits are characterized by greater linearity, with the exception of his *Portrait of a Lady* in the Mellon Collection (National Gallery of Art, Washington, D.C.). This is one of Van der Weyden's most impressive attempts to evoke a feminine figure and it may be a portrait of Marie de Valengin, the daughter of Philip the Good. The lady's pensive face is framed by a transparent wimple and her lips possess a sensual fullness.

If one wishes to discover an unforgettable face, it is sufficient to examine the *Man with an Arrow* (Musées Royaux, Brussels). This man wearing the necklace of the Order of the Golden Fleece may be Anthony, an illegitimate scion of the House of Burgundy.

Rogier Van der Weyden transports us away from earthly life and *natura naturans,* immersing us in a realm of religious devotion that he was the first to endow with such intense liturgical imagery.

Madonna Nursing the Christ Child, 1450–1460. →
(39 x 28 cm.). Art Institute, Chicago.
This painting offers another treatment of a theme previously adopted by Van Eyck.

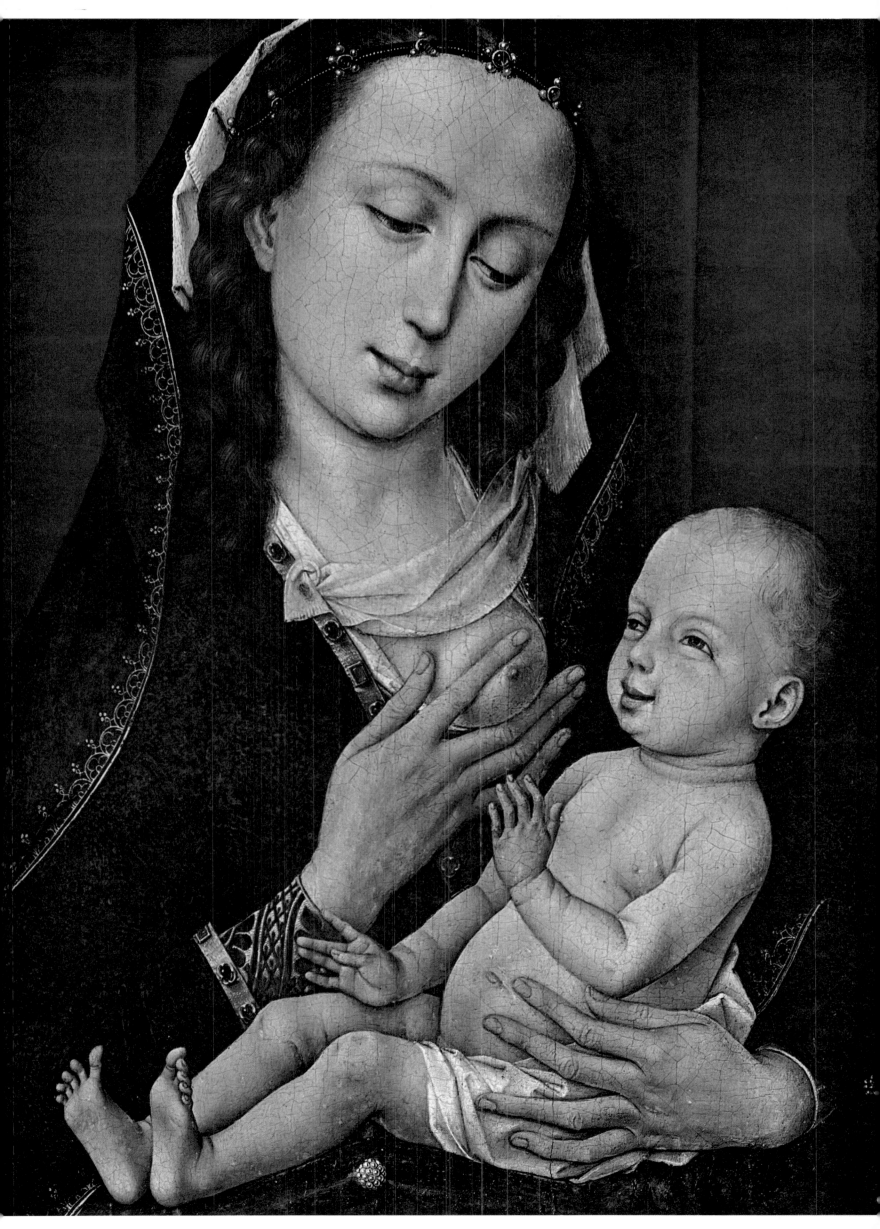

Thierry Bouts

1415–1475.

In Thierry Bouts' works, landscapes acquired an important role in painting. His paintings are distinguished by precise forms. The Last Supper was painted with a slanting perspective.

The style of Rogier Van der Weyden is echoed in approximately forty paintings completed by or attributed to Thierry Bouts. It is possible that some of these paintings were done by his sons Dirk and Albert who were his pupils and adopted the same techniques.

The Resurrection is the strongest expression of Bouts' talents.

In this painting dominated by upright figures, an angel in white robes stands on the overturned stone, behind an erect Christ figure who has emerged from the Sepulchre. These two vertical figures are offset by the awakened guards, who are cringing in fright. The colors are of an unexpected brilliance, varying from deep crimson to pure white, with changes in tone occurring in front of a vast landscape that extends endlessly amid shades of blue.

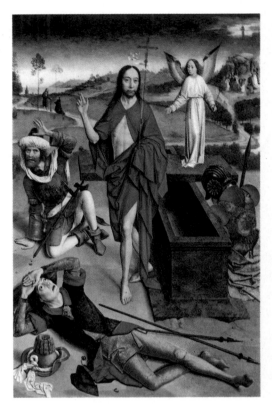

Resurrection, c. 1450.
(105 x 68 cm.). Alte Pinakotek, Munich.
Christ is shown emerging from the tomb, between a white-robed angel and the guards, who are overcome with fear at the sight of the Resurrection.

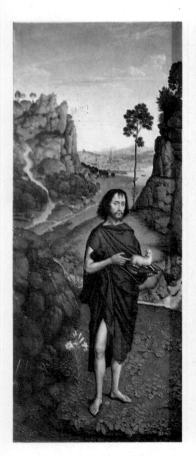
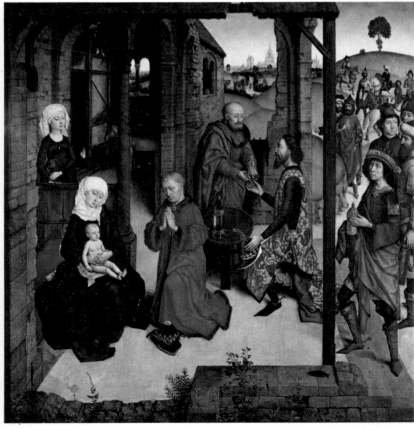
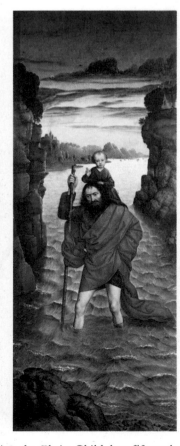

Adoration Triptych, c. 1445.
(Center panel: 63 x 62 cm.)
(Side panels: 63 x 28 cm.).
Alte Pinakotek, Munich.

Madonna Nursing the Christ Child, late fifteenth →
century.(37 x 28 cm.). National Gallery, London.
This Madonna nursing the Christ child closely
resembles Rogier Van der Weyden's version.

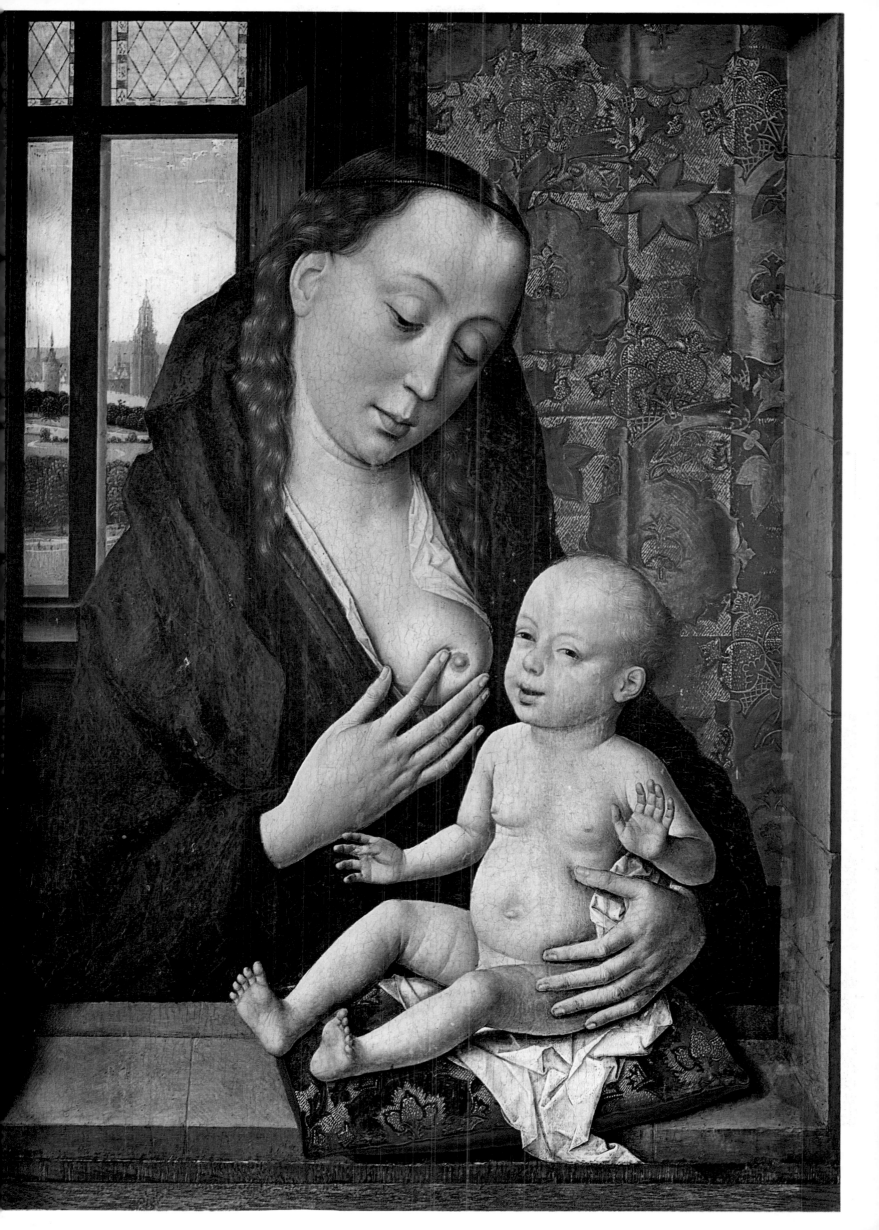

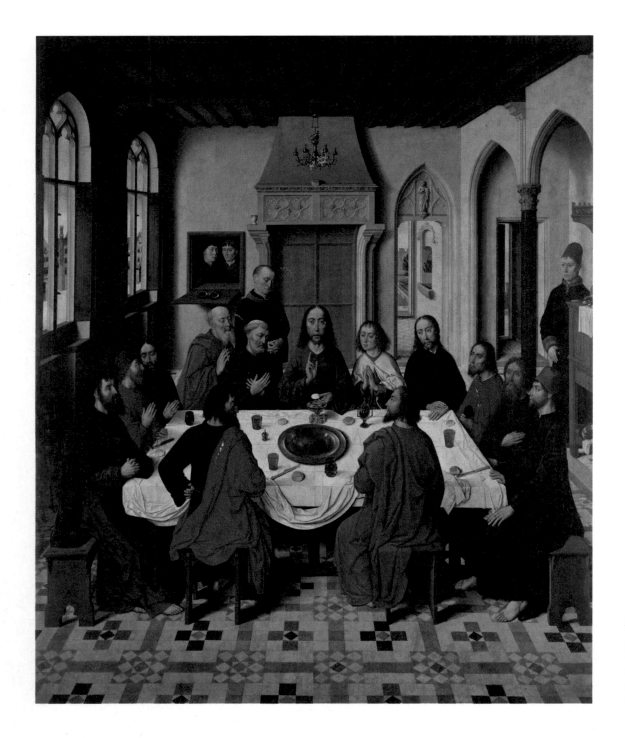

The Last Supper Altarpiece, c. 1457. Center panel: Church of Saint Peter, Louvain. This significant painting by Dirk Bouts is highly original because of the slanting perspective.

We also encounter the theme of the *Virgin Nursing Her Child* in a version similar to Van der Weyden's (in fact, the Christ Child is almost identical). Here, the Virgin is offering her breast to her child in front of a window revealing a town with castle-keeps and bell-towers beside a pink tapestry bedecked with gold.

It is known that Thierry Bouts was born in Haarlem and, after studying under Van der Weyden in Brussels, he married Catherine Van der Bruggen, a native of Louvain, in 1448. It is also known that she bore him several children. Residing in Louvain after 1457, he painted a *Last Supper* with a slanting perspective and an unusual layout (this altarpiece was placed in the Sint Pieterskerk in Louvain). Other works attributed to Bouts include two large panels for *The Trial of Othon* (Musées Royaux, Brussels) and an extremely unusual *Portrait of a Man* (Metropolitan Museum of Art, New York).

The principal trait which distinguishes Theirry Bouts from earlier painters is his contribution to portrayal of landscapes. For example, the principal scene of a triptych depicting the *Adoration of the Magi* (Alte Pinakothek, Munich) is accompanied by a left panel where Saint John the Baptist is surrounded by a vast landscape accentuated by trees and crags. The right panel showing Saint Christopher with the Christ Child on his shoulders contains a magnificent aquatic milieu that is more ocean-like than fluvial. This triptych became known as *The Pearl of Brabant*.

Hugo Van der Goes

1440-1482.

Van der Goes succeeded in giving an expressive richness and exceptionally bright color schemes to his paintings. Somewhat swept away by religious exaltation, he lost his sanity during the final years of his life.

One can recall the wonder of Hugo Van der Goes' *Portinari Triptych* at the Uffizi Gallery in Florence after protracted scrutiny of the Italian masters. The differences between Flemish and Italian art emerges with unprecedented sharpness. The close-woven style, with admirable precision (it has been suggested that Van der Goes was originally a miniaturist) and unexpected diversity of colors, was a bold contrast to the works of the Italian School. Here was a vision of another world, unexpectedly emerging among the works of art of that time.

In the *Adoration of the Shepherds,* a loftier reality encompasses the unveiled Virgin standing above the Christ Child reclining upon straw. The infant is surrounded by worshippers, including kneeling angels with white, blue, or golden robes and angels hovering in the air. The shepherds display both curiosity and reverence. Among the shadows, a white-bearded Saint Joseph stands beside an ox and an ass. For each element, such as a vase in the foreground that contains lilies and columbines, there is a precise location. What a miracle! A concerto of eyes and hands appears to flow toward the Christ Child.

In the two side-panels depicting saints, the patron and his family are also portrayed in more modest proportions. Tommaso Portinari, an agent of the Medicis in Brussels, is shown with his two sons, Antonio and Pigello, in the left panel, while his wife and daughter appear in the right panel.

This triptych, which has been attributed to 1475-1478, was originally placed in the chapel of the Hospice of Santa Maria Nuova in Florence. Folio Portinari, the father of Dante's Beatrice, had erected this chapel in 1285. Subsequently, Van der Goes' triptych was moved to the Uffizi.

Bold Colors

The tranquil mood of this triptych does not diminish its expressiveness, whereas its delicacy more fully awakens our emotions. The extremely distinctive color scheme is composed of beautiful blacks, aquamarines, scarlet-tinged reds, clear whites, and above all, a brightness that is astonishingly bold without ever becoming excessive.

The Holy Infant is barely visible amoung the many figures appearing in the center panel. The observer must look for him among the throng of worshippers where he almost appears to have the same composition as the soil. Christ's humanity has

Portinari Altarpiece, c. 1475–1478.
(Center panel: 253 x 304 cm.)
(Side panels: 253 x 141 cm.).
Galleria degli Uffizi, Florence.
In the first edition of his *Vite* (1550), Vasari cited this altarpiece as an important work commissioned by Portinari, the Medicis' representative in Bruges.

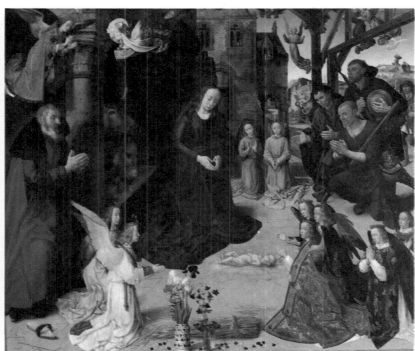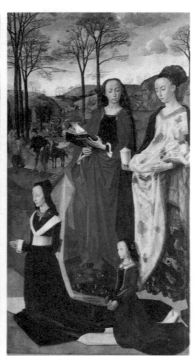

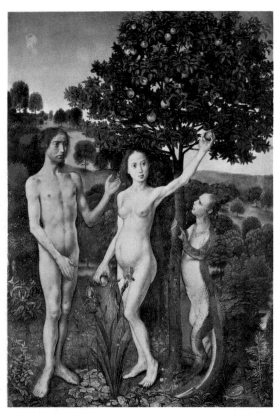

The Fall of Man, c. 1460–1470.
(34 x 23 cm) Kunsthistorisches Museum,
Vienna.
This painstakingly crafted painting is cited
in a list of paintings owned by Margaret
of Austria. It is reproduced in a miniature
in the *Grimani Breviary.*

HUGO VAN DER GOES

In the first edition of Vasari's Vite (1550), *there is a reference to Van der Goes and his masterpiece:* Hugo of Antwerp who created the altarpiece of Santa Maria in Florence. *This altarpiece was purchased by the Italian government for 900,000 lire in 1897 and was relocated to the Uffizi.*

Florentine painting at the end of the fifteenth century fully attests to the widespread influence of this Flemish Nativity scene in Italy. And it is certainly true that Florentine tastes inspired its completion. We are deeply indebted to the patron who commissioned the altarpiece. The memory of Tommaso Portinari enters the mind of knowledgeable travelers who visited the beautiful Hotel of Pierre Bladelin in Bruges (now converted into a museum) where the famous patron resided in 1479, or the stately Church of Saint Jacques, where the painter deployed his artistic skills to transform and enoble the "plebeians" who caught his eye, so that these reverent rustics jostling one another were not even surpassed by Bruegel. One acquires the impression of encountering a series of portraits where the master lavished his talents upon each detail. An unending quest for individualization marks the adornments, accessories, greenery and hands, even more than the faces. Every expression converges towards the center, with the same movement and inspiration emerging everywhere. One shepherd is already praying devoutly and another is kneeling as he gazes raptly at the Holy Infant. A third shepherd breathlessly raises himself to observe while others in the distance marvel at the sight of the angels, so that there are men trembling and rushing forth with the same love, from the depths of the horizon toward the mystery of the divine birth.

Fierens-Gevaert
_____ *La Peinture flamande,* Volume II

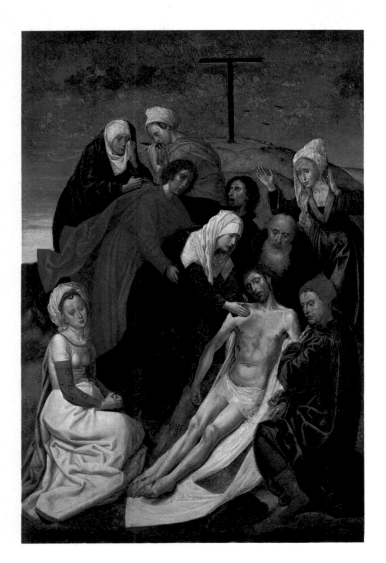

Descent from the Cross, late fifteenth
century.
(36.2 x 30.2 cm). The Hermitage Museum,
Leningrad.
This strikingly pallid Christ figure is surrounded by a large group of mourners.

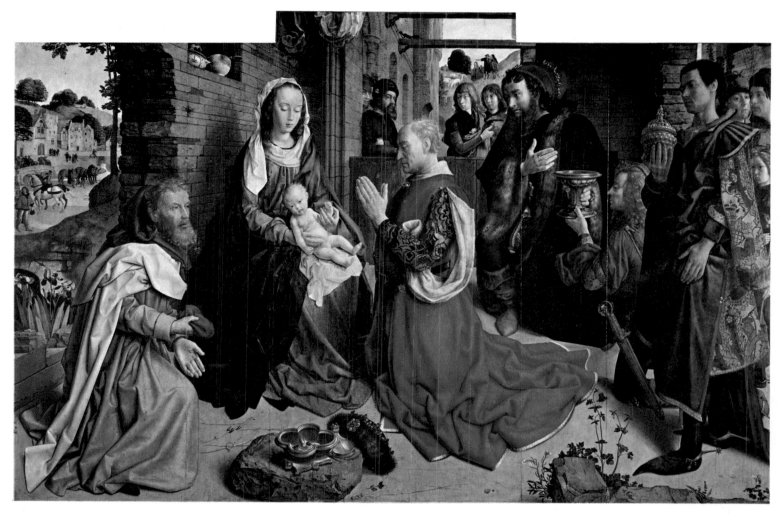

Adoration of the Magi, c. 1470.
(147 x 242 cm). Galerie Dahlem, Berlin.
Hugo Van der Goes portrayed this subject several times
and this is the most beautiful version. The altarpiece
adorned with angels filled a triangular pediment and
represented an object of fascination for the Antwerp
painters. This altarpiece was sent to a monastery in Mon-
forte, in Galicia (Spain), and it was purchased by the Berlin
Museum in 1912.

never been so humbly presented. Indeed, Van de Goes created
a formidable contrast that is entirely different from the qualities
of his *Adoration of the Maji* at Berlin's Galerie Dahlem.

In his *Fall of Man,* an unexpected iconography emerges, evok-
ing a dramatically different milieu. Here, amid an extremely
beautiful landscape, Adam and Eve are standing beneath the tree
of the waiting serpent. Eve's genitals are concealed by an iris and
Adam's are innocently covered by one of his hands, whereas his
other hand is held out to receive the fruit that Eve is plucking
from the tree.

Life and Faith Intertwined

On May 5, 1467, Hugo Van der Goes, who does not appear
to have signed any of his works, was admitted to the painter's
guild in Ghent, with Justus van Gent as his mentor. Seven years
later, he was cited in relation to decorative work completed in
Ghent and in Bruges. His creations reflected fervent religious
devotion and a degree of exaltation that fostered a sense of
unworthiness.

His absolute need to unify his life and his devoutness finally
led to torments of insanity.

At the end of 1475, as a mood of deep despair had intensified,
he became a lay brother in the monastery of the Rode Klooster
near Brussels. A monk named Ofhuys wrote an account of Hugo
Van de Goes' life in the monastery. In 1480, he was appointed
to appraise *The Trial of Othon,* a painting by Thierry Bouts.
Upon returning from a journey to Cologne, he was stricken by
an episode of insanity. As he oscillated between soaring exalta-
tion and abject humility, Hugo Van der Goes came to believe that
he was cursed and attempted to end his life. The abbot of the
monastery sought to calm him with music. Like Vincent Van
Gogh, Van der Goes continued to paint during his lucid inter-
vals. He died at the monastery and was buried in its cemetery.

Hans Memling

1435–1494

Memling, who was the most generously rewarded and renowned artist of his era, borrowed from his predecessors' works and filled the city of Bruges with flawless tableaux and portraits.

Hans Memling, who was born near Frankfurt in the village of Seligenstadt on the Main River, around 1435, traveled to Flanders at a relatively young age in order to study (perhaps after having lived in Cologne). By 1465, he was listed as a citizen of Bruges and married Anne de Valkenmaere who bore him three children. As the owner of several houses, he paid his share of the war tax levied by Duke Maximilian. Memling died in Bruges in 1494.

He painted for the Hospice of Saint John, which now serves as a museum for his works, and for wealthy patrons. Memling's foreign patrons included Sir John Donne, who escorted Margaret of York to her wedding with Charles the Bold in 1468, as well as the Italian banker Portinari. During his lifetime, Memling was highly esteemed as a portraitist and creator of altarpieces.

Exceptional Craftsmanship

Among the Flemish painters of his era, Memling displayed the greatest similarities to Italian painters and his works heralded the Renaissance. Colors, attire, hairstyles, tapestries, or his way of depicting interiors reflect an obsession with lavishness. Memling's works are characterized by a certain flawless monotony, where each element too consistently embodies the same level of skill and the same unfaltering hand. Despite Memling's competence, our emotions are seldom stirred. His style is most fully represented by the masterful *Madonna with Gift-Bearers and Saints,* or by the *Mystic Betrothal of Saint Catherine,* whose subject sits upon a dais between ornate columns surrounded by an abundance of

Epiphany Triptych (center panel), late fifteenth century. (95 x 145 cm). Museo del Prado, Madrid.
In comparison with the preceding altarpiece, this painting displays less fervor in spite of its consummate craftsmanship. The painting does not convey the ardent devotion and the profound truthfulness which inspired the creations of the painter who lost his mind during the final years of his life.

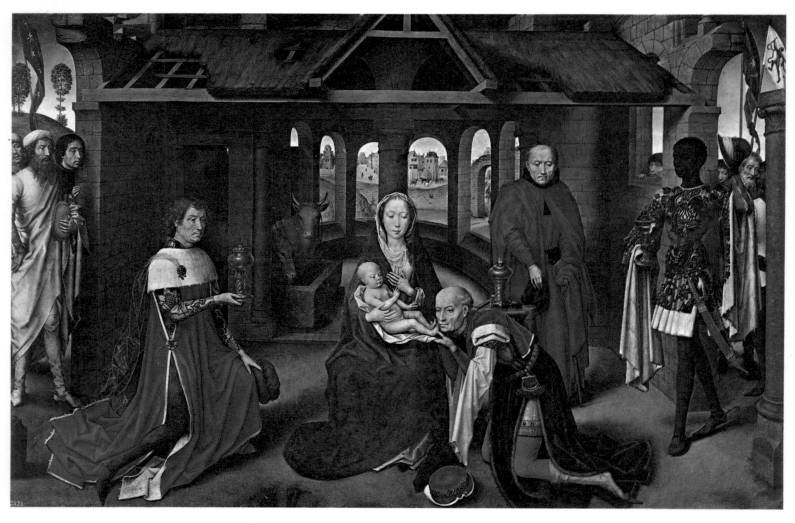

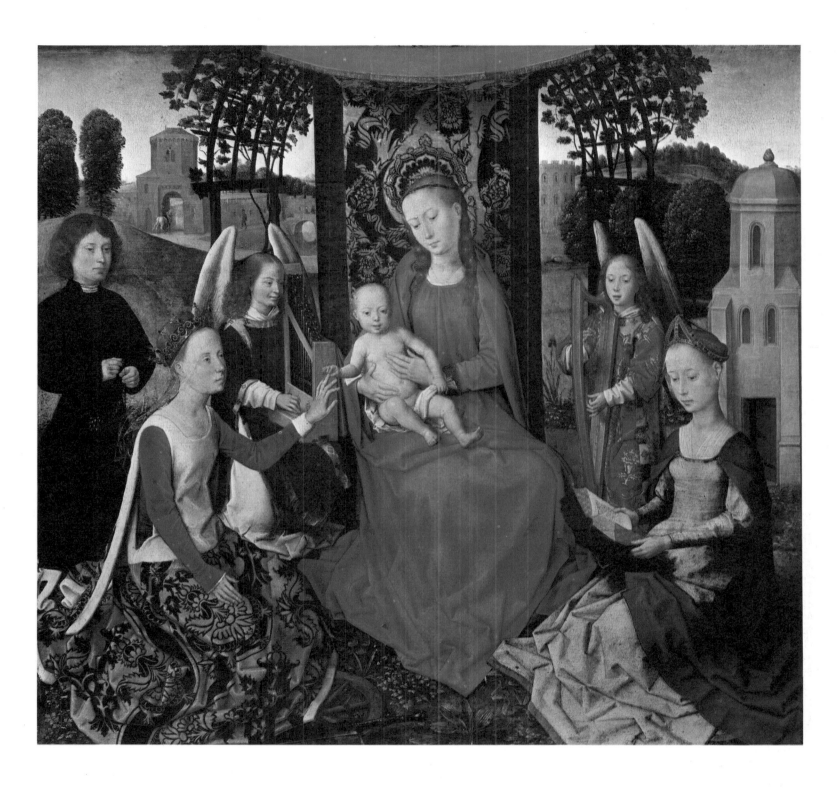

flawless harmony and sumptous colors. In this painting, each element was introduced with rigorous precision, and excessive ornamentation prevailed. Memling created several versions, with the earliest having been completed for the Hospice of Saint John in Bruges (probably in 1479). Other versions include the one belonging to the Metropolitan Museum of Art in New York, which has been reproduced here, as well as the Chatsworth version and another at the Louvre.

The same style was adopted for the *Epiphany Triptych* belonging to the Louvre. Memling's works are sometimes marred by blatant departures from reality. In the *Martyrdom of Saint Sebastian,* the archers were implausibly positioned directly in front of the martyr bound to a tree.

The Mystic Betrothal of Saint Catherine, 1479.
(69 x 73 cm). Metropolitan Museum of Art, New York.
The extremely beautiful Madonna sits on a throne with the Christ Child, surrounded by angels and by the donors. The canopy adorned with gold adds emphasis wile a landscape containing decorative trees appears on each side.

The influence of his predecessors (Van Eyck, Van der Weyden, Thierry Bouts) is obvious. Memling, with carefully composed scenes that are developed with unfailing impassiveness, was Bruges' foremost master of technique and indeed its virtuoso. To a certain extent he represents a compilation of his predecessors' styles. Memling was a stylist who tended to deemphasize the individual features of his models. Yet he was an ingenious colorist. One cannot overlook his deep reds, bright greens, sumptuous blacks, yellows resembling antique gold, or the rich fabrics that he portrayed. In all his works, one encounters lavish ornamentation and skillfully constructed landscapes.

It has been claimed that, as an impoverished young man, Memling only began to paint as a way of repaying his benefactors at the Hospice of Saint John. Fromentin, however, wrote: "What a shame! This pleasant tale is merely a legend which must be cast aside." Fromentin was enthralled by Memling's soothing

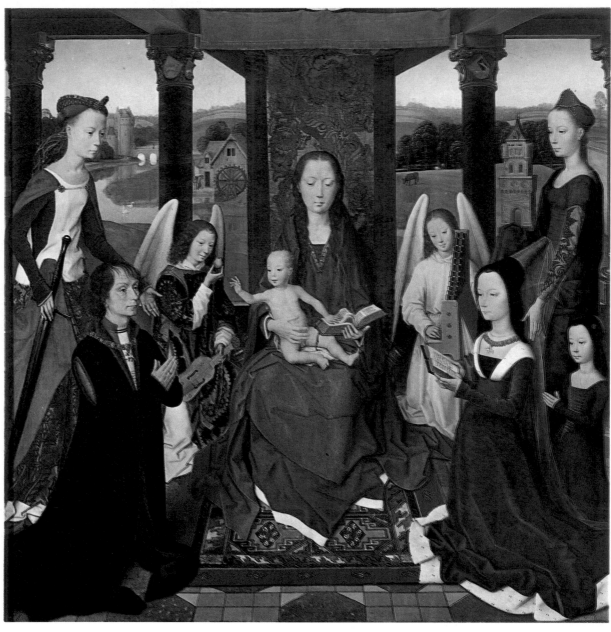

Madonna with Donors and Saints, c. 1477.
(69 x 71 cm). National Gallery, London. The same theme is presented somewhat differently in the center portion of the London triptych, where a full view of the Madonna's face is provided and where an angel is offering an apple to the Christ Child.

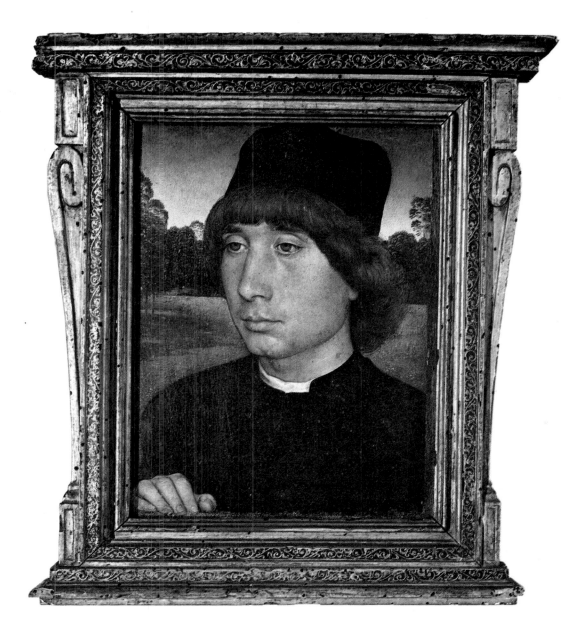

Portrait of a Young Man, 1473.
(26 x 20 cm). Accademia degli Belle Arti, Venice.
In this portrait Memling achieved a more personal quality. The subject's pose and the hand resting upon a wall reveal the influence of Italian artists.

craftsmanship. He considered this painter "distinct, unique, brilliant, and delightful, like a flower lacking visible roots or new buds. Memling was probably Fromentin's favorite among the fifteenth century masters.

Memling undeniably gained a reputation throughout Europe and his influence even became observable in Spain and in Portugal.

Everything in Bruges evokes his memory. The *Venice of the North* still reflects the presence of this artist and his creations. But his relatively unvaried techniques that established his success during his lifetime now evoke a certain sense of tedium.

His personality is most clearly recognizable in his portraits. In this domain, Memling's bold presentation of individuals, as his *Young Man* at the Accademia degli Begli Arti in Venice, estalishes him as a close rival of Antonello Da Messina. In our opinion, however, the Lourvre contains Memling's most signficant accomplishment within this genre. The *Portrait of an Elderly Woman* is characterized by a sensitivity that is somewhat rare for this painter. The pensive features beneath a large coif with flounces, the pursed lips, and a melancholy expression accentuated by a slight squint accompany a yellowish complexion. This woman is wearing a black gown trimmed with gray fur and her uplifted hand attests the ravages of time even more than her face.

HANS MEMLING

In 1480, probably during the month of May, Memling acquired a large house, domus magna lapidea, *on the street leading from the Pont Flamand to the city walls, along with two adjacent houses" (Weale). The painter was wealthy. There were only hundred and forty burghers in Burges whose taxes exceeded his. It is believed that his wealth was obtained through marriage. Indeed, between 1470 and 1480, he had married Anne, the daughter of Louis de Valenaere...*

Memling is a culmination of the fifteenth century. He softened the original forms of hs predecessors and revived their genius with deeply charming eclecticism. As a painter of Madonnas, he was overly stylized, attaining an excessively precise and simplistic perfection. As a painter of portraits, he foresook individual qualities without achieving the universality of Rogier (van der Weyden). Facile idealization may ccount for his exceptional success during his era and our own. Furthermore, there is a deep sense of orderly and rhythmic composition, along with subtle forms and pure, smooth colors. Even though dramatic beauty eluded him, he remained unchallenged with his lavish style as an assiduous chronicler.

Fierens-Gevaert
La Peinture flamande, Volume III

Petrus Christus

Master painter, 1444–1473

The well-deserved reputation of Petrus Christus emerged with a mysterious aura, especially because of his portrait of an unknown woman.

This painter may have been the "Piero of Bruges" mentioned in Milan in 1457. It is known that some of his works have been identified in Italy and that he is regarded as the creator of nearly twenty paintings in a style reflecting the pictorial preeminence of Jan Van Eyck and Thierry Bouts.

Petrus Christus signed his paintings with the characters "XPI." In 1462, he and his wife became members of the guild of Notre-Dame de l'Arbre Sec. He is also known to have fathered an illegitimate son, Sebastian Christus, who became an illuminator.

The Berlin *Madonna* one of Petrus Christus' earliest paintings, has a more fully developed counterpart, namely the Budapest *Madonna,* although the archway dominating the latter painting produces a somewhat static effect. The *Pieta* ("Descent from the

Portrait of a Young Woman, c. 1446.
(28 x 21 cm). Galerie Dahlem, Berlin.
This is an unforgettable image of a woman. Because of its smooth and detailed execution, this portrait has been referred to as the "Northern Gioconda."

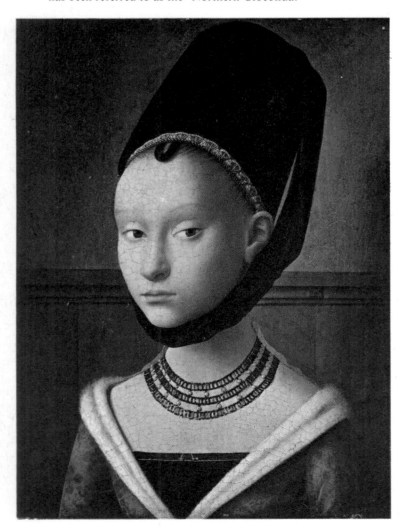

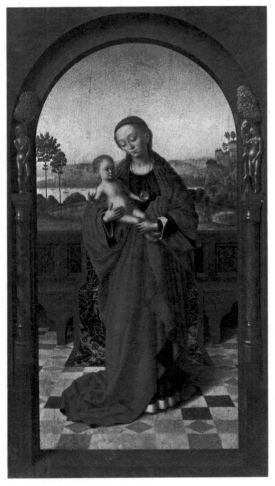

Madonna and Child, c. 1440–1450.
(55 x 31 cm). National Museum of Art, Budapest.
This standing Madonna, presented in an unusually subtle way, conveys the painter's emotions effectively.

Cross") at the Musées Royaux in Brussels is entirely different. Even though the attribution has been disputed, this painting is characterized by a distinct rhythm heightening its pathos. The principal scene is circumscribed by an oval, with the lower portion of the oval consisting of the shroud draped around Christ's body. At the center, Saint John is supporting the Virgin Mary, who is overcome by the sight of her son. To the left, Mary Magdalen stands isolated at the foot of the cross, her face turned aside. The painting is richly colored and reflects an unusual rapture with the Flanders landscape, whose hills appear in the background.

Without his *Portrait of a Young Lady* (Galerie Dahlem, Berlin), which is sometimes called *The Northern Gioconda,* Petrus Christus would undoubtedly have received less recognition and esteem. His female subject with long, slanting eyes possesses the mouth of a troublesome child. She is wearing an unusual conical headdress, with a loop comprising a chin-strap. A shiny dark curl accentuates the pallor of her forehead. The young lady is wearing a necklace composed of three gold chains and the blue bodice of her gown is trimmed with ermine. Her face is presented in smooth and limpid pale tones, whereas a trace of darkness is introduced by her expression.

Gérard David

1460–1523

Gérard David's works revealed an ability to bring new life to religious iconography by distinctly presenting certain details.

A considerable period of time elapsed before the works of Gérard David, the last master of the School of Bruges, were able to gain attention. Having joined the painters' guild in 1484, he became Bruges' leading painter when Hans Memling died. As a member of the "Arbre Sec" confraternity, he may have traveled to Genoa during 1511–1512 (some of his paintings have been discovered in Genoa). In 1515, he moved to Antwerp and became a member of the Guild of Saint Luke. Gérard David died on August 15, 1523, after having once again become a resident of Bruges.

An Original Iconography

One of the most impressive of Gérard David's works is the *Madonna and Child with Female Saints,* at the Musée des Beaux-Arts in Rouen. He is one of the few painters to have adopted this theme. The *Nativity* at the National Art Museum in Budapest is characterized by a highly original iconography. In front of an urban landscape and beneath the roof of a farmhouse, the Christ Child appears to lie partially on a rug and and partially on the floor. The Virgin and the figures standing around the Holy Infant form a semi-circle, wherein two minuscule angels in white robes are reverently kneeling at the center.

Perhaps the *Wedding at Cana* at the Louvre is the most deeply moving painting of Gérard David's. Its most striking figure is the young bride seated in the foreground beside Jesus. She is wearing a delicate gold crown and conveys a restless, detached, and somewhat anxious mood, ignoring the servant approaching her with a jug in his hand. The remains of the feast, lying in tin dishes, stand out against the whiteness of the tablecloth. Everything in this painting — facial expressions, colors, and the bride's attire — is marked by an irresistible charm.

Marriage at Cana, c. 1500.
(x cm) The Louvre, Paris.
This is the most appealing painting by the last of the great painters belonging to the School of Bruges.

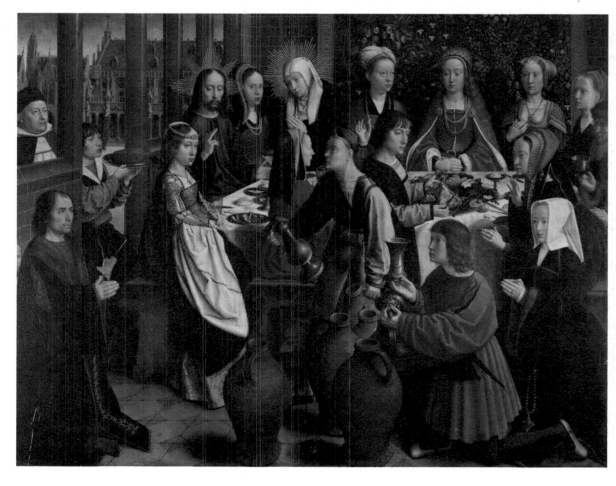

Quentin Metsys

1465–1530

Metsys introduced a certain degree of manner-
ism in selecting themes and he incorporated
craftsmanlike motifs in his paintings.

Quentin Metsys (also Matsys or Metsys) is the painter whose
works most fully reflect Italian influences on Flemish art. It is
believed that he initially studied under Thierry Bouts in Louvian,
and then upon becoming a master artist in Antwerp (1491), he
was exposed to the influence of Rogier Van der Weyden.

His career began at the point when Antwerp (he first became
a resident in 1491) was on the verge of becoming the economic
center of the Low Countries.

Although he initially painted in a Gothic style, Metsys promptly began to reflect the influence of the Renaissance. After 1510, he produced paintings for prominent men of wealth and humanists. He adopted natural themes with a distinctive sensuality, and the religious motifs represented by his *Burial of Christ* were gradually combined with an interest in realism.

The *Burial of Christ* reveals a throng of figures whose relative prominence is somewhat unconventional. The dignified person

The Burial of Christ, 1508–1511.
(Center panel: 260 x 273 cm. Side panels: 260 x 120 cm)
Musée Royal des Beaux-Arts, Antwerp.
The style of the Northern Renaissance began to replace the Gothic style of Van Eyck's successors, as this triptych demonstrates. The left panel presents *Herod's Feast* and the right panel *The Martyrdom of Saint John the Evangelist*.

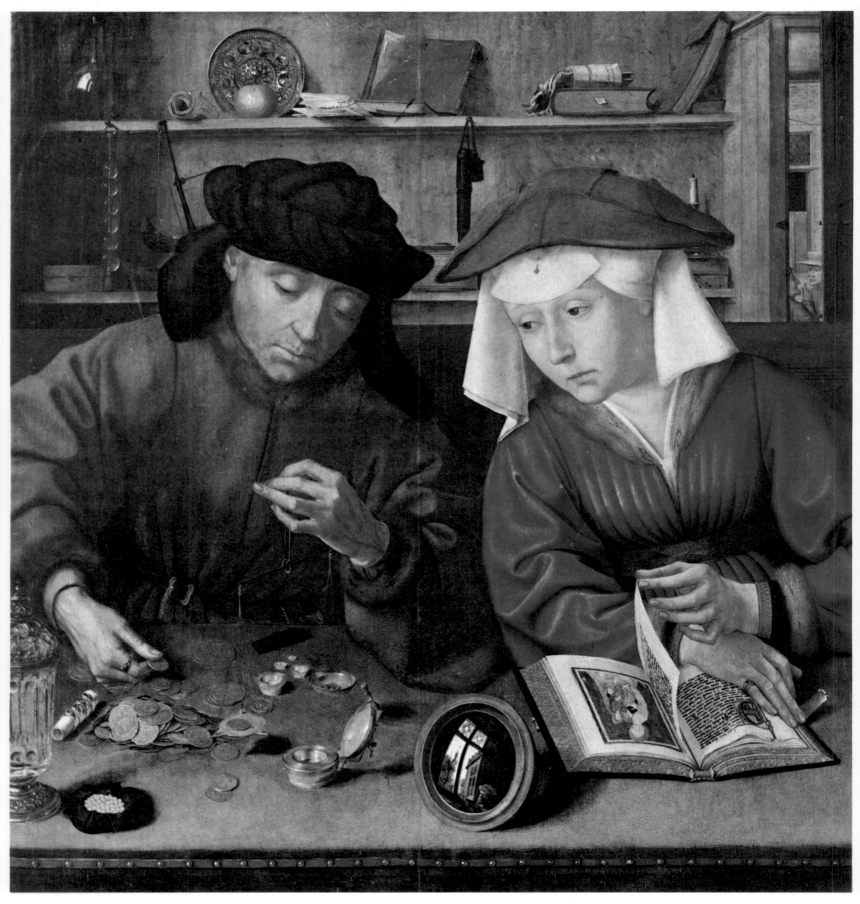

The Banker and His Wife, 1514.
(71 x 68 cm). The Louvre, Paris.
In this painting, the mirror previously seen in Van Eyck's
portrait of a couple reappears in a round frame. Quentin
Massys was closely associated with the humanists of his
era.

Quentin Metsys, the blacksmith from Antwerp, whose first creation was the well that can still be seen in front of the main gate of Notre-Dame, later used the same unerring and strong hands, with the same instruments as a molder of metals, to create the Louvre's Banker and His Wife *and the remarkable* Burial of Christ *at the Antwerp Museum.*

_____ Eugene Fromentin
_____ *Les Maitres d'autrefois*

appearing in the foreground, on the left side, almost overshadows the Virgin, who is leaning on Saint John, accentuated by a scarlet cloak. The other figures are set against a craggy landscape that provides a recollection of the Crucifixion. Nevertheless, the entire scene possesses a distinctive harmony, even though the figures appear to be devoid of religious fervor, with the exception of Christ, whose countenance bears an extraordinarily tormented expression.

Italian Influence

In the left panel, Mannerism is clearly represented by Salomé who is offering Saint John the Baptist's head to Herod. The right panel depicts the legendary and abortive martyrdom of Saint John the Evangelist, who was immersed in a pot of boiling oil outside the gates of Rome. The saint's bare torso emerges boldly and triumphantly from the cauldron, above the grotesque faces of his tormentors who are futilely stoking the fire. The Emperor Domitian, who is wearing a white turban, is shown observing the execution scene that failed to satisfy his intentions.

The most well-known painting by Quentin Metsys is a portrait known as *The Banker and His Wife,* (Louvre), attributed to the year 1514. This is a painting with carefully planned proportions in which Metsys borrowed Van Eyck's round mirror. The banker is counting his gold on the green tablecloth, while his bored wife turns the pages of an illuminated manuscript containing a portrayal of the Virgin with the Christ Child in her arms. These figures' hands reveal everything. Behind them, it is possible to observe shelves containing books, a dish, an apple, and documents...

Portrayal of Artisans

As he gradually abandoned religious or aristocratic motifs, Quentin Metsys finally rebelled against lofty subjects. As a result, he began to portray artisans at work, as the Swiss painter Nicholas Manuel did when he depicted a goldsmith's shop. This trend may be a reflection of the influence of the humanists with whom Metsys was acquainted (He had completed a portrait of Erasmus in Rome in 1517).

Jan Metsys and Frans Floris

The painter's son, Jan Metsys (Antwerp, 1505–1575), who was banished for heresy, was strongly influenced by the Fontainebleau School (*The Venus of Cythera*). Similarly, Frans Floris (Antwerp, 1516–1570) contributed to the popularity of an Italianate style with his *Sea Gods' Banquet,* a painting that foreshadows Rubens' eroticism.

Quentin Metsys' works are distinguished by bright and appealing colors. The round mirror (which reveals the reflection of a window) in *The Banker and His Wife* is an echo of Van Eyck and the *Master of Flémalle*. His Salomé (left panel, *Burial of Christ*) has a uniquely sinuous shape.

The Sea Gods' Banquet, 1561.
National Museum, Stockholm.
Frans Floris, an Antwerp painter who attempted to combine a Venetion style with Flemish traditions, created an authentic bacchanal in this painting.

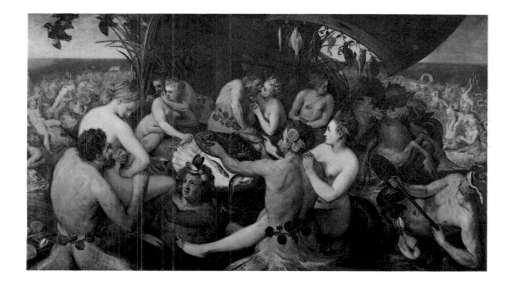

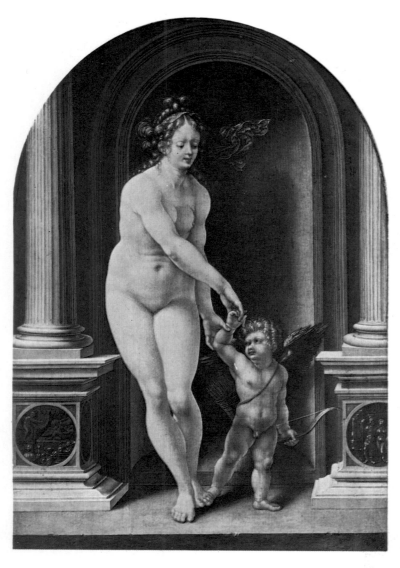

Venus and Cupid, 1521.
(36 x 24 cm.). Musées Royaux, Brussels.
Italian influence upon Flemish art is also represented by
this Venus standing beneath a series of columns, portrayed
by Mabuse (Jan Gossaert).

Jan Gossart, or Goassaert

Also known as "Mabuse", 1472–1536

*The sensuality impregnating the works of this
admirer of femininity reveals the influence of
Italian art.*

By a certain point, everything had been transformed. With
Mabuse, format, architectural elements, decorative aspects, and
the clothing of his subjects reflected the style of the Italian Ren-
aissance. Every painting was saturated with lavish finery and the
luxury of palaces, as can be observed in Mabuse's *Saint Luke
Painting the Madonna,* where the artist recreated a conventional
fifteenth century theme.

The profundity of Van Eyck's art was eclipsed. Figures became
actors in scenes that were more closely linked to the theatre than
to religious contemplation. They adopted poses and appeared to
be aware of their audiences.

On the one hand, Joos Van Cleve (1485–1540) represents a final
echo of spiritual preoccupation (one example is his *Holy Family*
but the Virgin is shown offering the Christ Child such a finely
shaped breast that it anticipates the sensuality of Mabuse's *Venus
and Cupid,* in which the painter tried to recapture the charms of
a woman whose sinuous body is offset by two vertical columns.

Similarly, Gossart's *Danae* receiving the golden shower appears
with an enticingly bare breast.

Toward the Introduction of a New Style

Mabuse is cited under the name "Gennyn of Hainault" (he fre-
quently changed his name) in 1503 in the archives of Antwerp.
At this time, he was serving the House of Burgundy. After hav-
ing visited Florence, Rome, Verona and Venice, he returned to
Flanders in 1508, saturated with Italian culture. He lived in
Brussels and in Malines and then moved to Utrecht with his
patron Philip of Burgundy who became the Bishop of Utrecht.
Subsequently, he entered the service of Philip's nephew and died
in Middelburg in 1536.

In the *Virgin with Angels* in Palermo, cherubic angels are
shown playing musical instruments at the Madonna's feet. The
Madonna and her child are surrounded by an accumulation of
flamboyant Gothic architectural elements expressing the intro-
duction of a new style.

Danae, 1527.
(114 x 95 cm.). Alte Pinakotek, Munich.
The legendary princess of Argos, whom Mabuse (Jan
Gossaert) has situated within a colonnade, is being seduced
by Jupiter in the form of a shower of gold.

47

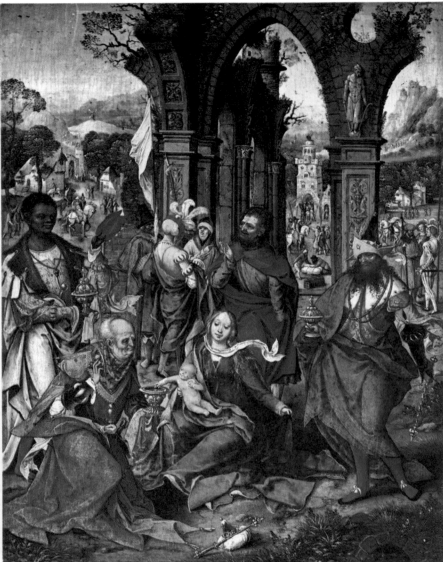

Adoration Triptych,
Early sixteenth century.
(Center panel: 29 x 23 cm.)
(Side panels: 29 x 9 cm.).
Musées Roayl des Beaux Arts, Antwerp.
In addition to the throng of figures sur-
rounding the Madonna in this altarpiece,
the painter included Mannerist portrayals
of Saint George and of Mary Magdelen.

Mannerism

Lavish decoration and mannerism attained even greater heights
in the *Adoration Triptych* of Antwerp, in which each element
constituted a manifestation of opulence and virtuosity. The center
panel depicts the *Adoration of the Magi* and the left panel com-
memorates *Saint George Slaying the Dragon.* In the right panel,
behind the kneeling patron, there stands a *Saint* who is the most
elaborate female figure to have appeared in Flemish art until that
time.

As a result, it is possible to understand the process that had
begun to unfold in Flemish art, whereby misinterpretations of
the Italian influence, represented by accumulation of colors,
figures, architectural embellishment, and minuscule clusters of
forms amid complex landscapes, gradually gave way to fanciful
and diabolical images.

A juncture emerged where it was probable that overpowering
theatrical adornment would permeate everything, unless a new
style representing wholly different concepts were to arise.

The Landscapes
of Joachim Patinir

1480–1524

For the first time in the art of this era, an artist evoked open spaces and vastness leaving our eyes to wander and derive pleasure.

Patinir occupies an exceptional position among early landscapists. There is the legacy of the backgrounds that adorn Van Eyck's *Mystic Lamb,* but the evocation of nature is presented in a total form for the first time, with an abundance of space, air, and land accompanied by water, vegetation and immense horizons (*The Passage of the Styx*). It could be said that Patinir had a premonition of Pascal's words nearly two centuries later: "The universe with its vastness understands me and engulfs me like a dot, while I understand the universe through thought." Indeed, tiny human figures are surrounded by vast evocations of Nature.

The Passage of the Styx, early sixteenth century.
(64 x 103 cm.). Museo del Prado, Madrid. As a departure from a type of art which was becoming overloaded with embellishments, here is a broad vista of the sky, landscapes, and the sea, or actually the Styx, the infernal river that offered invulnerability to those who crossed it.

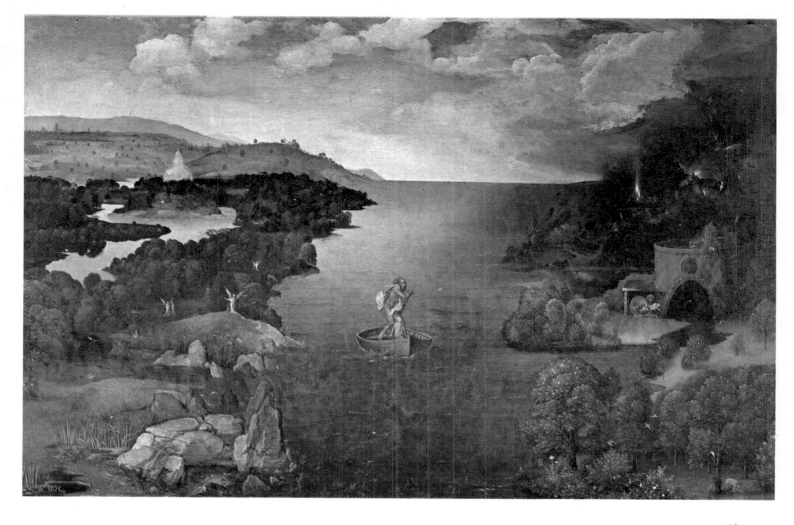

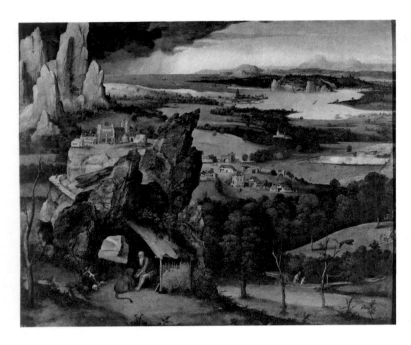

Saint Hieronymus, early sixteenth century.
(74 x 91 cm.). Museo del Prado, Madrid.
Patinir included minuscule human figures in his vast landscapes, thereby achieving a similarity with certain scenes in paintings from the Far East.

Rest on the Flight into Egypt, early sixteenth century.
(62 x 78 cm.). Galerie Dahlem, Berlin.
This restful scene with splendid colors is distinguished by exceptional diversity, with a still life placed in the foreground in order to divert attention from the Virgin's uncharacteristic actions.

Michelangelo maintained a harsh attitude toward landscape painters who, as he said to Francesco Da Hollanda, "paint heaps of bricks and mortar, grass in the field, shadows of trees, bridges, and streams; they call it a landscape and then they place a few little figures here and there."

The Vastness of Nature

Landscape painters pursued their endeavors for many centuries, although not in Europe. The Chinese appear to have been the earliest. Ancient scrolls from the eleventh century already depict the seasons, with new leaves bursting forth and with the first snowstorm of winter.

In Europe, the Limbourg Brothers, who were of Flemish origin, created the *Très Riches Heures* for the Duke of Berry in 1409, evoking the months of the year long before Patinir. Similar illuminated manuscripts such as the *Livre de Chasse* of Gaston Phebus (of Foix) and the *Bedford Breviary* already depicted the realms of Nature.

After Patinir, landscapes retained a vital role in western art until the Impressionists, who, according to Frédéric Amiel, affirming their presence in the air and in the sunlight with brushstrokes illuminated by their receptivity to what they encountered.

Patinir may have been trained in Bruges, under Gerard David. By 1515, he was a master artist in Antwerp, but research is hampered by the fact that only five paintings, bearing the signature of this friend and colleague of Quentin Metsys and Joos Van Cleve, have been identified. Patinir was the first painter before Claude Lorrain to create landscapes with an impression of vastness.

Shadows and Lights

Albrecht Dürer, whom Patinir met around 1521, acknowledged the Flemish artist's ability to extend our vision to the farthest reaches of the horizon by interposing cliffs, hills, forests, and an array of surfaces and colors that diminish as distance increases.

Albert Lhote observed that, in *The Passage of the Styx,* where Heaven and Hell are symbolically evoked and where diminutive figures (angels amid light, on the left side; demons amid fire and darkness, on the right side) are observable, the respective elements are superimposed upon one another, as if they were being presented on a screen.

A similar technique is apparent in Patinir's *Saint Jerome* at the Prado. Here, there are successive layers of shadow upon light and light upon shadow. In The Martyrdom of Saint Catherine, a large luminous boulder precedes a series of ascents and descents so that one encounters the same method again.

One needs a magnifying glass to discover the female saint praying as she kneels beneath the notched wheel, while an angel in

50

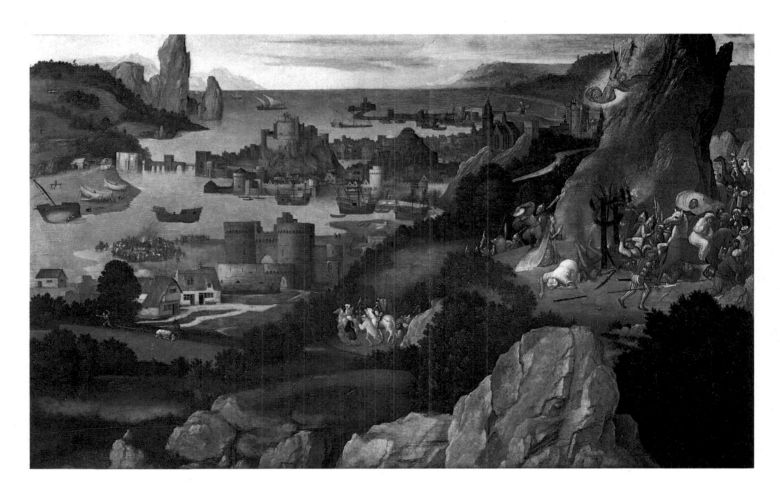

The Martyrdom of Saint Catherine,
early sixteenth century.
(27 x 44 cm.). Kunsthistoriches Museum,
Vienna.
Patinir situated *The Martyrdom of Saint Catherine* of Alexandria within a vast landscape. It is possible that the many human figures were painted by another artist.

the upper portion of the painting is brandishing his sword as he hurries to rescue her.

The painting is filled with groups of horsemen, houses, bucolic scenes, small groups of figures, ships and cliffs.

Stopping during the Flight of Egypt (Galerie Dahlem, Berlin) is admirably composed around an enlarged triangle formed by the Virgin and the Christ Child, who is being spanked by his mother (a bold and impertinent innovation!). A maze of winding roads, castles, rocky landscapes, and coastal inlets are visible behind the reds, whites, and yellow of the wicker basket.

Patinir succeeded in conveying an impression of vastness in paintings in which dimensions are often limited. For the first time, air flows over a landscape and the horizon expands into almost infinite regions.

Joos de Momper the Younger followed Patinir's methods in dividing his paintings into planes, despite an overabundant proliferation of themes.

In a later era, the works of Paul Bril, an Italian-influenced painter in Antwerp, partially reflected Patinir's influence.

JOACHIM PATINIR

He developed a distinct way of constructing landscapes with exceptional precision and refinement, with trees that resembled a fine stippling. He introduced delicate little figures, creating enthusiasm for his works, that sold well and were taken to many other nations. It was his custom to include in each of his works a tiny figure meeting natural needs and, as a result, he was given the sobriquet "the shitter." Sometimes, one has to hunt patiently for this small figure, like the owl in the works of Henri de Bles. Apart from his exceedingly refined artistic creations, Patinir was a vulgar man who drank heavily and spent entire days in taverns, freely spending his money until necessity forced him to wield his prolific brush again. Frans Mostaert endured an apprenticeship with Patinir. Mostaert was often purseued by his enraged and drunken mentor, suffering dearly for his great desire to learn.

Carel van Mander
Le Livre de peinture

THE "CREATORS OF DEVILS"

Jeroen Van Aken known as Hieronymus Bosch
1450-1516

Bosch was the first "creator of devils." His unbridled imagination created a vision of a mysterious world that foreshadowed Surrealism.

This figure represents a distinct exception in painting. Where else could one find such a malicious spirit with a style like his? Where else could one discover a similar mixture of the diabolical and the spiritual? Such draftmanship, such acerbic satire, such an exploration of everything that one can envision between dreams and reality, good and evil, the sacred and the profane, masochism and sadism, and life and death! No prior artist had endeavored to place such crazed debauchery before our eyes.

Bosch was also a talented decorator. In his vast paintings he clearly displayed and exceptional ability to create images and compose scenes. Such a description, however, does not seem sufficient to characterize this genius whose spirit burst forth in scenes embracing Heaven and Hell, the joys of love and the bitterness of persecution. Bosch is a master of the spectacular. His *Garden of Delights* transforms our perceptions into a vision. The external qualities of what we see correspond to our innermost thoughts. Moreover, his infernal circus is much more staged than portrayed. At certain points his vision comes into contact with Dante's *Inferno,* Francois Villon's *Ballad of Hanged Men,* the adventures of Rabelais' Pantagruel, the world of Shakespeare's clowns, and the erotic acrobatism of Chinese and Japanese artists. Bosch can also be considered a precursor of Goya, James Ensor, and the Surrealists.

A Transcendent Illustrator

Others see Bosch as an illustrator, but if this is true, he was a transcendent illustrator who probed humanity to its depths, encompassing everything that had been accomplished and would be accomplished until the development of cinematography. Yet Bosch's insights were expressed outside reality, apart from artistic tastes and from his own era, and free of any restrictions on his

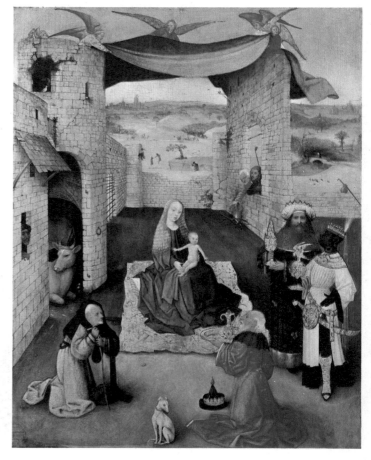

Adoration of the Magi,
c. 1480–1490.
(71 x 57 cm.). Metropolitan Museum of Art, New York.
It is already possible to detect artfully concealed hints of an inclination toward the diabolical, foreshadowing the fantastic images that would later appear in the works of the painter from Hertogenbosch.

The Seven Deadly Sins, c. 1475–1480. →
(120 x 150 cm.). Museo del Prado, Madrid.
The deadly sins appear in the four corners of this painting (originally intended as a table top), while the circles depict a man on his deathbed, the Last Judgment, sinners in Hell, and the joys of Paradise.

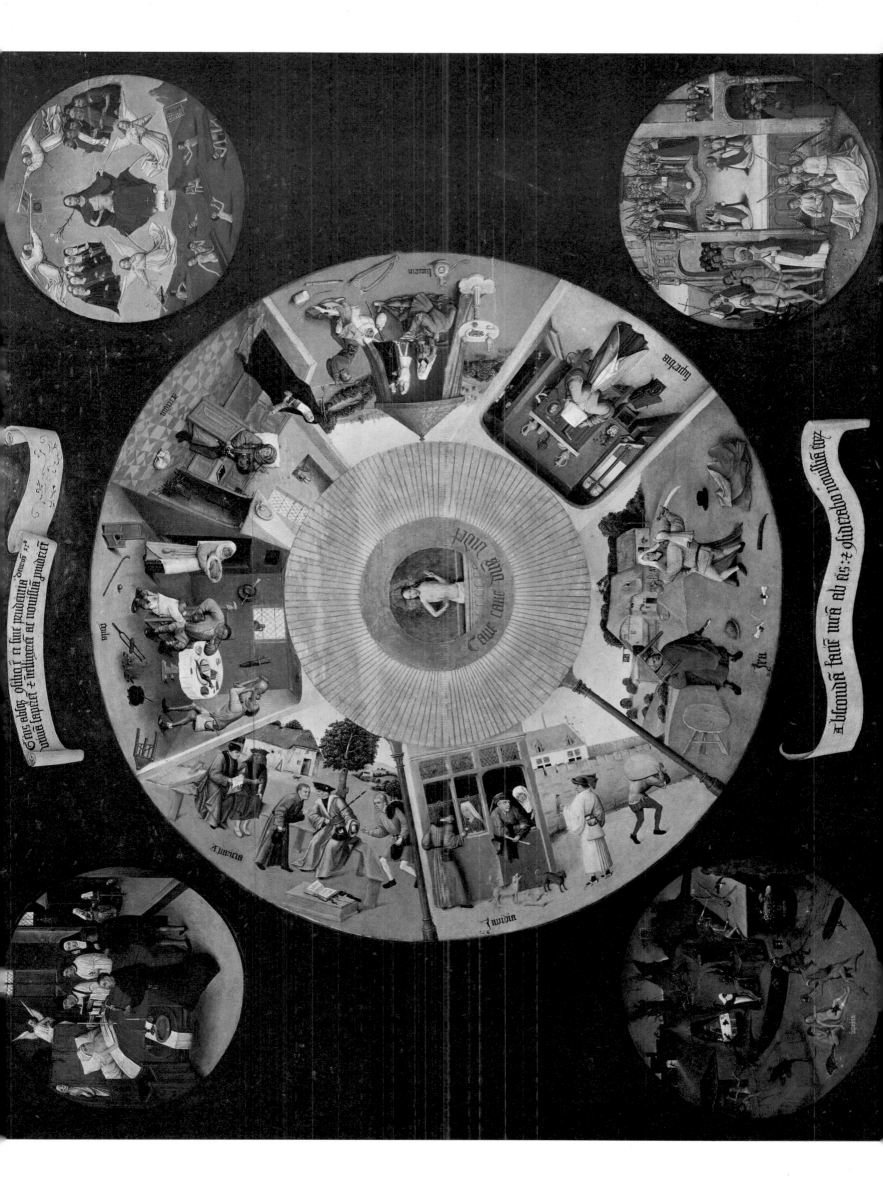

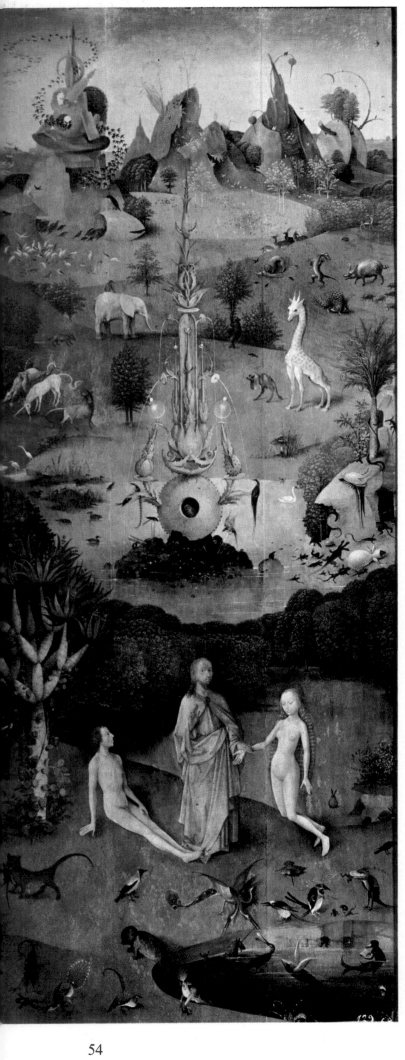
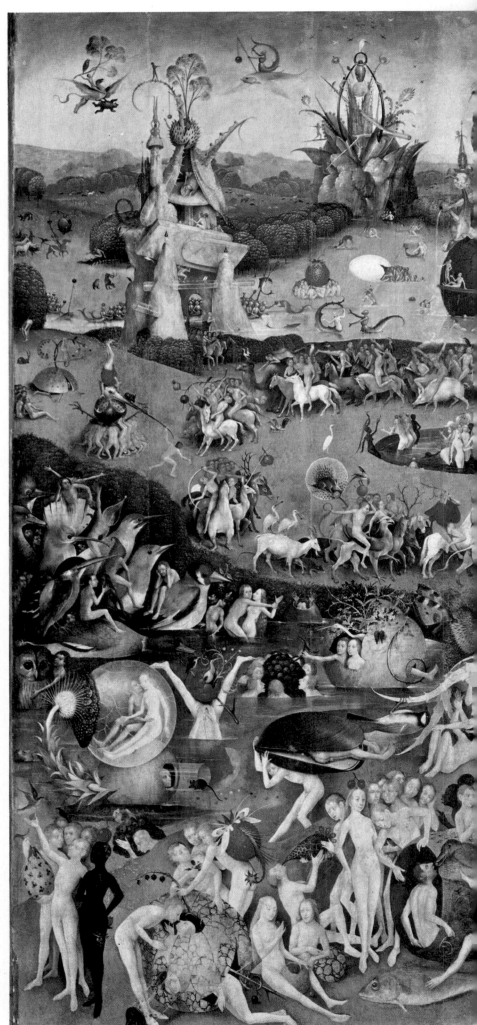

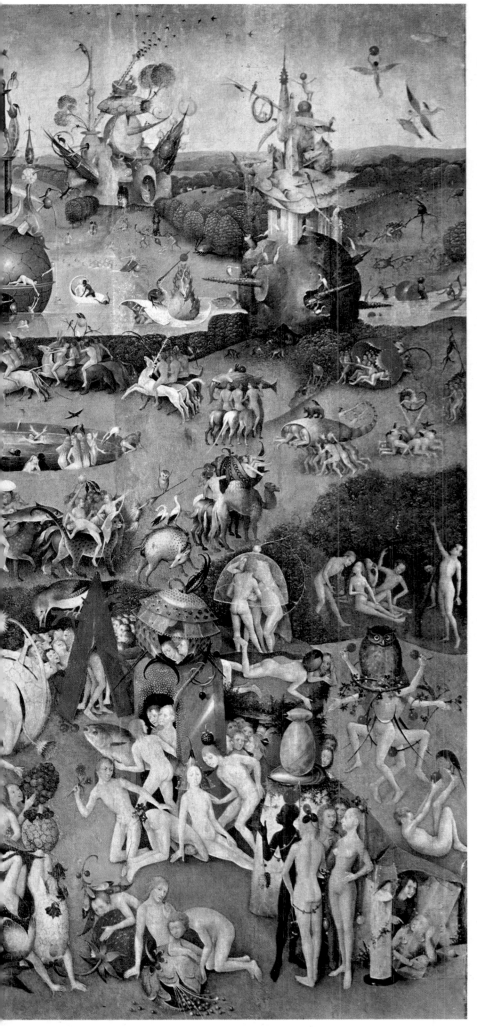
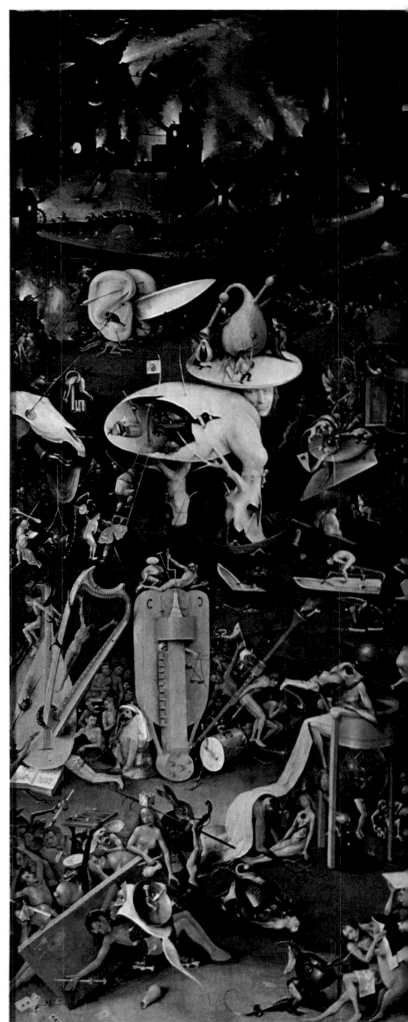

The Garden of Delights, c. 1490.
(Center panel: 220 x 195 cm.)
(Side panels: 220 x 75 cm.). Museo del Prado, Madrid.
This is the most fanciful triptych in the entire history of painting. The audacity of Bosch's imagination was entirely unrestrained.

Cure for Folly, 1475–1480.
(48 x 35 cm.). Museo del Prado, Madrid. This outdoor surgical procedure is characterized by such elements as cruelty, abandonment of the patient to the surgeon's skills, the aid of religion, and a hint of witchcraft.

skill for imagining, envisioning, portraying, discovering and communicating his world.

This is the man whom Pieter Bruegel the elder depicted in a portrait with a three-quarters perspective. Bosch is shown with his brush in his hand, while an astonished on-looker watches him at work. With long hair and a disenchanted expression, he peers out almost threateningly from beneath bushy eyebrows. This portrait actually displays affinities with the one on the Arras Compendium, where an even more angular Bosch bears the same vehement expression.

His father, Jan Van Aeken (or Aken) was an artisan and painter. In Hertogenbosch (the predominant town and production center in northern Brabant, present-day Holland), where he spent his entire life, Bosch had little contact with Antwerp, Bruges, and Brussels. It is believed that Bosch, the surname which he adopted, is an abbreviated form of Hertogenbosch (the Dutch

name for Bois-le-Duc), where plays with religious themes were often performed at the Cathedral of Saint John. Bosch became a member of the Confraternity of Our Lady, affiliated with this Cathedral.

As a result of his marriage to the wealthy daughter of an apothecary, Bosch was able to paint as he wished, without relying upon commissions, and was therefore in a position to depart from the norms of religious iconography.

One can, however, set aside these fragments of information which are incomplete and enigmatic like everything pertaining to this painter. Let us examine his works directly, without forgetting that they were created during a period in which the esoteric and even the diabolical were popular. For example, in one of his sermons, the Dominican Alain de la Roche described "animals symbolizing the deadly sins, with horrible genital organs spewing torrents of fire and darkening the earth with smoke."

As noted, Bosch approached religious subjects without heeding conventional constraints. His works reveal few traces of the familiar intimate art of Van Eyck and his successors, even though this type of art played a dominant role in Flemish and Dutch painting from 1432 to 1514.

Esotericism and Demonism

Let us examine his painting and try to understand their composition and development. In the latter domain it is difficult to establish a chronolgy. Max Friedlander himself found the chronological riddly to be particularly " unsolvable" because there are many copies and retouched versions of Bosch's paintings. It appears that the painter's earliest endeavors coincide with the *Adoration of the Magi* (Metropolitan Museum of Art, New York), prior to his *Healing of Folly* (1475–1480), in which the diabolical appears in an unambiguous form for the first time. In Flanders, it was customary to say of a simpleton or a madman, "he has a stone in his head," and, at the bottom of the painting, Bosch wrote in Gothic characters, "Hasten to remove the stone, Master!"

The scene is enhanced by a sorcerer and a monk, whereas a female healer stands behind the table, balancing a book on her head. The patient sits with his head upturned, as he clings to the arms of a chair, while the operation takes place in front of a vast and realistically depicted landscape. Paul Fierens has pointed out that this painting is one of the earliest artistic representations of a proverb.

Saint John at Patmos (1504–1505) embodies a vision of the Apocalypse. Its striking images are revealed without satirical elements. The saint, who is presented according to a profile view, is wearing a pink cloak with prominent folds and is eagerly listening to an angel. In the bottom portion of the painting, we observe a dreadful black demon with an insect-like body, who is carrying a trident and is unnoticed by the evangelist. This creature appears to be one of Hell's denizens.

Bosch's paintings have a Spanish aura that explains Philip II's deep admiration for his works. The Spanish monarch never tired of contemplating the *Seven Deadly Sins* (1475–1480) arranged in a circle around Christ, who is standing within his tomb. In 1574, Philip II issued an order for the painting to be taken to the Escorial. It is largely as a result of the foresight of this ruler, who was the son of Charles V, that some of Hieronymus Bosch's creations have been passed on to us.

A Penchant for the Bizarre

A fanciful mind saturated with the occult also guided the painter from Hertogenbosch when he painted the *Hay Wagon* (1500–1502). The center portion has been reproduced in this book. Here, reality and the bizarre intermingle, and one can see both the angelic and the demonic. It appears that this painting may have been inspired by a verse from the *Book of Isaiah*: "All flesh

Saint John in Patmos, 1504–1505.
(63 x 43 cm.). Galerie Dahlem, Berlin.
This is a deeply reverent painting, with benedictions offered by the Virgin and an angel.

Calvary, c. 1485.
(73 x 61 cm.). Musées Royaux, Brussels.
In the few paintings where Bosch did not create fanciful or diabolical scenes, he remained loyal to tradition.

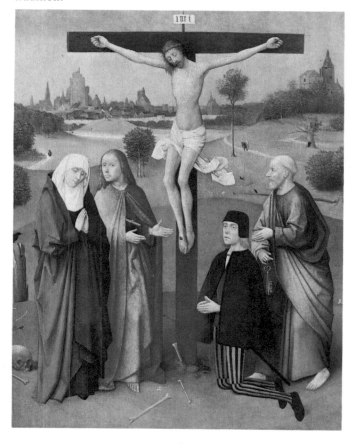

is hay and all glory like unto grass in the fields." Warriors with zoomorphic heads are pulling a wagon laden with an enormous pile of hay. The wagon is surrounded by a turbulent mob in which some people try to clamber onto the wagon as others struggle to grasp whatever they can. There are musicians and a pair of lovers seated between an angel and a devil, beneath a Christ with outstretched arms who is lost in the clouds. Behind the chariot, a pope and an emperor ride at the head of a long retinue. As is always true of Bosch's paintings, there are a thousand possible interpretations.

Subsequently, there is the *Garden of Delights,* the consummate expression of Bosch's predilections. This painting has engendered the greatest number of interpretations, and still continues to elicit endless commentary from critics. In Spain it is known as *Lechery's Festival.* The painting is divided into zones in an assymetrical arrangement that is wholly non-traditional. The merchant Jerome Cock (who introduced Bruegel the Elder to Bosch's works) disseminated many copies and engravings of the *Garden of Delights.*

The Hay Wagon, 1500–1502. (135 x 100 cm.). Museo del Prado, Madrid. This is the center portion of a triptych which, in a closed position, portrays a traveler confronted by the hazards of the Road of Life. When the triptych is opened, the left panel reveals the Creation, the Temptation of Eve, and the Fall of Man, while Hell is depicted in the right panel. The painter' signature appears in large characters beneath the group of nuns.

The Painter as Sorcerer

Creating temptations, allegories, monstrosities, and visions of Heaven and Hell, Bosch arranged his human figures and bizarre animal forms in scenes dominated by torment and deformity. By adopting vertical perspectives he was able to multiply his creations and superimpose scenes in a panel depicting Adam and Eve in Paradise, and joined by Christ. The panel on the right reveals the nether world. The center panel presents a formidable array of the tribulations of human life with its virtues and vices. With disproportionate dimensions, gigantic animals are offset by minuscule pairs of men and women. Some are copulating in acrobatic poses and others resemble animals. In Bosch's garden, fish fly, the strings of a harp are transformed into a gallow, and male and female figures copulate under glass covers. Amid the overlapping flames of hell, shellfish are placed in treetops and a knife is slicing an immense ear that is crushing a group of tiny figures. There are scenes of flagellation and mussels closing their shells on entangled lovers. It would be impossible to enumerate the comical and tragic fantasies revealed in the center and side panels of this unique triptych that is a consummate expression of visual audacity.

With Hieronymus Bosch, we encounter a final retrospective of the entire Middle Ages, with its turbulent visions, its malicious abysses, and its monstrous and diabolical temptations.

The artist unleashed his ironies upon the virtuous and the wicked alike. Allegory, symbolism, fascination with religious devotion and Christian inspiration, and a caustic or even sarcastic wisdom that is often cleverly concealed transform his works into a perpetual inquiry, embellished by allusions, enigmas, and irreverent oddities. This was a painter with the attributes of a sorcerer...

HIERONYMUS BOSCH _____

Bosch overturned the themes of religious iconography, but his contemporaries bore no grudges. Although his dreams were unrestrained, it is an error to regard him merely as a satirist and an "odd character." He was admired by his contemporaries precisely for his adherence to purely medieval traditions. The humor and irony permeating his works are directed against the spectator instead of against the figures whom he depicted. Bosch painted for humble people who, like Villon's mother, could affirm:

Ne riens ne scay; oncques lettre ne leuz.
(I know nothing and I've never read a single letter.)

Didactic necessities led him to discover the domain of morally instructive allegories and whimsical symbolism. Bosch painted with a religious impetus and a desire to proselytize. Subsequently, Bruegel inaugurated the modern era of art for its own sake. These two geniuses — Bosch and Bruegel — were men of the people in the highest sense, but also encyclopedic on account of their inexhaustible knowledge. On the other hand, Bosch relied upon insinuation. His art, if it were possible to explain all of its enigmas, would increasingly resemble a sermon — vibrant, realistic, and harsh — entirely in keeping with the end of the Middle Ages. The Spaniards, who greatly admired Bosch's works, granted their highest esteem to his exhortatory moralism.

Fierens Gevaert
_____ *La Peinture flamande,* Volume III

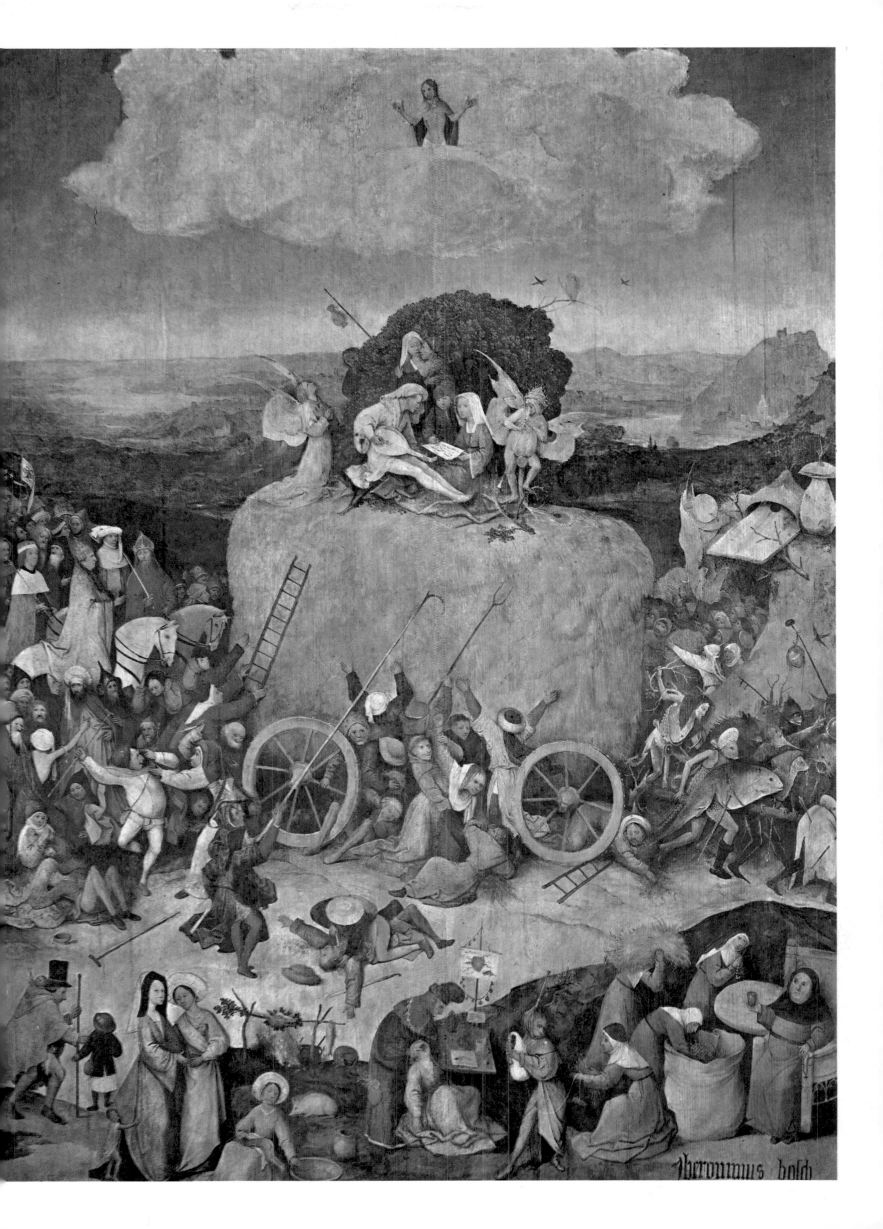

Pieter Bruegel the Elder

1525-1569

Although he was initially influenced by Hieronymus Bosch, Bruegel dramatically returned to realism in his evocations of nature, the seasons and peasants' festivities.

Bruegel (or Brueghel) and Bosch would initially seem to be representatives of the same current. Both established a new orientation in Flemish painting by departing from the tradition of Van Eyck.

But, upon close scrutiny even though both artists were "creators of devils" their worlds are significantly different. In contrast to the Boschian milieu populated with phantasmagorical creations, Bruegel's world, without andy loss of imaginative breadth, is marked by a gradual departure from extraterrestial irreality. Bruegel's satirical or dramatic scenes transpire amid vast landscapes. He has no counterpart in portraying the indifference of a peasant tilling his field in the *Fall of Icarus,* in which Icarus'

legs are shown protruding from the surface of the sea. Bruegel sarcastically recaptured the essence of proverbs; he knew that when it is impossible to fulfill one's wishes, one must strive for what is possible. Such wit, lucidity, and awareness of human nature — such fruitful labors!

Bruegel's Travels

Pieter Bruegel, who was born between 1525 and 1530 in the village of Brueghel near Breda in the Limbourg region, began his artistic career by producing drawings. After serving as an apprentice to Pieter Coecke in Antwerp, he became a master artist and joined the Guild of Saint Luke. In 1552, he traveled through the Alps (during his journey he completed admirable drawings of mountains) to Italy, where he visited Rome and probably Naples and Messina. During the following year he returned to Antwerp and was employed by Hieronymus Cock, a seller of prints. At this point Bruegel began to paint. In 1563, he married Maria, the daughter of Pieter Coecke. Because he had been maintaining a liaison with a female servant in Antwerp, his mother-in-law compelled his to reside in her home in Brussels, where she owned a

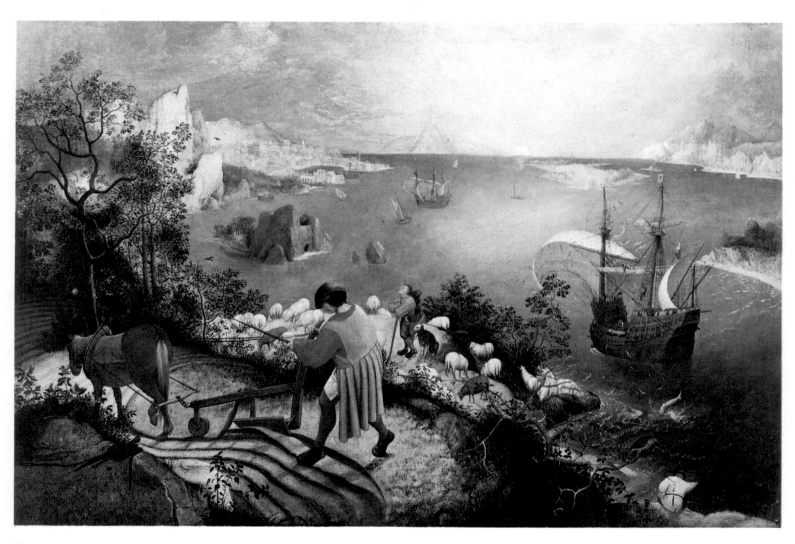

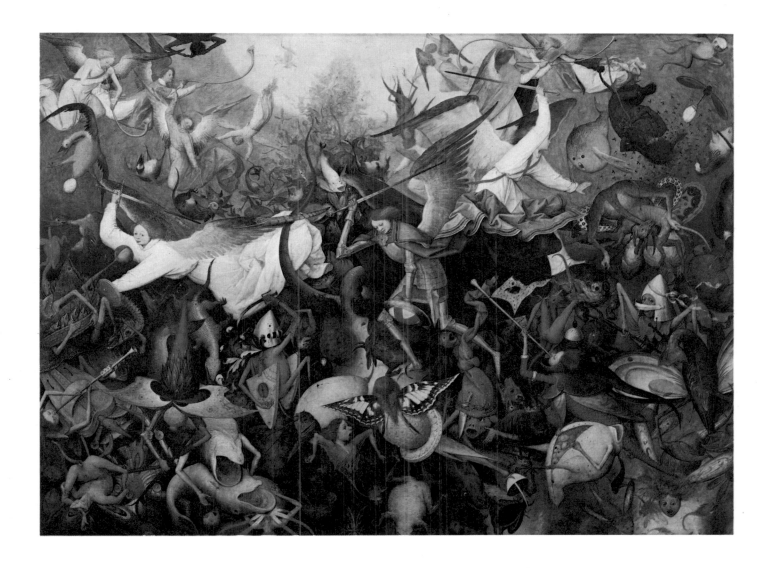

The Defeat of the Rebel Angels, c. 1562.
(117 x 162 cm.). Musées Royaux, Brussels.
This is one of Bruegel's paintings (along
with *Dulle Griet* and *The Triumph of
Death*) where the influence of Bosch is still
observable.

← *The Fall of Icarus,* c. 1562.
(74 x 112 cm.). Musées Royaux, Brussels.
Icarus, the son of Daedalus, flew so close
to the sun that the wax holding his wings
in place melted, causing him to fall into
the sea. Bruegel counterposed the indiffer-
ence of a peasant tilling his field to this
mythological fantasy.

Next page:

Flemish Proverbs, 1559.
(117 x 163 cm.). Galerie Dahlem, Berlin.
More than a hundred figures were created
to illustrate Flemish proverbs in satirical
or naturalistic scenes. In 1568, Goedthal's
Flemish Proverbs was published by the
humanist, scholar, and publisher Plantin
(who was a friend of Bruegel).

publishing house. Bruegel fathered two sons, Pieter (1564) and
Jan (1568). He came into contact with humanistic circles and read
the works of Erasmus and Rabelais as well as the classics. Ini-
tially, he led a prosperous life (Antwerp was one of the cities in
which speculators thrived at this time), but signs of a financial
crisis and the subsequent "Beggars' Revolt" against Inquisition
and Spanish rule were already visible. Bruegel died in Brussels
on September 5, 1569 when he was approximately forty-five years
old.

The influence of Hieronymus Bosch is readily observable in
Mad Meg (*Dulle Griet*) or in *The Fall of the Rebel Angels,* in
which white-robed seraphim armed with swords vent their wrath
against a swarm of foes. Similarly, in *The Triumph of Death,*
a procession of victims of shipwrecks, hangings, decapitations
is combined with all of the horrors of war to evoke reality. The
composition of this painting in which Bruegel created super-
imposed layers is in harmony with the landscape. Skulls, coffins,
and tombs marked by crosses contribute to the deathly proces-
sion. Bruegel painted this awe-inspiring spectacle on a large
wooden panel around 1562. The panel had several sections fast-
ened together, and was coated with thick layers of paint that were
extensively retouched.

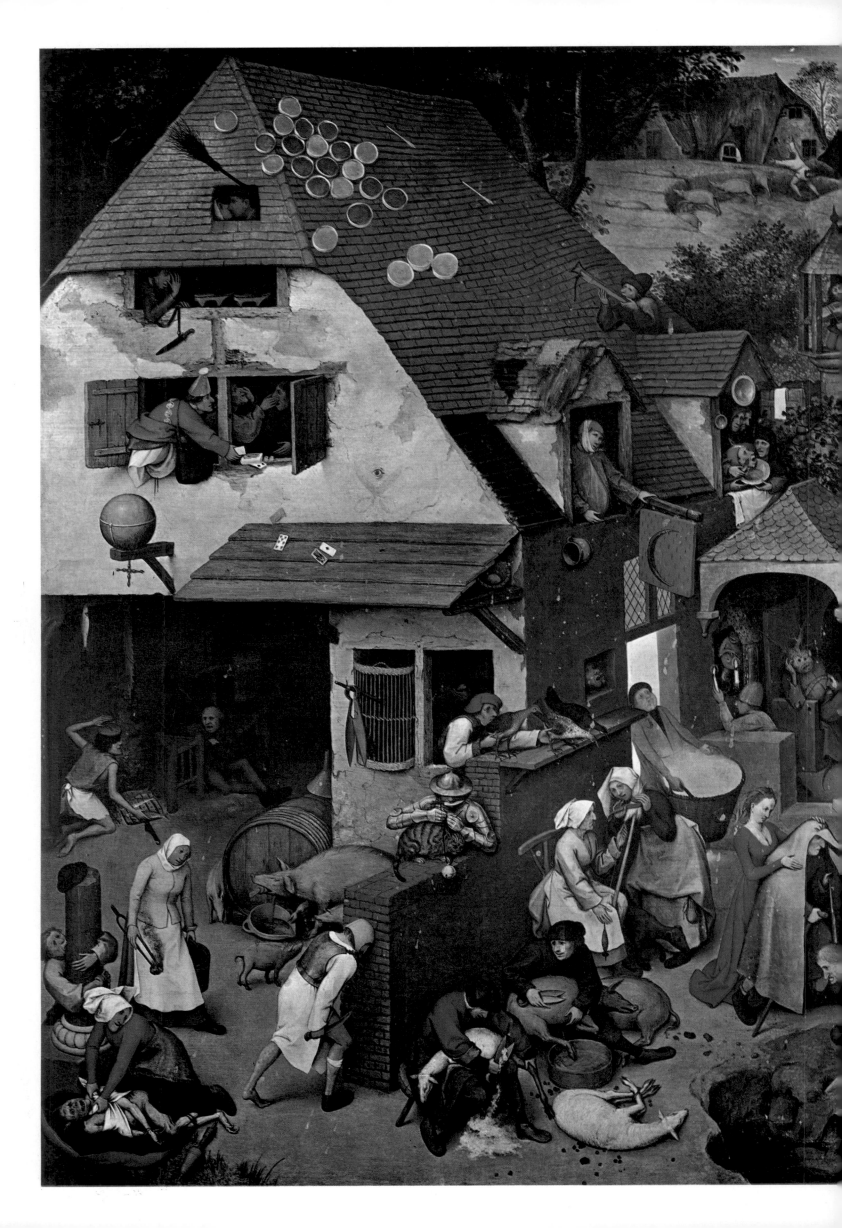

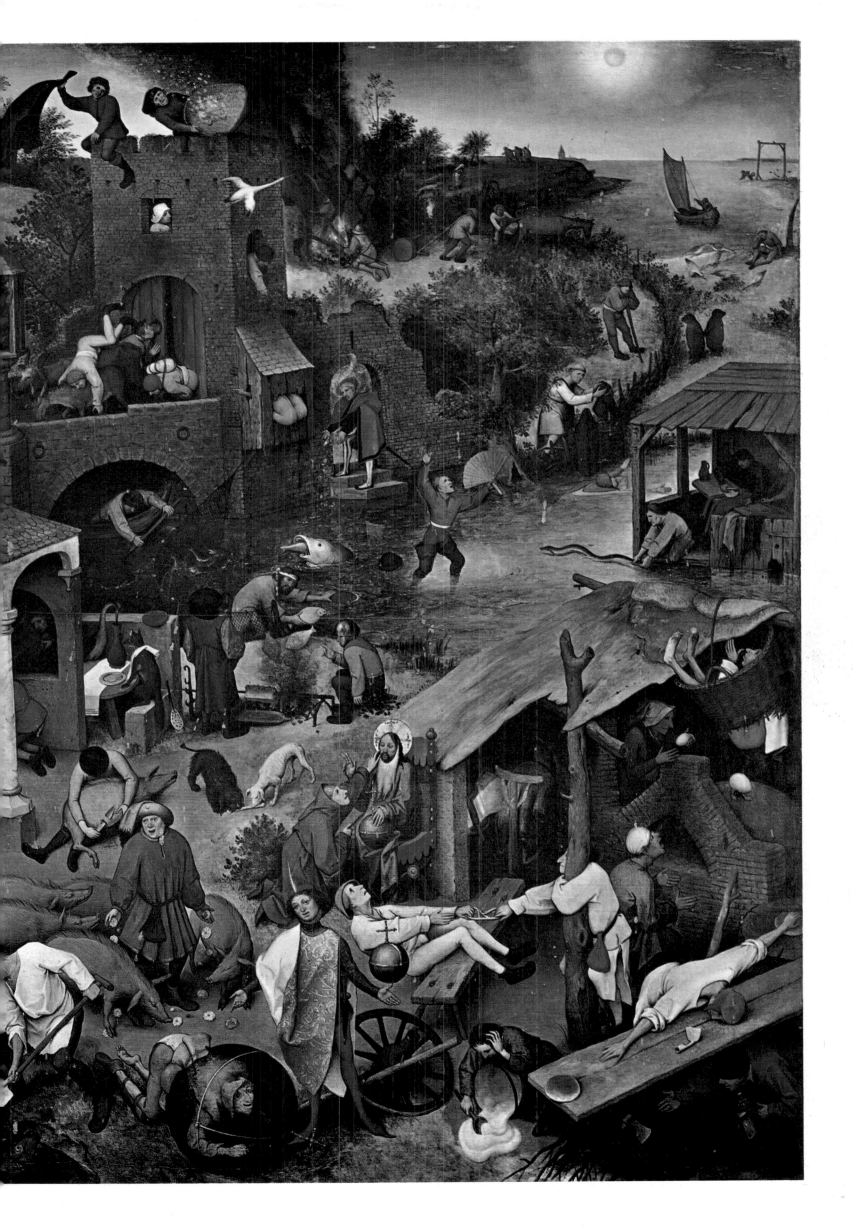

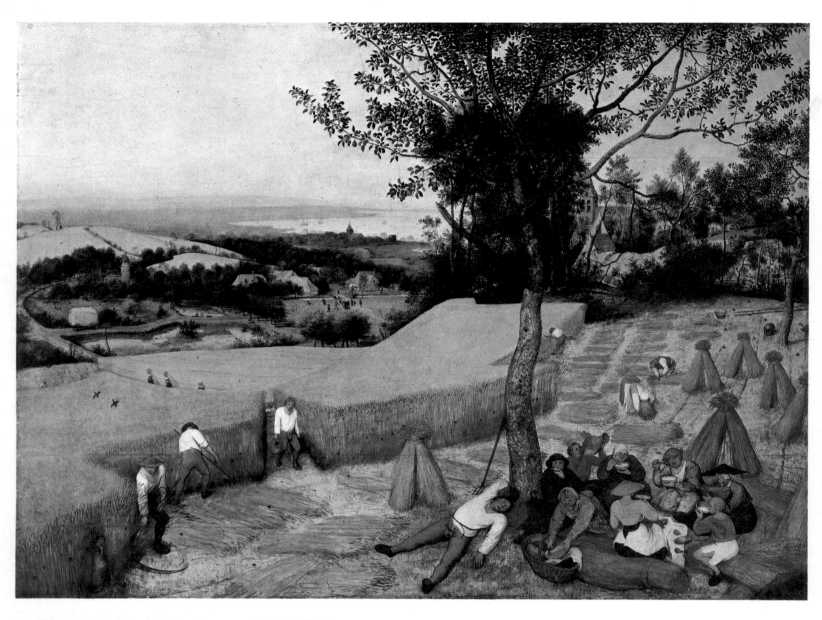

The Harvest, 1565.
(118 x 161 cm.). Metropolitan Museum of
Art, New York.
This painting is dominated by the russet
and yellow hues of the wheat. There is a
certain sense of immobility caused by the
summer heat. The enlarged detail shows
the peasants eating.

Bruegel's contact with humanists led to a return to simpler and
eternal realities such as those expressed by proverbs. He tried to
communicat their profundities. At this point, his paintings fall
into specific contexts, with multitudes of figures appearing
everywhere. Children are shown playing in squares in front of
houses; battles unfold in narrow mountain passes; criminals are
punished before large throngs and immense landscapes arise in
front of the sea. In Bruegel's paintings, everything has its place:
earth, water, sky and mountains. Every event transpires *within
a temporal and spatial framework.* The four elements acquired
an increasingly important role in his paintings. Like the Limbourg
Brothers or Claude Lorrain in the next century, he created an
almanac. Bruegel assiduoulsy scrutinized rural life.

In *The Harvest* the wheat that must be cut resembles a large wall. Beneath a tree, women are shown eating, as they sit around an exhausted man sleeping with this legs spread apart (he closely resembles the satiated man depicted in the *Land of Plenty*).

Whereas Bosch's *Hay Wagon* is filled with often incomprehensible allegories, Bruegel's bucolic scene is saturated with the reality of agricultural labor and the scent of the peasant's harvest. A balance structure is achieved by a large tree. The reapers appear in the foreground, along with sheaves of wheat and the meal awaiting the harvesters.

What a difference between the hay loaded onto a wagon in the *Haying Scene* and Bosch's painting! Bruegal does not rely on any secret allusions. In his painting, the hay is an integral part of the activities of midsummer and it appears in the form of a large grayish-blue mass amid the yellow stubble.

Around 1565, Bruegel completed *January: The Return of the Hunters* which was painted with oils upon a wooden surface. The trees and the hunters are silhouetted against the white of a snowy landscape, while a black jackdaw appears at the top of a tree in order to suggest its height.

Haying Scene, 1565.
(117 x 161). National Gallery, Prague. Prior to 1931, the lower left portion of this panel contained a false signature. It is appropriate to observe the bold colors counterbalancing the green background and the blue tints of the landscape.

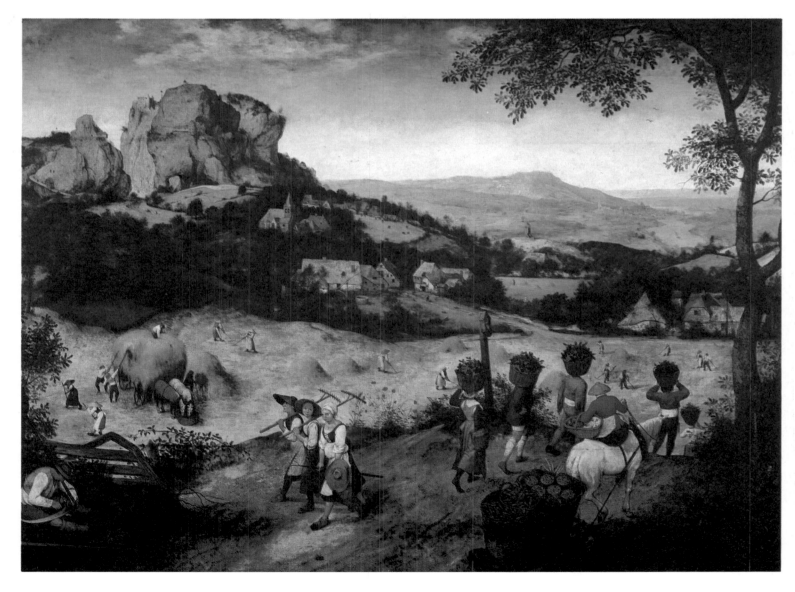

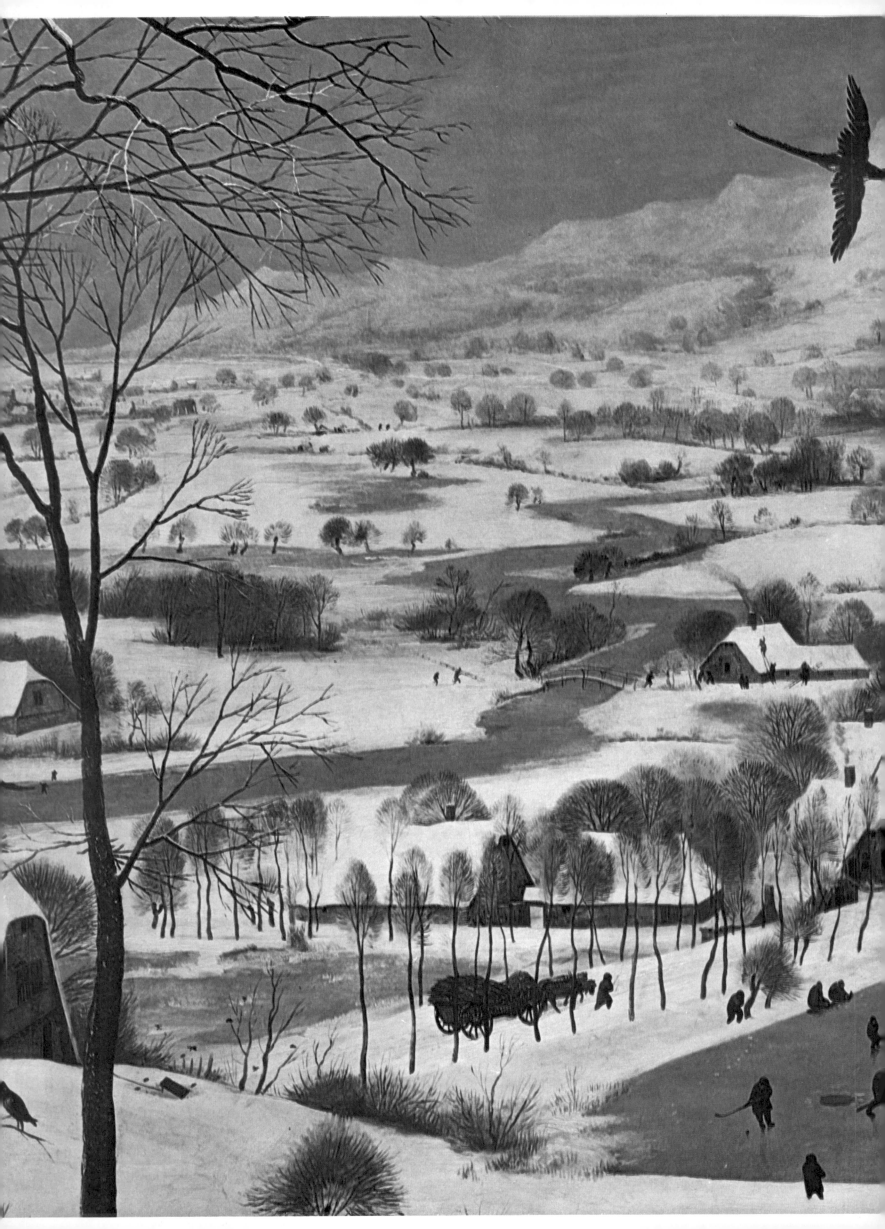

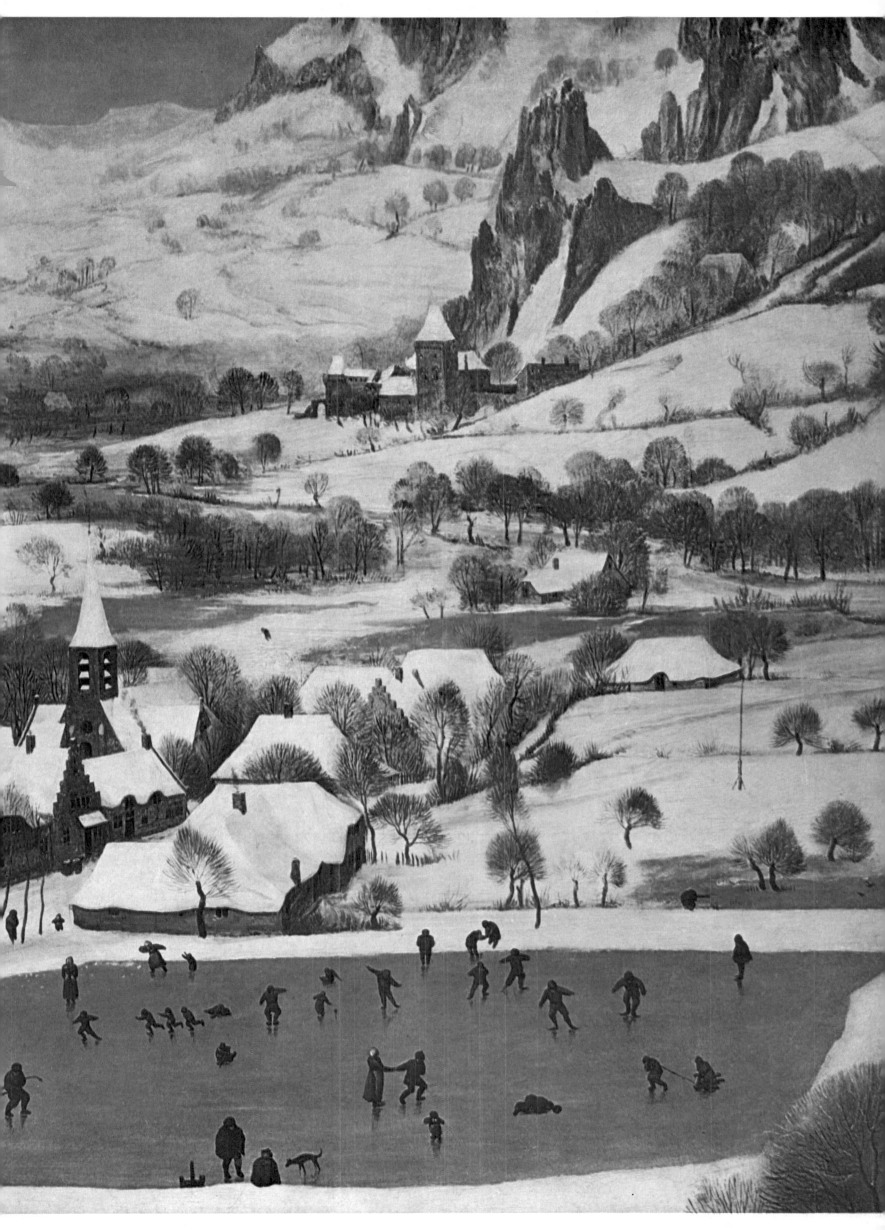

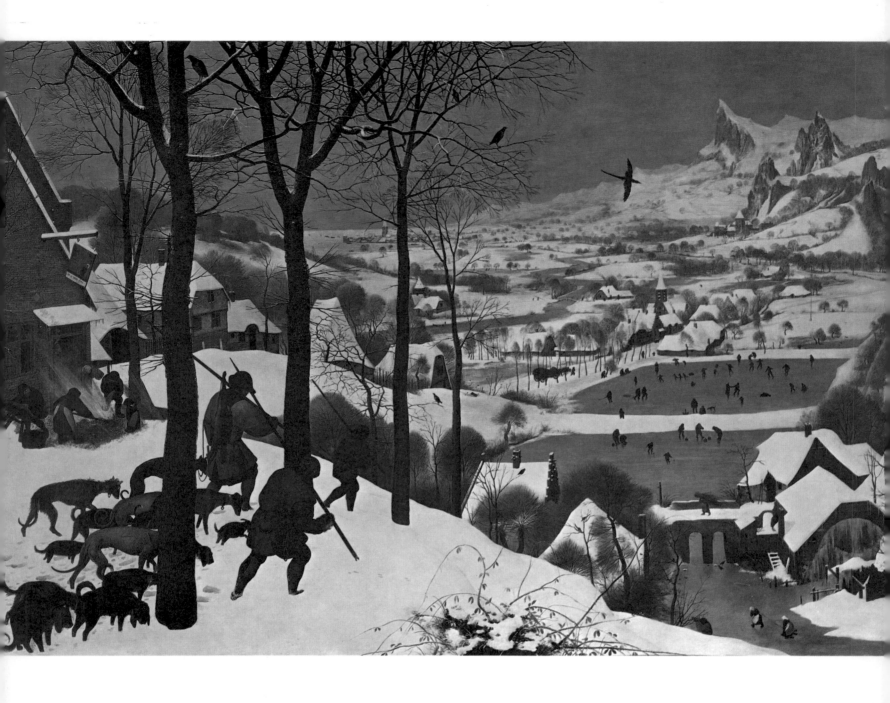

January: The Return of the Hunters,
c. 1565.
(117 x 62 cm.). Kunsthistorisches Museum,
Vienna.
Amid a vast snow-covered landscape,
three hunters are shown returning to the
village, accompanied by their dogs. They
are passing in front of an inn where grain
is being cooked. This painting belongs to
a sequence known as *The Seasons.*

Preceding page:

This detail shows Bruegel's close attention
to anecdotal elements. Small silhouettes of
persons trying to keep confined to the
hearth appear in the center.

Eating and Drinking

Eating and drinking occupy a highly significant role in Bruegel's
paintings. For example, there is his *Peasant Wedding* (1566). The
festivities are taking place within a barn. The bride is wearing a
crown and servants are carrying large platters filled with food.
The atmosphere is filled with plebeian serenity of unrestrained
indulgence. The silence of eating replaced laughter.

This painting is reminiscent of Tintoretto because of its diag-
onal layout.

Also known as *The Wedding Feast,* this painting on a wooden
panel has no date or signature. It was subsequently enlarged by
five centimeters. There are a rake and two sheaves hanging on
the wall, emblems of rural life. The guests' gustatory pleasure is

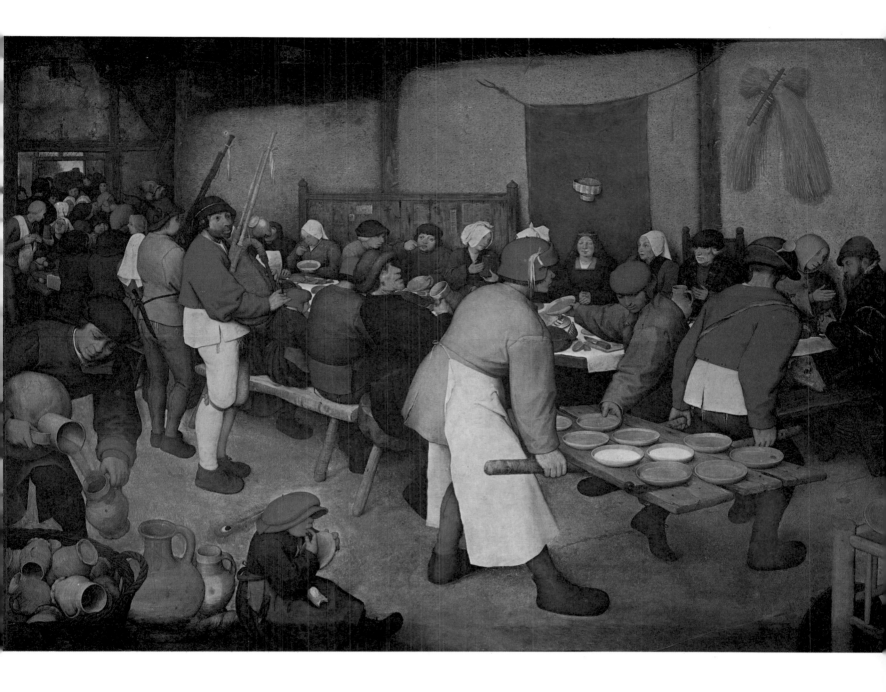

heightened by music from bagpipes. In this case, Bruegel unostentatiously maintained a comic and earthy perspective. He created blissful, gluttonous, and somewhat dull-witted faces, like those of the pipers and servants. A few persons, such as those who are waiting at the door, are set apart by expressions of astonishment or impatience.

In the foreground, a child wearing an enormous red cap has a serving dish, avidly sticking his fingers into it and smacking his lips. On the right side, a seemingly devout figure, who is sitting at the table with his hands clasped, is eagerly confessing to the monk beside him.

Upon observing this scene of gluttony, we may wonder what has become of the groom. Maybe he is the young man turning away from the table to get another serving for himself.

Peasant Wedding, c. 1566.
(114x 64 cm.). Kunsthistorisches Museum, Vienna.
In 1659, this panel, which does not bear a signature or a date, was listed within the collection fo Archduke Leopold Wilhelm. Subsequently, it was enlarged by 5 centimeters in the bottom portion.

When Bruegel turned his eyes on human suffering, his outlook was tinged with a somewhat harsh humor and he refrained from evoking misery too starkly. In *The Blind Leading the Blind* and in *The Beggars,* he successfully transposed his emotions into realistic evocations of the depths of sordidness.

In *The Blind Leading the Blind* in a museum in Naples, we wondered how this painting could have traveled from Flanders to the capital of Campania. Subsequently, we learned that this tempera on canvas painting belonged to the collection of Count Masi in Parma during the seventeenth century and that, after being confiscated by the Farnese and rediscovered at the Palazzo del Giardino in 1660, it was taken to Naples during the eighteenth century.

An Exploration of Suffering

This particular painting is a recreation of the Flemish proverb, "When one blind man follows another, both of them will fall into a ditch." Notwithstanding the farcical undertones, one cannot ignore the artist's emotional response to the misfortune of these woeful figures, victims of their blindness. The painting is distinguished by precise lines, boldly set before our eyes. Maurice Genaille believes that Bruegel's last great painting expresses the sadness and desolation of the artist during his final years.

Bruegel sometimes wavers between the grotesqueness of the maimed and the pity that they inspire. This ambivalence is observable in *The Beggars,* a small painting at the Louvre. With all of his vibrancy, the artist created a type of dance performed by the legless cripples who have to travel on sticks; the painting resounds with the deep laughter and harsh irony of Bruegel as a peer of Rabelais. The lines are fluid and strongly accentuated, while the colors possess an admirable brightness, with whites, reds and greenish grays set against a brown background. This panel has been attributed to 1568, and it is the smallest painting created by Bruegel. The crippled beggars are wearing symbolic emblems: a pasteboard crown (the king), a paper shako (the soldier), a beret (the burgher), and a mitre (the bishop).

Pieter Bruegel the Elder was the first artist before Claude Lorrain and long before Claude Monet to introduce time in paintings and to structure it as a calendar of human labors from one season to the next. His paintings give us the scent of fodder, the aroma of ham, a taste of pork eaten at a farmer's table and the voices of children playing in the snow.

Bruegel's Techniques

How did Bruegel paint and which techniques did he employ? He began with careful drawings containing a multiplicity of forms. Then he added depth to his sketches by incorporating themes far more diverse than those of his predecessors. Without falling prey to virtuosity or feeling obliged to complete works commissioned by the Church or by groups of burghers, Bruegel always painted without constraints. He pursued a customary mode of composition that was observable among Flemish

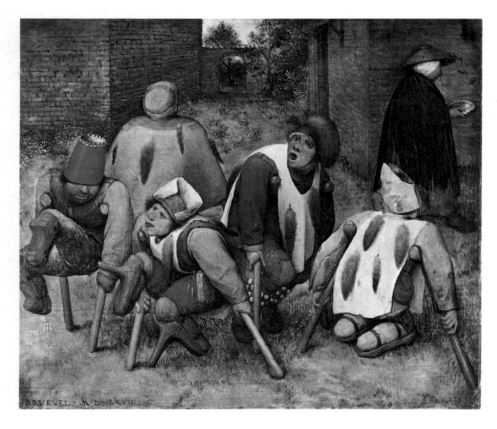

The Beggars, 1568.
(18 x 21 cm.). The Louvre, Paris.
Bruegel's signature and the date appear in the lower left portion of this painting in distemper (water and an agglutinating substance added to pigments).

The Blind Leading the Blind, →
Museo del Capodimonte, Naples.
Whereas this portion of the painting inspires sympathy for the blind man's affliction, the entire painting (next page) conveys a farcical tone.

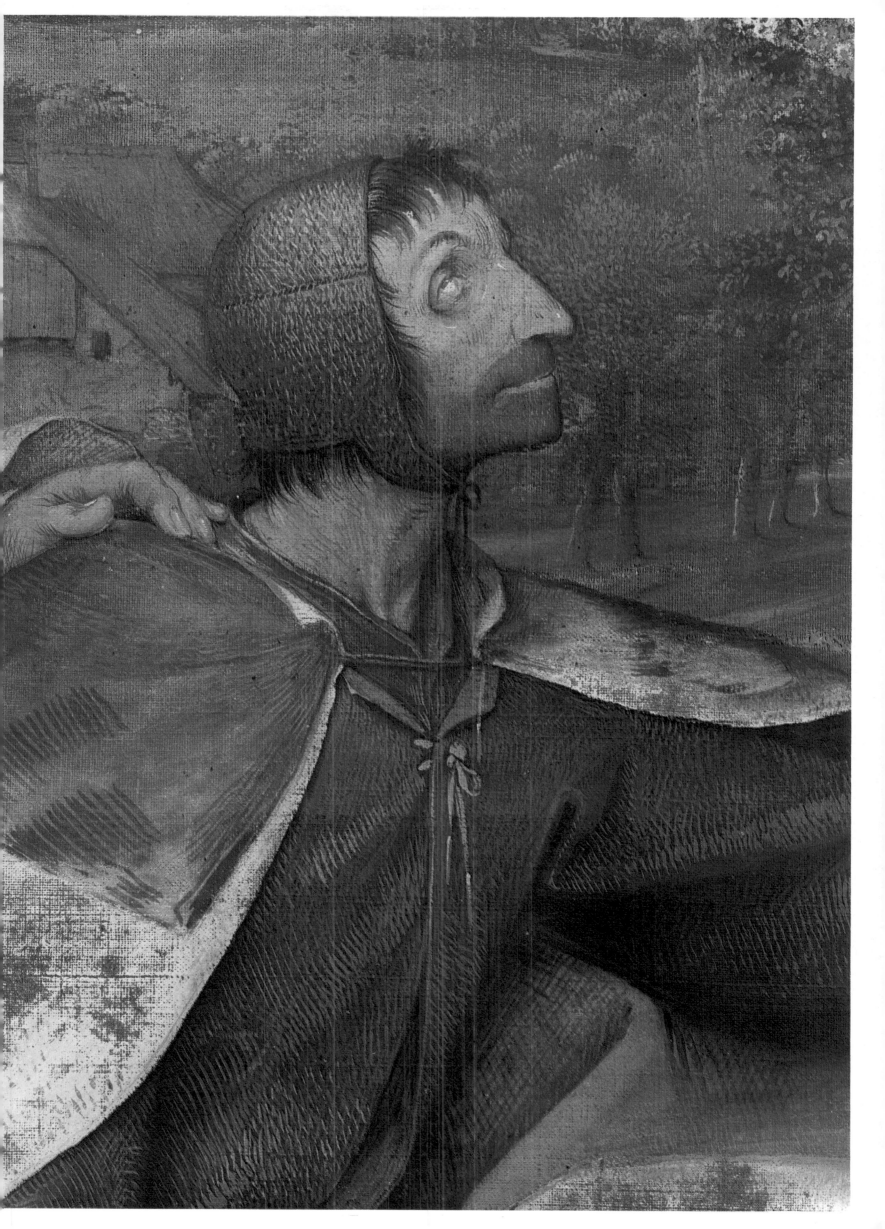

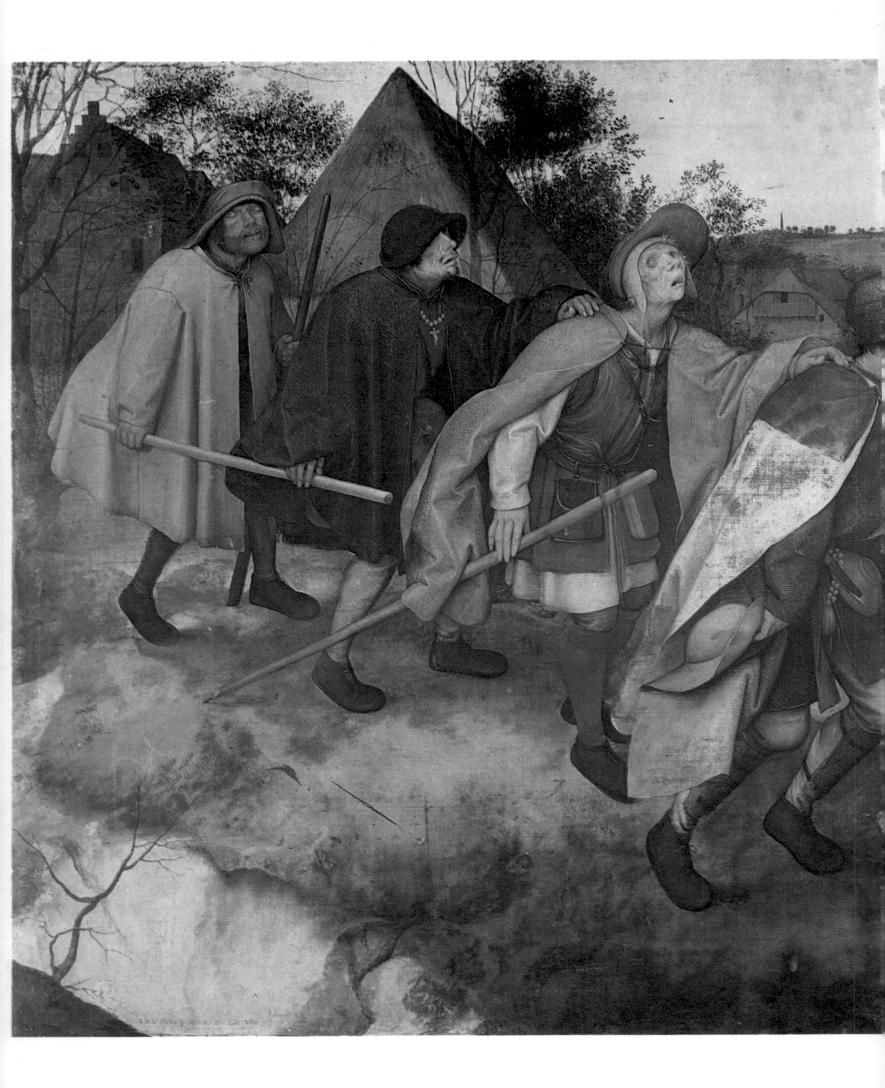

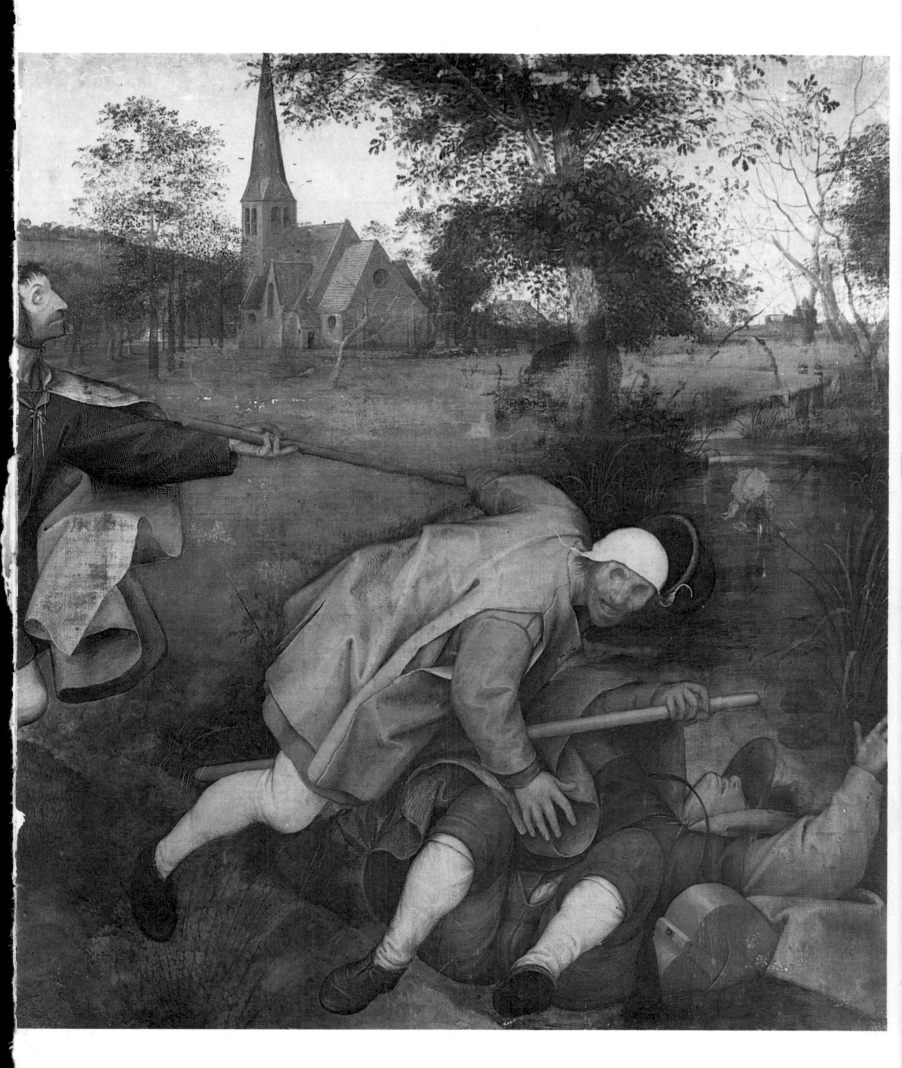

painters since the time of Van Eyck. Bruegel constructed scenes in such a way that we scrutinize them from above, with a descending perspective. In this way, it was possible to attract our eyes to vast spaces and to set motifs before us on a broad scale. Bruegel succeeded in maintaining an exceptional equilibrium between nature and figures who are often represented by large silhouettes. He knew how to attract and focus our attention in relation to the elements he tried to emphasize. Although he did not adopt chiaroscuro techniques, his paintings abound with contrasts, with alternation between dark and light colors, and light and dark. Spreading in large expanses around natural settings or flowing around his figures, Bruegel's colors are distinctive because they outline each element and establish distinct tonalities — red, blue, green, or yellow — in order to provide emphasis in relation to backgrounds.

Bruegel's humanism impelled him to return to nature and to remind city-dwellers of the dignity of rural life. This inclination emerged at an extremely early point. His trip to Italy, for example, did not lead to the fascination with Antiquity that had become fashionable among artists and travelers during that era. Instead, Bruegel studied scenes transpiring in front of his own eyes, away from walls laden with frescoes and paintings, and far from the masters who had created these works.

In our era where there are greater possibilities of living many years, it is tempting to imagine Bruegel the Elder (or the Old Man, as he would have been called not long ago) as a robust figure with a flowing beard, perhaps ninety years old. This great portrayer

of life, who created so many profound works, was only forty-five years old when he died, leaving behind a world that he so deeply understood and expressed, a world that was given the greatest visual pleasure.

With Bruegel even more than with Bosch, the art of the former Low countries lost its specifically linear quality and became accessible to color, nuances of volume, and density of substance. What an artist! What multiplicity he was able to reveal with groups of persons, swarms of human figures, and a torrent of ideas!

Jan ("Velvet") Bruegel
1568–1625

Within the Bruegel dynasty, Jan ("Velvet") Bruegel, the second son of Pieter Bruegel the Elder, must be granted a separate position. Jan Bruegel, who was trained in Antwerp and became a friend and colleague of Rubens, painted admirable floral compositions, including the large *Vase with Flowers and Insects* at the National Museum in Stockholm. This painting is a masterpiece in terms of structure and color, with butterflies appearing here and there among roses, irises, tulips, and anemones. "Velvet" Bruegel also completed a series of paintings entitled *The Five Senses*, wherein *Taste*, at the Prado, encompasses a magnificent profusion of foods capable of satiating our greed, amid the splendor of the velvety tones that were the source of the nickname given to this artist.

Taste, late sixteenth century.
(64 x 108 cm.). Museo del Prado, Madrid.
Bruegel the Elder's second son (Jan Bruegel), who was a friend and colleague of Rubens, displayed praiseworthy talents when he created a series of paintings depicting the *Five Senses*. In this painting, he has assembled a prodigious array of items to tempt the palate.

Flowers in a Vase, with Insects, c. 1600. →
(73 x 59 cm.). National Museum, Stockholm.
These flowers in a vase, with butterflies and other insects scattered among them, reveal astonishing use of the palette to create tulips, roses, and irises. This is one of the most beautiful bouquets in the history of painting. Indeed, its proportions and colors are those of a masterpiece.

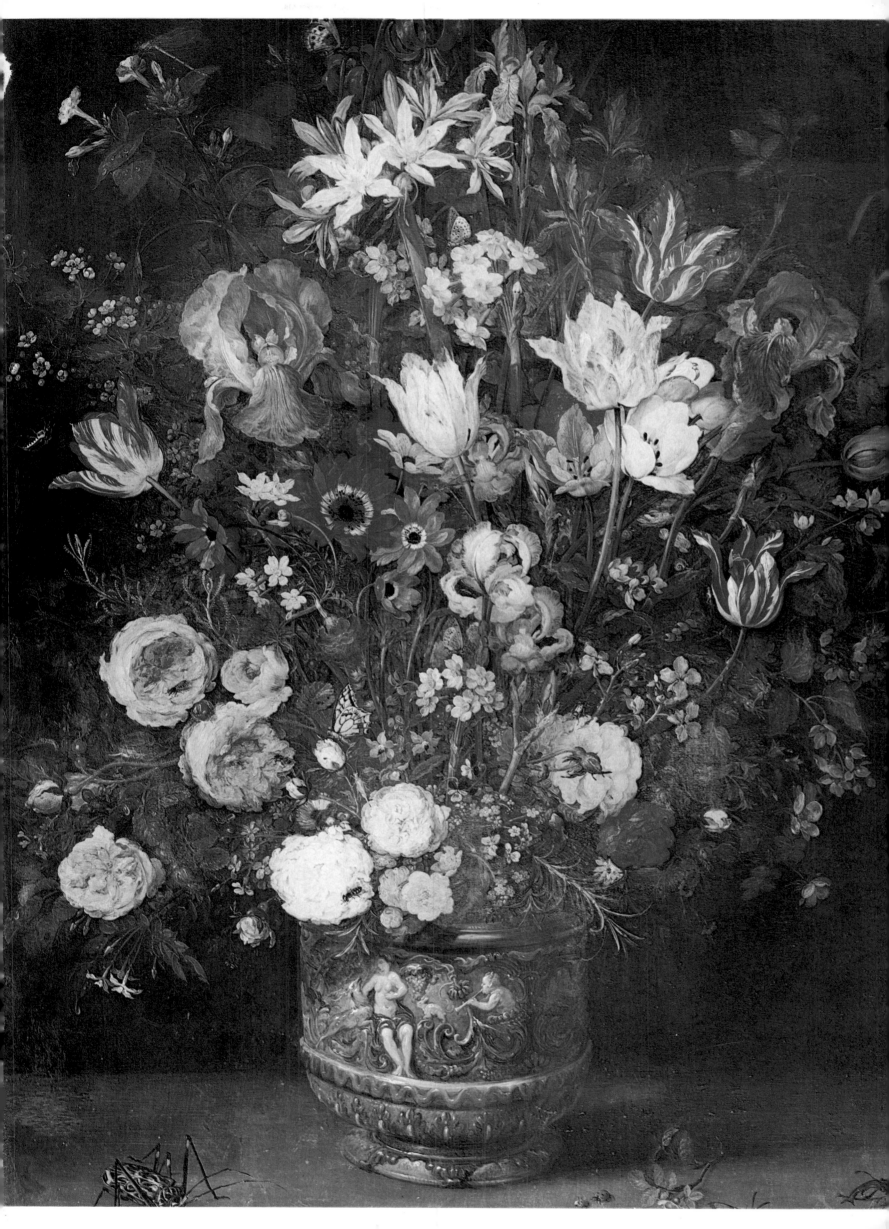

RUBENS AND HIS CIRCLE

Peter Paul Rubens

(1577–1640)

This was one of the greatest painters of all time, an admirable virtuoso with the brush, a man enraptured with life and women, and a joyful man who knew how to accomplish everything and to portray life with incomparable brio.

Rubens' deft strokes evidenced his extraordinary powers of execution. It is easy to see why he was greatly admired by Delacroix, who in 1841 copied the *Miracles of Saint Benedict,* which was an initial version of an incompleted painting that remained in Rubens' studio. Rubens is simultaneously optimized by a natural elegance, a talent for painting a vast range of subjects, and the opulent sensuality of his women.

Peter Paul Rubens was born in 1577 in Seigen (Westphalia), a small German village not far from Cologne, where his father, a magistrate from Antwerp, was living in exile. In his youth, the artist returned to Antwerp, then the commercial center of Europe. Whether he actually served as a page to the Countess of Ligne-Arenberg, as has been claimed, is of no consequence. He studied Latin and learned to paint in the studios of Adam Van Noort and Otto Van Veen. In 1600, before traveling to Italy, he joined the Antwerp guild of master artists.

For eight years, Rubens remained in the service of the Duke of Mantua, painting portraits of his family. Tintoretto and Titian appear to have been his favorite Italian painters. In 1603, after he had completed several paintings for churches, he painted a *Baptism of Christ* (now lost) for the Jesuits of Mantua and visited Genoa.

Rubens and Isabella Brandt, c. 1610. (178 x 136 cm.). Alte Pinakotek, Munich. The master painter of Antwerp depicted himself and his first wife with astonishing deftness and exceptional knowledge of form and colors, as well as consummate elegance.

Extraordinary Execution

Upon returning to Antwerp under the sponsorship of the Burgomaster, Rubens became the court painter to the Governor of the Low Countries, Archduke Albert the Pious. In 1609, he married Isabella Brant, the daughter of an official. She appears at his side in the double portrait belonging to the Alte Pinakotek in Munich. Rubens' spouse is as delicate and as elegant as a fresh rosebud. At this time, she was eighteen, whereas the artist, who

Helena Fourment and Rubens' Children, c. 1635. (113 x 82 cm.). The Louvre, Paris. Rubens' second wife, Helena Fourment, is depicted with their children with an energetic style and admirably harmonious colors. The woman who was often a model for Rubens appears here as the mother of a family.

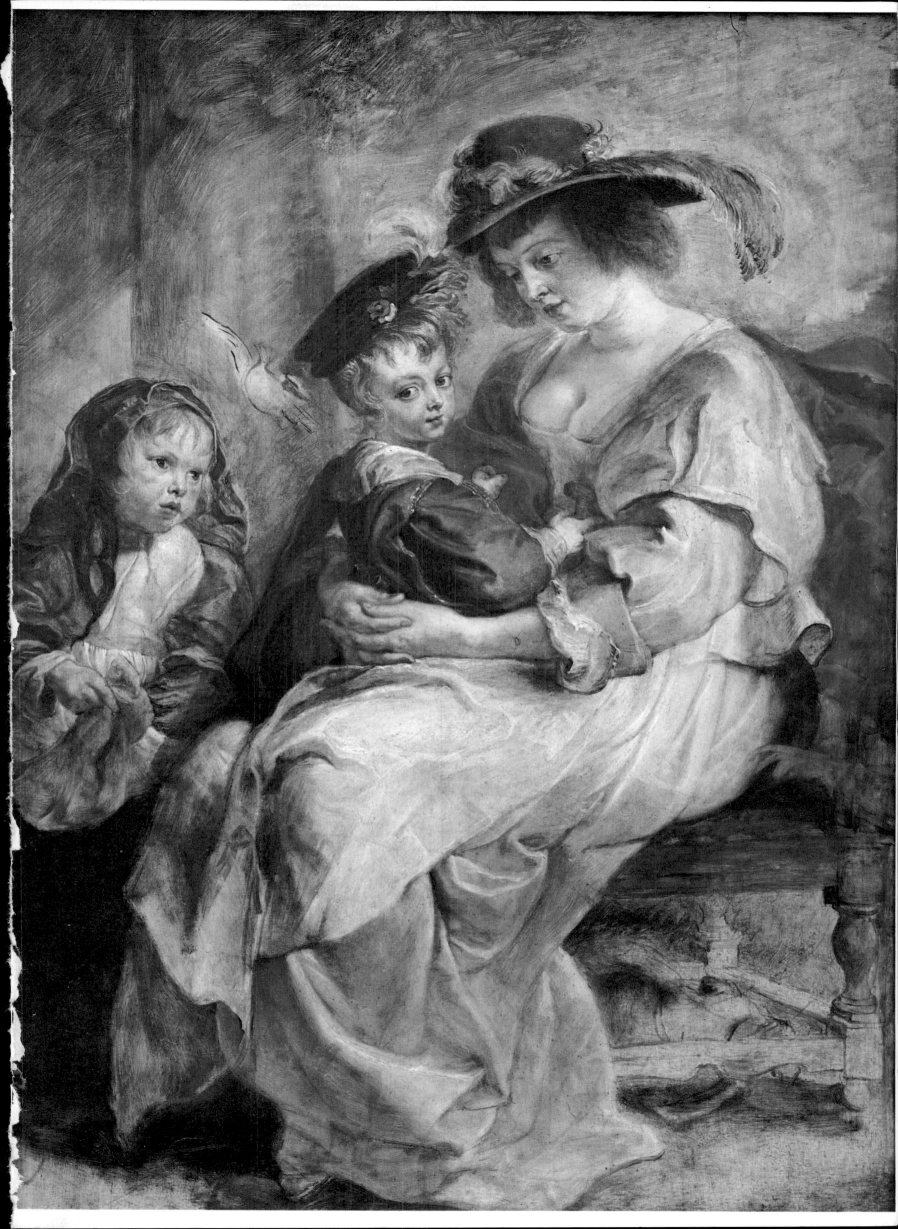

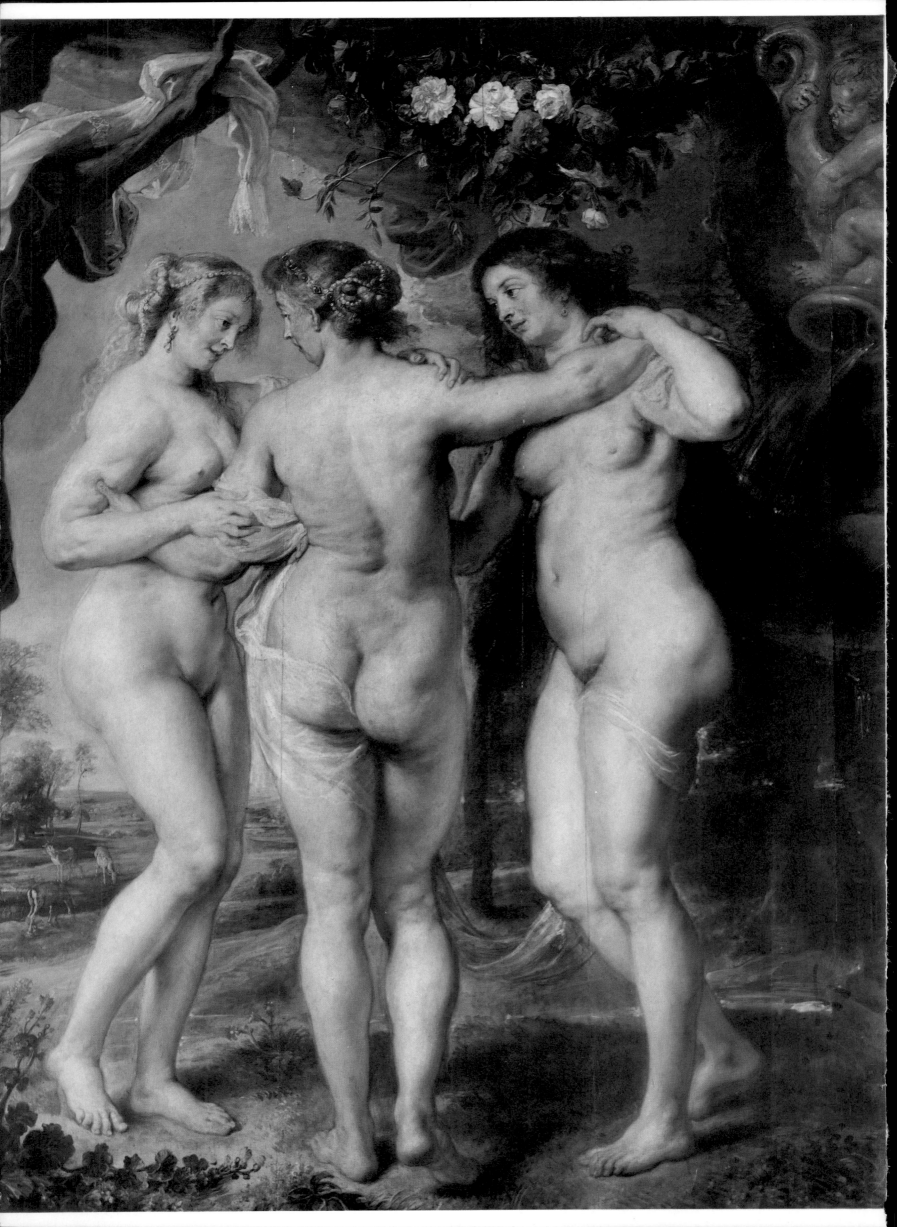

appears with a carefully trimmed mustache and beard, was thirty-two.

Rubens lived in a large house with a studio. Two years after moving there, as he approached the height of his glory, he completed a *Raising of the Cross* and a *Descent from the Cross,* in which strikingly expressive effects emerged. Rubens was fascinated with movement and the creation of elliptical rhythm. During this period, he completed paintings for the altars of churches in Antwerp, Ghent, Malines, Lille and Cambrai, renewing the most conventional religious themes with distinctive originality.

When Rubens was summoned to Grance to complete paintings for the Galerie de Medicis at the Palais du Luxenbourg, recently built by Clément Metézeau, he completed a series of twenty-one large paintings that are now displayed at the Louvre. In this prodigious series, he succeeded in bringing glory to the *Life of Queen Marie de Medicis* (1622). Subsequently, he was commissioned to commemorate the reign of Charles I of England.

Nothing deterred him. The most burdensome commission, where in another artist's results would have borne the imprint of pomposity or insincerity, acquired freedom, improvisational charm, and the joyfulness of creation triumphing over all other concerns. Rubens succeeded in mastering everything, as if his creativity was entirely free from constraints. We recall our surprise at Florence's Gallerie degli Uffizi at the immense *Triumphal Entry of Henry IV in Paris after the Battle of Ivry* (1630), which is a work radiating the boldness of spontaneous creation.

Rubens' Studio

Rubens also cherished the concept of collective endeavors. In addition to his own prestigious skills, he was capable of persuading his colleagues to paint animals, flowers, sill lifes, and embellishments for his own creations, thereby obtaining completely harmonious accompaniments for his works. Rubens' studio was always enlivened by the visits of fellow artists and admirers, as can be observed in a painting done by one of his pupils. Under numerous paintings belonging to the Master's collection (some of these are even hung from the ceiling), groups of visitors are shown in every corner, standing or sitting around tables containing assortments of musical instruments, vases, paper and items that could be used by an artist performing his tasks.

Subsequent to his journeys to other nations, Rubens acquired the *Wapper* manor, where Isabella cared for his three children. In 1625, when she was deeply depressed by the death of their daughter, he completed several portraits of her. Isabella Brant died during the follow year on June 20, 1626.

Rubens remarried four years later, on December 16, 1630. His second wife was Helena Fourment, the youngest of the eleven

children fathered by his friend Daniel Fourment. At the time of their marriage Rubens was fifty-three years old and she was sixteen. She was a superbly beautiful woman whose attributes became a recurrent subject of his paintings.

At this time, Rubens was already afflicted by gout (perhaps caused by excessive drinking, but there is no conclusive evidence). His health was also impaired by rheumatism but his hand displayed an unprecedented flexibility in wielding the brush to capture the charms of his new spouse, who so often served as his model. He portrayed her in an exceptional range of poses. Thus, Helena Fourment is the majestic nude appearing the *The Fur Wrap* (1638). Although Rubens exalted her sensuality, he never lapsed into vulgarity.

By 1638, attacks of gout and rheumatism sometimes prevented Rubens from using his pen or his brush. Nevertheless, he completed the *Judgment of Paris* and *Nymphs and Satyrs,* followed by the panel known and *The Three Graces* and a sketch for *The Temple of Venus.* Like Renoir at the end of his life, Rubens

Child with a Bird, c. 1616.
(49 x 40 cm.). Galerie Dahlem, Berlin.
A small and affectionate masterpiece.

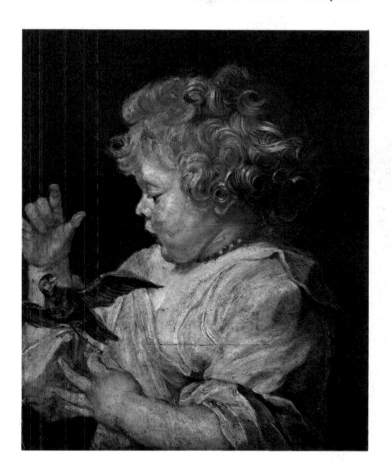

The Three Graces, c. 1639.
(221 x 181 cm.). Museo del Prado, Madrid.
Both the blond and dark-haired nude possess the statuesque proportions of Rubens' wife, who posed for him on many occasions.

The Arrival of Marie de Medici in Marseille, 1622–1624.
(394 x 295 cm.). The Louvre, Paris.
These are the naiads appearing in one of the large paintings in a series at the Louvre.

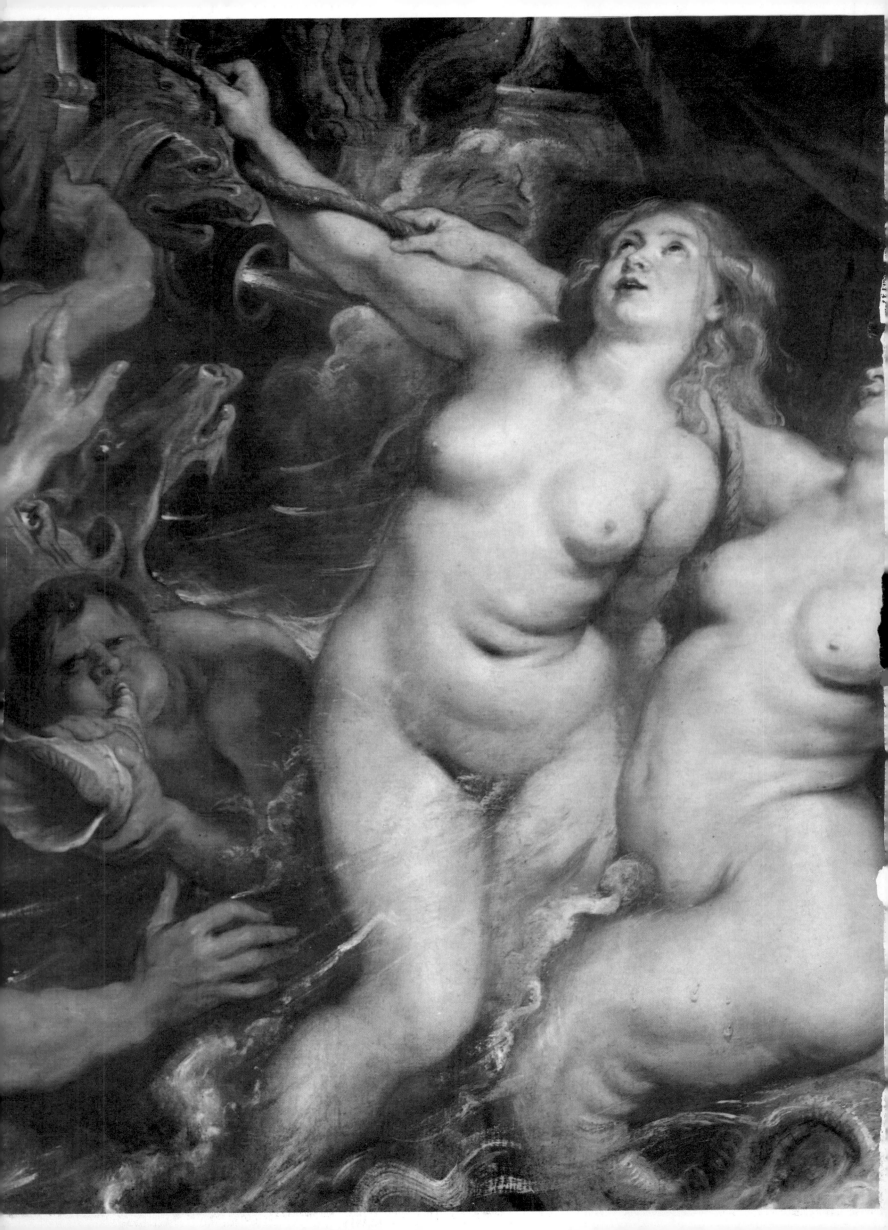

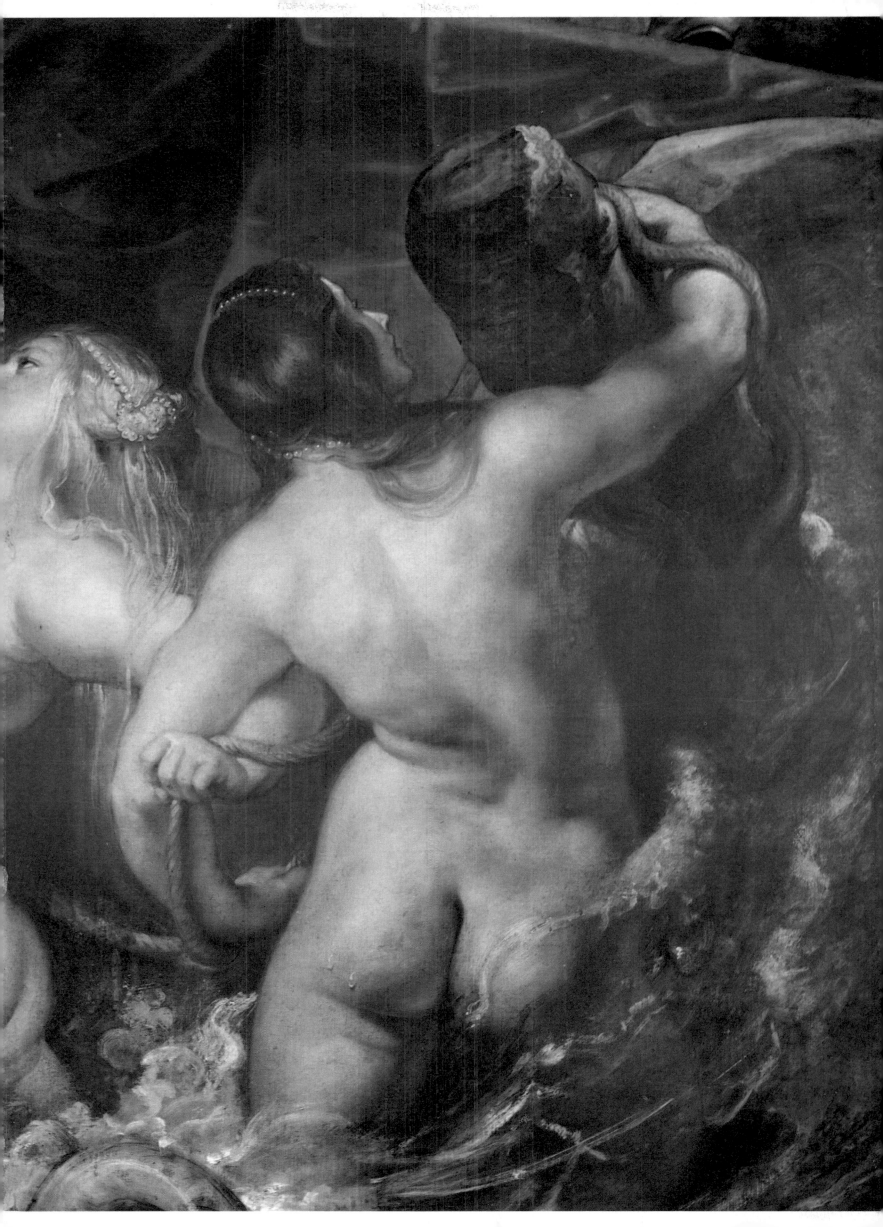

 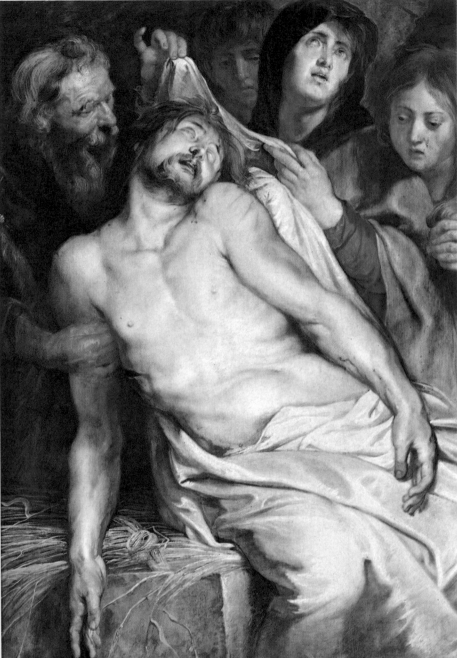

sought to bestow even greater glory on the female body. He died at the age of sixty-three on February 30, 1646.

In paintings with religious themes, Rubens emerged as the leading artist of the Counter Reformation. In response to Protestantism, he created a visual commemoration of Saint Ignatius Loyola and Saint Francis Xavier entitled *The Triumph of the Church* (1627).

At times, Rubens was overly ostentatious and filled his paintings with too many figures, as in the large *Adoration of the Magi* (Antwerp), in which the elderly man in a scarlet cloak who appears on the left side reflects a pompous style and is surrounded by many other figures, not including those on camels in the background.

Crucifixion Triptych, c. 1618.
(Center panel: 135 x 98 cm.)
(Side panels: 135 x 40 cm.). Musée Royal des Beaux-Arts, Antwerp.
This triptych, which is also known as *Christ upon the Straw,* contains a center panel where the Christ figure forms a prominent diagonal. The Madonna and her child appear in the left panel and Saint John the Evangelist appears in the right panel.

The Lance Thrust, 1620.
(429 x 311 cm.). Musée Royal des Beaux-Arts, Antwerp.
In this large painting, Rubens expressed his sense of drama by means of the lance thrust, the repentant thief turning toward the Savior, the Virgin and Saint John averting their eyes from the scene, and Mary Magdalen lying at the foot of the cross.

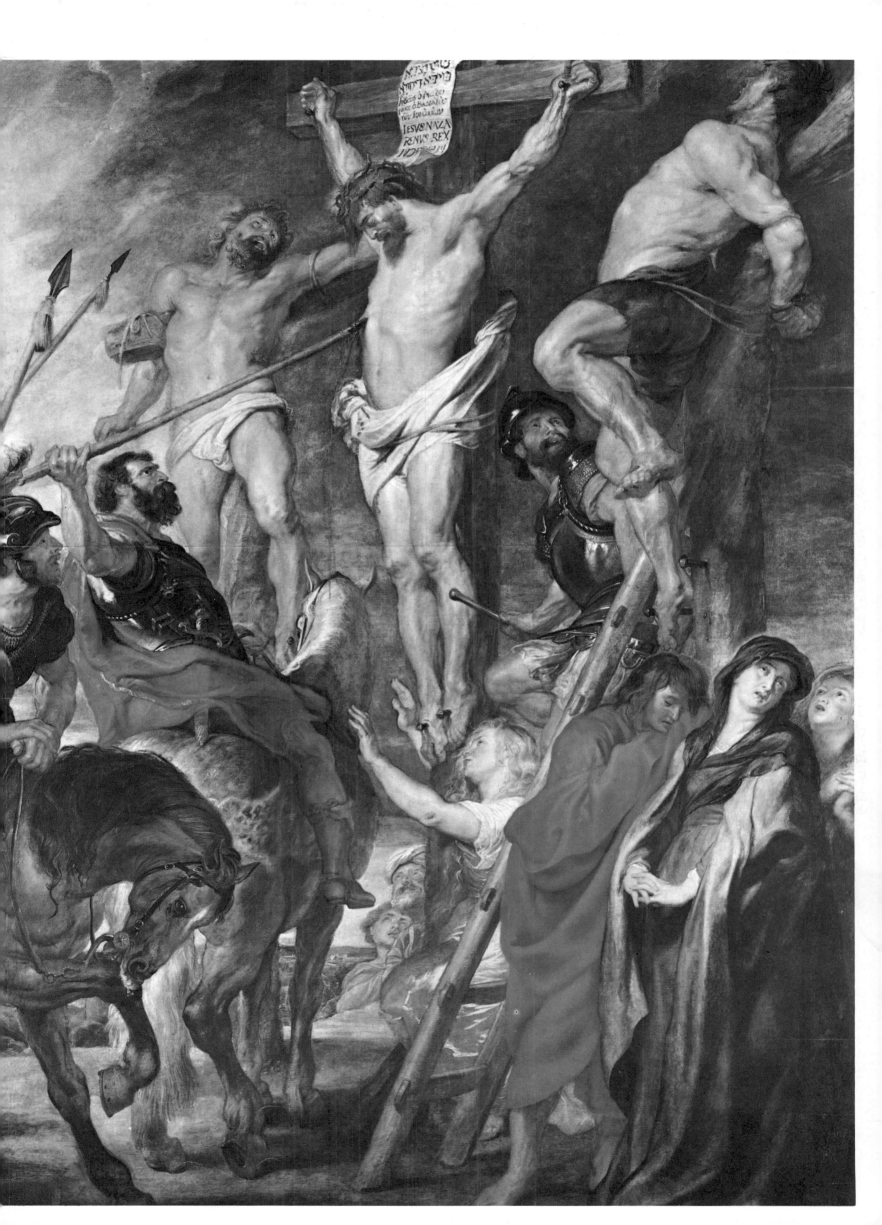

Tactile Art

Among his religious paintings, Rubens even surpassed himself with *The Last Communion of Saint Francis of Assisi.* Of course, this painting is extremely different from the *Poverello* created by Giotto for the Chapel of Santa Croce. With contrasting diagonal patterns, the saint is shown almost naked as he kneels before the priest offering him the sacrament. His face bears an unforgettable expression, with the luminescence of his faith, even though he is dying and, in the upper portion of the painting, angels appear to be waiting for him, next to a Baroque ornamental structure.

No painting is more moving than Rubens' *Lamentations upon the Body of Christ,* in which the corpse lies full length upon a cloth in front of two tearful women gesticulating in the darkness. As Rubens' nearly monochromatic sketches show, colors were modulated with exceptional subtlety. In this case, the painter has conveyed an undefinable chill floating around a torch illuminating the dark scene, like a scene from Shakespeare's tragedies.

Rubens was, first and foremost, a portrayer of women — even though this fact seems to have somewhat eluded Fromentin. Tactile art never acquired such magnetism, except perhaps in Titian's works. In comparison, the Greek and Classical artists are characterized by a dispassionate obedience to convention, whereas Rubens (Renoir inherited the same gift) expresses the true warmth of women who are alive, in front of our very eyes.

In evoking legends, mythology, history, allegories and scenes from the life of Christ, Rubens is clearly one of the most outstanding visual commentators. "Chamber music and loud organs" was Pierre Cabanne's analogy. Rubens succeeded in painting in every genre — portraits, landscapes, compositions — and did not encounter discouraging results. His *Christ on the Straw* (a "Pietà" triptych) reveals a prostrate figure lying diagonally, with his body rendered even more pale by the adjacent colors. In *The Lance Thrust* (1620), Christ on the cross forms a large vertical figure in contrast to the twisted bodies of the two crucified thieves and the figures in the bottom portion of the painting.

Susannah and the Elders, 1614–1616.
(94 x 76 cm.). Galleria Borghese, Rome.
In this painting, which is one of several versions of the same scene, Rubens expressed his subject's shock and fear with harmoniously arranged nocturnal, bluish, and muted tonalities.

Adoration of the Magi, 1642.
(447 x 336 cm.). Musée Royal des Beaux-Arts, Antwerp.
This is a detail from an *Adoration* scene which has not been fully reproduced. In this case, Rubens' grandiloquence is somewhat theatrical.

The Portrayer of Women

By the time Rubens was thirty-seven years old, his fascination with the female body had emerged. In *Susannah and the Elders* (1614–1616), the painter seems to have taken the place of the elders in the bluish darkness in order to spy upon and covet his startled subject. Then there is the magnficent *Rape of the Daughters of Leucippus* (1618), in which the perpetrators are Jupiter's twin sons. In this painting, the female victims do appear entirely unwilling.

The Baroque qualities of Rubens' art reached magnificence in the latter painting. Nothing is comparable to the splendor of this composition, in which an astounding series of counterbalanced curves delineates the two womens' bodies. Their flesh is stupen-

The Rape of the Sabines, c. 1630–1640.
(197 x 234 cm.). National Gallery,
London.
A detail from this large painting in London demonstrates the Baroque genius of Rubens' treatment of a tumultuous scene.

dously accentuated against their abductors' capes and the horses' forequarters in brown in gray.

Between 1635 and 1638, Rubens continued to produce paintings exalting the female body, with Helena Fourment as a constant source of inspiration. She was portrayed as Venus emerging from the sea and, in *The Judgment of Paris,* as the Aphrodite who was chosen over her two rivals. There are two versions of this painting. In the one at the National Gallery in London, the three goddesses are considerably more prominent than their surroundings, whereas in the larger painting at the Prado, the figure of Paris is more fully emphasized.

This woman who would be twenty-six years old at the time of her husband's death is constantly present. Rubens' exceptional mastery of texture and structure is exemplified by his way of depicting his family, by the beautiful face of Helena Fourment beneath a plumed hat, by the distinctness of her body beneath a cream-colored gown, by the young boy with brown eyes, and by the expression of his daughter entering the scene. Without extremely thick impasto, the dense portions of *Helena Fourment*

and His Children convey an impression of solidity, while areas in which the artist only used light brushstrokes provide contrasting effects.

Still the artist was already seriously ill when he completed this masterpiece.

Rubens differed sharply from Rembrandt, who was almost a contemporary. He was a dramatist, a scenarist, and a colorist who was able to create pyrotechnic effects with the hues from his palette. He was able to being with monochromatic gray and to attain a resounding crescendo of stunning vermilions. He was able to journey from the tragedy of the Crucifixion to the most seductive portrayals of femininity. He was an artist with prodigious skills and was consistently successful. His opposite was a fiercely individualist and capricious figure, overflowing with humanity and deeply preoccupied with the essential qualities that Rubens so boldy externalized. Rembrandt was a mournful explorer of the human soul, a visionary.

PETER PAUL RUBENS

The Crucifixion *and the* Descent *from the Cross are two moments in the drama of Mount Calvary for which the triumphal painting in Brussels serves as a prologue. With the distance separating these two paintings, it is possible to distinguish the principal hues, to recognize the dominant tonality, and hear the noise: it is enough to allow a quick understanding of the painter's mode of expression and to interpret its meaning.*

Here, we encounter the dénouement, presented with solemn sobriety. Everything has ended. Night has fallen, or the horizon is at least filled with dull black hues. There is silence and weeping. The majestic cadaver has to be retrieved and difficult tasks have to be completed. This is even more so if words being exchanged are those that escape from one's lips after the loss of a loved one. His friends and his mother are there, and we first observe the most compassionate and most vulnerable of all women — she whose fragility is the incarnation of grace and the absolution of all earthly sins that are now pardoned, expiated, and redeemed. The hues of living flesh contrast with funeral pallor. Even death itself acquires beauty.

The Christ figure resembles a beautiful flower that has been uprooted. Yet he can no longer hear those who mourn for him. He belongs neither to mankind, time, wrath, nor pity; he is detached from everything, even from death.

Here, there is no counterpart. Compassion, pity, his mother, and his friends are far away. In the left panel, the painter evoked the fullest depths of sorrow with a turbulent group of persons in mournful or desperate poses.

Eugene Fromentin
Les Maîtres d'autrefois

The Birth of Venus, early seventeenth century.
(27 x 28 cm.). Musées Royaux, Brussels.
This Venus emerging from the sea permits us to recognize the masterful quality of Rubens' draftmanship.

The Rape of the Daughters of Leucippus, 1618.
(222 x 209 cm.).
Alte Pinakotek, Munich.
This composition where the nudity of the two women is expressed by a splendid assortment of counterposed curves possesses an incomparable lavishness.

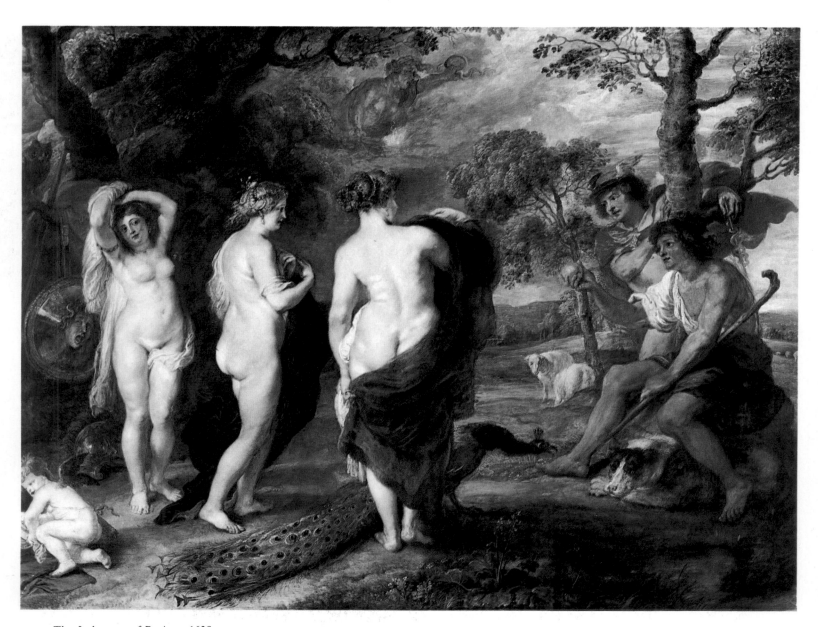

The Judgment of Paris, c. 1638.
(145 x 194 cm.). National Gallery,
London.
Toward the end of his life, Rubens painted
two versions of the *Judgment of Paris.* In
this version, the three goddesses are more
clearly differentiated.

Rubens was a virtuouso with the brush, capable of depicting anything with extraordinary verve, self-assurance, joy, boldness, and dexterity. He was enraptured with the warmth, movement, and clamor of life as he captured its undulations and turbulence. He personified the zenith of Flemish art.

He attained a culmination of his bacchanals, with themes that were later adapted by Nicolas Poussin. There is his *Andros,* which is a wondrously rhythmic composition, or *Nymphs and Satyrs* at the Prado in which the maenads are confronted by the pranks and the lustfulness of deities with bovine horns and hooves. This scene unfolds amid lush foliage, deep greens, and tourmaline blues in a landscape inhabited by stags, dogs, sheep and peacocks. The painter achieved an unequaled contrast between the majestic nudity of his female subjects and the dark, muscular skin of the satyrs.

Toward 1639, Rubens departed from thse celebrations of love and the flesh to create the exalted tranquility of the *Three Graces* (Prado) — Algae, Thalia and Euphrosyne, who appear un-clothed. Regardless of whether the figure's hair is blond or dark, one can still recognize the body of Helena Fourment. The Three Graces appear beneath a thicket filled with roses, while a small onlooker is concealed between the branches of a tree. The blond deity on the left is boldy outlined against the sky, whereas her dark-haired companion on the right has taken the arm of the figure at the center, whose callipygian charms fully reflect the preferences of that era. In this masterpiece, one encounters the promise of a sublime joy that renders untrue the following verses by Baudelaire:

> *"Rubens, river of oblivion, garden of indolence.*
> *A pillow of soft flesh that one cannot love..."*

Anthony Van Dyck

1599-1641

Van Dyck created portraits of the rulers and noblewomen of his era, displaying them in their best finery. He was a precursor of the British portraitists.

Small Pietà, 1634.
(116 x 208 cm.).
Musée Royal des Beaux-Arts, Antwerp.
This painting reveals all of the attractiveness of Van Dyck's style. Even when he depicted a religious theme, its seductive qualities were observable.

Portrait of the Princess of Orange,
1618–1620
(140 x 107 cm.).
Pinacoteca di Brera, Milan.
This is one of the consistently admired portraits done by the most prolific portrayer of royalty during his era.

When one examines Van Dyck's self-portrait at the Hermitage, it is possible to recognize that this is indeed the aristocratic and somewhat pensive young painter whom Fromentin described so eloquently. The half-smiling face beneath his stylishly arranged hair, the fashionable attire, and the somewhat nonchalant position of his hands — everything about Van Dyck reflects a studied elegance.

What were the origins of this handsome youth? Van Dyck was the son of a cloth merchant who fathered eleven other children. At ten years of age, he became an apprentice to Hendrik van Balen but his exceptional talents were promptly recognized. He was soon able to open his own studio with the aid of other painters, and on February 11, 1618, he became a master artist. Then he spent two years painting in the studio of Rubens, whose fame had already been established. Van Dyck readapted his mentor's themes in a less bold form.

A Certain Lack of Unity...

In order to be aware of the qualities that distinguish Van Dyck from Rubens, one has to compare two paintings by each painter of the same subject: a *Pietà*. Rubens' version has the vigor and dramatic qualities of a masterpiece; every element suggests a unique and evocative style. In contrast, Van Dyck's *Small Pietà* (it is only "small" in name because its dimensions exceed one meter by two meters) reveals insufficient unity. Christ's body appears to be more alive than dead, the Virgin Mary has spread her arms in a beseeching gestrue, while Saint John is pointing his finger at the corpse, as he stands beside the weeping Mary Magdalen. Each figure was painted separately, and the colors appear to be isolated in every case. Rubens began with the visual response and compelled us to share it, whereas Van Dyck deftly created figures who could be individually detached, as if they were separate portraits.

Van Dyck's association with Rubens ended in 1619 when a patron invited him to undertake his first journey to Italy (he visited Genoa, Venice, Mantua, Milan, Rome and Palermo), where he painted portraits of the Genoese nobility, including members of the Pallavicini and Grimaldi families.

From the end of 1626 until the beginning of 1632, Van Dyck resided in Antwerp. While Rubens was travelling to Spain and England, Van Dyck occupied himself with paintings for churches. Toward 1630, he began a series of portraits of famous persons of his era (he ultimately painted at least a hundred portraits).

Portrait of Sir Endymion Porter and the Artist, 1623.
(119 x 144 cm.). Museo del Prado, Madrid.
Van Dyck, who became one of the favorites of King Charles I, painted this portrait of himself standing beside the Duke of Buckingham's secretary.

Today, it is difficult to appreciate this genre, which we only tend to admire in the form of such typical faces as that of the *Man with Gloves*. Our curiosity promptly falters when we look at the series of painted figures and faces who inhabit museums. Do we ever return to them? Why not? As Delacroix observed, "Novelty is very old, and one could even say that it is the oldest of all things."

Traditionally, the British were the most fervent admirers of portraiture as a genre. As early as the era of Henry VIII, Holbein was invited to England to paint the most prominent members of the Court, beginning with the king. In turn, nearly a century later, in March, 1632, Charles I summoned Van Dyck to London. The monarch lavished favors upon his guest and visited his studio. Van Dyck spent seven years in England, except for occasional trips to Flanders.

An Incomparable Portraitist

In England, he produced a profusion of portraits: the king, the royal family, countesses, lords, and courtiers. Van Dyck was constantly beset by new commissions and love affairs. In 1639, when he was forty years old, he married Mary Ruthven, a member of the Scottish nobility. The Crown and England itself were soon threatened by civil war. Rubens had already died and Van Dyck himself became ill, dying in December, 1641.

In portraiture, Van Dyck had no rivals. He revealed himself as an artist whose brush could seductively capture not only the king but the king's steed and the adjacent landscape (*Equestrian Portrait of Charles I*). Each element produces fascination. Van Dyck was often asked to create double portraits, such as the one in which he depicted himself standing beside Sir Endymion Porter, the Duke of Buckingham's secretary. Here, we encounter mellow tones with subtle nuances.

Van Dyck's *Queen Henrietta*, who is wearing a black hat with feathers and a blue silk robe with shiny pleats, is astonishingly beautiful. She is shown stroking a small monkey held by a dwarf wearing a pink velvet suit. This portrait overflows with majesty and is almost excessively beautiful.

A Spanish painter subsequently challenged his Flemish predecessor with an adaptation of this portrait in which the Duchess of Alba replaced the resplendent image of Charles I's wife.

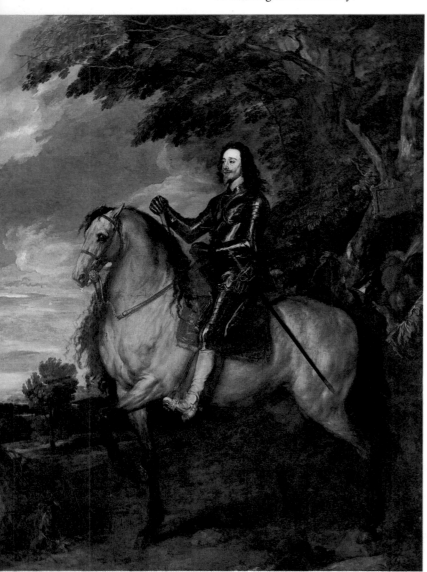

Equestrian Portrait of Charles I, 1635.
(365 x 289 cm.). National Gallery, London.
This portrait has a notably majestic quality. Every aspect is magnificent, from the horse to its rider, the King of England, Scotland and Ireland. He governed without Parliament and enraged Cromwell and many others, even though he was a knowledgeable patron of the arts. The king was executed at Whitehall in 1649.

Self-Portrait, early seventeenth century. (116.5 x 93.5 cm.). The Hermitage Museum, Leningrad.
This is the self-portrait of Van Dyck that is described by Fromentin. The smile, the finely shaped nose, and the carefully posed elongated hands evoke the artist who lived luxuriously in London until his death.

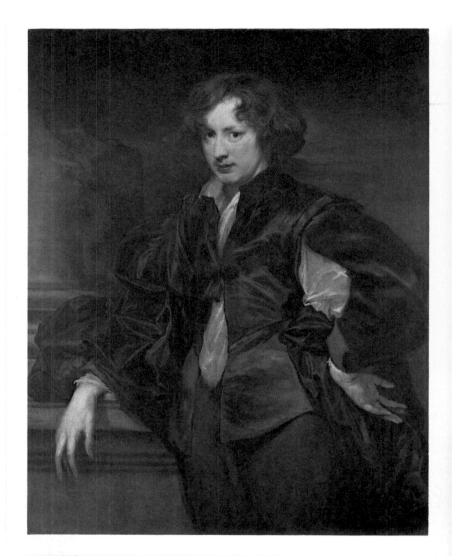

ANTHONY VAN DYCK

This is how one might create a portrait of Van Dyck in a quickly sketched form with somewhat rapid brushstrokes:

A young prince from a royal dynasty, endowed with every advantage, from beauty, elegance and splendid talent to a unique education, and above all, the benefits of an auspicious birth; pampered by his mentor, who indeed became a fellow pupil; acclaimed everywhere, invited everywhere, and welcomed everywhere, even more in foreign lands than in his native country; an equal to the most prestigious lords, a favorite and a friend of kings; promptly partaking of the most coveted things on earth — talent, fame, glory, luxuries, affairs of the heart, and adventures; always youthful, even in his maturity, and always wise, even in his final days; a rake, a gambler, a seeker of money, a prodigal, and a spendthrift who delighted in revelry and, as people would have said in his time, surrendered to the devil for handfuls of guineas, which he then threw away on horses, festivities and ruinous pleasures; a man who loved his art to the fullest extent, but sacrificed it for less worthy passions, less faithful loves, and less fruitful pursuits; a handsome and strong-bodied man with a noble stature, such as one encounters among the second generation of an aristocratic line, even though his complexion was less manly and indeed delicate; a man who more closely resembled Don Juan than a hero, although there was a tinge of melancholy and a shadow of sadness accompanying his revelry; the tenderness of a heart which readily fell in love, along with a certain disenchantment that is unique to those who are smitten too often; a temperament which was more inflammable than ardent; indeed, more sensuality than true passion, and less impetuosity than lack of restraint; a man who was less inclined to dominate his world than to be dominated by it and enmeshed in it; a person with exceptional charms who was susceptible to all charms and consumed by the most demanding things in the world, his Muse and women; a man who abused his merits, his health, his dignity, and his talent; overwhelmed with needs, worn out with pleasure, depleted of strength: a truly insatiable man.

Eugene Fromentin
Les Maitres d'autrefois

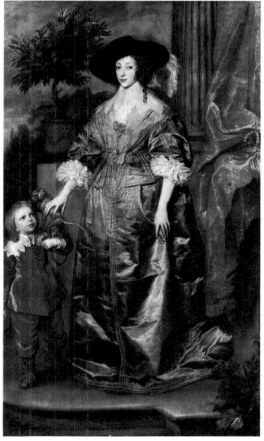

Queen Henrietta Maria, 1633.
(219 x 134 cm.). National Gallery of Art, Washington, D.C.
This portrait depicts Henrietta Maria of France, the queen of England and wife of Charles I, in her fullest *haute couture* splendor, accompanied by her dwarf. The accessories are regal, the colors are sumptuous, and the queen represents the epitome of elegance.

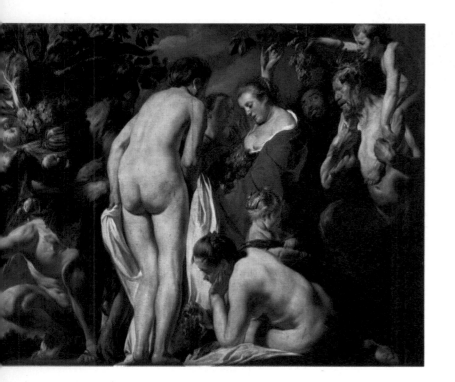

Original Sin, 1630.
(185 x 221 cm.). National Museum of Art, Budapest.
This painting reveals the characteristics that separate Jordaens from Rubens. There is less illumination and greater use of chiaroscuro.

The Earth's Fecundity, 1622.
(180 x 241 cm.). Musées Royaux, Brussels.
The painting is an allegorical evocation of fertility, with its fruits, vegetables, female nudes, and grapes on a trellis.

Jacob Jordaens

1593 — 1678

Jordaens was the most typical representative of the sensuality of the Antwerp School, endowing his works with an energetic and plebeian ruggedness. He collaborated closely with Rubens and was the mentor of lesser Flemish masters whom he overshadowed with his exceptional diversity.

This was an artist filled with natural vitality, an unerring and prolific craftsman, and a molder of dimensions and flesh. His opulent Flemish wife had a plebeian quality, entirely unlike Rubens' wife. Jordaens' collaboration with Rubens began in 1630. In his works, every element is robust, energetic, fecund and lavish. He painted in thick layers, dexterously wielding his brush and mixing his colors unsparingly. Jordaens exemplified ease and adroitness.

His prolixity was astonishing and inexhaustible. Like his mentor and perhaps to an even greater extent, he was capable of painting everything: nudes, faces, animals, flowers and landscapes. Jordaens was an incomparable craftsman.

Jordaens, who was the son of a linen draper in Antwerp, initially painted with tempera (a technique that he continued to employ for sketches). He married the daughter of Adam Van Noort, the Mannerist painter who was his first mentor.

It would be reasonable to expect that Jordaens' attraction to revelry would have rendered him vainglorious, but the opposite is true. He disdained honors and only consented to become the dean of the artists' guild after persistent pleas.

Thriving Sensuality

In 1621, when he was living on the Rue Haute, Jordaens was chosen as a decorator for the city of Antwerp. At the same time, he completed paintings that the King of Spain had commissioned from Rubens and created many mythological scenes. With his assistants, he agreed to decorate thirty-five ceilings for Queen Christina of Sweden. Jordaens also completed a series of allegorical tableaux for Amelia of Solms, near the Hague.

Jordaens promptly advanced beyond artisanry to establish himself as a painter and leading artist. Whereas Rubens often relied on light brush strokes, Jordaens used thick paint and conveyed a crude decisiveness.

The Bounty of the Earth (1622) contains a proliferation of subjects: female nudes, satyrs, fruit, birds, all depicted with unfaltering enthusiasm. Jordaens skillfully alternated between warm and cool hues.

With somewhat excessive sensuality, Jordaens filled his canvases with impressively developed forms. During the same period, he completed *Antiope's Dream* and produced family portraits.

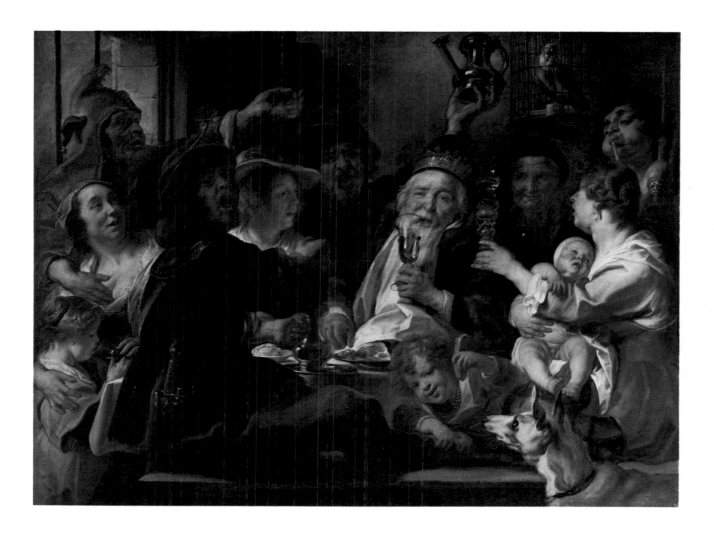

He also created a series of paintings entitled *The King Is Drinking* (with squalling children and singing adults), in which he almost lapsed into vulgarity. Among the persons shown feasting at the table, there is a mother swaddling an infant and the atmosphere is filled with laughter, shouts, and bawling...

The King is Drinking, c. 1638.
(160 x 213 cm.). The Hermitage Museum, Leningrad.
Jordaens painted this scene on more than one occasion. He did not hesitate to unveil the vulgar aspect of these revels in which adults sing while the children are neglected.

A Hint of Caravaggismo

The duration and decisive importance of Jordaens' association with Rubens was undoubtedly exaggerated. It is true, of course, that Jordaens was Rubens' friend and collaborator for several years and that he perfected his skills by working under Rubens' supervision. However, he possessed his own temperament, his own palette, and his own perspective of nature. His realism, which embodied the influence of Aertsen, also displays traces of *caravaggismo*. Even though the similarities between Jordaens' talent and Rubens' genius may initially seem striking (even more so that in the case of Van Dyck), it is subsequently possible to recognize significant differences. Jordaens' stature tends to diminish as a result of the close presence of such a prolific creator as Rubens. Still, Jordaens is an equally noteworthy example of the pictorial richness of Flemish art before it atrophied after Van Dyck and became submerged in banality for more than a century.

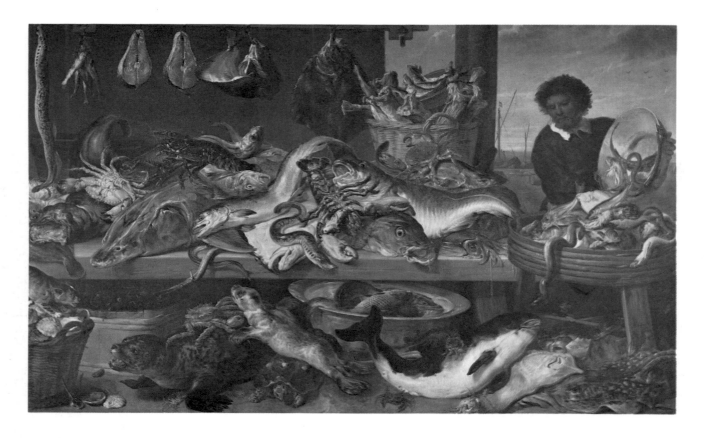

The Fish Market,
early seventeenth century.
(210.5 x 343.5 cm.). The Hermitage
Museum, Leningrad.
This large painting depicting sea-creatures
demonstrates the competence achieved by
Frans Snyders, a colleague of Rubens. The
entire painting is marvelously coherent.

Saint Ignatius amid a Garland of Flowers,
early seventeenth century.
(190 x 120 cm.).
Pinacoteca Vaticana, the Vatican.
Hercules Seghers specialized in painting
arrays of flowers. He was born in Antwerp
in 1590 and died there in 1661.

It would be difficult to provide a detailed description of the
many collective endeavors in which Rubens may have obtained
the aid of other painters. It is well known that many apprentices
and master painters were always at work in his studio. For ex-
ample, it is known that the unrivalled master admired the talents
of Jan "Velvet" Bruegel (1568–1625), who specialized in depicting
animals and flowers and whose only human figures appear in
Adam and Eve in Paradise (Mauritshuis, The Hague). The artists
who assisted Rubens in Antwerp also include Fyt, who was
renowned for his images of fruit, and Frans Snyders (1579–1657)
even though it has not been possible to identify their contribu-
tions to Rubens' paintings in a precise form. This difficulty is
insignificant, however! The truth is that it is not possible to
express excessive admiration for Frans Snyders' *Fish Market* (The
Hermitage, Leningrad). With its unusual heap of sea creatures,
such a painting suffices to establish Snyders' position as an
outstanding painter.

PORTRAYERS OF ANIMALS

Among painters subsequent to Rubens, it would be impossible to overlook some whose works deserve to be cited.

Roelant Savery

(1576-1639)

After beginning his career under the influence of Gilles van Coninxloo and Bruegel the Elder (*The Tower of Babel*), Roelant Savery (Courtrai, 1576-Utrecht, 1639) traveled from the Low Countries to Austria and arrived in Prague in 1604. There, he produced sketches and drawings of animals for Emperor Rudolph II. His zoological knowledge was combined with unusual elements of fantasy, as it is possible to observe in his *Landscape with Birds*, where an eagle is placed beside peacocks and swans. This painting reflects a magical atmosphere representing a continuation of (Gilles) Van Coninxloo's landscapes. Savery painted with an abundance of light and he tried to create pure colors.

Paul de Vos

(c. 1596-1678)

With its Baroque structure developed from circular motion, the *Stag Attacked by Hounds* (the Prado) offers evidence of the unduly ignored talents of Paul de Vos (c. 1596-1678). This painting is a worthy counterpart to his *Hunting the Doe*, also displayed at the Prado.

These are two of the most outstanding examples of hunting scenes that collectors eagerly sought to acquire during the first half of the seventeenth century. The two paintings were given to Philip IV of Spain by the Marquis of Leganes.

Adriaen Brouwer

(1605-1639)

Adriaen Brouwer (Oudenaarde, 1605-Antwerp, 1639), whose father produced designs for tapestries, left his family's home when he was sixteen and probably traveled to Antwerp. In 1625, he was residing in Amsterdam and subsequently painted in Haarlem with Frans Hals. During 1631 or 1632, he became a master artist in Antwerp, where he resided until his death in January, 1639, when he was still in his thirties. However, Brouwer completed a large number of paintings. When he became completely impoverished, Brouwer was imprisoned for seven or eight months and continued to paint during his confinement, until he was aided by Rubens. He was fascinated with nocturnal scenes and moonlight. Brouwer's paintings are often distinguished by sombre tones.

The Boar Hunt, 1609.
(25 x 35 cm.). Alte Pinakotek, Munich.
This is a vigorous and fierce hunting scene by Roelant Savery. The artist's signature and date were provided.

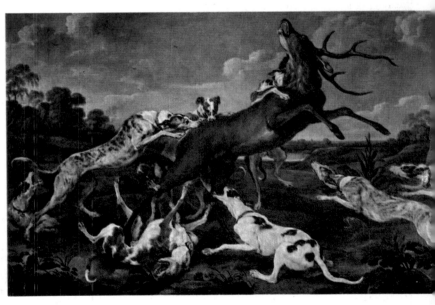

A Stag Attacked by Hounds, early seventeenth century.
(212 x 347 cm.). Museo del Prado, Madrid.
This large painting by Paul de Vos is distinguished by its admirable structural qualities. The stag attacked on the right and the left by the hounds forms an immense triangle.

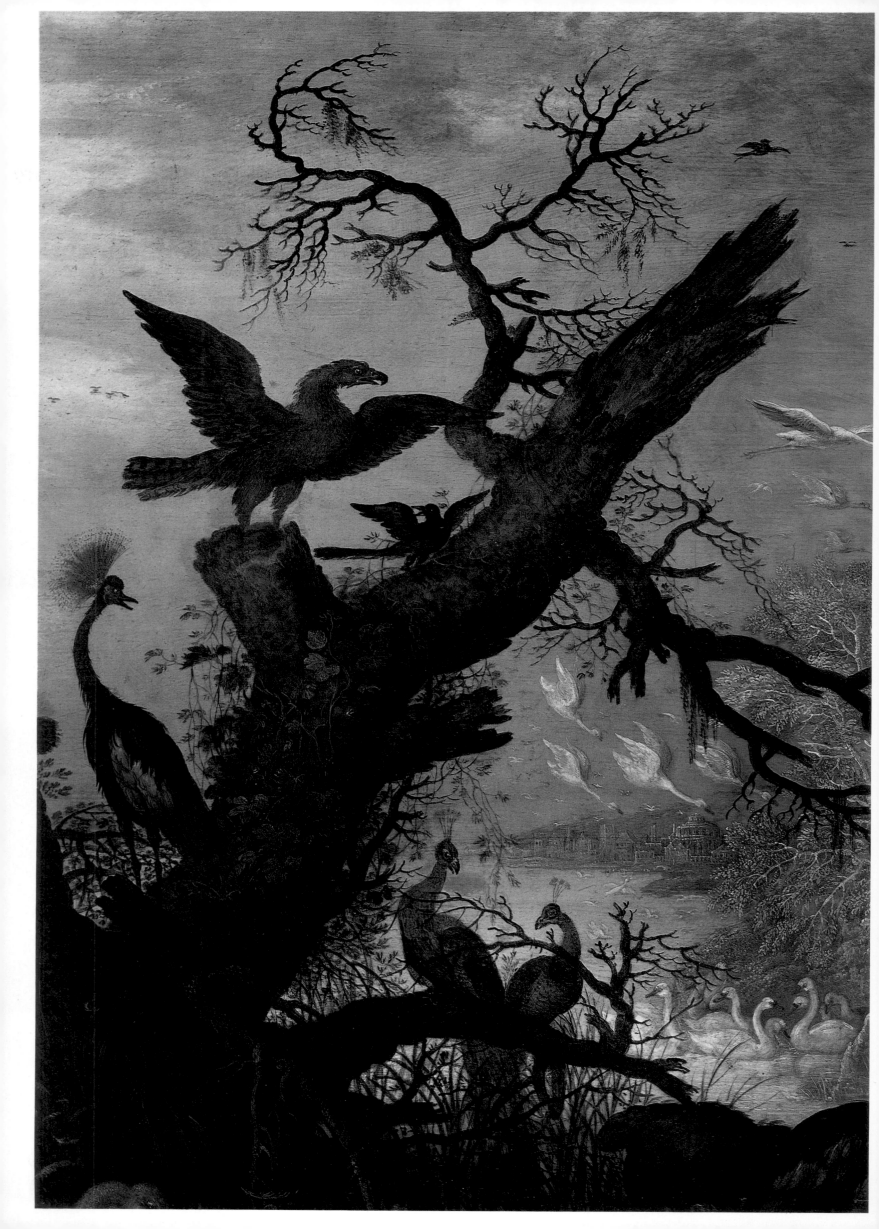

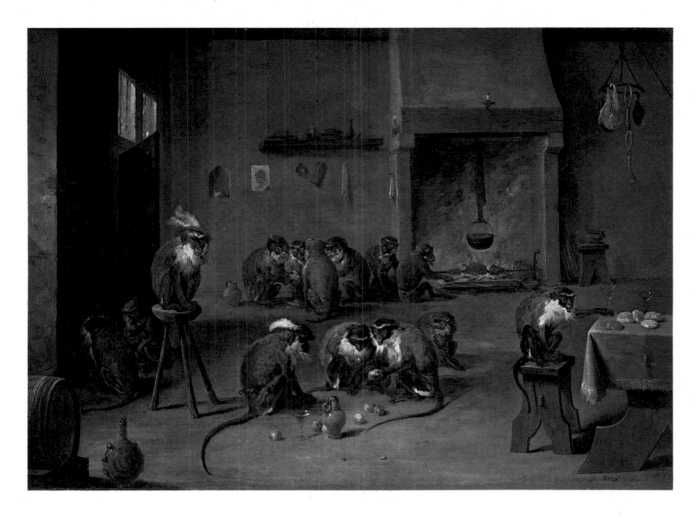

David Teniers the Younger

(1610–1690)

David Teniers the Younger (Antwerp, 1610-Brussels, 1690) resided in both Antwerp and Brussels after 1651. Archduke Leopold Wilhelm, the Governor of the Low Countries, commissioned Teniers to assemble a collection of paintings. In keeping with the tastes of that era, Teniers produced paintings depicting various collections. He died near Brussels, where he had acquired a small manor.

Although one cannot admire the alchemists and witches portrayed by this artist who married the daughter of Jan Bruegel, one should not overlook *Monkeys in a Kitchen*, in which Teniers' craftmanship attained a degree of individuality, refinement and vitality that strongly reflects his talent.

Jean Siberechts

(1627–1703)

During his successful period as a painter, Jean Siberechts (1627–1703?) proved to be a stunning precursor of the naturalism and realism of Courbet. For example, there is *Fording the River* at the Royal Museum in Antwerp. Indeed, it is difficult to believe that this luminous and attractive painting was completed in the seventeenth century.

But shadows were beginning to descend. After Rubens, his colleagues, and his successors faded from sight, the continuity of Flemish creative capacities was interrupted for an extended period. After the flowering of ogival art, the "creators of devils," the return to nature, and the height of Rubensian baroqueness, more than two centuries elapsed before a highly imaginative painter from Ostend attained such heights.

Landscape with Birds, 1622.
(54 x 108 cm.). National Gallery, Prague.
In this imaginative painting, Savery depicted birds representing a number of species.

Monkeys in a Kitchen, late seventeenth century.
(36 x 50 .5 cm.). The Hermitage Museum, Leningrad.
These monkeys frolicking within a kitchen were painted by David Teniers the Younger in shades of gray and brown that accentuate the white fur on their chests.

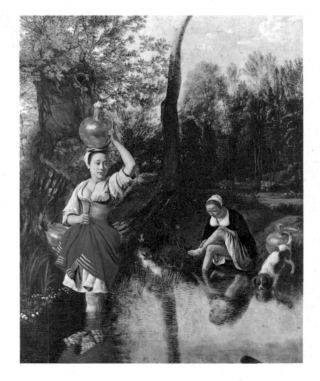

Crossing the River, 1665.
(120 x 100 cm.). Musée Royal des Beaux-Arts, Antwerp.
Jan Siberechts was a seventeenth century painter who was a forerunner of the realist painters of 1850.

99

THE REBIRTH OF FLEMISH ART

James Ensor

(1860–1949)

We are indebted to Ensor for the renewal of the Flemish tradition. He was one of the great painters of modern times, characterized by an incisive palette and by the imagination and style of an outstanding master of lines, colors, and etching techniques.

The Astonished Masqueraders,
1879–1893.
(100 x 80 cm.). Musées Royaux, Brussels. Ensor was always haunted by masked figures and disguises. As a mischievous painter and outstanding colorist, he perpetuated the tradition of Bosch to a certain extent.

When the King of Belgium granted James Ensor a baronage, a dinner was given for the artist at the *Cercle interallié*, in Paris. The artist, as several of us observed, was as always, unpretentious and natural. When the *maître d'hotel* solemnly announced, "Baron James Ensor has arrived," the great painter sat beside us and immediately rose to utter the dictum that he never failed to offer during festive occasions: "Clamorous self-congratulation brings to mind the final gasps of frogs."

What an exceptional man and what a roguish sense of humor! Within the context of ostensibly modern art, Ensor was the northern painter whose creations most closely rivalled those of the greatest French painters of his era.

"The Cezanne of Belgian Painting"

Ensor was a man of the sea. As early as 1882, the scent of the sea permeated one of his paintings, the *Woman Eating Oysters*, a reminder perhaps of his father's shellfish shop in Ostend. At this point, the young artist was wearing a mustache and sporting a beard.

Paul Fierens referred to him as "the Cézanne of Belgian painters." In his earliest canvases, Ensor adopted the fine, deft, and tactile brushstrokes that, with the quality of his illumination, his bold outlines, and his delicate tonalities, bore certain resemblances to the palette of Matisse during his youth. *Russian Music* (1881) creates an atmosphere of intimacy.

Then, with astounding capriciousness, Ensor shifted from the satirical to the tragic, after *Beggars Warming Themselves* (1882). Indeed, he revived the diabolical and phantasmagorical spirit of his predecessor Hieronymus Bosch, although a note of British wit was added to his unrestrained inventiveness.

Ensor sought to liberate art from the shackles of the academies. His studio in Ostend, which was filled with petrified algae, sea-urchins, pearly shells and aquariums, resembled "an Oriental bazaar, a palmist's studio, and the Grevin Museum" (A.H. Cornette). The walls of his home on the Rue de Flandre were filled with paintings and etchings while masks, skulls, chasubles, and tattered banners adorned the tables and chairs.

Ensor sought adventure everywhere. He was a talented musician who enjoyed playing his own compositions, such as *The Barrel Organ*, on the harmonium. He likewise enjoyed drinking cognac and describing carnivals, which were the source of the masked figures who are a recurrent theme in Ensor's works.

The Mysterious Masks, which is distinguished by a combination of bright hues and beautiful blacks, provides an eerie dialogue without words, in which a witch-like female figure appears at the door with a stick in her hand, confronting a man sit-

Masqueraders Quarreling over a Hanged Man, 1891.
(59 x 74 cm.). Musée Royal des Beaux-Arts, Antwerp.
In this painting, masquerade figures are shown quarreling over a hanged man's "jug" in front of curious onlookers.

ting with a bottle at his side. Ensor himself said: "I gladly confined myself to the solitary domain of trickery, in which disguises reign supreme and where violence, light, and surprise abound. These masquerades impart bright colors, lavish adornment, majestic and unexpected gestures, shrill expression, and exquisite turbulence."

The Most Bizarre Creations

Ensor was haunted by death. In one of his prints he even depicted his own prostrate corpse in a macabre fantasy that he referred to as "a mere foretaste." In 1889, he also produced a "self-portrait of his skeleton." Similarly, there is a painting of two aged women where Ensor added the following words: "They are dead; they ate too much fish."

One of his unforgettable creations is *The Animals' Concert* (1891), a droll painting in which a cat, a magpie, a parrot, a crab, and fish comprise an entire orchestra. "Colors sing out clearly in the studio," the painter wrote, "and the sea infinitely displays its softest hues, like a delightful plainsong."

This is how he worked, pursuing morbid fantasies that could engender the most bizarre creations. He also wrote, "Shame! Shame! Shame! Let the critics say what they will!" The same attitude prevailed in the comic opera scenes that he painted for the *Garden of Love*.

Ensor was fascinated with fairs, public concerts, music-halls, and fishwives hawking their wares beneath an ancient cathedral facade appearing in a corner.

He limited his range of colors to those that appeared in a somewhat bolder form in portrayals of sea-creatures, such as *The Skate*. Yet the sense of adventure consistently emerges in his works, attaining its zenith in *Christ's Arrival in Brussels*, which is one of the most extraordinary paintings from the period marking the end of the last century.

Intrigue, 1890.
(90 x 150 cm.). Musée Royal des Beaux-Arts, Antwerp.
Once again, a group of masquerade figures appears. They are surrounded by the commotion of a carnival.

The Apparition of the Wouse Masquerade Figure, 1890.
(109 x 131 cm.). Musée Royal des Beaux-Arts, Antwerp.
The painter from Ostend created an unusual contrast by placing the image of an elderly witch with a parasol in front of figures representing the dead.

This immense painting conveys an awe-inspiring vision: an enormous throng of figures that also includes a procession huddled under banners, a group of masquerade figures, skeletons with top hats, rows of soldiers, brass bands, and clusters of flags, with officials on a reviewing stand beside a clown. The background is filled with houses and crosses, while Christ stands at the center, giving a benediction beneath a large golden halo.

The entire scene undulates with the slow back-and-forth motion of enormous throngs. "Long live the crowd!" appears on one of the banners.

The pure and incisive colors of Ensor's palette burst forth with unrestrained freedom. Swaths of lemon yellow and emerald green are accompanied by densely applied or smudged vermilion and orange to create a world that would once have been labeled caricaturesque, although it clearly does not belong to the realm of caricature. Instead, the artist has imparted a vision of life itself, recaptured by an inspired brush.

In 1934, Ensor wrote the following words to Jules Jouet, who had been chosen to paint a portrait of him: "As for *Christ's Arrival in Brussels*, it was never exhibited because no one wanted to exhibit it... After the canvas hung on the wall of an attic for a long time without a frame, and was damaged because of rain leaking into the attic, it was finally presented to the public during the exhibition at the *Palais des Beaux-Arts* in Brussels. "When I painted it, I was looking for a refuge among masked figures in order to free myself from fear, from intruders, and from anyone who would have interfered with my work."

An Ignored Artist

It is necessary to acknowledge that Ensor's paintings did not win recognition, either at home or in other nations. When one of his paintings was exhibited in the window of Mme. Hertog's gallery in Ostend, the public's response consisted of derision and insults. Ensor's irreplaceable talents were only acknowledged belatedly. At least, he was acclaimed during his lifetime and he welcomed recognition without "clamorous self-congratulation," as a modest reward.

James Ensor died on the morning of November 19, 1949, at a local clinic where he had been admitted upon becoming ill. He was eighty-nine years old.

It is also appropriate to cite certain other artists who lived and painted before 1900, such as Felicien Rops (Namur, 1833- Corbeil, 1898), Henri de Braekeleer (Antwerp, 1840–1888), and Henri Evenepoel (Nice, 1872–Paris, 1899), along with those whose careers spanned two centuries, such as Rik Wouters (Malines, 1882- Amsterdam, 1916) and Constant Permeke (Antwerp, 1886–Ostend, 1952). At the same time, there are contemporary artists for whom there will be a few fleeting words.

Felicien Rops

1833–1898

After studying law and painting in Brussels, and after founding the satirical publication *Uylenspiegel* (1854) with money in-

A *Woman from the Lower Classes*, before
1887.
(46 x 38 cm.). Musées Royaux, Brussels.
De Braekeleer painted many exceptionally
detailed indoor scenes and cabaret scenes.

← *Christ's Arrival in Brussels*
Private collection.
This scene emerged from the imagination
of a great visionary, a whimsical painter
with a sense of fantasy. This is one of the
masterpieces of our era.

herited from his family, Felicien Rops attempted to revive
Boschian diabolism, although as an illustrator. He was primari-
ly a printmaker. Admirers of engravings eagerly tried to obtain
his frontispieces, such as *Mors Syphilitica*. Rops' few paintings
sometimes anticipatd the style of Toulouse Lautrec. Attracted by
the milieu of crime and prostitution, Rops produced the *Cythères
parisiennes*, in which morbid and pornographic themes interm-
ingle. In some respects, his work is reminiscent of Baudelaire's
Fleurs du mal, although there is a dash of patchouli. Felicien
Rops was an artist who achieved moments of exceptional
originality and he has earned recognition in our era.

Henri de Braekeleer

(1840–1888)

Although Henri de Braekeleer was born in Antwerp in 1840,
prior to the birth of James Ensor, and died there in 1888, his
painstakingly realistic creations should not go unmentioned. With

delicate brushstrokes, he portrayed tailors' shops, laundries, and
the *Man in the Window* (1876) belonging to the Musées Royaux
in Brussels. Like Vincent Van Gogh, de Braekeleer lived in pov-
erty and was beset by insanity. His paintings have a certain
charm, even though they no longer appeal to the public. This art-
ist bore no envy toward Alfred Stevens, another Belgian artist
whose works won acclaim in Paris, while he himself remained
at home, painting tradesmen and women from the lower classes.

Henri Evenepoel

(1872–1899)

Henri Evenepoel (along with Matisse and Rouault) studied art
in Paris with Gustave Moreau, who taught him to paint "with
admiration for what one accomplishes." He traveled to Algeria
to regain his health and, after his return in 1898, he completed
his best paintings, such as *Sunday in the Bois de Boulogne*.
Evenepoel, who associated with the *nabis*, was a high-spirited

man, a sensitive artist, and a seeker of companionship. When he was twenty-seven years old, he died from tuberculosis, an incurable disease at that time.

Evenepoel created large and colorful panoramas with an impressive degree of coherence, although he never revealed the emotional conflicts that brought torment to his personal life.

Rick Wouters

(1882–1916)

In France, the paintings of Rik Wouters have never received the recognition they deserve. Along with Ensor and Permeke, Wouters was one of Belgium's leading painters at the turn of the century. Chronologically situated midway between Impressionism and Fauvism, he developed a style that closely resembled that of his French contemporaries. His paintings are distinguished by bold colors with delicate tonalities and astonishing brightness. The creations of this frequently ill artist who sought joy through his endeavors readily bring pleasure to the observer's eye. As the son of a woodcarver who initially pursued the same occupation, Wouters endured a difficult life. With assistance from a patron, he was able to visit Paris in 1912 (where he discovered Cézanne's works). He was conscripted in April, 1914, and was imprisoned after the capture of Antwerp, although he was later released because of his illnesses. Wouters then moved to Amsterdam with his wife, but he failed to regain his health and died there in 1916 (he was thirty-four years old).

Rik Wouters continued to live in the milieu of his early years as a craftsman. He lived "without comforts, in wretched lodgings, where he constantly faced bitter poverty. He only had two or three friends. This native of Malines was a small but robust and muscular man" (Elslander).

At a time when all of the Post-Impressionists were displaying certain similarities to one another, Rik Wouters' paintings were immediately distinguished by their unrestrained energy, their sensitivity, and their carefully developed color schemes. His most typical painting, *Birthday Flowers*, which belongs to the Cléomir-Jussiant Collection in Antwerp, depicts a table laden with flowers and fruit according to a descending perspective. The woman who is pensively resting upon her elbows at the table is his wife Nel, whom Wouters often painted as a "polychromatic apparition" (Paul Hasaerts).

Constant Permeke

(1886–1952)

In contrast to Rik Wouters, whose paintings are distinguished by diversity of tones and colors, Constant Permeke created a dense and shadowy world in which human silhouettes are transfixed between heaven and earth or between the sea and the shore. A basket full of sole or haddock carried on the arm of a heavy-breasted woman may emerge from the shadows, or there may be a pair of figures standing mysteriously before the sea, as if they had arisen from the deep.

Permeke initially studied in Bruges, Ghent, and Brussels. Along with Gustave de Smet and Fritz Van den Berghe, he subsequently resided in an artists' community at Laethem-Saint-Martin (1909). After being wounded during World War I, Permeke was sent to England, where he began to create his rough-hewn paintings.

What was the source of these crude and asymmetrical forms that appeared to have been created with a pruning-hook and were accompanied by simple accessories (string, seals, bowls, and coffee-pots)? What was the source of these entirely bestial human faces portrayed with a somewhat mannered grotesqueness and why did something tragic emerge from this oceanic or rural inferno, even more forcefully than in Rouault's works? This painter boldly reconciled the particular and the general, thereby contrasting the limited nature of reality and the vastness of the spiritual. His array of brown of greenish landscapes is an invocation to the unknown elements of destiny. His works evoke eternal movements, and also convey the scent of seaweed. Nothing is more evocative than some of Permeke's landscapes in which an egg-yellow sun fills the horizon with a lustre that seems to originate in another world.

Woman Ironing, 1912.
(107 x 123 cm.). Musée Royal des Beaux-Arts, Antwerp.
This painting by Rik Wouters is distinguished by delicate and joyful colors. He may be the only Belgian painter who mastered the undulating brushstrokes of Impressionism.

Lastly, it would be impossible to forget Valerius de Saedeleer's descriptive and carefully structured landscapes — the outlines of leafless trees against the snow emerge in a truly inspired form. There are also the highly stylized paintings of Gustave Van de Woestine. We should also cite Hippolyte Daye and Gustave de Smet as artists who pursued a certain intentional abstractness, and especially Fritz Van den Berghe, who was the most recent heir of the tradition of art dominated by fantasy. There is also Magritte with his deceptive surrealism and, finally, Delvaux with his dream-like nocturnal scenes inhabited by unclad women.

At this point, we have come to an inconvenient but inevitable boundary, where Flemish painting and Dutch painting must be separated from one another. It is obvious that Geertgen Tot Sint Jans would more closely resemble Van Eyck's successors than Pieter Aertsen, who is clearly set apart by his fully developed sensuality. On the other hand, Geertgen Tot Sint Jans may be regarded as a transitional figure, because, in this way, it is once again possible to acknowledge the limitations of the more geographic than legitimate boundaries that have been maintained for these abridged descriptions of individual artists.

The Fisherman's Wife, 1920
(100 x 124 cm.). Musée Royal des Beaux-Arts, Antwerp.
In contrast to Rik Wouters, Constant Permeke sought to create sculpture-like figures, evoking the sea and its scents.

At this point, we have come to an inconvenient but inevitable boundary, where Flemish painting and Dutch painting must be separated from one another. It is obvious that Geertgen tot Sint Jans would more closely resemble Van Eyck's successors than Pieter Aertsen's, who is clearly set apart by his fully developed sensuality. On the other hand, I am not dissatisfied with adoption of Geertgen tot Sint Jans as a transitional figure, because, in this way, it is once again possible to acknowledge the limitations of the more geographic than legitimate boundaries that I have been obliged to maintain for my abridged descriptions of individual artists.

DUTCH PAINTING

LIGHT AND SUBSTANCE

Geertgen Tot Sint Jans

(1460–1495)

This artist who created strikingly beautiful landscapes and was fascinated by the progeny of Jesse and the family of Jesus was an outstanding colorist whose originality and vivid themes awaken deep emotions. One can define his works as a departure from the tradition of Van Eyck.

We can examine the works of Geertgen Tot Sint Jans to demarcate the transition from Flemish to Dutch p;ainting. This extremely talented artist succeeded in combining intense emotional content with admirable clarity, thereby developing a style that can be defined as a definitive departure from the tradition of Jan Van Eyck. Geertgen Tot Sint Jans was a pupil of Albert Van Ouwater and resided with members of the Order of Saint John until his death at the age of thiry-four.

This artist, who became known as "Gerard de Saint-Jean" in France, produced such exceptional works as *Saint John the Baptist*, in which the saint is depicted in an extremely beautiful natural milieu as he sits and prays with his bare feet placed atop one another.

A Contemplative Spirit

The *Holy Kinship of Christ* is, to a certain extent, a family portrait. Jesus' closest relatives are depicted inside a church. Saint Odile, the Virgin Mary's mother, appears on the left side, while the Virgin, whose blond hair is carefully arranged, sits next to her with the Christ Child in her arms. Saint Joachim appears behind them leaning upon a staff, and Saint Joseph is holding a lily. On the right side, a seated Saint Elizabeth is holding the young John the Baptist (who is reaching toward the Christ Child). Mary Salome and Mary Cleophas appear outside the foreground, and among a group of children standing on the colored-tile floor, it is possible to distinguish Saint John the Evangelist holding a chalice, and Saint James the Greater pouring sacramental wine.

There was no need for haloes. Apart from the figures cited, a prominent triangle at the center contributes admirable structural unity. This triangle is framed by columns and it is accentuated by an exceptionally long stick that the young Judas Thaddeus, the son of Jacob and Leah, is using to light the candles at the altar. The painting is divisible into three sections with different color schemes, beneath the whiteness of the nave in the uppermost portion. The colors of the foreground are admirably balanced.

The Holy Kinship in a Church, late fifteenth century.
(138 x 105 cm.). Rijksmuseum, Amsterdam.
The family of Christ is depicted in this impressive painting where even the smallest details possess a deeply religious meaning.

The Family Tree of Jesse, late fifteenth century.
(89 x 59 cm.). Rijksmuseum, Amsterdam.
This painting contains such an accumulation of figures that it is difficult to believe that its creator was the same artist who painted *The Holy Kinship in a Church*.

Saint John the Baptist, late fifteenth century.
(42 x 28 cm.). Galerie Dahlem, Berlin.
Geertgen Tot Sint Jans also created a touching image
of Saint John the Baptist sitting next to his lamb and
meditating amid a profoundly harmonious landscape.

Pieter Aertsen

1508-1575

Like Beuckelaer, Pieter Aertsen can be regarded as a forerunner of the Antwerp School and of the painters who provided gastronomic adornments for Rubens' works.

Pieter Aertsen's works are distinguished by their evocation of gastronomic delights. He was a masterful creator of still lifes and marketplace scenes. His accumulations of food almost appear to demonstrate Taine's theory because the painter was a native of a country where eating copiously is encouraged. In *The Cook*, Aertsen's subject is surrounded by an abundance of vegetables

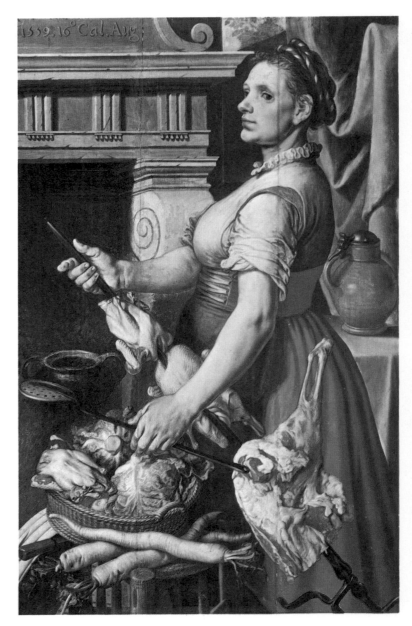

The *Holy Kinship* inspires a strong emotional response. What is the source? Could it be the warmth and exceptional variety of the artist's colors? Could it be the meditative quality permeating the scene? Or the naturalness of the figures? Or the children who are so cleverly placed among adults? Or the unexpected compositional coherence? The entire context creates a contemplative mood with an irresistible power of attraction.

The Virgin's Genealogy

What can be said of *The Progeny of Jesse*? This painting has sometimes been attributed to one of the master's pupils on account of the profusion of figures, apart from the young woman dressed in white representing the patron who commissioned this painting.

The most outstanding painting created by Geertgen tot Sint Jans may be the *Virgin in Glory*, a small painting belonging to the Van Beuningen Collection. Here, the Virgin Mary appears within a fiery globe with a radiance that is entirely unique. The bright gold hue of the heavenly flames turns to orange as the distance from the Virgin increases. A choir of angels and archangels surrounds the Virgin who is trampling on a serpent. This painting is a marvel that defies description: one must see it in order to discover its radiance.

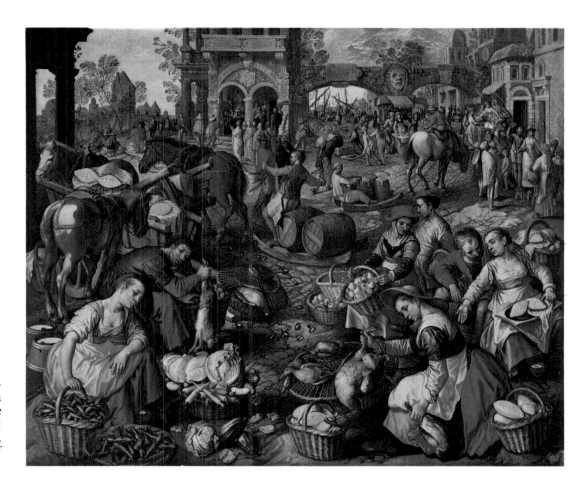

The Market, 1566
(145 x 199 cm.). Gallerie
Nazionali di Capodimonte,
Naples.
A fascination with food dom-
inates this painting, in which a
vast array of items to please the
palate have been assembled:
meat, seafood, vegetables,
cheese, fruit, and casks of
wine.

and meat. A robust woman with a firmly delineated plebeian ap-
pearance has just placed a leg of lamb, a duck, and a chicken on
her enormous skewer. Aertsen signed the painting with his initials
and a weaver's card in order to allude to his father's occupation.

The artist who was also known as *Lange Pier* (Peter the Tall)
began to paint in Antwerp, where he was a citizen. Living in com-
fortable circumstances, with numerous commissions (church win-
dows, altarpieces, portraits), he painted in both Antwerp and
Amsterdam until he chose to reside in Amsterdam in 1557.

Aertsen's work was continued by his nephew Joachim
Beuckelaer (c. 1530–1574), whose style is exemplified by *The City
Market*. In this painting, the eye is overwhelmed by women sell-
ing fish, fruit, fowl, and game, as well as casks of wine and beer.
The setting is large square in a harbor, with ships visible in the
background.

← *The Kitchen Maid*, 1559.
(128 x 82 cm.). Musées Royaux, Brussels.
This array of food differs from the expan-
siveness of the preceding scene. It reveals
the other side of Dutch art, namely exalta-
tion of copious meals.

PIETER AERTSEN _____

*Such was the situation of Pieter Aertsen, the famous painter
from Amsterdam who was usually known as "Peter the Tall" on
account of his tall and lanky form. The same nomenclature was
adopted in Italy where he gained fame for his talents and was
known as "Pietro Longo," although the second name — which is
not a family name — should not be misinterpreted. Pieter Aert-
sen was born in Amsterdam in 1519. His parents, who were
natives of Purmer, preferred to live in Amsterdam. His father,
who was a weaver, wanted his son Pieter to pursue the same
trade. His mother, however, opposed this because she did not
wish to see her son's artistic inclinations and talents stifled. Thus,
she said, "So long as I must earn money with my spinning-wheel,
he'll learn to paint..."*

*His interests were primarily oriented toward depicting kitchens
stocked with provisions and victuals of all types. He reproduced
them in a natural form in such a distinctive way and with such
believable hues that each object appeared to be real. By painting
in this style, he became an unrivalled master craftsman at com-
bining and varying his tones.*

Carol Van Mander
_____ *Het Schilder-Boeck*

Frans Hals

1581-1666

Hals, who was a virtuoso with the brush, a painter of incomparable deftness, and a precursor of Manet, was a heavy drinker and gourmandizer attracted by all forms of sensuality.

Frans Hals was undoubtedly the painter who most strongly influenced the greatest French painters of the second half of the nineteenth century. He outdid all others in using discernible brushstrokes. By considering the period when he pursued his career, namely the period of Nicolas Poussin and Claude Lorrain, one can better appreciate the importance of his innovations in pictorial elaboration. Continuity of form still prevailed, although there were here and there, a few beautiful examples of densely applied pigments, such as one finds among Rubens' works.

Brushstrokes were never so fluid nor so spontaneous, nor was an artist's style ever so directly conveyed. Thus, it is easy to understand why Manet and the Impressionists regarded Hals as a precursor.

Nearly all of the Dutch painters specialized in clearly defined genres. Aertsen devoted his efforts to food in marketplaces; the Claesz brothers to still lifes; the van Ruysdaels to landscapes; and Saenredam to the naves of churches. Of course, there are also the interiors of Jan Vermeer and Pieter de Hooch.

Portraits of Militia Companies

Among these "specialists," Frans Hals excelled in portraying militia companies. Thus, the officers of the Saint George's company and the arquebusiers of Saint Hadrian's company are shown feasting or unfurling their flag. These group portraits were several centuries earlier than the groups of painters, poets and musicians depicted by Fantin-Latour whenever he was not recreating bouquets of roses. Individual portraits, however, were the true specialty of this painter from Haarlem.

A Diversified Talent

During a visit to the Frans Hals Museum in Haarlem, these numerous portrayals of local gatherings, as *The Regentesses of the Haarlem Old Men's Home,* gave a feeling of saturation. Hals seems to have abandoned all forms of *virtuosismo* in order to attain the highest expression of his talents. It was astonishing to see this group of women who administered the hospice for elderly men where the painter himself was to spend his final days. Hals succeeded in capturing the character of these women, allowing us to perceive them through their faces and hands. It could be recognized that their temperaments varied significantly and could not always be easily reconciled. It was entirely different from the exercises with brushstrokes that characterized other portrayals of groups. The artist's emotions were revealed as was his role as a master painter. Surprising, too, were the black garments, the white collars set above shrunken breasts, the stern quality of these faces, and the positioning of the women. This was the masterpiece created by Frans Hals when he was completely destitute.

Portrait of Willem Croes; c. 1658–1660. (47 x 34 cm.). Alte Pinakothek, Munich. This painting permits us to recognize the free style that Manet would promote in a later era: a mode of painting liberated from continuous volume, where brushstrokes are easily recognized.

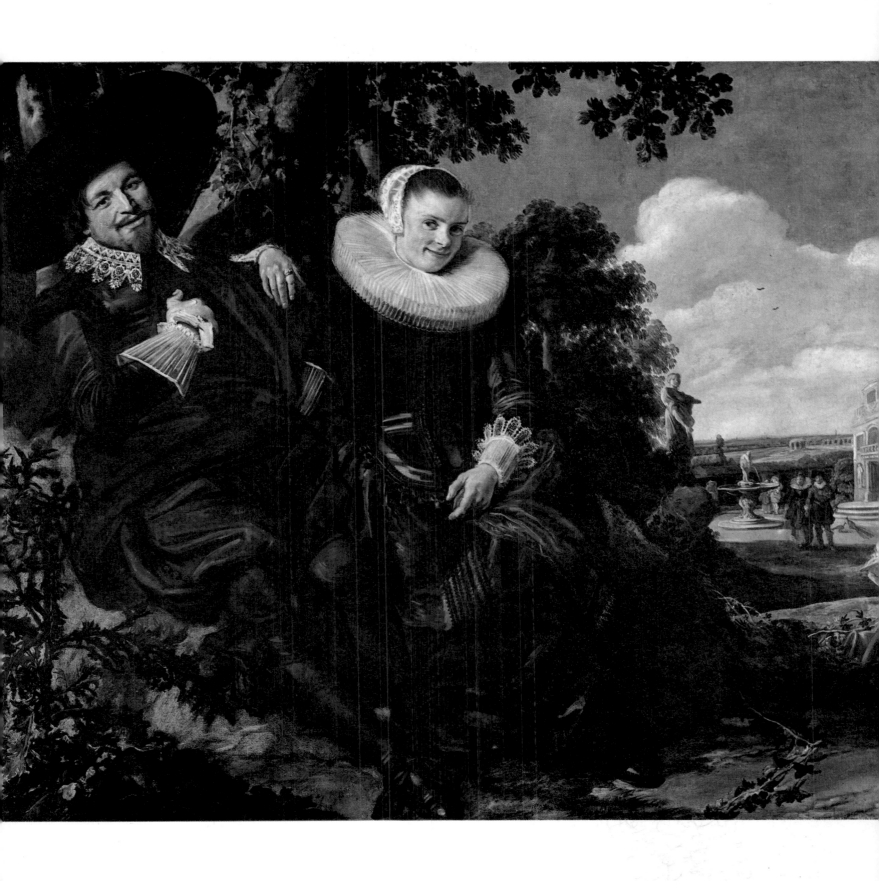

Portrait of Isaac Massa and Beatrice Van der Laen, c. 1621.
(140 x 186 cm.). Rijksmuseum, Amsterdam.
This happy couple may reflect the painter's own spirit. The man and woman are set apart from a landscape where there is a clear blue sky with white clouds. A sprig of ivy is shown at the woman's feet and thistles have been placed in front of her husband.

113

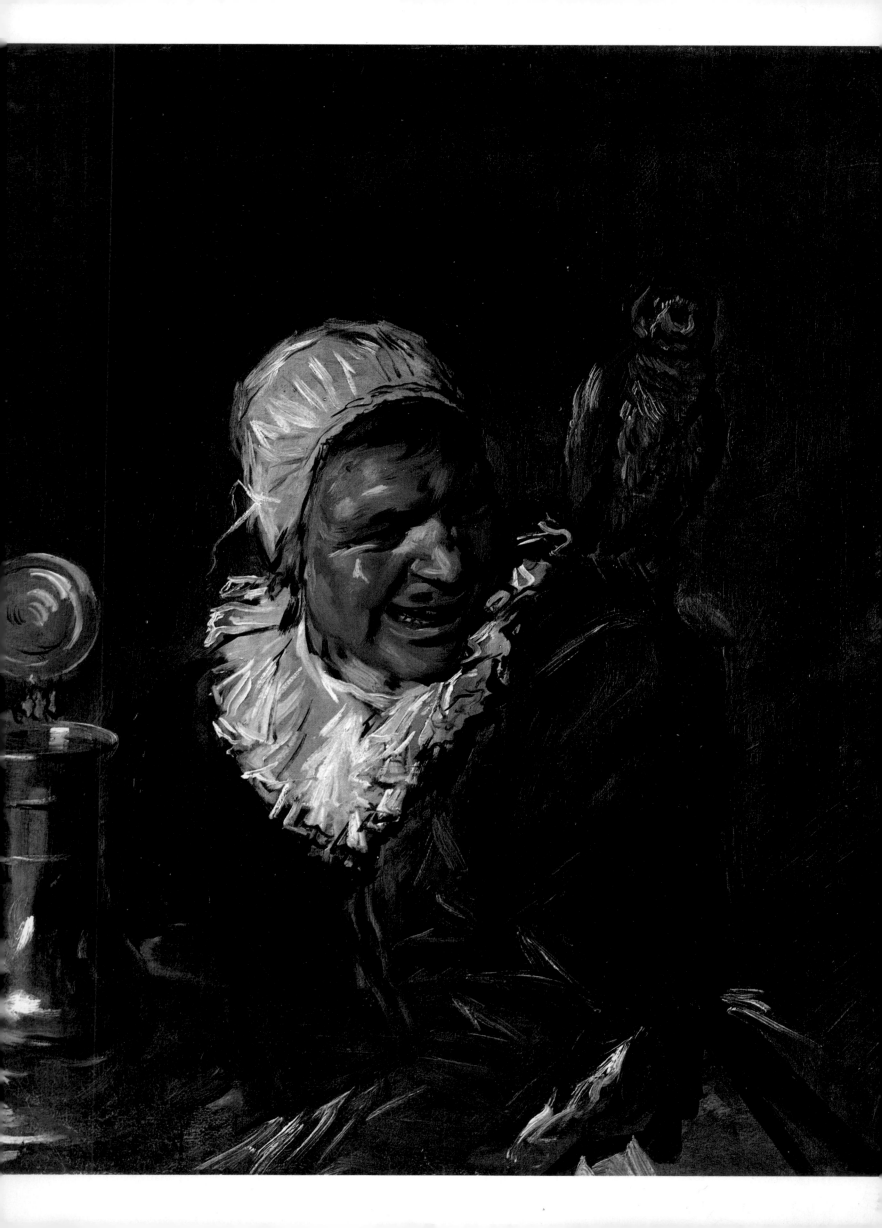

Hille Bobbe, before 1630
(75 x 64 cm.). Galerie Dahlem, Berlin
The "witch" here seems to have an extraor-
dinary vitality.

Little is known about Hals' life, although there are accounts
of turmoil, scandals and financial hardships despite his success.
Indeed, the painter's misfortunes finally left him penniless. It is
known that Hals was an apprentice in the studio of the
miniaturist and humanist Carel van Mander. In 1610, he became
a member of the artists' guild in Haarlem, the town where he
chose to live. He was a member of the local militia, which pro-
vided a source of motifs for his numerous group portraits.

His first wife, Anna Hermans, bore him a son in 1611. Fif-
teen years later, Hals was reprimanded for drunkenness and
beating his wife. In 1617, he married Elizabeth Reyniers, who
bore eight children, including a daughter who was insane and six
sons who became painters. Around 1640, Hals was influenced
by the works of Rembrandt.

He appears to have lead a tumultuous life in which he sought
the company of drunkards, wanderers and gypsies. He was a man
who was attracted by clamor and brio, with an indulgent *joie de
vivre* that was conveyed by rapid brushstrokes and masterful
fluidity of the brush. Frans Hals was also capable of paying

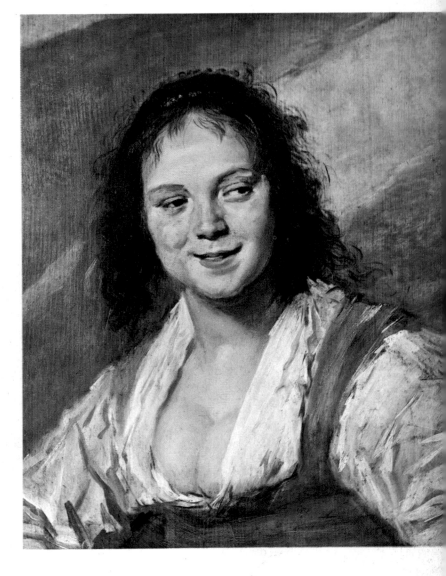

Gypsy Girl, 1625.
(58 x 52 cm.). The Louvre, Paris.
This painting, which anticipates the clear
illumination of Impressionism, represents
a summation of the two previous
paintings.

FRANS HALS

*A painter seeking beautiful and unforgettable lessons should
allow himself the pleasure of seeing Frans Hals' works in
Haarlem. Everywhere else, in French museums or exhibition
rooms and in Dutch galleries or collections, the impression that
one acquires of this brilliant and extremely diversified master art-
ist is appealing, benign, spiritual, and somewhat futile; but this
is neither true nor just. The man himself is diminished as much
as the artist is reduced in stature. Hals produces astonishment and
delight. With his unmatched rapidity, abundant joyfulness, and
the eccentricities of his methods, he separated himself from the
austere context of art during his era by pranks created by his in-
genuity and his hands. He conveys the impression that his
wisdom matched his skills and that his irresistible verve was
merely a graceful display of exceptional talents. Then, as soon
as he blunders and discredits himself, he disappoints you. His
portrait at the museum in Amsterdam, where he depicted himself
on a true-to-life scale as he stood on a rural hillside beside his
wife, presents him more or less as one would imagine him to have
been during those occasions when impertinence induced him to
tease and mock us to some extent. Painting and poses, methods
and physiognomy — everything in this overly unpretentious por-
trait is meant to please us. Hals is laughing aloud and the cheer-
ful wag's spouse does likewise while the painting, for all its
skillfulness, is hardly more serious than its subjects.*

*This is the image conveyed by the famous painter who gained
a prestigious reputation in Holland during the first half of the
seventeenth century if one merely looks at his lighter side.*

Eugène Fromentin
Les Maîtres d'autrefois

tribute to the most worthy aspects of traditional art. In his por-
trait of *Isaac Massa and Beatrice Van der Laen*, Hals boldly con-
trasted his subjects with the freshness of a beautiful landscape
and displayed unusual skill in evoking the black hues of their
apparel.

Manet was deeply impressed by Hals' deft touch and fluid
brushstrokes. Indeed, Hals is most often remembered for *The
Gypsy Girl* (1625) at the Louvre and for *Malle Bobbe (The Witch)*
at the Dahlem Galerie in Berlin. The latter painting is a master-
piece that irrefutably demonstrates the prodigious skills of the
painter from Haarlem. Each element — the expression of the
swarthy face framed by a bonnet and white collar with diabolical
implications, the brightness of the pewter pot, and the owl on the
witch's shoulder — represents a burst of energy. With three
brushstrokes, Hals was able to create separate planes and pro-
duce zigzag patterns for the folds of a sleeve. No one equalled
him in depicting light, as reflected by the faces of his subjects.

Rembrandt Harmenszoon Van Rijn, known as Rembrandt

1606–1669

Rembrandt was capable of transforming the darkest clay into gold. As a profoundly spiritual artist, contemplative and warm, he possessed universality and a capacity to awaken the deep emotions that are unmatched by other painters.

There are artists whose lives and creations intermingle with humanity itself. This is true of Rembrandt, who is capable of kindling our emotions to such a degree that we even forget that he was an artist. When we are confronted by this phenomenon in which emotion is predominent in relation to technique, we tend to say: "This man was truly a painter!" We almost reach a point of not believing such an affirmation because Rembrandt was a man whose creations touch our hearts so deeply, because he was a poet whose talent is so closely intertwined with the very essence of human nature so that we are led to believe that with Rembrandt, there is no distinction between the artist and his creations, which form an indivisible whole in our perceptions of his thoughts and in the innermost qualities conveyed by his mode of expression. Yes, Rembrandt was an artist but we only recognize this truth belatedly, after his genius has been revealed.

A Miller's Son

Rembrandt was born on July 15, 1606, in Leyden, where his father was a miller. At an early age he enrolled in the University of Leyden as a student of Latin and classical literature. When he was fourteen, he began an apprenticeship with Jacob Van Swanenburgh and became acquainted with the works of Jacques Callot. In 1624, he spent a month in Amsterdam as a pupil of Pieter Lastman, a painter of historical scenes who introduced Rembrandt to the works of Caravaggio and contributed significantly to his training. When Rembrandt returned to Leyden, he and Jan Lievens opened a workshop. The two young painters had many pupils, including Gerard Dou.

In 1631, Rembrandt became a tenant of the art dealer Van Uylenburgh in Amsterdam. He later married Van Uylenburgh's cousin, Saskia, who appears with a smile in several of his paintings. Wealthy merchants and the famous professor of anatomy Doctor Tulp recognized his talents as a portraitist and engraver, and he was given many commissions.

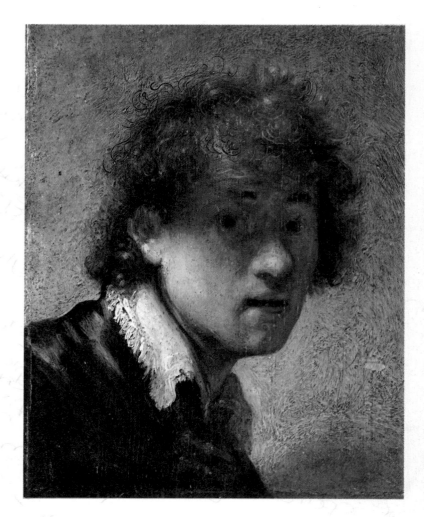

Self-Portrait, 1629 (16 x 13 cm.). Alte Pinakotek, Munich. In this self-portrait on wood, the young Rembrandt already revealed his desire to become a master of shadows and light.

Self-Portrait as the Apostle Paul, 1661. (91 x 77 cm.). Rijksmuseum, Amsterdam. Similar craftmanship appeared much later in this self-portrait, which was completed around 1661, during the period when Rembrandt was painting apostles and saints. It is possible that this portrait of the artist in the guise of Saint Paul was commissioned as part of this series of Biblical figures. In any instance, this is a captivating image whose countenance bears the signs of many misfortunes.

116

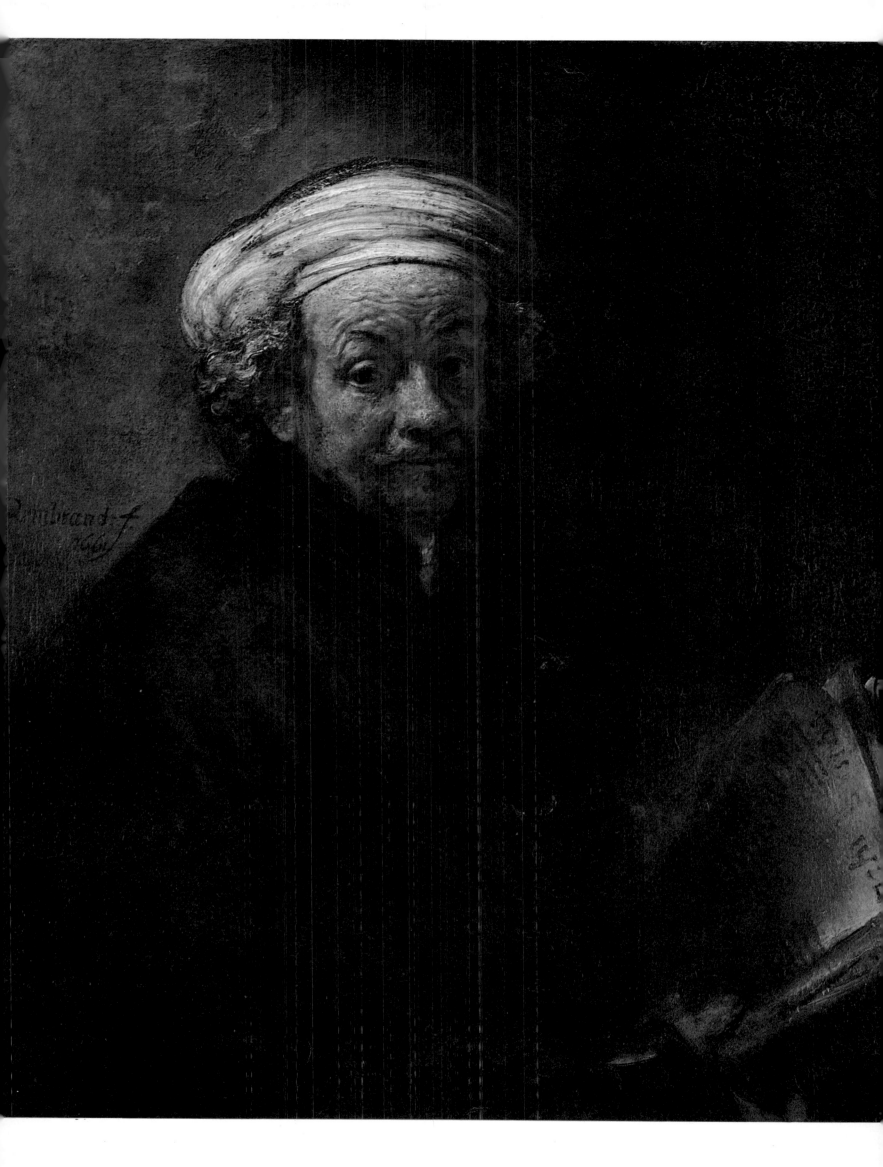

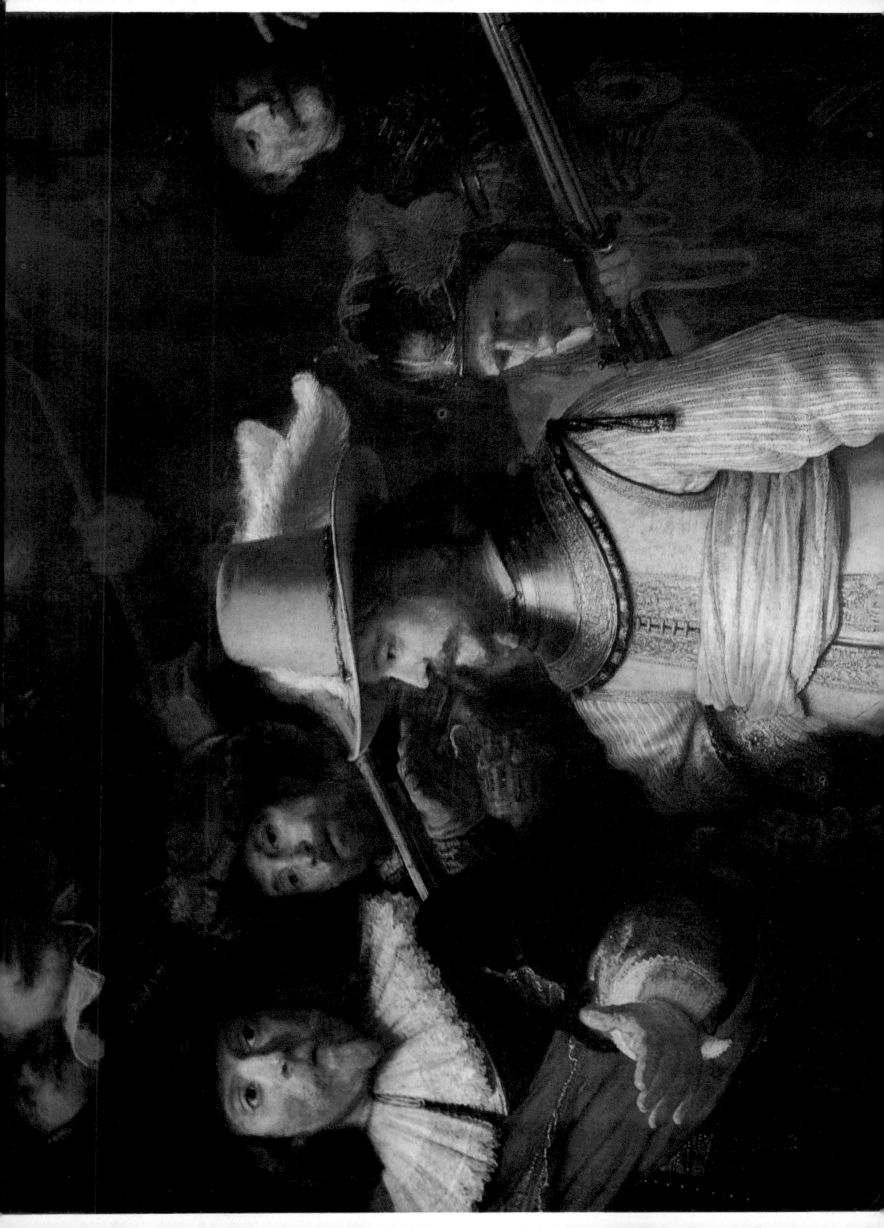

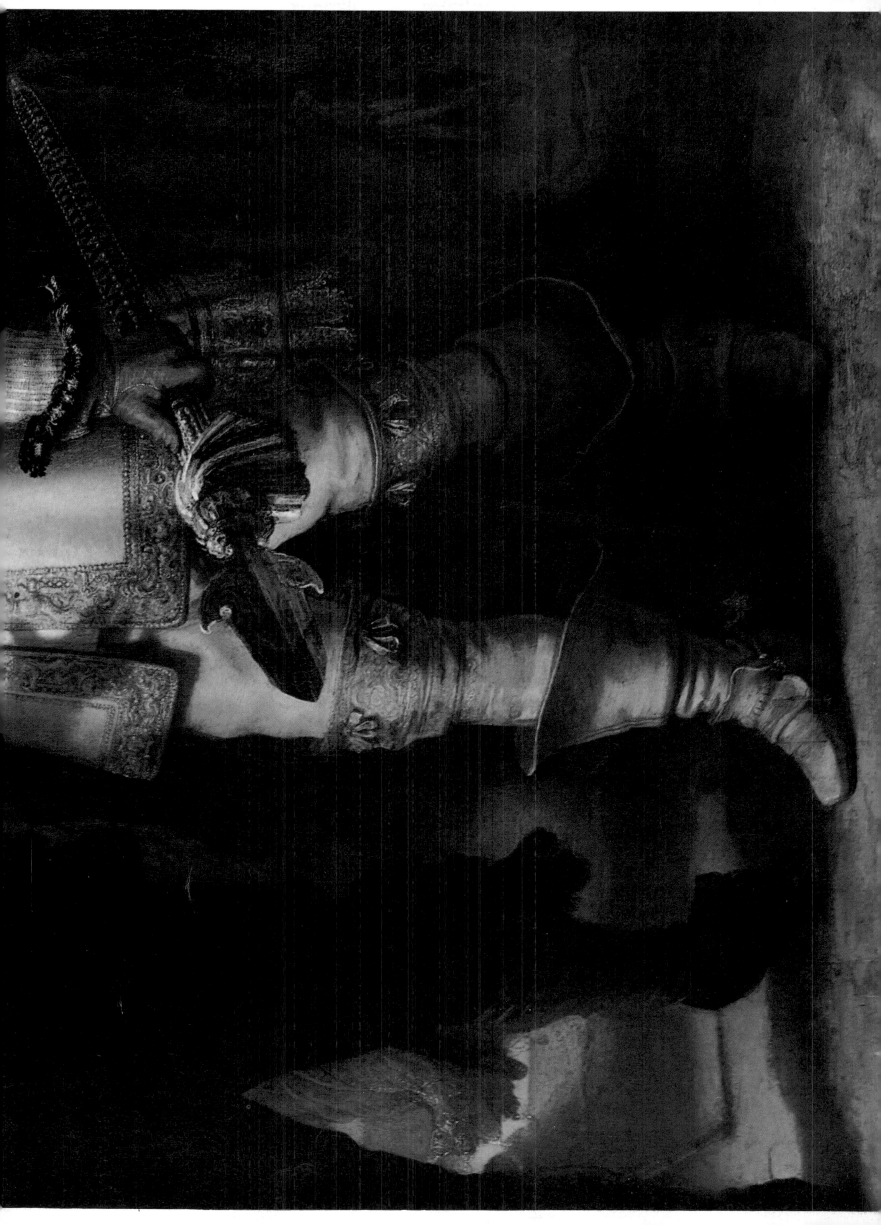

Preceding page and to the right:
The Night Watch, 1642.
(359 x 438 cm.). Rijksmuseum,
Amsterdam.
Captain Banning Cocq, who is ordering
the lieutenant at his side to assemble his
company, appears in the center of this
large painting completed in 1642. The
scene is set in a dark and narrow street in
Amsterdam. It was only quite recently
determined that Rembrandt had por-
trayed a *daytime* gathering of the militia.

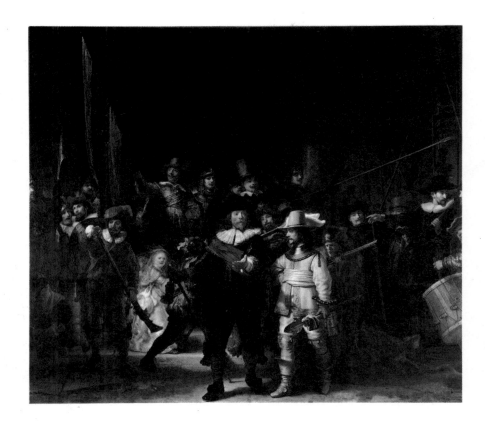

Rembrandt himself became an art collector (jewelry, tapestries, trinkets, drawings, engravings, sculpture). This extremely cost- ly pastime later contributed to his financial difficulties. In 1639, he bought a large house on the Breestraat adjacent to his father- in-law's home, and was obliged to continue paying substantial sums for many years.

Two years later, Saskia bore him a son, Titus, who was the on- ly one of Rembrandt's children to live beyond early childhood. Saskia died shortly thereafter, from consumption, during her thirtieth year. At this time, Rembrandt had been commissioned to paint *The Night Watch*. During the same period, his mother also died.

After having lived briefly with Geertghe Dircx, an emotionally disturbed woman whom he had hired as a nursemaid for Titus, Rembrandt became embroiled in a sordid legal dispute with her over money. From then on, he began to choose his own models for portraits.

A Difficult Life

Around 1646, Rembrandt began to live with Hendrickje Stoffels Jegers. But the Church would not allow them to marry because a codicil in Saskia's will prevented Rembrandt from remarrying without losing the right to make use of her in- heritance. Hendrickje's loyalty to Rembrandt endured, however, and she assumed responsibility for Titus' upbringing. On July 26, 1656, Rembrandt was declared insolvent because of his enormous debts, and the Bankruptcy Court seized all of his belongings to pay his creditors. Hendrickje and Titus aided Rembrandt by becoming his guardians and by acquiring the right to sell his

paintings so that he could continue to paint without being burdened by material needs. His legal difficulties continued on account of the relationship with Hendrickje, whom he was never able to marry. She died in July, 1663.

Rembrandt subsequently moved to the Rosengracht and, in 1664, he was living on the Lauriengracht, where Titus died at the age of twenty-seven. From then on Rembrandt only painted ac- cording to his own preferences. He began to spend money freely and, in spite of the aid which Six provided, he promptly en- countered calamities. Despite his international reputation, he was ignored and forgotten in Holland and died one year after his son, on October 4, 1669, when he was sixty-three years old.

Such was Rembrandt's career. Above and beyond his painfully tumultuous life, his visionary mind, and his religious proclivities, his mode of expression embodies qualities that catch our eyes and kindle our emotions to an unprecedented degree. In Rembrandt's work, the brushstrokes do not convey premeditation or arduous efforts. Everything is contained within a certain outpouring of the soul and, in some rare instances, within the brief pleasure of a joyfully uplifted glass of wine, when Saskia is sitting on his lap and is portrayed with a smile. When Hendrickje Stoffels became a member of his household (she was still an adolescent and was descended from a military family), she became a source of hap- piness for Rembrandt (he was nearly forty years old).

A Universal Aura

Rembrandt never adopted a moralistic posture. His creations radiated an expansive and natural spirit of toleration or under- standing of all philosophies and religions. This assiduous reader

Descent from the Cross, 1633
(93 x 68 cm.). Alte Pinakotek, Munich.
It is possible to recognize the painter
himself as the figure who is devotedly
helping to remove Christ's body from the
cross. This painting was completed on a
cedar panel and it conveys an impression
of downward movement.

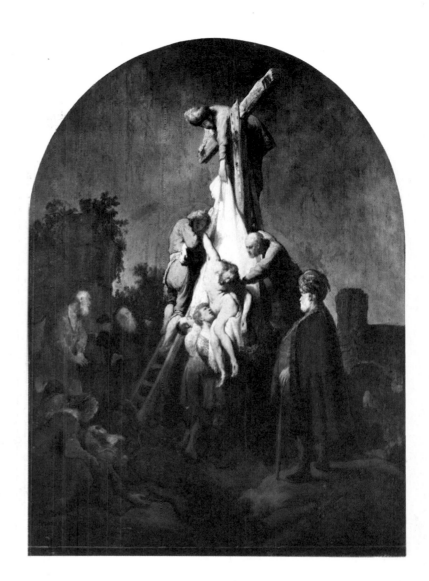

The Jewish Bride, 1666.
(122 x 167 cm.). Rijksmuseum,
Amsterdam.
This painting, completed around 1666, is
dominated by red and gold hues. Many in-
terpretations have been proposed, espe-
cially with respect to the man's protective
gesture as he places his hand upon the
woman's breast. The image of Isaac and
Rebecca comes to mind. Above all, this
painting expresses a strong sense of
humanity.

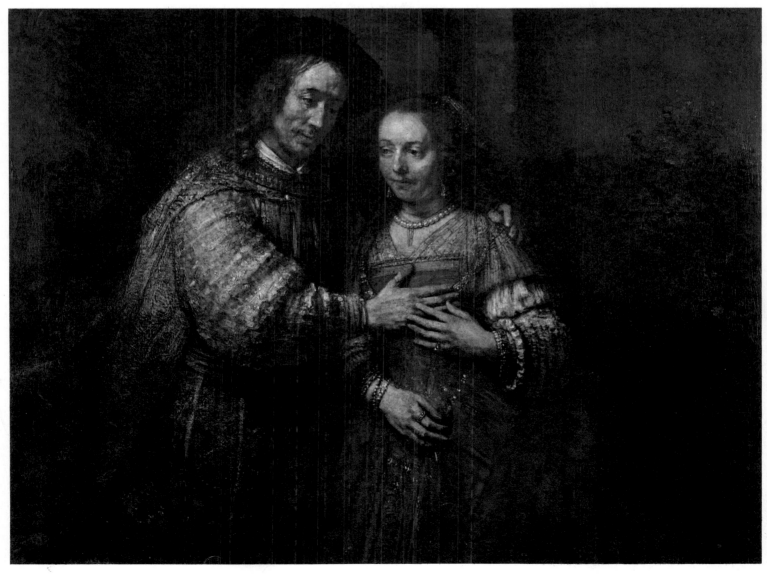

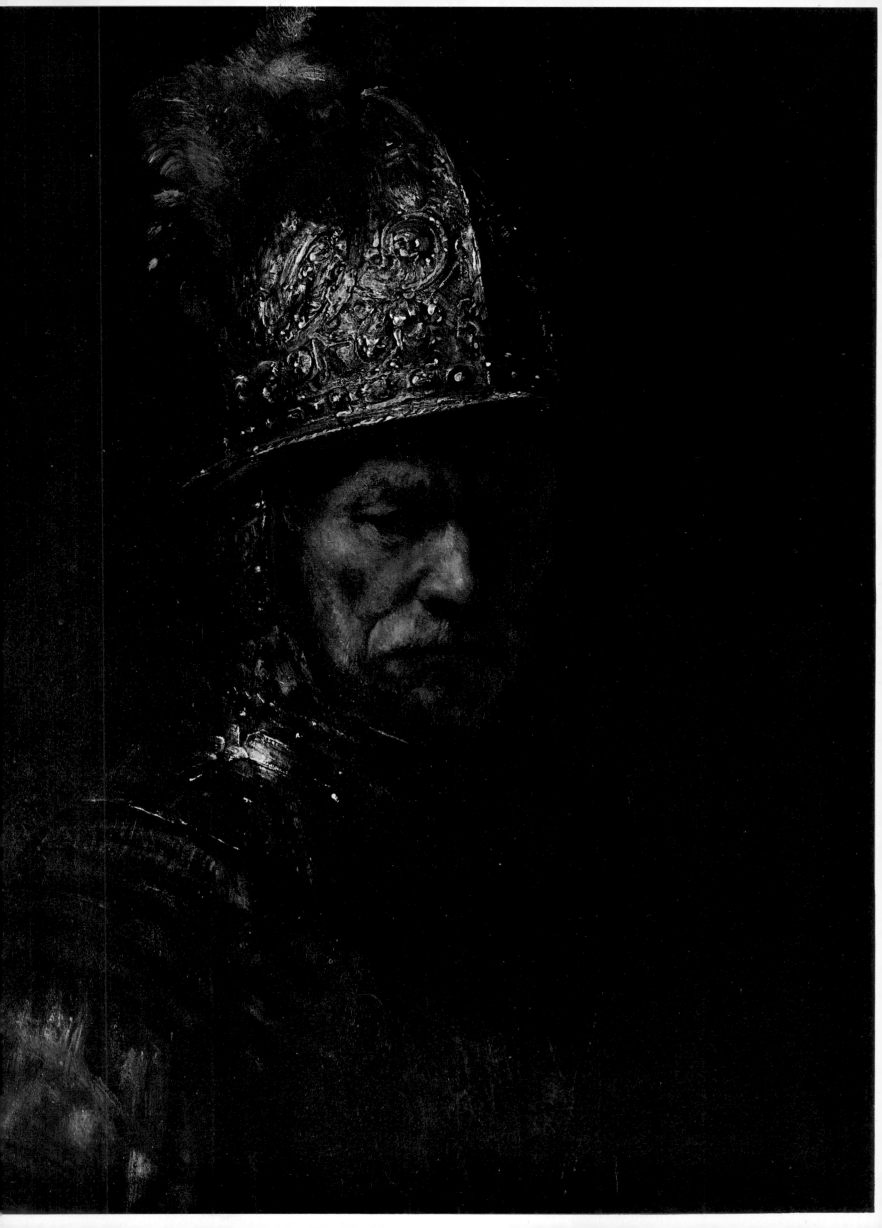

of the Bible painted *Jacob Blessing the Sons of Joseph* and *The Jewish Bride* with as much intensity as *The Descent from the Cross* and *The Supper at Emmaus.* A burst of spirituality is always present.

In 1642, Rembrandt created *The Night Watch,* which, now that the canvas has been cleaned, is known to depict a daytime sortie of the arquebusiers. The diminutive woman in bright apparel appears as an evocation of fantasy surrounded by military uniforms.

In *Artistotle Contemplating the Bust of Homer* (around 1653), which was painted one year after the *Man with the Golden Helmet,* Rembrandt counterposed the plaster bust of the Greek poet (nothing is more anti-pictorial than this arid and lifeless image) to the philosopher who enunciated the concept of a *primum mobile* for all matter. What is the quality that moves us so deeply? It is the passage of time: "What you are, I have been; and what I am, you shall be."

During the same year Rembrandt depicted Hendrickje Stoffels as *Flora* (National Gallery, London). This is an entirely different creation from the *Flora* where Saskia appeared banally bedecked in heavy and gaudy garments! Hendrickje is also the woman who calmly advances toward us in *Woman Bathing,* or is the model for the contemplative *Bathsheba* of the Louvre (1654). The latter painting may be one of Rembrandt's most evocative nudes. His subject is nude but not unclothed because an impression of modesty endures. She lacks the exuberant sexuality of Rubens' nudes because her sensuality is combined with an unmistakable gentleness.

The Man with the Golden Helmet, c. 1652.
(67 x 50 cm.).
Galerie Dahlem, Berlin.
This painting, which is unique in the history of art, depicts a man emerging from the shadows like a ghost although the poetry of light is miraculously present.

Danae, 1650.
(185 x 203 cm.). The Hermitage Museum, Leningrad.
Danae, whom Jupiter visited in the form of a shower of gold and who later became the mother of Perseus, has been portrayed in Rembrandt's own distinctive style.

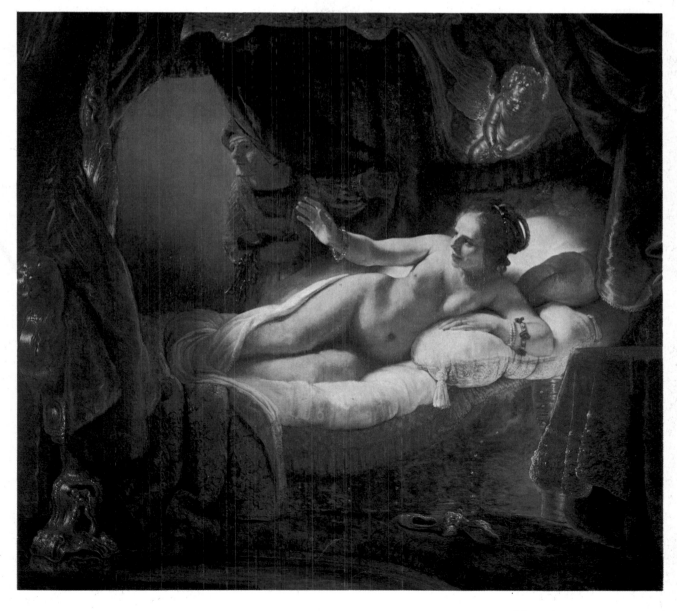

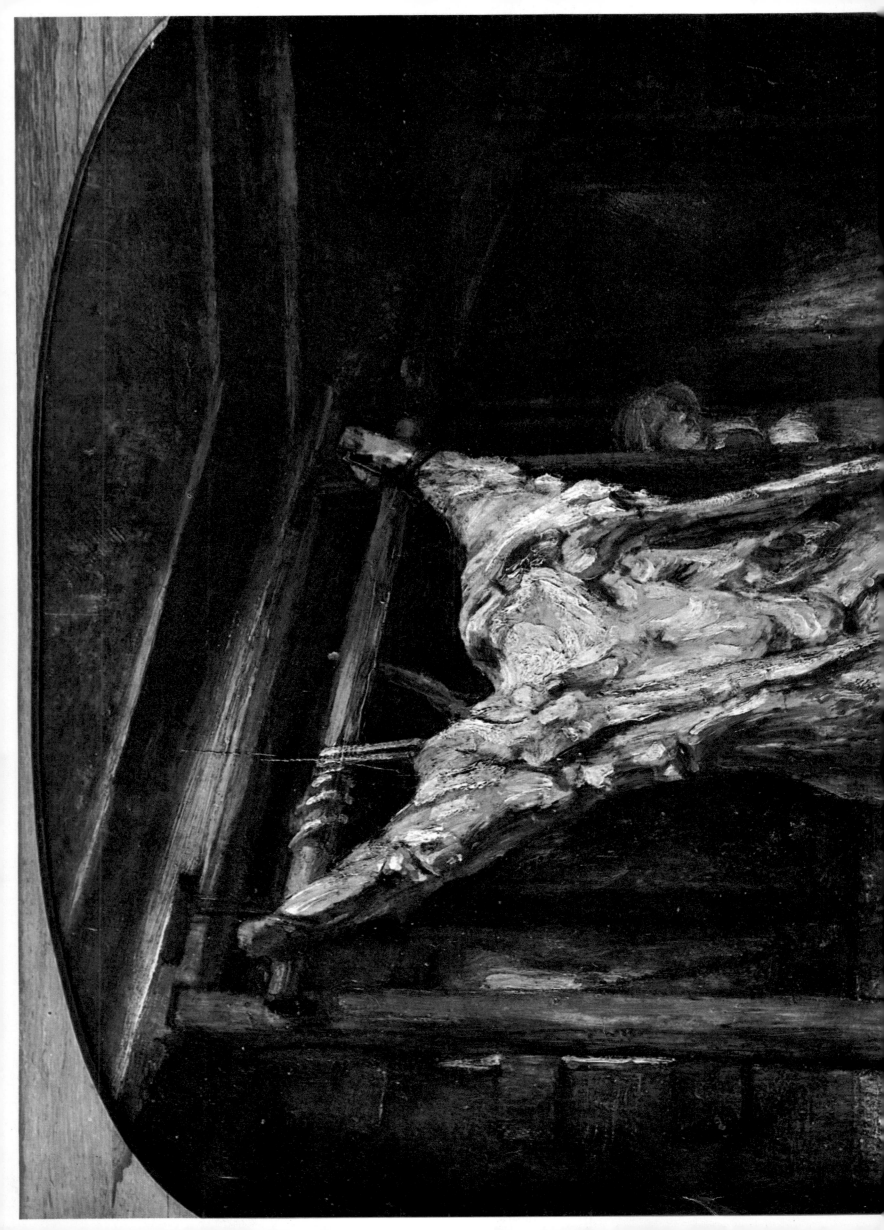

Whereas Rubens constantly radiates joy, the humanity of
Rembrandt's creations was forged by adversities. The two
painters are truly opposites, even though both led prolific lives,
with Rubens surrounded by his colleagues while Rembrandt
labored alone in his studio.

It is possible to conclude that, if Rembrandt had been an
author, he would have resembled Dostoevsky, or, if he had
chosen music, Beethoven. His paintings convey his need to un-
burden himself or to release the tensions that inspired his
endeavors. Indeed, this need took precedence over any desire to
demonstrate his talents. It could be said that Rembrandt was a
man who painted compulsively, without needing an audience.

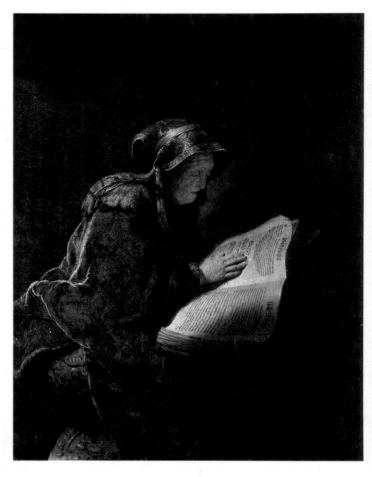

The Artist's Mother, 1631.
(60 x 48 cm). Rijksmuseum, Amsterdam.
Rembrandt's paintings of members of
his family suggest that he was strongly
attached to them. This is a portrait of his
mother.

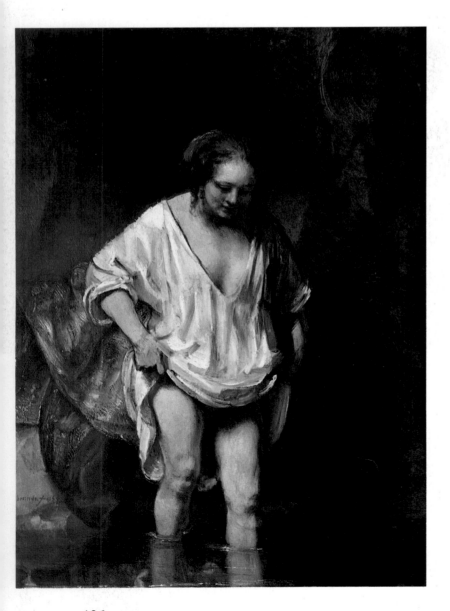

Woman Wading in a Brook, 1654.
(62 x 47 cm). National Gallery, London.
This painting was inspired by Hendrickje
Stoffels, who was Rembrandt's compan-
ion after the death of Saskia.

Thus, he had no qualms about depicting subjects that did not ap-
peal to the public. The idea of portraying a bull being skinned
(this theme was often adopted by Soutine) had not previously
entered anyone's mind. Only an outstanding genius would have
dared to display the mutilated and bloody body of a bull in the
slaughterhouse, hanging from a thick wooden beam.

An even more terrifying motif dominates *Doctor Deyman's
Anatomy Lesson,* which was painted twenty-four years after the
portrayal of Doctor Tulp. According to Otto Benesch, the earlier
painting is "almost a group portrait," whereas the other anatomy
lesson is significantly more evocative even though it has only been

partially preserved. We are confronted by the foreshortened image of the cadaver's open abdomen while the doctor's hands are shown dissecting the brain.

In contrast to this tragic apparition, Rembrandt sometimes created an enchantment-filled milieu like that of *Esther* (1660) at the Pushkin Museum in Moscow, where his subject appears amid a glittering background of golden and coral hues.

As for Rembrandt's techniques, everything is carefully molded and recaptured with the raw materials and impasto of incessantly evoked human qualities surrounded by the awesome images of daily life. Everything is impregnated with the essence of this

Ahasuerus, Haman, and Esther, 1600. (73 x 94 cm). Pushkin Museum, Moscow. This painting is characterized by a pervasive atmosphere. The colors create an impression of mystery and enchantment.

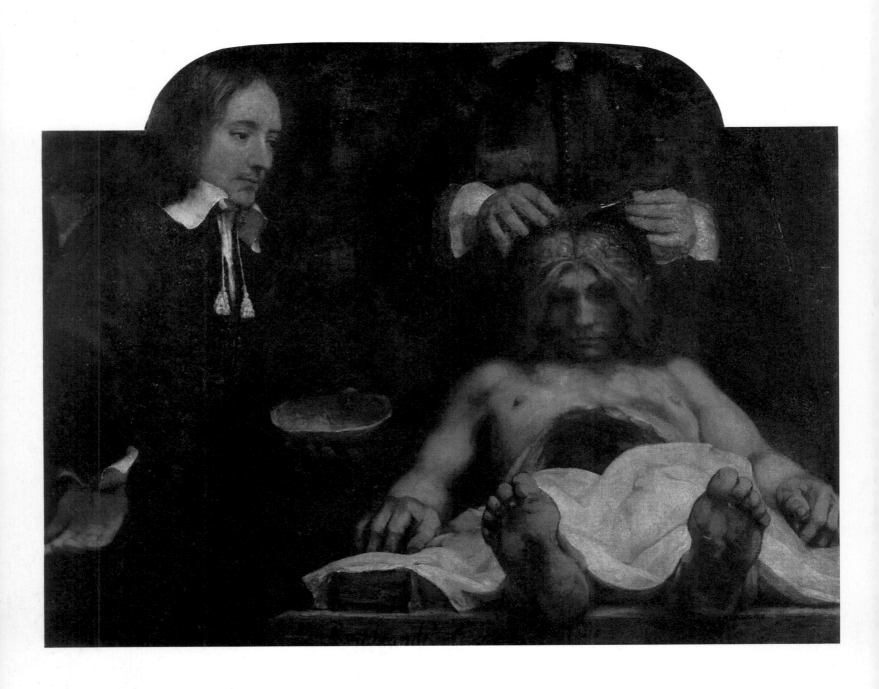

Doctor Deymen's Anatomy Lesson, 1656.
Rijksmuseum Amsterdam.
In this preserved fragment of a painting by
Rembrandt, the master artist's talent is
demonstrated by dramatic foreshortening
of the cadaver.

The Holy Family, 1645.
(117 x 91 cm). The Hermitage Museum,
Leningrad.
This image of the Holy Family, with
angels hovering above, fully expresses the
deep sense of humanity and religious
belief that dominates Rembrandt's works.
The Virgin is interrupting her reading of
the Bible in order to tend to the Christ
Child sleeping in his crib.

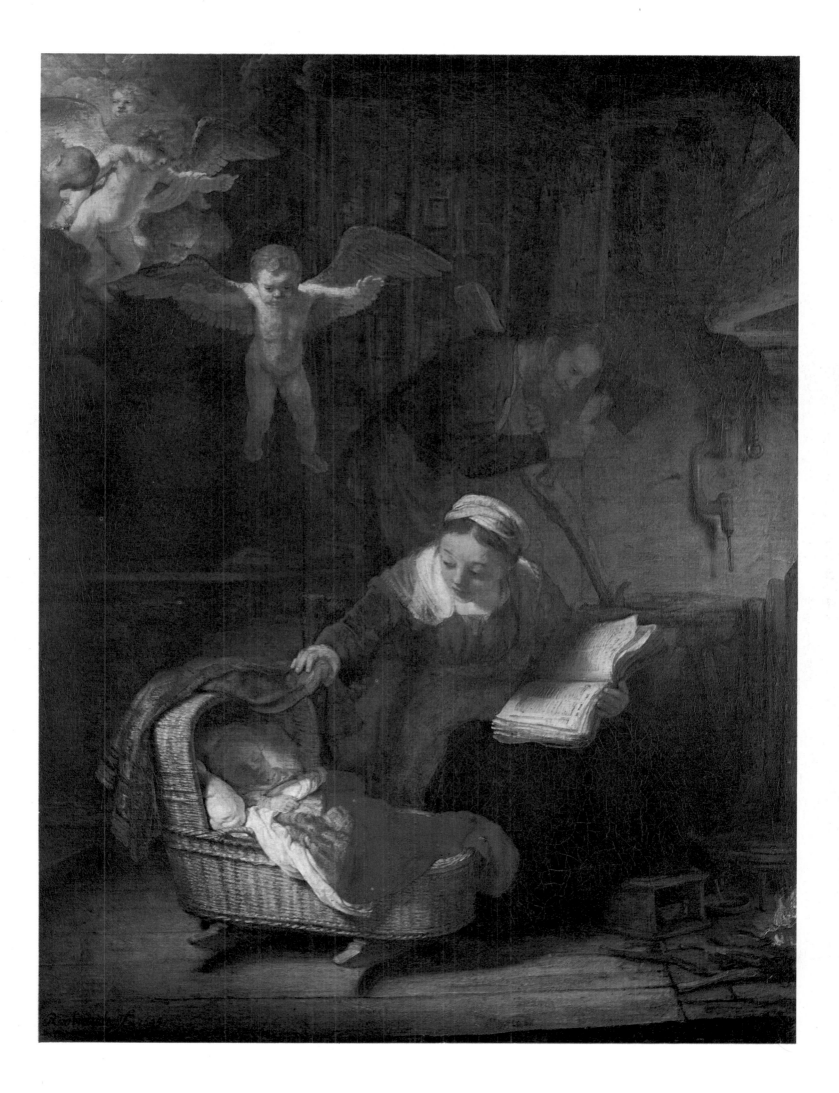

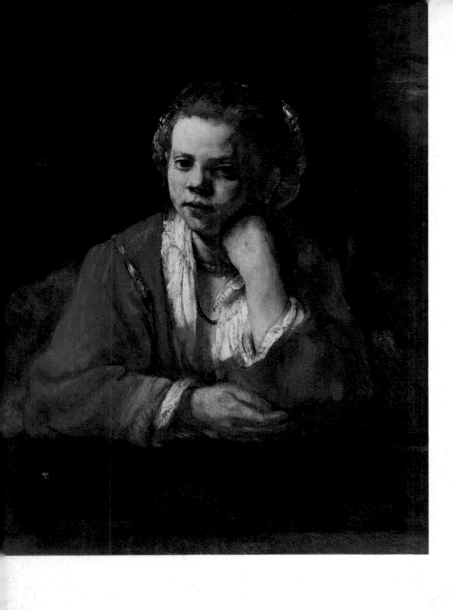

Young Woman in a Window, 1632.
(78 x 63 cm). National Museum,
Stockholm.
The face of this peasant girl conveys a certain pensiveness.

brownish impasto that Rembrandt combined with unfailing humor and gentleness. One can only observe his loving way of portraying his aged mother or the placement of a bright gold helmet above the somewhat obscure face of a man who resembled him. The image of this glittering helmet emerging from the darkness expresses Rembrandt's innermost qualities. Although reliable evidence is unavailable, it is possible that the man with the helmet may be Rembrandt's brother because his face bears some similarities to the painter's own countenance.

Rembrandt's most outstanding portrait, in Amsterdam, of Jan Six, which was painted without a commission, conveys his deep friendship for the burgomaster-poet who was so strongly influenced by the humanists. One can still envision the admirable bare hand placing a glove upon the other hand and the pensive mood of the subject in his red cloak. For more than three hundred years, the painting remained in a small drawing-room on the Heerengracht, beside a canal filled with fallen flowers.

Rembrandt painted every generation, from his son Titus, who died at an early eage, to elderly women such as his mother, his sister-in-law, and Margaretha de Geer in her ruffled collar.

A Sense of Time

Rembrandt was an artist with a sense of time, whereas the sense of space is dominant among certain other artists. Time is the ray of light falling upon *The Philosopher Meditating,* or it is expressed by the galloping movement of the *Polish Knight* (Frick Collection, Metropolitan Museum of New York). Time is the flight of the angel departing from the family of Tobias, or the storm momentarily disturbing a landscape, or the procession of Captain Banning Cocq and his arquebusiers, or the flame-like appearance of the Eucharist in the *Supper at Emmaus* in the Jacquemart-Andre Museum (Paris). Time is also conveyed by

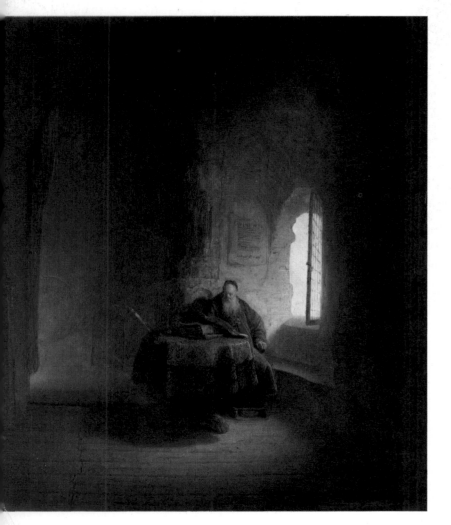

Saint Anastasius, 1631.
(60 x 48 cm). National Museum,
Stockholm.
In this painting, Rembrandt reveals himself to an even greater extent as a master of light.

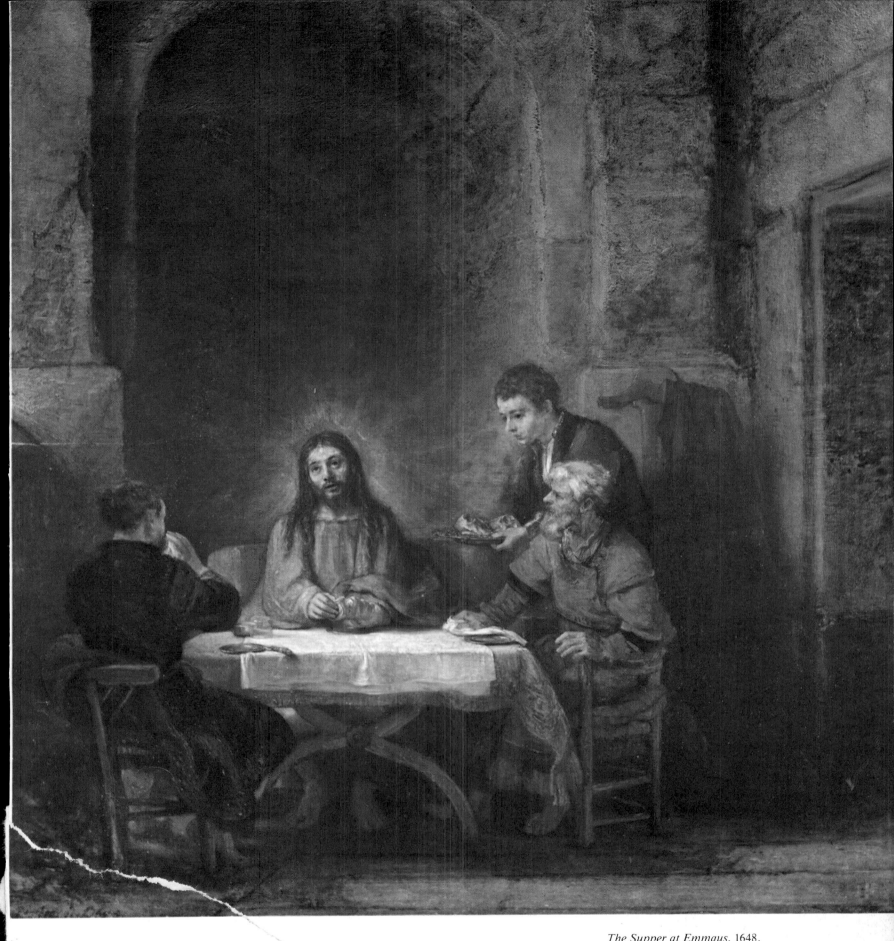

The Supper at Emmaus, 1648.
(68 x 65 cm). The Louvre, Paris.
This painting was more influenced by
Caravaggio than by realism. The artist
succeeded in creating a solemn mood by
distributing light within the background
surrounding the Christ figure who is
breaking the bread.

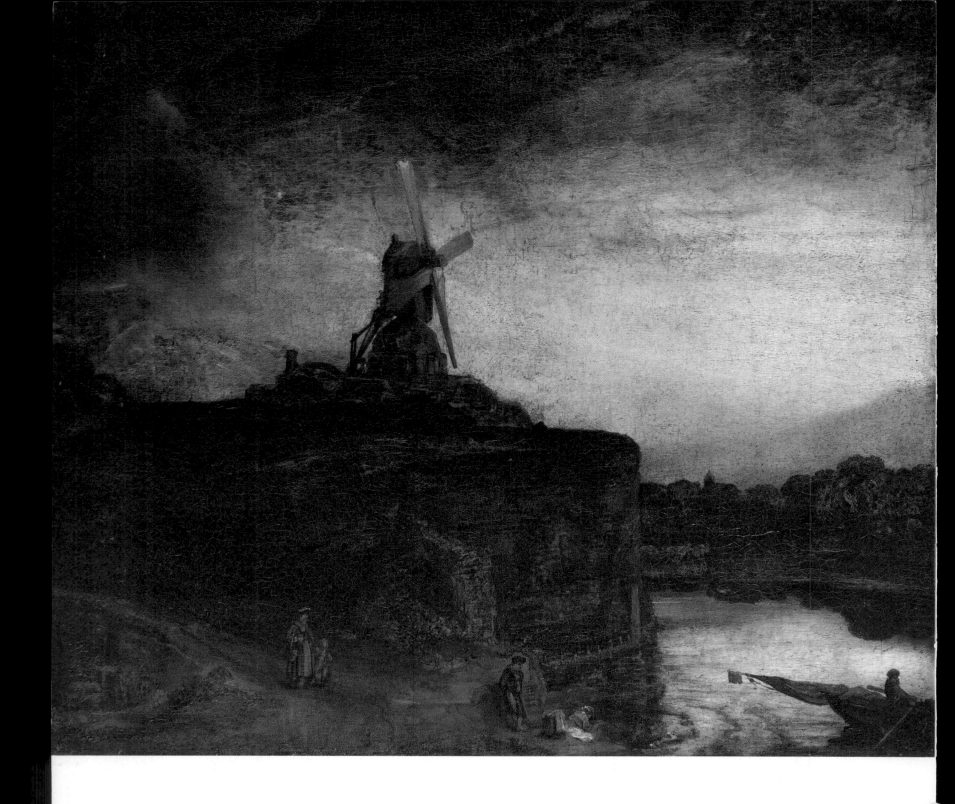

Rembrandt's series of self-portraits, from the young *Rembrandt in Armor* (1629) to one of his final self-portraits in 1661. In the latter instance, Rembrandt is believed to have portrayed himself as Saint Paul because he appears with a sword and a book, which are the characteristic symbols of the Apostle.

The face belongs to a man whose life has been beset by turbulence and numerous adversities. (Several years before Rembrandt completed this self-portrait, he had been declared insolvent. His house and his art collection were auctioned soon thereafter). The expression of this weary face (Rembrandt was only fifty-five years old, however) embodies an attitude of resignation in the face of human folly and its perpetuation. The wrinkled forehead beneath the white headband, the simultaneously mistrustful and compassionate eyes, and the almost mocking mouth capture the artist *observing us,* with full knowledge of what he has accomplished. Rembrandt was undoubtedly the artist who most deeply understood the innermost depths of human nature.

Among the artists who influenced Rembrandt, it is appropriate to cite Hercules Seghers, whose work was ignored for a long time. Seghers influenced the master who created *The Storm* and Seghers was responsible for his interest in imaginative landscapes. Rembrandt's etchings and reflect Seghers's intense use of black have an impressively contemporary quality. J.G. Van Gelder wrote that, "His landscapes are dominated by the dense, warm light of an afternoon coming to an end, whereby natural colors become darker and indistinct shadows or overly tenuous nuances are eliminated in order to create a static but radiant world resembling a lunar landscape."

The artists who studied with Rembrandt include the mysterious Carel Fabritius, who was born in Amsterdam around 1620. This artist pursued his career in Delft until he was killed in an arsenal explosion on October 12, 1654. It is impossible to forget Fabritius' *Self-Portrait*. The boldness of its colors, the impression of virile energy, and the audacious face differ sharply from the small *Goldfinch* at the Mauritshuis (The Hague).

REMBRANDT VAN RIJN

Among Rembrandt's creations, his paintings are the portion of his works which inspired the strongest objections and the most unfavorable comments by his contemporaries. Even though his drawings only circulated among a small group of cognoscenti, they were greatly admired, while his etchings, even during his life, had already earned abundant praise and international renown. As a painter, however, Rembrandt always encountered acute disapproval from critics, who became even more hostile toward the end of his life, and he was incessantly confronted by objections. When he was young, he was reproached for dashing ahead too boldly. Later, he was condemned for not conforming to the tastes of his era. In his verses addressed to the painter Philips Koninck as a warning, the classic Dutch poet Vondel compared Rembrandt, without citing his name, to an owl living in darkness and dubbed him a "son of darkness." Rembrandt's chiaroscuro actually inspired constantly increasing reservations among his contemporaries, who universally admired paintings with clear tones. During subsequent centuries, his pictorial style still continued to shock such enlightened minds as William Blake and Jacob Burckhardt while academic critics did not overlook any opportunity to invoke his flaws — even though their adherents, in some instances, secretly borrowed the most meritorious aspects of his lessons (as Reynolds did, for example). Rembrandt, since the nineteenth century, has achieved a singular triumph in the contemporary history of art precisely on account of his paintings. For thousands of admirers, he is now the Prince of Painters and his glory today is almost entirely derived from his endeavors as a painter.

There are many elements which link his works to those of his predecessors and contemporaries.

Otto Benesch
Rembrandt

The Windmill, c. 1650.
(87 x 105 cm). National Gallery, Washington, D.C.
This painting, which suggests the influence of Hercules Sehers, is Rembrandt's most impressive landscape, apart from *The Storm.*

The Syndics of the Drapers' Guild, 1662.
(191 x 279 cm). Rijksmuseum, Amsterdam.
In this famous painting, Rembrandt revealed a deep knowledge of human nature. He succeeded in endowing each of these individuals with distinctive characteristcs.

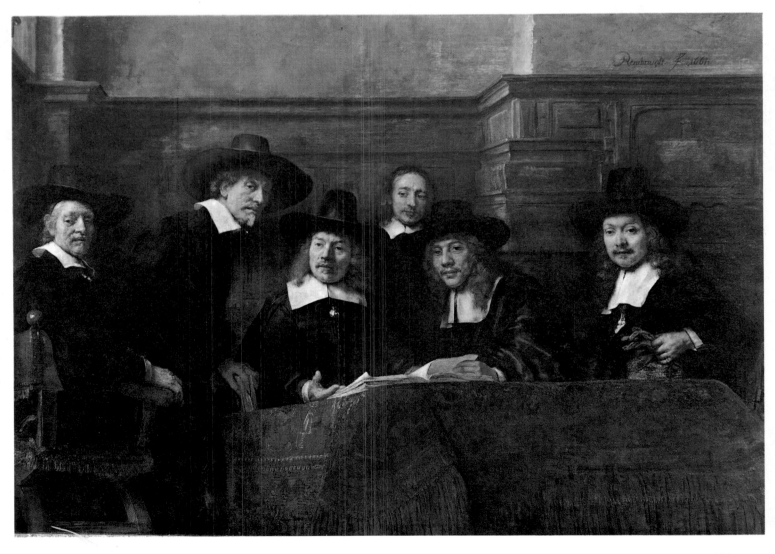

Jan Vermeer of Delft

1632–1675

No painter succeeded as he did in expressing so much through depiction of elemental reality. There is truly a mysterious transubstantiation whereby his seemingly modest creations become the source of secret pleasures.

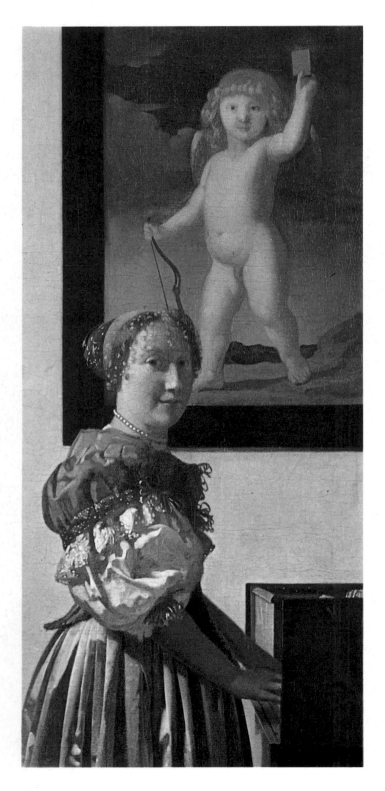

Like Piero Della Francesca or Jan Van Eyck, Jan Vermeer created his own style, colors, light and concealed meanings. His art reconciled naturalistic depiction of daily life with unfathomable ambiguities. What would seem to be more simple than a painting by this Dutchman who could portray with uncommon meticulousness a stone from a house in Delft, a man standing before a seated lady, or maiden wearing a blue turban? He is an artist who succeeded in rendering indispensable each miniscule detail within his paintings. With Vermeer, indeed, one acquires the impression that motifs were only of secondary importance. As with Cézanne, everything is a language created to convey an inner presence.

Not unlike El Greco, Vermeer slipped into oblivion for many years on account of changes in taste. Nearly two centuries elapsed until the perceptive critic Thoré-Burger, in 1866, in the *Gazette des Beaux-Arts,* described this forgotten painter whose works he encountered during a trip to Holland. Vermeer was recognized during his lifetime, but only by being included among those who are now referred to as "minor Dutch painters." His contemporary, Pieter de Hooch, was more widely recognized.

Simple Reality

Even earlier than Thore, the Goncourt brothers discovered Vermeer's individuality. A September 8, 1861, entry in their *Journal* mentions "a deucedly original master, this Van der Meer!" In turn, the Goncourts said, "It could be affirmed that his *Kitchen Maid* is the ideal pursued by Chardin. There is the same soft-hued paint, the same texture with small dabs of colors mingling with the whole, the same buttery swashes, the same undulating impasto for accessory elements, the same spattering of blues, bold reds for flesh tones, and even pearl gray in the background."

Since then, it has been acknowledged that Vermeer was a painter who excelled in imparting profound emotions to transposed reality. There are hardly more than thirty paintings attributed to Vermeer, because he endeavored to pursue another occupation that would allow him to concentrate fully on each of his works.

The painter, who was the son of a weaver, Reynier Vos Vermeer, was born in 1632 in Delft, a town that was always associated with his name. Initially, he was an apprentice of

The Kitchen Maid, c. 1658. →
(46 x 41 cm). Rijksmuseum, Amsterdam. The painting possesses a strong three-dimensional quality. It is almost a sculpture, with exceptional evocation of the contours of objects.

← *A Young Woman Standing at a Virginal,* c. 1670.
(50 x 45 cm). National Gallery, London. In this exceptionally luminous painting, the lace of the woman's bodice is accentuated by light.

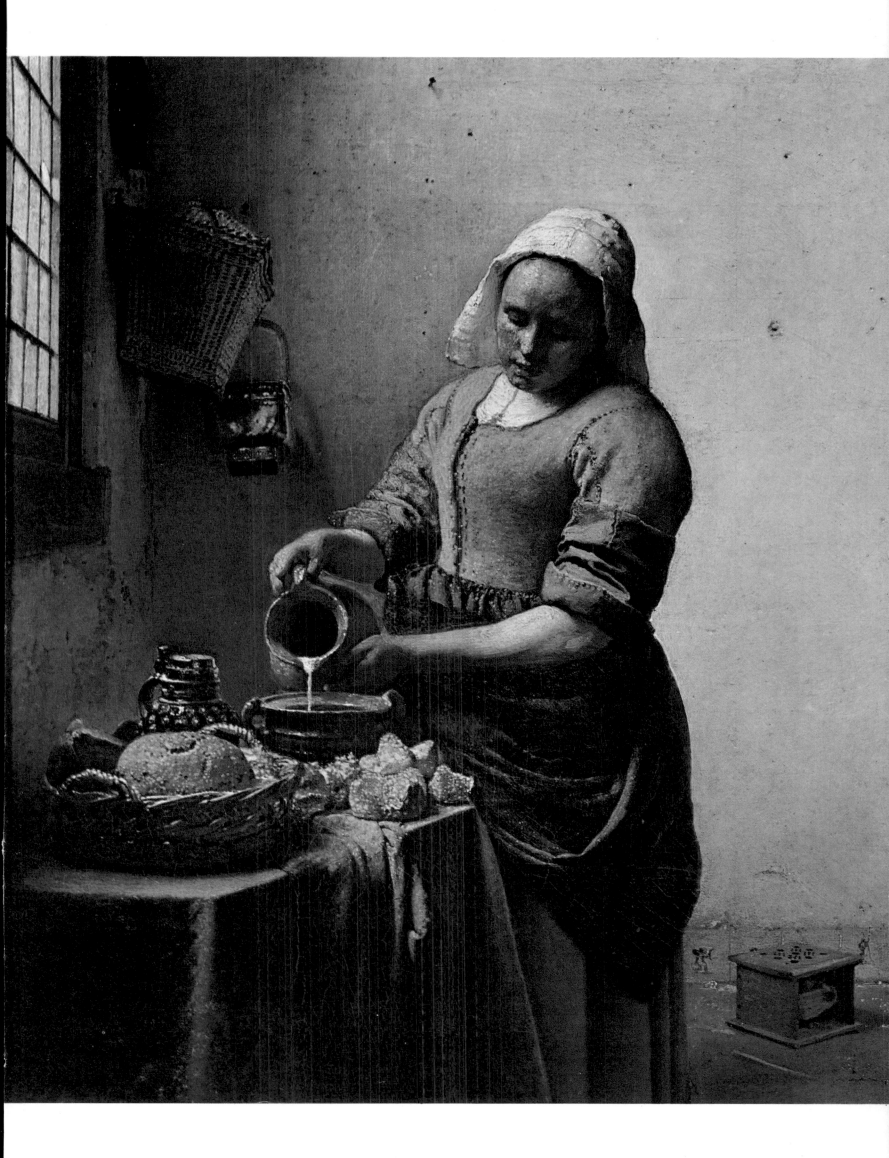

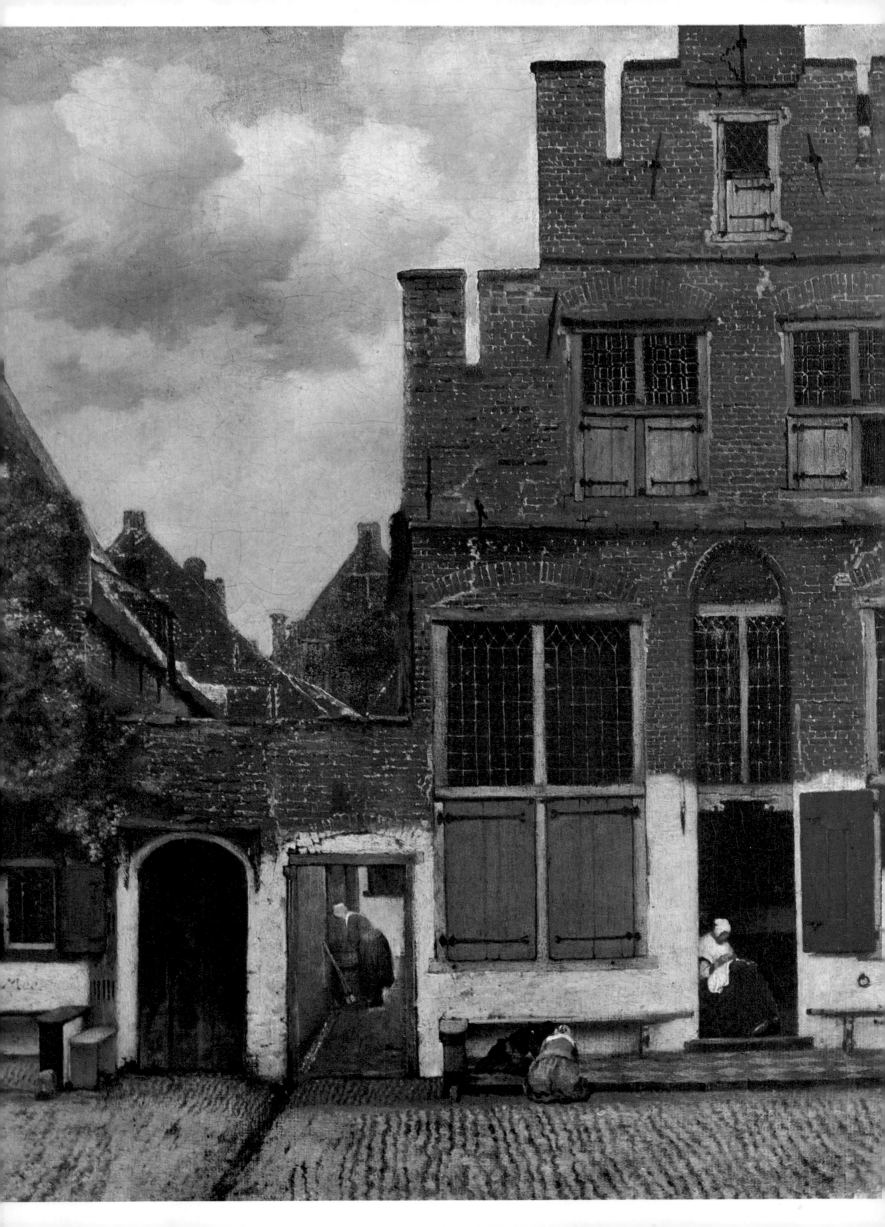

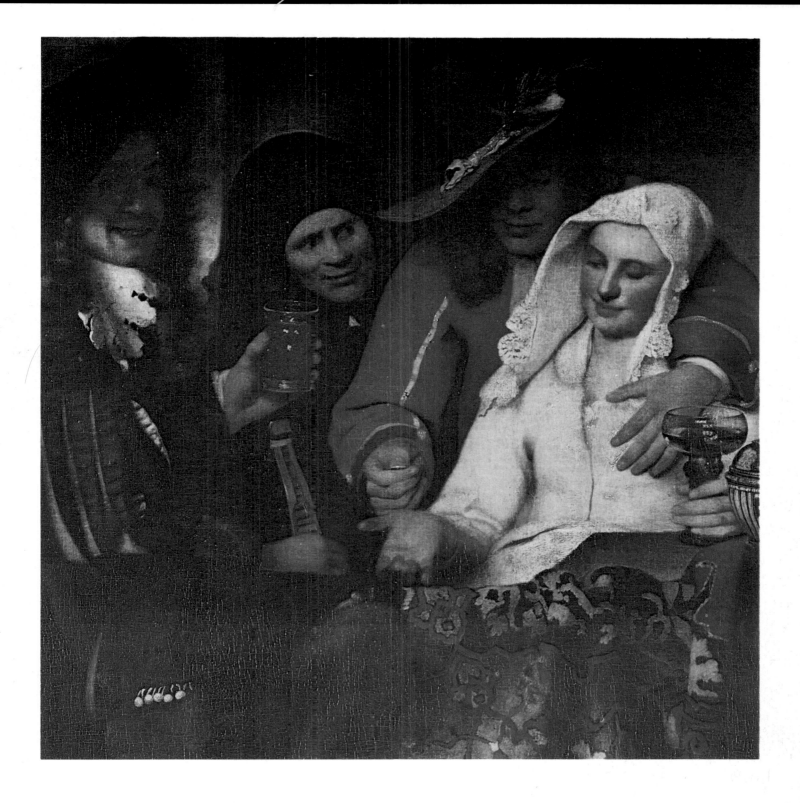

The Little Street, c. 1658.
(54 x 44 cm). Rijksmuseum, Amsterdam.
Vermeer often portrayed the facades of
old buildings in Delft. This building may
have been a hospice for elderly women on
the Voldersgracht.

The Procuress, 1656.
(143 x 130 cm), Art Gallery, Dresden.
The subject of this painting represents a
departure from Vermeer's usual serious-
ness.

Leonaert Bramer, but he subsequently became a pupil of Carel Fabritius. In 1553, he married Catherine Bolnes, who bore him eleven children, and converted to Catholicism. After being admitted to the artists' guild of Antwerp, he served as its presiding official on two occasions (1663 and 1670). At the same time, Vermeer became an art dealer in order to support himself (he was cited as pursuing this occupation in the Hague in 1672). It is difficult to establish a chronology for his paintings, which were frequently copied and forged. In 1672, Vermeer encountered overwhelming financial adversities because he always painted slowly and meticulously.

After having initially painted historical scenes in a somewhat Italianate style *(Christ Visiting Mary and Martha),* Vermeer

began to specialize in intimist paintings with a lavish texture and with intensely developed volume, creating interiors with much more vividness than those of Pieter de Hooch. The same qualities are observable in Vermeer's infrequent outdoor scenes, such as the *View of Delft* (which now seems somewhat dissonant), where space is boldly suggested, and *The Little Street,* which depicts the Voldersgracht (where an atmosphere of ordinary tasks and tranquility prevails) as the artist observed it from a window in his home.

In *The Procuress* (1656), in which the influence of Caravaggio's followers in Holland is partially observable, Vermeer continued to evoke the interiors that would be a predominant element of his art throughout the rest of his life.

137

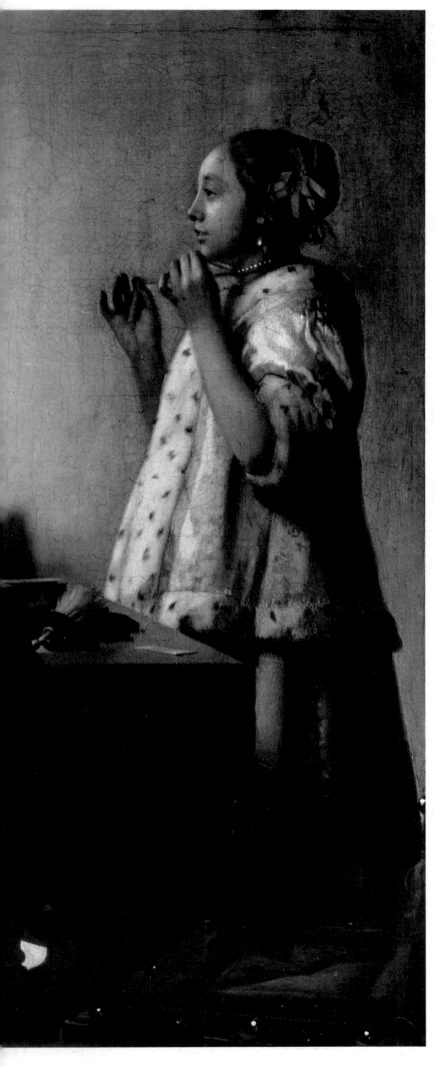

At this point, it becomes possible to explore distinctive characteristics. Firstly, there is the simplicity of Vermeer's subjects: walls, houses, the face of a seated woman drinking a glass of brandy as a man stands beside her in the dusk, a woman leaning forward in front of a window in order to read a letter, the painter in his own studio with his model, and the ubiquitous pearl. These pearls that are truly a leitmotif in Vermeer's paintings, as René Huyghe has observed, first appeared in the *Woman Weighing Pearls.* There is also the portrait of a woman holding a pearl necklace between her fingers or *The Young Woman with a Turban,* whose subject is wearing a shiny pearl in her ear. At the same time, pearls are mysteriously evoked again by the crust of a loaf of bread in *The Kitchen Maid,* and they are discretely suggested alongside the bright eyes and glistening teeth of the *Woman in a Red Hat.*

Intimacy, Contemplation, and Silence

Everything in Vermeer's paintings appears to embody ordinary realty but a transfiguration occurs without any change in the natural structure of his paintings. Vermeer's secrets are concealed beneath an appearance of conventionality. There are no drawings or sketches attributed to his unerring hands. There are no roads to guide us to these houses standing beside canals, nor are there any histories or genealogies to explain the faces of men and women whose lives unfold within domains demarcated by doors and windows, with soft light flowing into these rooms. Intimacy, contemplation, and silence are omnipresent.

Silence would seem to be the principal secret of Vermeer's paintings. Even when men and women appear together, one encounters protracted pauses. It is possible that the tranquility of Vermeer's color schemes and his way of introducing light place his talents on an even higher plane.

Who would be a counterpart to this painter who successfully concealed the secrets of his own life beneath a conventional guise?

Woman with a Pearl Necklace, c. 1663–1665.
(55 x 45 cm). Galerie Dahlem, Berlin.
Pearls are a leitmotif in Vermeer's paintings. This painting was purchased in 1869 by Thoré-Bürger, who "discovered" Vermeer. Subsequently, it was acquired by the Kaiser Friedrich Wilhelm Museum in Berlin.

Woman Weighing Pearls, c. 1662–1663.
(41.5 x 35 cm). National Gallery, Washington.
This painting was sold for 155 florins on May 16, 1696 and for 235 florins at the Nieuhoff sale in Amsterdam on April 14, 1777. After the Casimir Perier sale, it was taken from France to London and, subsequently, to the United States.

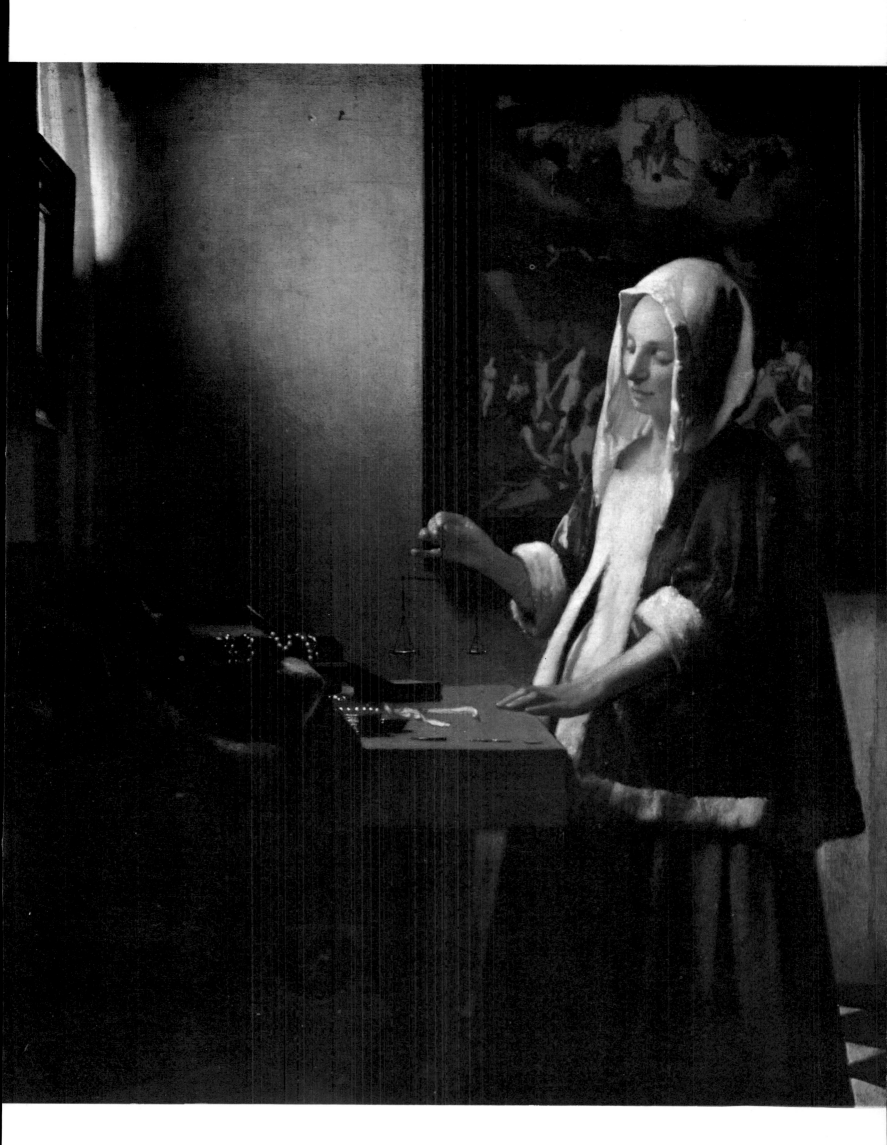

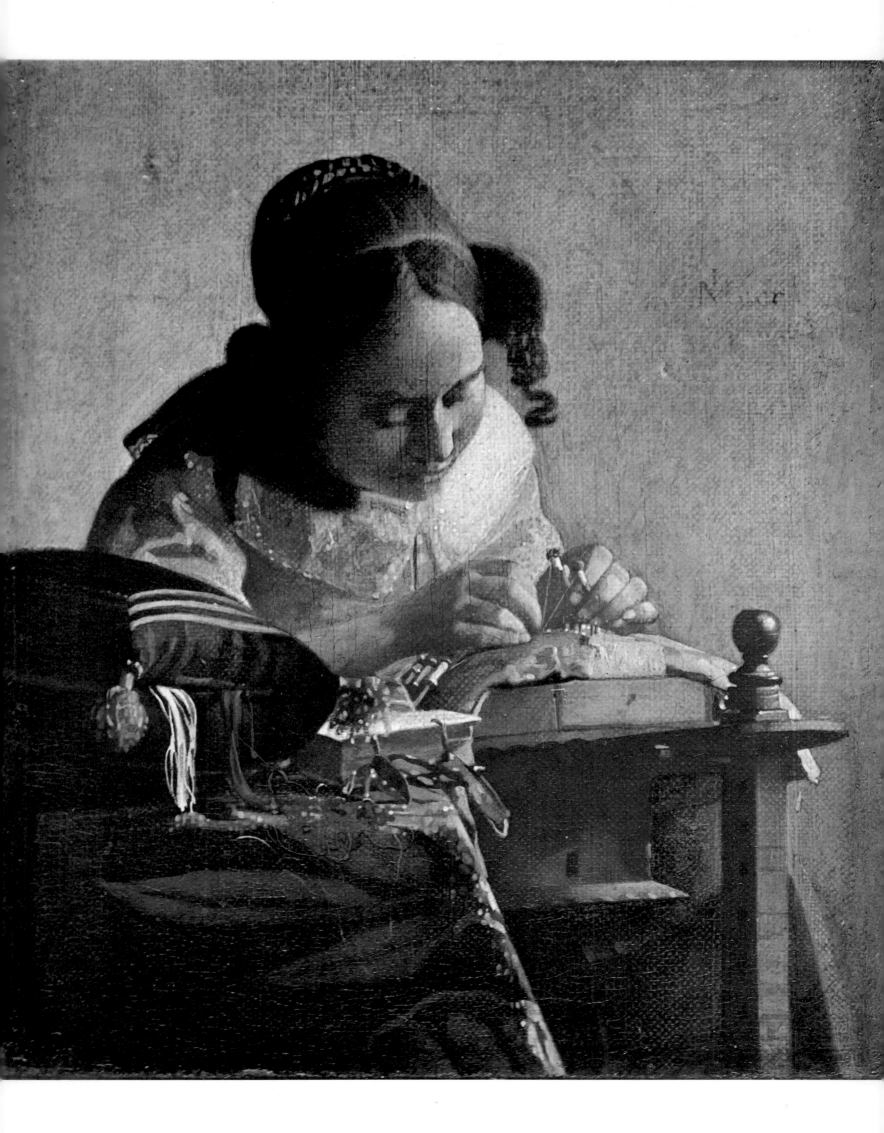

He offers some similarities to Chardin, the resident of the Rue du Four in Paris, who echoed his style nearly a century later. Is it not true that both artists emphasized colors in the same way be creating exceptionally bright tonalities on canvas or wood? In comparison with Chardin, however, the Dutch painter appears to have added an unfathomable form of sorcery to the patient efforts of his hand. Vermeer knew how to wait until a painting had nothing more to say to him. Without haste or weariness, he molded the physical expressions of his thoughts. Diversions? It was sufficient to roam within a single room, with a geographic text as a compass or with an astrological text as a map of the world.

Vermeer knew how to wait until a painting had nothing more to say to him. Without haste or weariness, he molded the physical expressions of his thoughts. Diversions? It was sufficient to roam within a single room, with a geographic text as a compass or with an astrological text as a map of the world.

Slices of Life

In Vermeer's paintings, objects are richly and sharply outlined. It would almost seem possible to touch his creations. His detailed way of depicting the simplest of objects provides unusual gratification: the heaviness of a curtain, the texture of a cushion, a piece of wool, or a segment of a tapestry. In *The Little Street,* one can observe the attention lavished upon each tile or his way of arranging figures, such as the woman laundering clothing in a tub, a woman sewing, or a child kneeling beneath a bench. In *The Procuress* the folds of a blanket appear to conceal lascivious hands. Vermeer did not hesitate to provide something to drink for the women whom he portrayed with male companions such as the young woman in a painting at a Brunswick Museum or her counterpart in *A Soldier and a Young Woman* which belongs to the Frick Collection (Metropolitan Museum of Art, New York). In the Metropolitan Museum of Art's *Allegory of the Faith,* sacramental wine is vividly depicted.

In *The Kitchen Maid* at the Rijksmuseum in Amsterdam, by showing milk flowing from the pitcher, Vermeer evoked the passage of time within the silent kitchen, amid ordinary objects upon the table, such as a loaf of bread and pieces of cheese. With her yellow blouse and blue skirt, the kitchen maid appears to have been carved from the space around her. This masterpiece clearly demonstrates Vermeer's ability to immortalize slices of life.

Clear Softness of Light

Vermeer's painting offers one of the clearest visions of reality bequeathed to us by the art of his era. There is no guest for the spectacular nor any attempt to create effects that would have clashed with a category of art where the artist confined himself solely to optical observations and creation of pleasure through colors and form. Light softly takes possession of the woman, following her, caressing her, and harmoniously molding her. Light defines her dimensions without any reliance on chiaroscuro contrasts. Color provides intensity but with an inner meaning;

VERMEER OF DELFT

The intimate nature of matter has never been more deeply explored. By crystallizing it within his paintings, while leaving its texture, its solidity, and its silent inner life untouched, Vermeer captured the essence of matter with all of the limpid brilliance and warm transparency that could be imparted to it by a man who was probably the most clear-sighted painter who ever lived. There is such a strong bond between substance and its accompanying harmonies that everything appears to emerge from within, springing spontaneously from the depths of objects like a fruit which gains a deeper color as its juices ripen. Color is kneaded into the texture of things, in soft faces filled with the vigor of youth, in a hand resting upon a yellow bodice, or in blacks and reds which are as unfathomable as translucent stones. Vermeer never painted a silken gown, a piece of lace, eyes, lips, cheeks, velvet cloaks, or a feather in a felt hat without recalling the black diamonds formed by herds scattered among emerald-green fields...

Vermeer of Delft is the essence of Holland. He had all of the typical traits of the Dutch painters, bound into a single sheaf and exalted to the supreme power of a single thrust. This man who was the greatest master in depicting matter itself had no imagination. His aims did not extend beyond the reach of his own hands. He accepted reality wholeheartedly and set out to record it. He did not allow anything to come between his own vision and the world itself, limiting his efforts to recreating the greatest lustre, intensity, and concentration which could be discovered from an ardent and careful scrutiny of life. Vermeer was the opposite of Rembrandt as he wandered alone amid the splendid bourgeois and physical influences of his milieu, striving to immerse himself in their strength and to journey toward infinite horizons of contemplation.

Elie Faure
Histoire de l'art

The Lacemaker, c. 1664.
(24 x 21 cm). The Louvre, Paris.
The Louvre purchased this painting on April 1, 1870. Vermeer's pearl motif appears in the foreground.

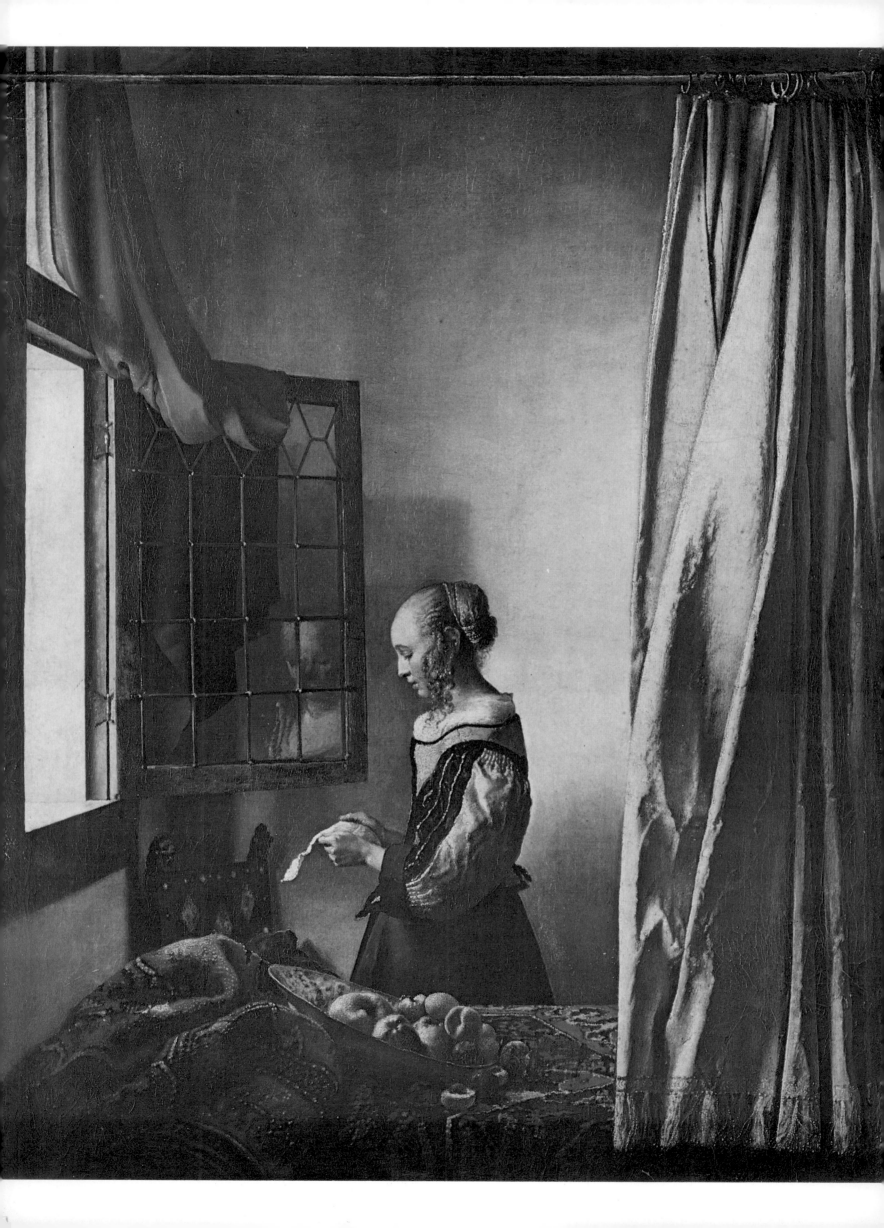

it represents a message traveling inward so that forms are transsubstantiated. The striking aspect is that, long before the Cubists, Vermeer successfully exalted the purest qualities of art while remaining within the realm of figurative design and expression.

In the *Tribune de Genève*, beside the Christ figure at the center, there was a figure possessing the traits of a studio model. The painting turned out to be an imitation by Van Meegeren.

Calm Limpidity

The Lacemaker at the Louvre is distinguished by an extremely delicate limpidity. In turn, Vermeer completed two versions of the *Woman Reading a Letter*. One is at the Dresden Museum and the other is in Amsterdam. In the earlier version, the woman appears behind a basket of fruit, beneath a high wall and in front of a heavy curtain. The importance of the woman, whose face is exceptionally beautiful, is slightly diminished by her surroundings. Her hair and the gilded fabric of her sleeve adorned with pearls.

The Amsterdam version was painted several years later. Here, Vermeer emphasized his subject more fully and naturally. The woman (who appears to be pregnant) is clearly distinguished by her dark blue garments which are counterbalanced by an old map and a light blue wall.

The painting which appears to express the essence of Vermeer's art to the fullest extent is *The Artist in His Studio* at the Kunsthistorisches Museum in Vienna. Along with Velazquez's *Meninas* and a similar painting by Courbet, this is one of the most beautiful evocations of a painter at work. Whereas Courbet's large painting appears to be tumultuous on account of the figures who surround the artist, Vermeer's painting is saturated with tranquility and silence, accentuated by a heavy drape that has been pulled to one side in order to admit the light softly flowing onto the young woman dressed in blue.

With his typical restraint, Vermeer portrayed himself from the rear. He is wearing a black beret and a black velvet jacket (his footwear consists of cream-colored indoor boots, folded at the top so as to reveal red stockings). The painter is shown sitting in front of his canvas drawing the laurel leaves that his model is

Woman Reading a Letter or *Young Woman in Blue,* c. 1662-1663.
(47 x 39 cm). Rijksmuseum, Amsterdam. Because of its more contemplative mood, this painting differs significantly from Vermeer's other painting with the same subject. It was completed around 1662-1663 and is a more unified painting. The monumental scene unfolds in front of a map. This painting is a melody in blue.

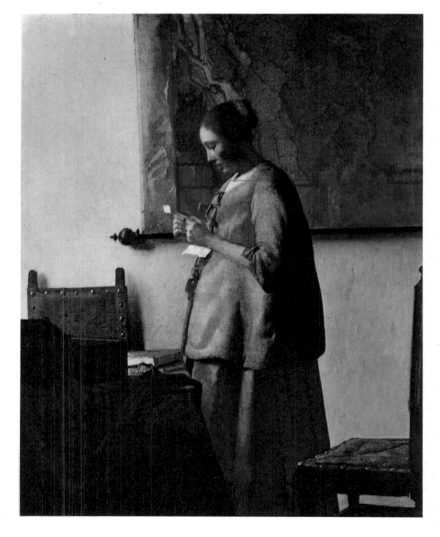

Woman Reading a Letter, c. 1657-1659.
(83 x 64.5 cm). Art Gallery, Dresden. The woman reading a letter is standing beside curtains and there is a bowl of fruit upon the table. The painting was successively attributed to Rembrandt and to Pieter de Hooch.

143

wearing on her head. The painting is flawlessly laid out so that each element is stationary and cannot be removed from its appointed location without disrupting the entire scene. As a subtle contrast, a large map hanging upon the wall provides an isolated and remote evocation of the high seas.

painting was donated to the Mauritshuis in the Hague in 1903). This is a portrait that remains in our minds along with other unforgettable images of women. It is a bewitching painting. Whenever Vermeer is mentioned, the *Young Woman with a Turban* immediately enters my mind again.

The Dutch Gioconda

At a sale of Vermeer's works on May 16, 1696, the *Young Woman with a Turban* was listed with the title *Bust Clothed in a Classical Style*. For valid reasons, this painting was later referred to as *The Dutch Gioconda*. At the end of the nineteenth century, Mr. A. des Tombes purchased this painting that is unique even in relation to Vermeer's works for the sum of 232 florins (The

A Difficult End

In all of his works, Vermeer succeeded in establishing a specific moment for lapsing into a silence flowing far beyond the point where mere contemplation would carry the observer. His endeavors to impart perfect purity to his creations bore a high price. When Vermeer died at the age of forty-three, he left behind a widow with eleven children and insurmountable debts.

Couple Drinking Wine, c. 1658–1660. (65 x 77 cm). Galerie Dahlem, Berlin. Vermeer recreated the theme of this painting in another painting belonging to the Frick Collection (Metropolitan Museum of Art, New York). The man with the large black hat appears in both paintings and the woman may also be the same.

The Painter's Studio, c. 1660–1662. (120 x 100 cm). Kunsthistorisches Museum, Vienna. This painting epitomizes Vermeer's mastery of silence and interior scenes.

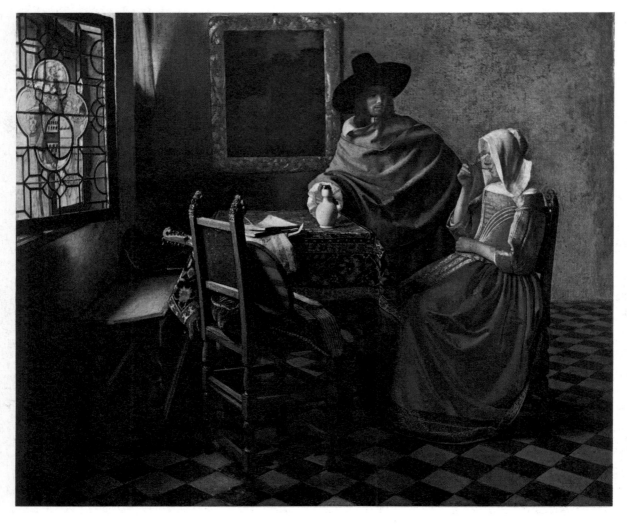

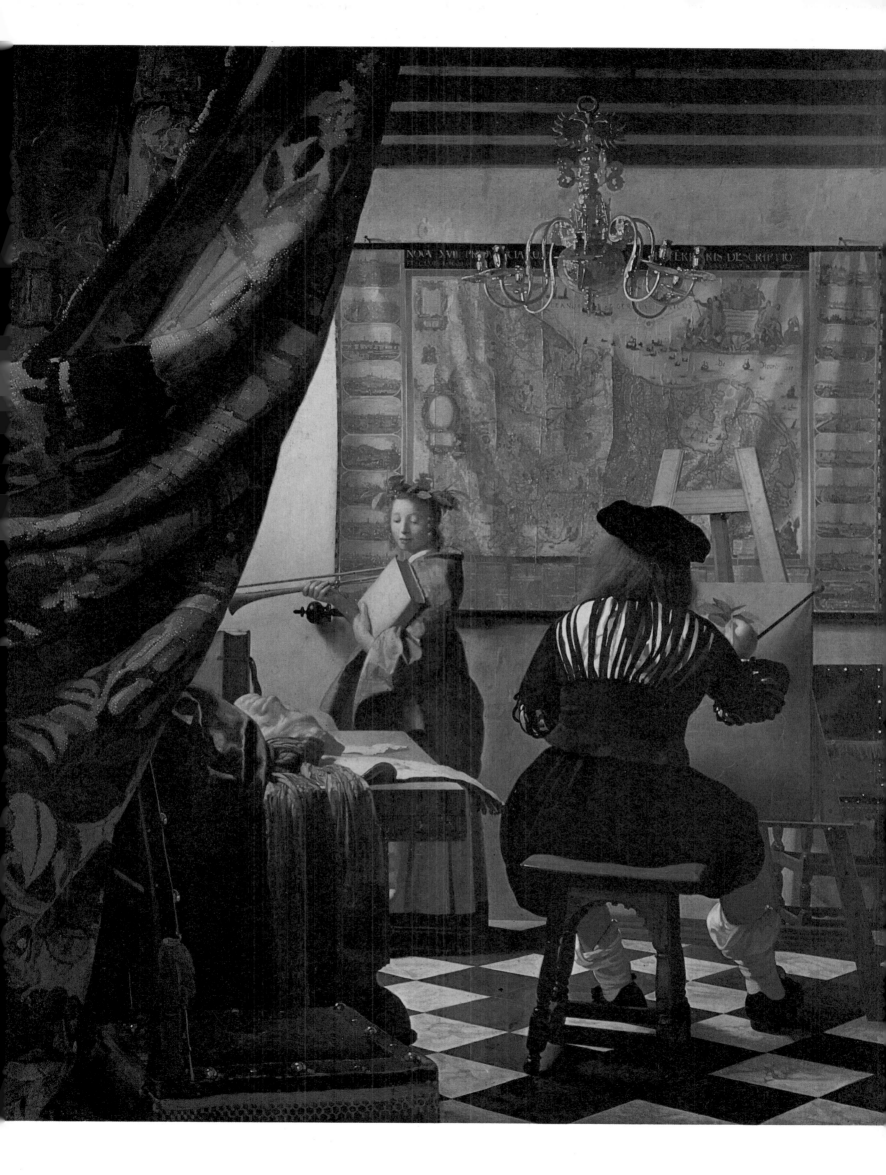

LANDSCAPE PAINTERS

A climate that is often rainy, skies filled with clouds, and trees beaten by the wind contributed to the scenes frequently observed by Dutch painters. Furthermore, one seldom encounters composite landscapes among their works; instead, delicate description of Nature prevails, as in Potter's rural scenes, Van Goyen's serene vistas, or the fields and mills painted by the van Ruisdaels and Hobbema.

Dutch painters who depicted landscapes attained far greater realism than their Flemish peers, although Rembrandt and Vermeer, of course were exceptions. One seldom encounters the diversified vistas that appear in the backgrounds of Flemish paintings from Van Eyck to Bruegel, nor is there a counterpart to Patinir's symbolic unfolding of vast horizons. The Dutch painters were predominantly naturalistic.

According to Kenneth Clark, affluent Dutch patrons during the sixteenth century were only interested in the "identifiable." This bourgeois audience "lavished gold upon Douet Mieris, drove Hals into exile, forced Rembrandt into bankruptcy, obliged van Ruisdael and Hobbema to live in absolute poverty, and compelled Hobbema to give up painting." Are there not many artists, however, who gain posthumous fame after suffering such a fate? The same pattern has arisen with many artists whom our knowledge and our tastes have subsequently rescued from protracted oblivion.

With the van Ruisdaels, landscapes filled the entirety of a canvas or a panel and human beings are often absent. Jacob van Ruisdael, however, still precedes Romanticism by many years; his landscapes are realistic evocations derived from painstaking observation, which led to the oak trees and *Fontainebleau* scenes of painters such as Dupré and Théodore Rousseau.

There was a new element among the Dutch painters of this era: landscapes were no longer studio exercises or accessories but the fruit of objective and relentless observation. Subsequent to Patinir, another innovation arose. This was the first time that the sky became so important in painting. Much later, John Constable wrote, "I believe that the sky should be and always shall be an

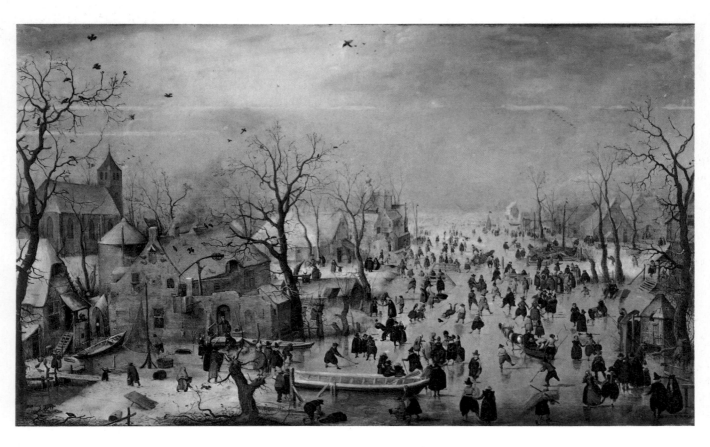

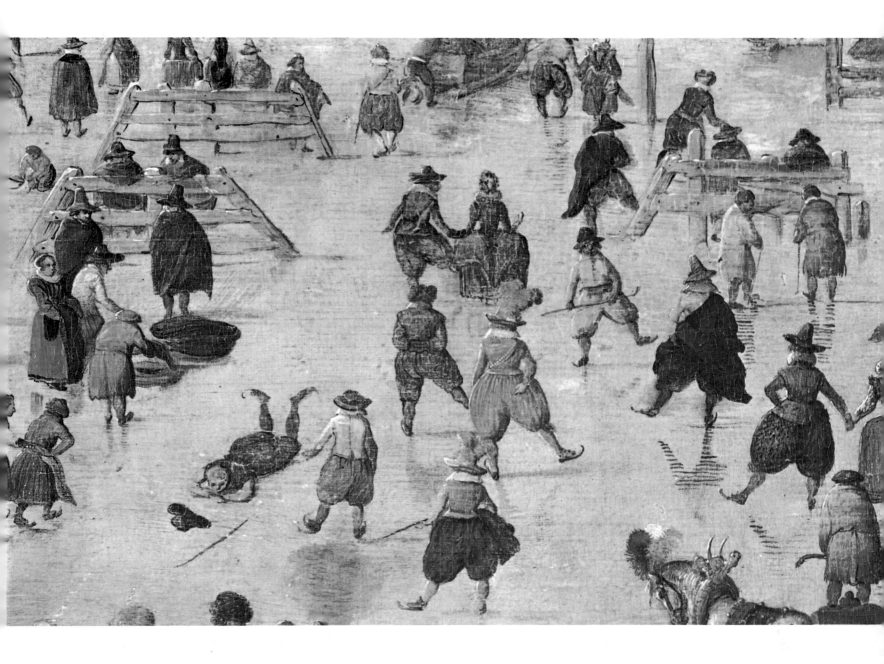

integral part of composition..." From the van Ruisdaels to Jong-
kind, the Dutch were the foremost portrayers of the sky. They
enthusiastically transcended their native soil and seas to exalt the
mobility of air and the wind, or the passage of time above the
monotony of Nature.

Hendrick Avercamp

(1585–1634)

Hendrick Avercamp (Amsterdam, 1585–Kampen, 1634) rep-
resents a link between the category known as genre painting and
authentic landscapes. He was known as "the Mute of Kampen,"
because it appears that he was a man of few words. In *Winter
Sports*, skaters are depicted with a sense of humor that is reminis-
cent of Bruegel, who had influenced Avercamp. Indeed, he was
an artist with a matchless talent for portraying human figures.

A Scene on the Ice near a Town, early
seventeenth century.
(78 x 132 cm). Rijksmuseum, Amsterdam.
Avercamp depicted skaters, executing
turns joyfully. The detail shown above
reveals his anecdotal and humorous mode
of expression.

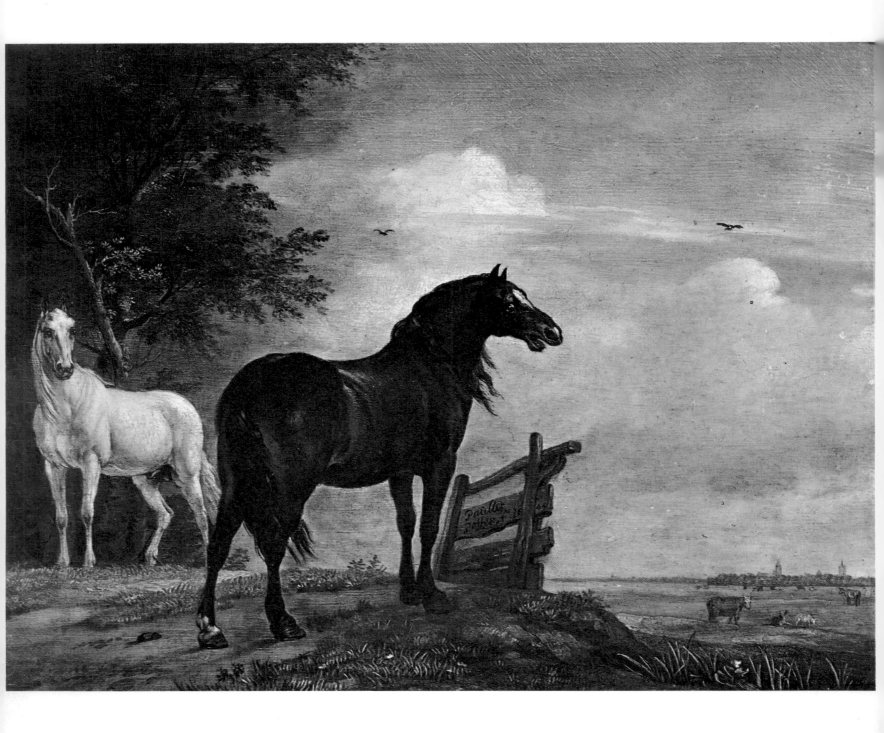

Paulus Potter

(1625–1654)

One might be inclined to place Paulus Potter (Enkhuizen, 1625–Amsterdam, 1654) among the artists who specialized in depicting animals, but he should be regarded as a landscapist in spite of his cows and horses. In examining one of his paintings depicting a bull (did he not specialize in bulls?), one might be astonished not only by the strength concealed beneath the simplicity that the painter had imparted to the bull, but by his skillful depiction of a field containing scattered blades of grass. This was a naive painting although its simplicity did not exclude deep comprehension of nature and an intimate knowledge of the soil and vegetation, or a humility that produced a truly awe-inspiring accuracy of observation, similar to the attributes that subsequently reappeared in the works of Van Gogh.

Horses in a Meadow, 1649.
(24 x 30 cm). Rijksmuseum, Amsterdam.
Paulus Potter, who specialized in painting bulls, also depicted horses in Dutch meadows, evoking the grass in a painstakingly accurate way.

The Bull, early seventeenth century. →
(21.5 x 28.5 cm). The Hermitage Museum, Leningrad.
Like the bull in painting at the Maurits-huis, this bull, representing one of Potter's favorite themes, has been placed in front of a vast landscape.

PAULUS POTTER

When Paulus Potter painted his Bull *in 1647, he was only twenty-three years old, merely a youth; indeed, like many men of twenty-three, he was almost a child. To which school did he belong? None. Who were his mentors? It has not been possible to identify anyone other than his father, Pieter Simonsz Potter, who was an undistinguished painter, and Jacob de Weth (in Haarlem), who lacked the vigor to influence such a pupil for better or for worse. Thus, at the very beginning or in the studio of his second master, Paulus Potter only received rudimentary advice without absorbing any specific doctrine. This extraordinary pupil asked for nothing more. Until 1647, Paulus Potter lived in Amsterdam and in Haarlem: in other words, between Frans Hals and Rembrandt, in the most active and tumultuous artistic center with the most distinguished masters that the world had ever known, except for Italy a century earlier...*

It would be possible to say The *Bull, and this would be the highest praise which could be granted to a painting which is so powerful in spite of the mediocrity of its flawed portions.*

Nearly all of Paulus Potter's paintings are of a similar nature. He usually set out to study an aspect of the physiognomy of Nature or some new element of his own art, and one can be certain that, at that point, he would succeed in imbibing and instantaneously recreating whatever he had learned...

His craftmanship is limited, hesitant, and sometimes inept. The strokes are somewhat childlike. Yet Paulus Potter's eye, with incomparable precision and with inexhaustible perceptiveness, continued to enumerate, to examine, and to recreate endlessly, never straying and never ceasing to explore.

Eugène Fromentin
Les Maîtres d'autrefois

Jan van Goyen

(1596–1654)

One of the predecessors of the naturalist current was Jan van Goyen (Leyden, 1596–The Hague, 1654). Van Goyen painted in the town of his birth and later in Haarlem. Subsequently, he traveled to France before settling in The Hague in 1634. He constantly recorded his observations and filled notebooks with sketches. In order to live without excessive hardship, he sold furniture and paintings as well as growing tulips, although these occupations did not avert poverty during his later years. Van Goyen was the father-in-law of Jan Steen, who was his pupil. His *Two Felled Oaks,* which was painted around 1645, is characterized by bold contours. His numerous seascapes situated beneath vast

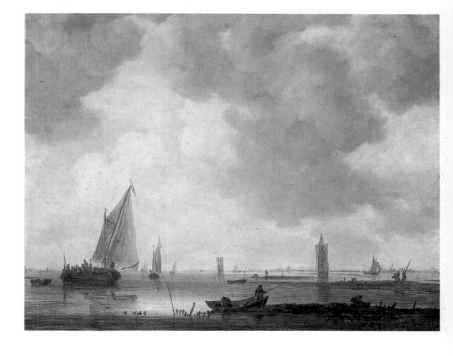

Ships on a Calm Sea, 1646.
(51 x 66 cm). National Gallery, Prague.

skies are perhaps more commonplace. The trait which distinguishes van Goyen from his contemporaries is extremely fluid draftmanship. His paintings are almost monochromatic, as in *Cottages beside a Well,* in which one can observe subtle shades of brown that sometimes acquire greenish tonalities. In terms of his promptly recognizable style, van Goyen can be regarded as a precursor of Rembrandt.

Cottages beside a Well, 1633.
(55 x 80 cm). Art Gallery, Dresden.
With almost monochromatic harmony, Van Goyen painted seascapes and rural scenes.

149

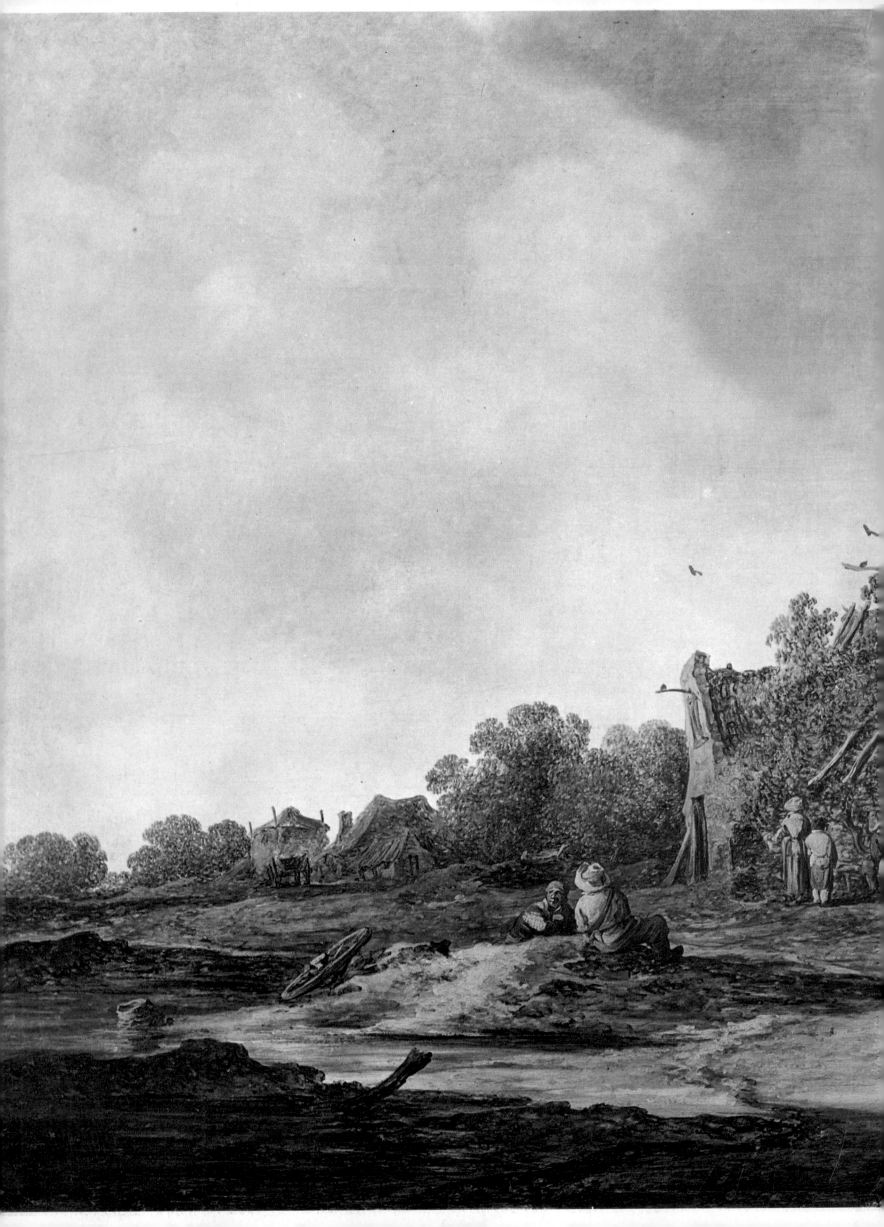

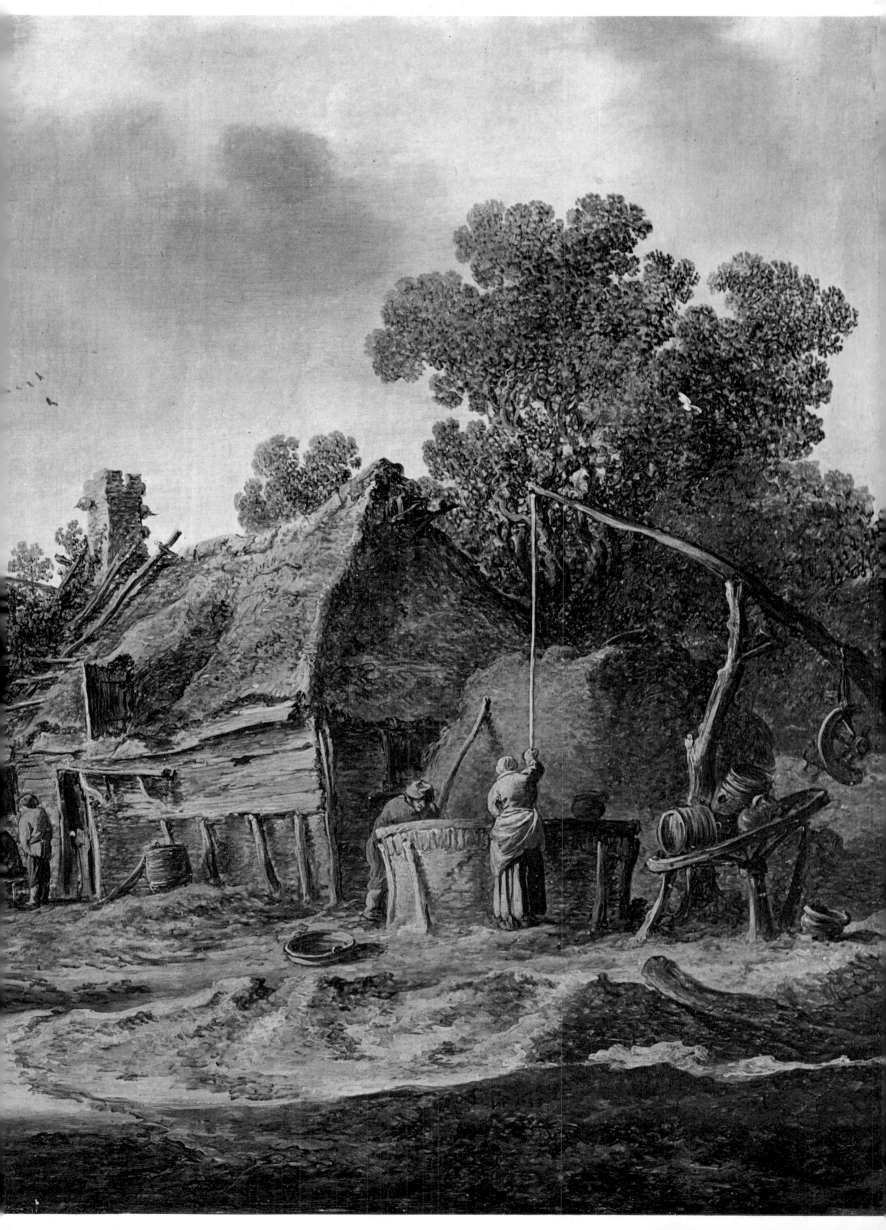

Salomon van Ruisdael

(1600–1670)

Jacob van Ruisdael

(1628–1682)

Salomon van Ruisdael (Naarden, 1600–Haarlem, 1620) and his nephew Jacob (Haarlem, 1628–Amsterdam, or the Haarlem hospice, 1682), who is the most famous Dutch landscape painter, were both influenced by van Goyen. After being a pupil of his uncle, Jacob van Ruisdael became a member of the artist's guild in Haarlem in 1648 although he moved to Amsterdam in 1656. Twenty years later, he studied medicine at the University of Caen. Jacob van Ruisdael painted wheat fields, stormy landscapes, oncoming storms overshadowing the sun, and forests. His landscapes became naturalistic creations derived from detailed observation. Fromentin praised his *Thicket* at the Louvre and his *Burst of Sunlight*. Whereas the French author characterized van Goyen as "uncertain, volatile, rarified, and transparent." He described Jacob van Ruisdael in these terms. "He had his own way of adopting a stance, declaring his presence, gaining respect, and obliging the observer to recognize that someone's spirit stands before him."

In the *Wheat Field*, Jacob van Ruisdael evokes the presence of a few human figures wandering somewhere along a road. This is not a painting that can be scanned with a single glance. It is

Among all of the Dutch painters, van Ruisdael is the one who most resembles his native land. He offers open spaces, sadness, a somewhat mournful placidity, and a monotonous and tranquil charm.

With fleeting contours, rigourously chosen colors, and two explicitly physical features — namely endless gray horizons and gray skies where the infinite unfolds — he created a portrait of Holland, not as a family portrait, but as an intimate, charming and admirably exact portrait that is ageless. For other reasons as well, van Ruisdael is the most outstanding figure among the artists after Rembrandt. That is not an insignificant distinction for a painter who only created so-called inanimate landscapes where no living creatures appear. Indeed, he painted unaided by anyone else.

It should be kept in mind that, if one were to consider detail alone, van Ruisdael would possibly be a lesser artist than many of his countrymen. In the first case, he was an unskilled artist when deftness was the hallmark of talent for his era and for his genre. Indeed, the firmness and usual solidity of his thoughts may have arisen from his lack of dexterity. Furthermore, van Ruisdael was not extraordinarily inventive. He painted competently and did not pursue originality in his craft. He expressed himself precisely and firmly but deliberately and unambiguously, without ardor or guile.

Eugene Fromentin
Les Maîtres d'autrefois

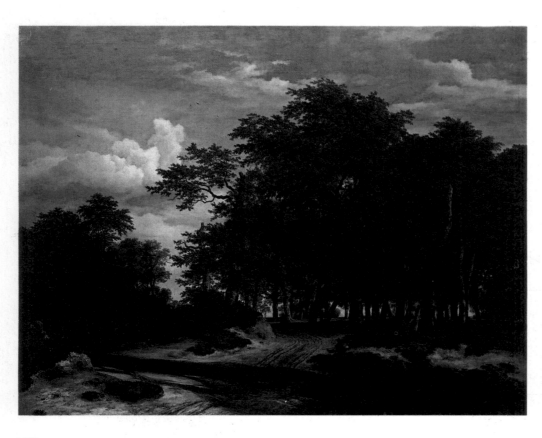

Forest Scene, c. 1660.
(139 x 180 cm). Kunsthistorisches Museum, Vienna.
As this forest with ancient trees demonstrates, the van Ruisdaels were creating masterful realistic landscapes long before the Barbizon School.

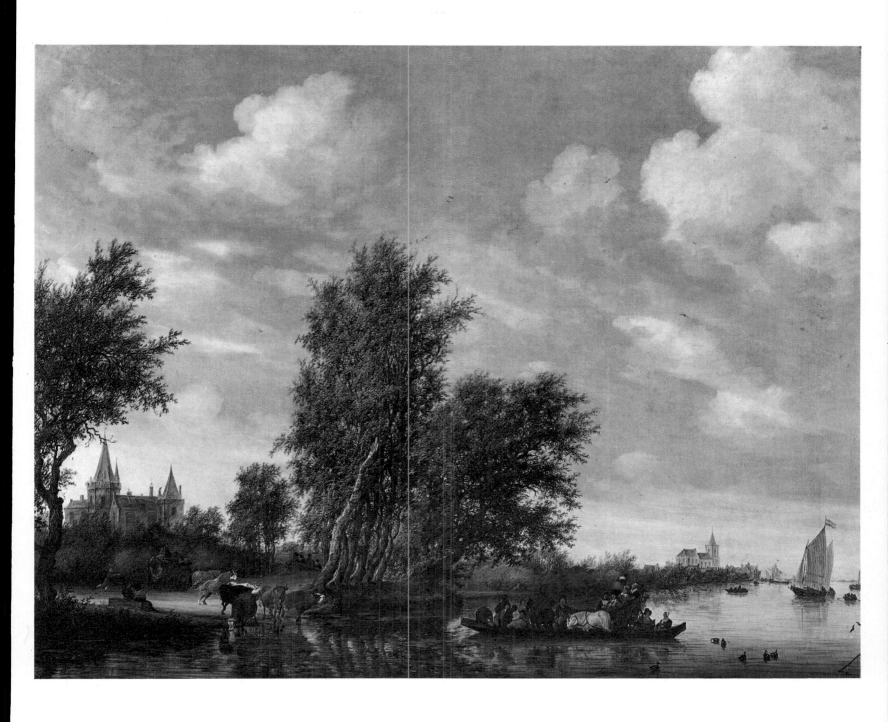

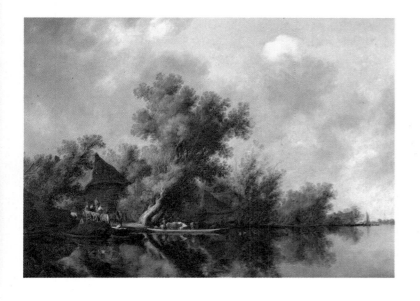

River Landscape, 1649.
(100 x 133 cm). Rijksmuseum,
Amsterdam.
Salomon van Ruisdael, the uncle of Jacob
van Ruisdael, strongly influenced his
nephew. His works have been unduly
neglected. In this river landscape, he
revealed deep admiration for bucolic
settings.

River Bank, c. 1630.
(65 x 95 cm). Alte Pinakotek, Munich.
The motifs contained in the preceding
painting seem to reappear in this riverside
scene, where there is greater unity and a
broader horizon.

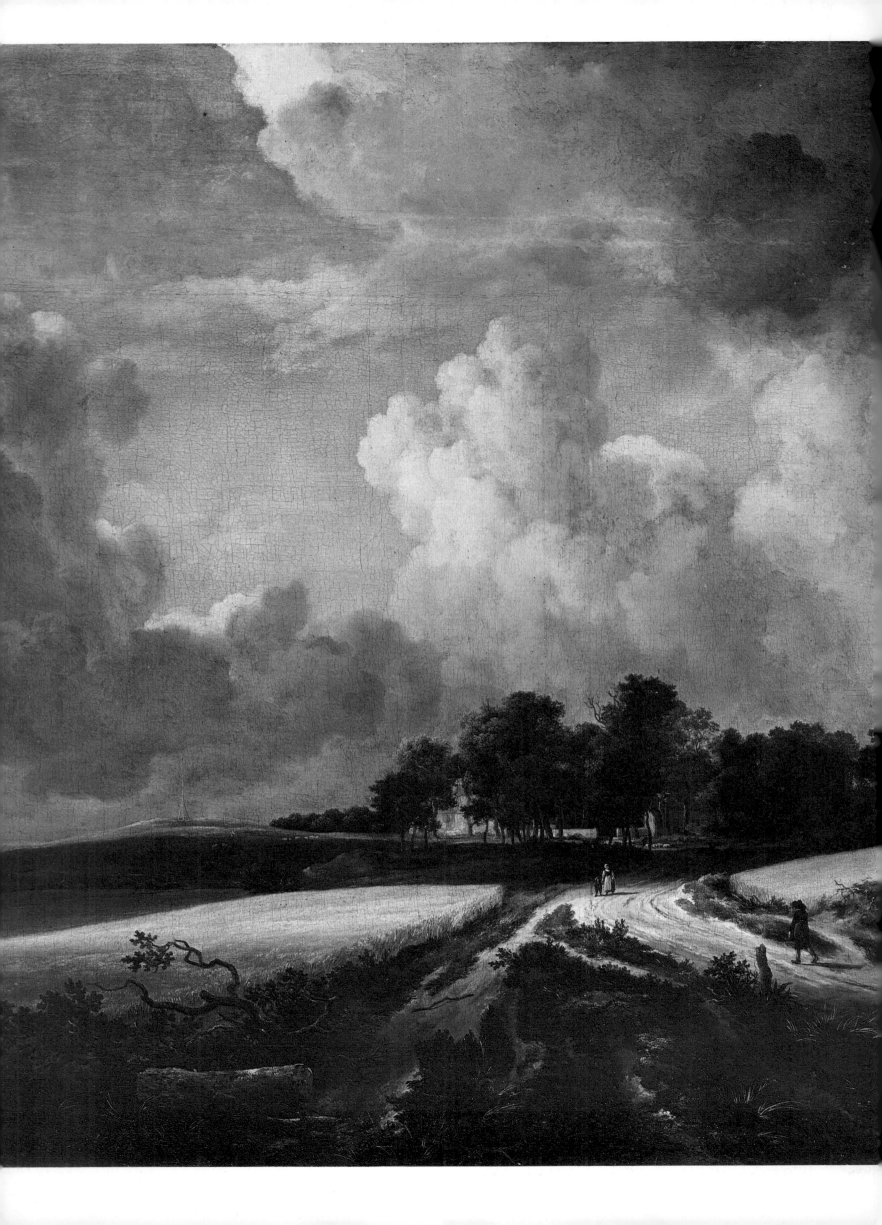

filled with details and the observer absorbs the scent of Summer beneath threatening skies, the silence of Nature, and the artist's contemplativeness.

Whereas Jacob van Ruisdael's merits clearly deserve praise, it would be unjust to ignore (as many have done) the influence of his uncle whom Fromentin did not discuss. Jacob van Ruisdael undeniably displayed strong poetic instincts, complete absorption of the scenes that he observed, and a talent for transposing these scenes into painstakingly developed perspectives but Salomon van Ruisdael's *Banks of a Stream* has appealing luminous qualities and his *River Landscape* is an extremely tranquil painting.

The creations of the van Ruisdaels are significantly different from those of a French artist who was their elder and who spent most of his life in Rome. Notwithstanding the true-to-life qualities of Dutch landscapes or in spite of detailed arrays of roads and trees, or carefully observed skies accentuated by silvery or somber massses of moving clouds, these paintings are to a certain extent *snapshots* in comparison with Claude Lorrain's harbors and rustic scenes in which illumination varied according to the time of day, or in comparison with Nicolas Poussin's robust and captivating creations.

JACOB VAN RUISDAEL

(Van) Ruisdael's paintings, like his way of thinking, were marked by soundness, strength, and expansiveness. The external qualities of his creations offer a relatively clear indication of the essence of his spirit. In these austere, painstaking, and somewhat proud creations, there is an undefinable melancholy aloofness communicated from afar. Close at hand, the observer is enthralled by the charm of an entirely distinctive natural simplicity and familiarity. (Van) Ruisdael's paintings are creations which convey a sense of order, a comprehensive vision, an overriding purpose, and a desire to portray some aspect of his native land once and for all. It is also possible that the desire to record the memory of a moment from his life is present. Here, we encounter solid backgrounds, a need to construct and to organize, subordination of details to the whole, skillful use of color, and the appeal of objects within their respective milieux.

Eugene Fromentin
Les Maîtres d'autrefois

Wheat Fields, early seventeenth century. (100 x 130 cm). Metropolitan Museum of Art, New York.
This painting is superior to the preceding paintings. It provides a justification for the views of those who regard Salomon van Ruisdael's nephew, Jacob, as a greater artist.

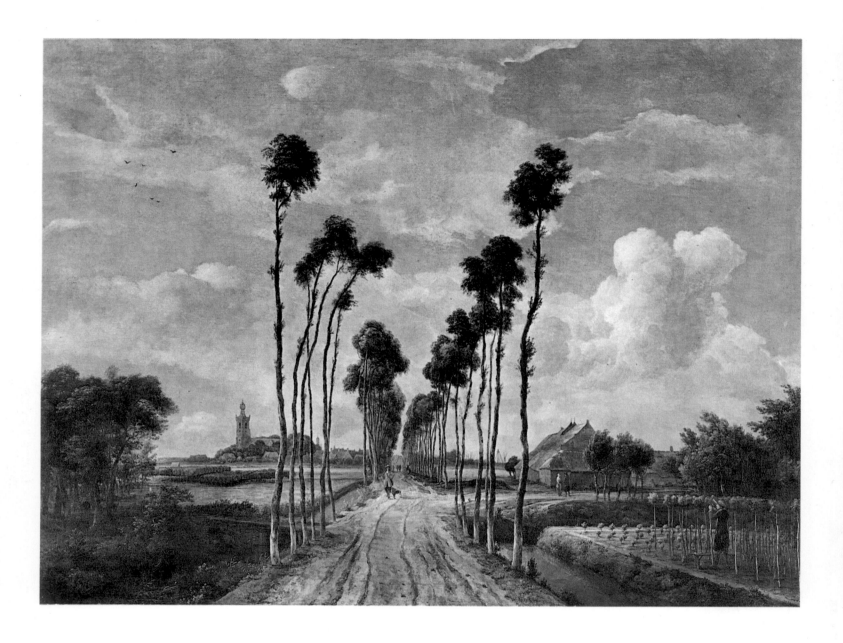

Meindert Hobbema

(1638–1709)

In our era it is perhaps possible to appreciate more fully the works of Meindert Hobbema (Amsterdam, 1638–Amsterdam, 1709), who pursued the same genre as the van Ruisdaels and was inspired by the scenery of eastern Guelderland. The luminous quality of Hobbema's paintings foreshadows Sisley's creations. In *The Avenue, Middelharnis*, bright colors, extremely delicate tonalities, the contours of a road set between two rows of tall trees with slender trunks, and a deep blue sky invite the observer to advance toward the houses that are visible in the background of this beautiful landscape.

Hobbema's contemporaries include Philips Koninck, Jan Van de Capelle, and Willem Van der Velde. Koninck was a precursor of Constable, while Van de Capelle created magical evocations of misty landscapes. Van de Velde specialized in depicting ships with billowing sails, driven forward by the wind. Another member of this group was Gerret Adriaensz Berkheijde, who created harmonious and well-balanced cityscapes in Haarlem.

The Avenue, Middelharnis, 1689. (104 x 141 cm.). National Gallery, London. Hobbema marks a decisive turn toward bright illumination. It is possible to regard him as a forerunner of the Impressionists.

Fromentin acknowledged that Hobbema's paintings, unequalled by other Dutch painters of his era, led him "to feel less admiration for (van) Ruisdael at certain times... Hobbema's forms are so precise and so solid, his craftmanship with such powerful and beautiful colors is so recognizable from one painting to another, and his skies are of such exceptional quality, that everything would seem to have been carefully engraved before he began to paint."

Landscape, c. 1640.
(93 x 112 cm.).
Rijksmuseum, Amsterdam.
In portraying vast horizons such as this one, Philips Koninck established himself as a creator of far-reaching skies that almost fill the entire canvas.

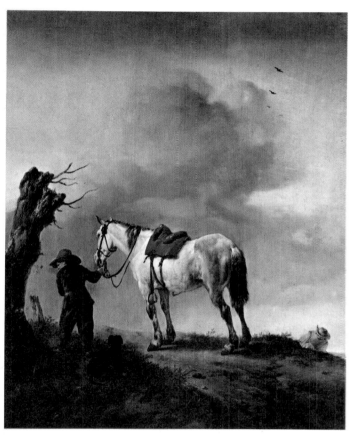

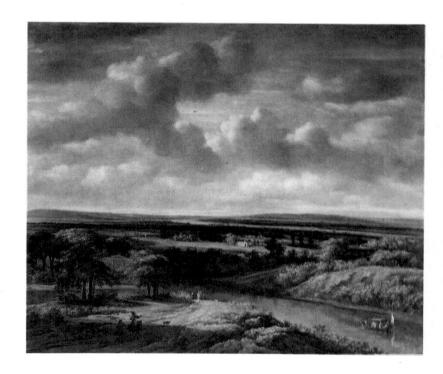

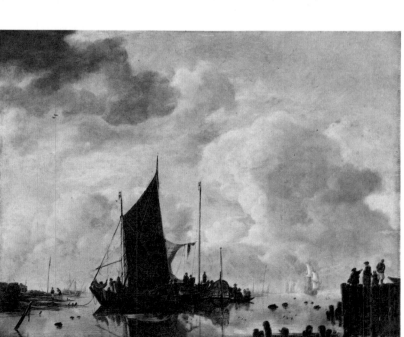

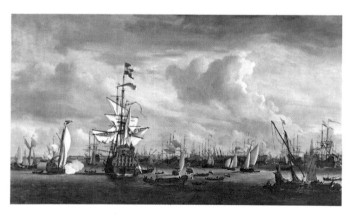

The Harbor of Amsterdam, with the Flagship "De Gouden Leeuw." 1686.
(180 x 316 cm.).
Rijksmuseum, Amsterdam.
This painting by Willem Van de Velde provides an astonishingly luminous horizon filled with sails moving across the water in all directions.

Reflections from the Waters of a Harbor, 1649.
(55 x 70 cm.).
National Museum, Stockholm.
Jan Van de Cappelle created evocative seascapes. He demonstrated an exceptional capability for emphasizing sailing vessels and their riggings against a marine background.

STILL LIFES

This genre was perfectly consistent with the intimacy sought by Dutch painters. It allowed those who depicted motionless objects to pursue their explorations of the most delicate nuances of color and light.

The French term *nature morte*, which is used to refer to paintings of fruit, flowers, vegetables, and inanimate objects, has a somewhat mournful or even funereal connotation. The English expression "still life" is somewhat more elegant. This is an improvement, although it involves a certain departure from the visual domain. Is it not true that paintings are always silent, whatever the theme may be? "I am creating silent art," Nicolas Poussin proclaimed. For my own part, I would prefer that these paintings of glass objects, delicacies, and seafood be categorized as "paintings of inanimate objects."

The artists who created the mosaics of Herculaneum and Pompeii were already producing still lifes. Many examples exist in Flemish art and this is one of the genres that deeply fascinated Dutch artists. Their customary isolation in their dwellings led to an interest in accumulations of food on dining room tables. They most frequently chose to depict copious servings of seafood or ornate vessels intended for beverages. These refined images had been preceded by profusions of vegetables recreated by Pieter Aertsen, who had been the first artist to depict market stalls surrounded by merchants selling their wares. In Flanders, this category of painting was enriched by the endeavors of "Velvet" Bruegel and Frans Snyders, who influenced such contemporaries as Paul de Vos and Jan Fyt.

None of the Flemish artists, however, proved capable of attaining the emotional overtones that Dutch painters created by depicting food displayed upon tables.

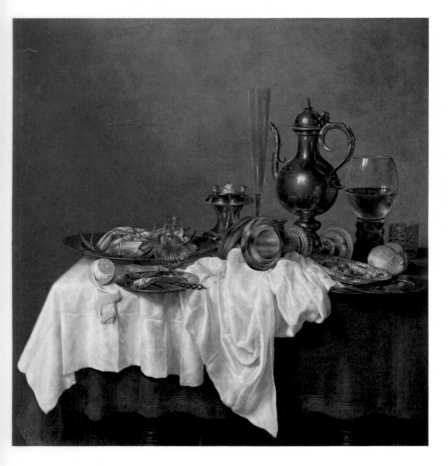

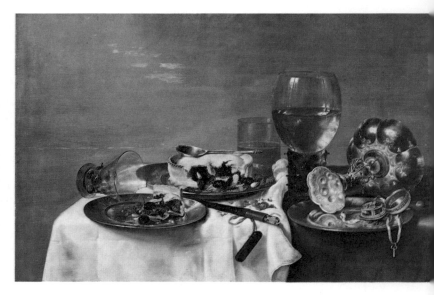

Still Life with Lobster, 1648.
(118 x 118 cm.). The Hermitage Museum, Leningrad.
In this painting, Willem Claesz Heda placed a tempting seafood specimen between a lemon and a glass of white wine. The forms are extremely subtle.

Still Life with Blackberry Pie, 1631.
(54 x 82 cm.). Art Gallery, Dresden.
This painting offers an invitation to the palate. The overturned cup and glass foreshadow elements that reappear much later in Cézanne's still lifes.

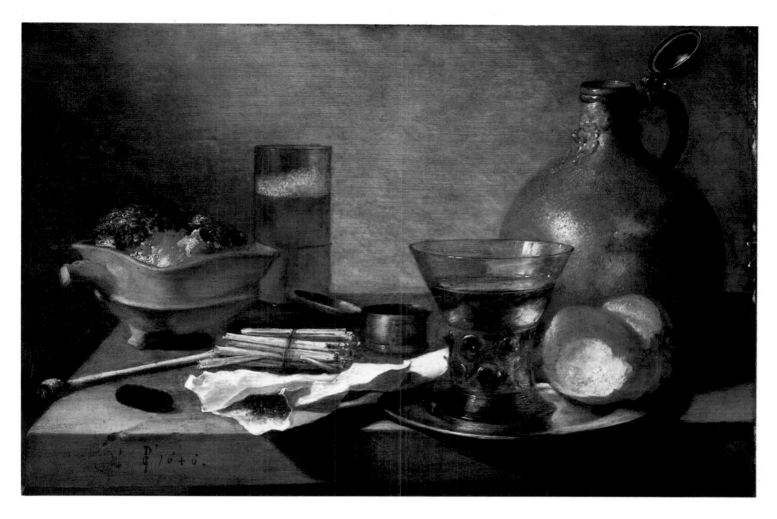

Still Life, 1646.
(40 x 61 cm.). National Gallery, Prague.
Pieter Claesz, who anticipated the tactile
creations of Chardin, skillfully captured
reflections from a glass and a pewter dish
upon the table.

Willem Claesz Heda

1594–1680

Today, it is possible to express even greater admiration for the Dutch still life painters because our partial abandonment of the figurative realm has allowed us to better appreciate the tonalities and luminosity of their still lifes. Willem Claesz Heda's *Unfinished Breakfast with Blackberry Pie* offers a rare harmony between blues and grays, with an astonishingly dexterous rendition of reflections from the serving dishes. At the same time, a half-folded napkin provides a broad swath of white. Little is known about the painter's life although he was probably born in Haarlem. He painted a *Vanity* in 1621 and, in 1631, he was listed as a member of the artists' guild in Haarlem, where it is believed that he painted altarpieces.

Today, we are extremely receptive to portrayals of inanimate forms, whereby the artist, free from distracting quests for the spectacular, can benefit from seeking purely pictorial qualities, such as delicate modulation of colors and extreme refinement in capturing the luminosity of objects.

Pieter Claesz

1597–1661

There is a similar paucity of information concerning another painter with the same surname. Pieter Claesz was born in Burgensleinfurt (Westphalia) around 1597 and became a resident of Haarlem, where he died in 1661. His *Still Life with a Large Goblet* at the Haarlem Museum is characterized by extraordinary limpidity. On account of his restrained style, Pieter Claesz appears to be the still life painter who creations are most appealing to contemporary admirers. His *Still Life* at the National Gallery in Prague is distinguished by golden hues and by monumental forms. The artist placed the year of completion, 1646, and his signature on this painting. Pieter Claesz was the father of Nicolaes Berchem, who became a renowned landscape painter. Luminosity, substance, rich tonalities, and warm colors are qualities that place Pieter Claesz and Willem Claesz Heda among the leading Dutch painters in this particular genre. The elements that Chardin appears to have borrowed from these Dutch predecessors include the transparency of glass, the dull sheen of pewter plates, tobacco wrapped in paper, a clay pipe resting upon a table, or a partially peeled lemon.

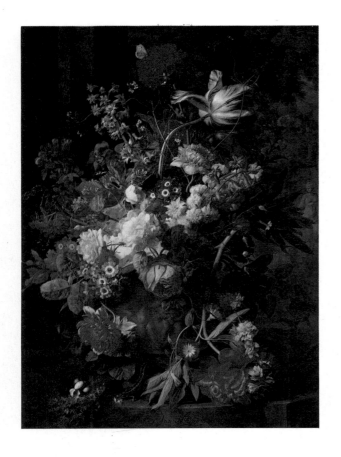

Janz Van de Velde, *c.* 1620–1662
Abraham Van Beyeren, *c.* 1620–1690
Willem Kalf, 1622–1693
Jan Van Huysum, 1682–1742

Artists who pursued a poetic vision were followed by such painters as Janz Van de Velde (*c.* 1620–1662) and Abraham Van Beyeren (The Hague, 1620/1621–Overschie, 1690), whose work offers fewer nuances. At times, these painters depicted tilted plates and overturned cups such as those that reappeared in Cézanne's paintings.

As is true for any pictorial evolution, one can observe that Dutch still lifes underwent a transformation beginning with the relatively uncomplicated creations of Willem Claesz Heda and Pieter Claesz and culminating in accumulated ornamentation represented by ewers and priceless objects in the paintings of Willem Kalf (Amsterdam, 1622–Amsterdam, 1693), where one also encounters sumptuous glass carafes and the sophisticated trappings of pretentious Mannerism.

Finally, there are the floral compositions of Jan Van Huysum (Amsterdam, 1682–Amsterdam, 1742), where the freshness and delicacy that won admiration from Liotard (insects or butterflies often appear among the flowers) emerge within a commonplace context.

STILL LIFES

When these bourgeois painters discovered silvery grays and blacks framed by dull reds emerging from shadows and encountered the signs of family life on beautiful tapestries, in inkwells, open books on tables, carved boxes, or musical instruments, and in rooms drenched with ashen yellow light, they were compelled to sit down in front of silver fruit dishes, earthenware plates, and crystal goblets. The yellowness of lemons, the skins of roasted fowl, and the topaz or ruby hues of wine filled their eyes with the domestic melodies created by lustrous floors, satin gowns, velvet draperies, and stoneware jugs in these surroundings.

Elie Faure
Histoire de l'art

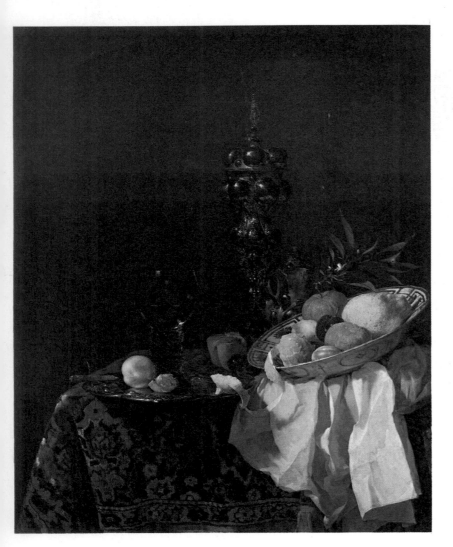

Bouquet, early eighteenth century.
(80 x 60 cm.). Kunsthistorisches Museum, Vienna.
The freshness of Van Huysem's flowers was created by extremely delicate brushstrokes.

Still Life, late seventeenth century.
(105 x 87.5 cm.). The Hermitage Museum, Leningrad.
In the period subsequent to Willem Claesz Heda and Pieter Claesz, Willem Kalf created more painstaking and more ornate images of fruit and luxurious glassware.

Still Life, late seventeenth century.
(74 x 60 cm.). Pushkin Museum, Moscow.
Abraham Van Beyeren relied upon the motif of an overturned glass and placed a pipe and tobacco beside his bread and fish.

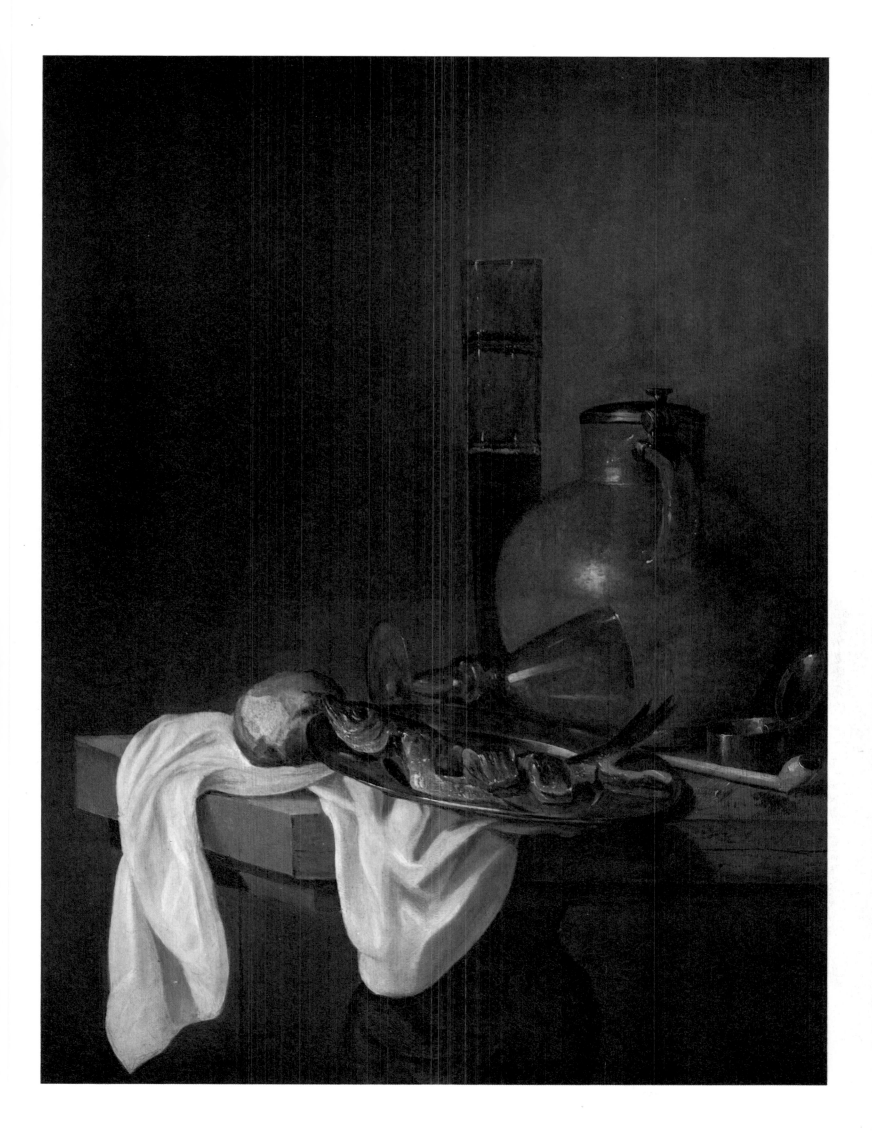

INDOOR SCENES

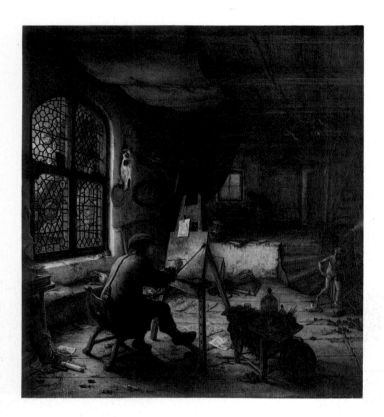

The artists referred to as the lesser Dutch masters were predominantly satisfied with confining themselves to the silent or noisy intimacy of indoor scenes.

In Holland, one looks at a predominantly gray panorama where it is possible to encounter windmills, an oyster-colored sea, foggy skies, thickets flattened by the wind, and all of the themes of Dutch landscape paintings. This encounter makes it possible to understand why many Dutch artists prefer to paint indoor scenes.

Inside their dwellings, these painters reveal rooms opening into corridors where women silently and slowly complete their tasks. Even more frequently, there are small scenes where the most carefully preserved silence gives way to the uproar of unrestrained drinking bouts.

Ariaen van Ostade, 1610–1685
Gerard Dou, 1610–1685
Jan Steen, 1626–1679

In *A Painter's Studio,* Adriaen van Ostade (Haarlem, 1610–Haarlem, 1685) portrayed himself completing a canvas amid harmoniously dispersed light. The meticulousness of Gerard Dou (Haarlem, 1610–Haarlem, 1685) or the small and somber-hued paintings of Jan Steen (Leyden, 1626–Leyden, 1679) are less appealing.

The Studio, 1663.
(40 x 35 cm.). Art Gallery, Dresden.
Adriaen Van Ostade carefully recreated his studio in this painting.

The Doctor and His Female Patient,
c. 1660–1670.
(76 x 63 cm.). Rijksmuseum, Amsterdam.
The paintings of Jan Steen always abound with humor and subtleties.

The Concert, c. 1675.　　　　　→
(56 x 44 cm.). Galerie Dahlem, Berlin.
Every aspect of this painting by Gerard Terborch reflects refined selection of colors.

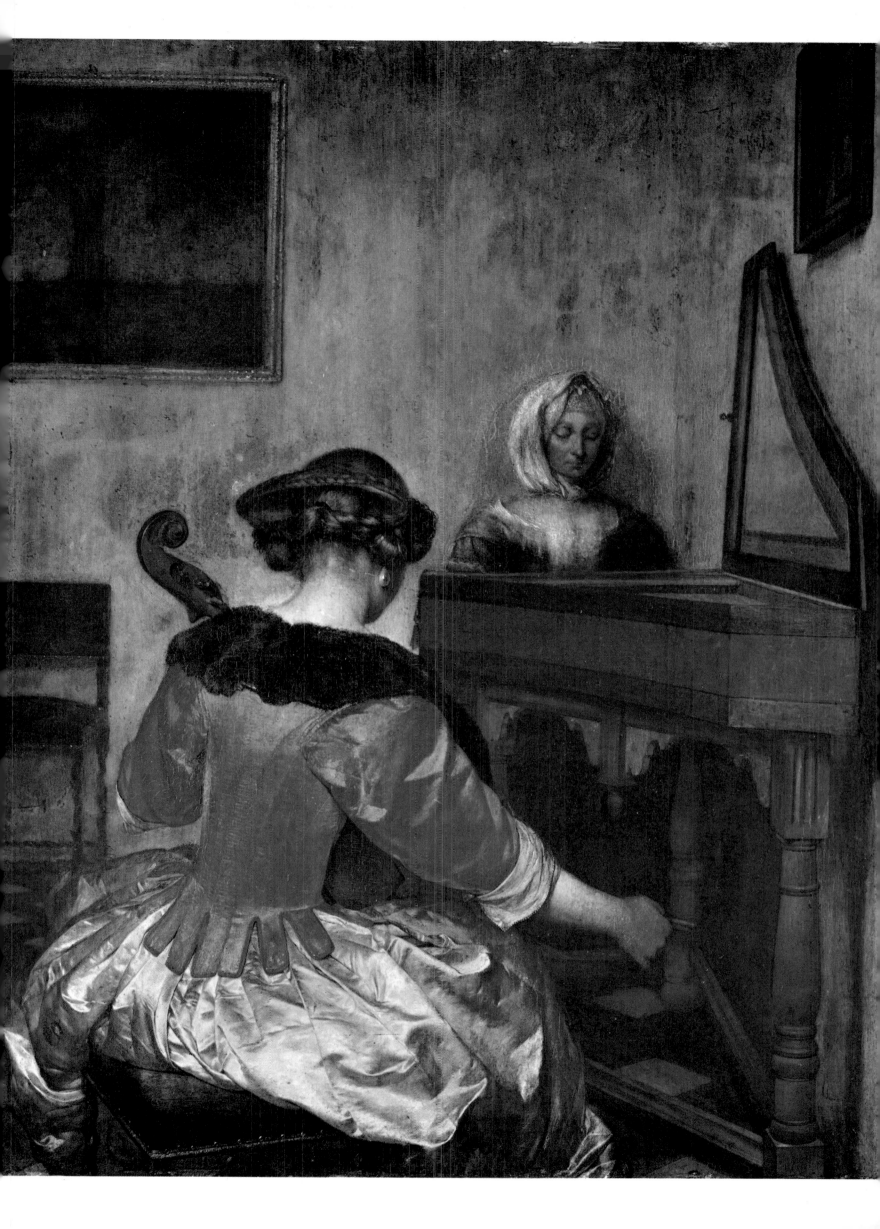

Young Boy Playing the Flute, early seventeenth century. →
(73 x 62 cm.). National Museum Stockholm.
This young flutist reveals the talent of Judith Leyster, who
was one of the most important female painters of this
period.

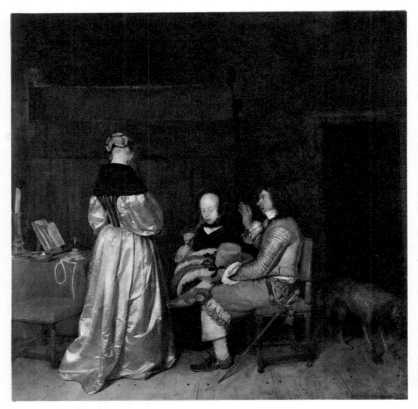

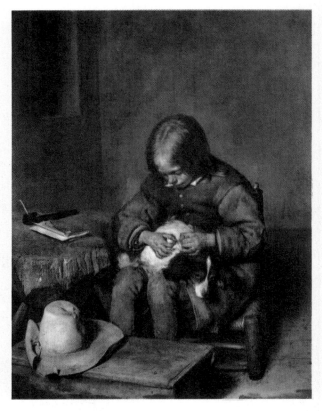

Family Gathering, c. 1650–1654.
(71 x 73 cm.).
Rijksmuseum, Amsterdam.
Terborch often portrayed members of his own family with
carefully chosen colors (he also created miniature portraits).

The Sick Child, c. 1660.
(33 x 27 cm.). Rijksmuseum, Amsterdam.
In spite of the restricted format, Gabriel Metsu achieved
excellent structural qualities in this painting.

Boy Removing Fleas from a Dog, c. 1654.
(35 x 27 cm.). Alte Pinakothek, Munich.
Terborch's exceptional talents are revealed in this intimate
scene painted upon an oak panel.

Gerard Terborch

(1617–1681)

In comparison with the grotesqueries popularized by Pieter van
Laer, who was known as *Il Bamboccio* and who spent more than
ten years in Rome, Gerard Terborch (Zwolle, 1617–Deventer,
1681) achieved a far more subtle form of art not only in his *Young
Boy Removing Fleas from a Dog* but in his *Family Gathering*
(Rijksmuseum, Amsterdam), where the lady of the house appears
in a bright blue gown. *The Concert* (Galerie Dahlem, Berlin)
deserves to be regarded as a masterpiece on account of its delicate
tonalities and the elegance of the figures' apparel. The astound-
ing female violoncellist with a red bodice and a white silk gown,
whom we only observe from the rear, is entirely consistent with
the "French tradition," whereas the less prominent female figure
playing the harpsichord with her eyes focused upon the keys of-
fers a disquieting image of femininity.

Gabriel Metsu

1629–1667

In *The Sick Child,* Gabriel Metsu (Leyden, 1629–Amsterdam,
1667) delicately revealed the influence of Vermeer in terms of the
continuity of the mother's contours, whereas the child's eyes con-
vey a feverish bewilderment. In spite of its limited scale, this
painting possesses a noteworthy equilibrium on account of two
overlapping diagonals intersected by horizontal lines within the
background.

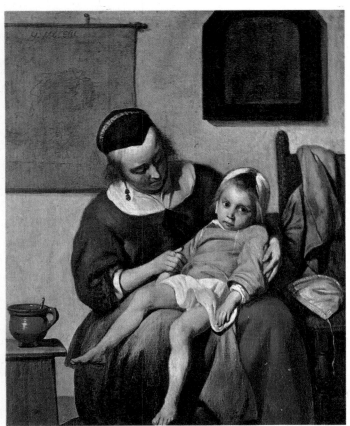

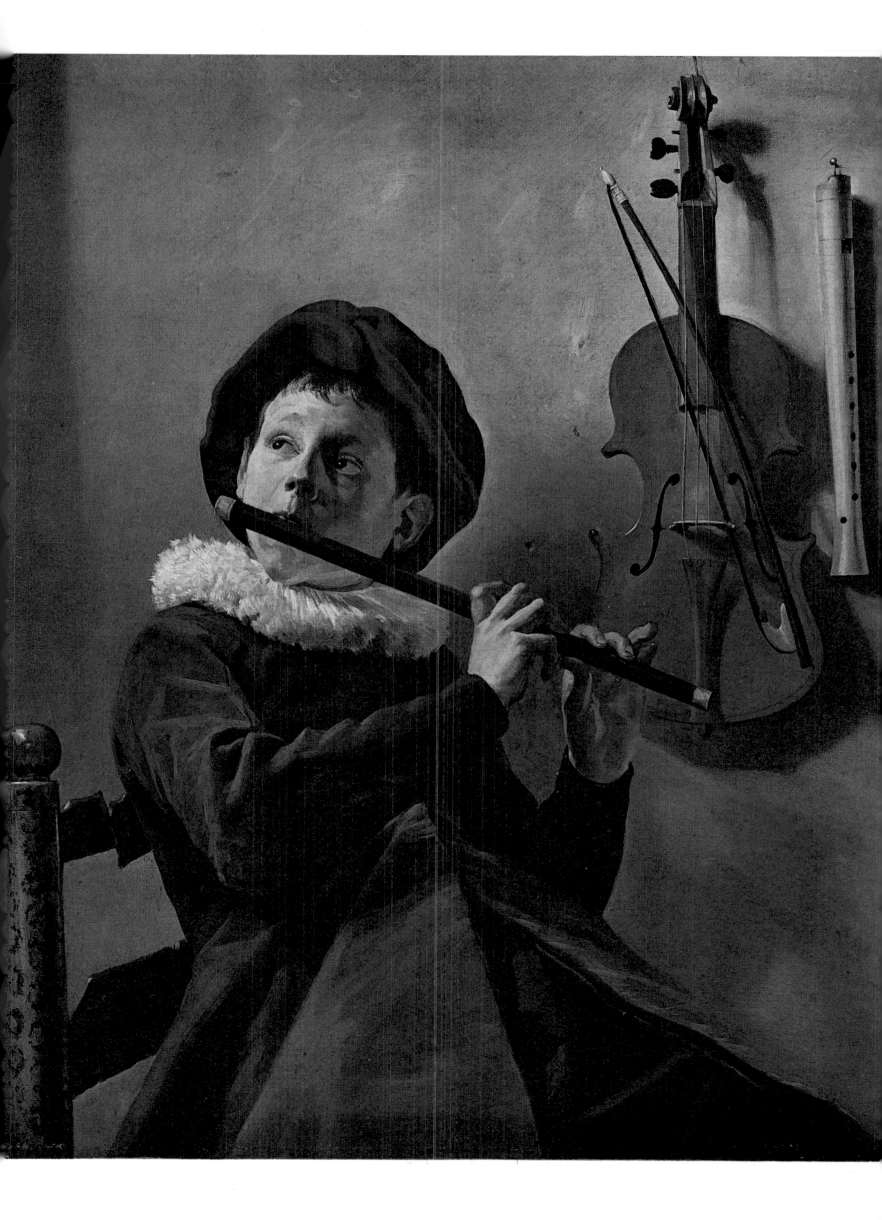

Judith Leyster

1609-1660

Judith Leyster (Haarlem, 1609–1660) also deserves to be separated from the minor painters of her era because of her masterful precision and because of the admirably firm hand displayed in her *Young Boy Playing a Flute.* This painting places Judith Leyster, the daughter of a brewer in Haarlem (she was a pupil of Frans Hals), among the best painters of her era. Her talent for creating genre scenes significantly exceeded the skills of her husband Jan Miense Molenaer. These two artists lived in Amsterdam and later in Heemstede. Judith Leyster's paintings between 1629 and 1652 are signed with a monogram and a star symbolizing her name.

Her paintings, characterized by large dimensions, luminosity, imaginatively established planes, and clearly defined structure, include *The Merry Companions* at the Louvre, *The Baker* in Haarlem, a portrait belonging to the Van Beuningen Collection (Rotterdam), and *A Suitor's Proposal* at the Mauritshuis (The Hague).

Pieter de Hooch

1629-1683

Pieter de Hooch (Rotterdam, 1629–Amsterdam, 1683) was an artist who, on some occasions, appeared to be an imitator of Vermeer. He sometimes succeeded in creating a visual dialogue between figures placed between tile walls and garden gates *(Woman and Servant in a Courtyard).* De Hooch primarily created indoor scenes. By opening doors and windows within hallways, he allowed the observer to see the intimacy of certain rooms. His most evocative painting may be *The Mother* (Galerie Dahlem, Berlin). In this painting, a woman is leaning over a wicker crib near an alcove. One can also observe a dog, a table

A Lady and Her Kitchen Maid, 1652-1654. →
(53 x 42 cm.). The Hermitage Museum, Leningrad.
This luminous and somewhat detached painting is a typical specimen of the category formerly known as "genre scenes."

The Mother,
c. 1652–1654.
(92 x 100 cm.).
Galerie Dahlem, Berlin.
The intimate scenes created by Pieter De Hooch were often mistakenly attributed to Vermeer. However, he did not achieve the density and the admirable boldness of form that characterized his contemporary from Delft.

containing a candle, and a young girl approaching a door that is accentuated by a feeble ray of sunlight. The painting reflects the intimacy of domestic life where bliss requires no diversions other than light softly entering a room.

In *Woman in a Window* (Lugt Collection), Jacob Vrel, who resembles the creators of indoor scenes, comically offset the vertical patterns of glass windows with the image of an elderly woman whose curiosity compels her to sit precariously on a tilting chair.

A Woman and Her Servant in a Courtyard, late seventeenth century. (74 x 63 cm.). National Gallery, London. This is one of the most outstanding examples of De Hooch's talents. He provided light, depth, and an admirable open-air luminosity.

The Larder, c. 1658. (65 x 61 cm.). Rijksmuseum, Amsterdam. This painting is also known as *The Cellar.* The detail reproduced here demonstrates the delightful craftsmanship displayed by the intimist painter in his most outstanding moments.

Pieter Jansz Saenredam

1595–1665

Among the interiors created by Dutch artists, there are also the white walls of churches evoked by Pieter Jansz Saenredam (Assendelft, Northern Holland, 1595 or 1597–Haarlem, 1665). Saenredam, whose father was an architect and painter, promptly began to recreate urban scenes, often depicting the interiors of churches. He customarily prepared multiple architectural sketches beforehand for paintings of this type. Like Claude Lorrain, Saenredam often relied upon another painter (possibly van Ostade) to create the minuscule figures appearing in his works. Saenredam's paintings convey a profound understanding of space and of abstract harmonies between lines and planes. The latter characteristic contributed to increased interest in his works after Mondrian earned recognition, and one can regard Saenredam as a precursor of Mondrian. Above and beyond architectural harmony, Saenredam successfully expressed his innermost moods by the form of ogives and by the vastness of walls overshadowing a pair of organs or a Resurrection panel in a church *(Interior of the Church of Saint Bavo in Haarlem)*. He was a master who cleverly adapted his proportions, counter-balancing delicately modulated whites with remarkably distinct shades of gray. Saenredam's works reflect far more talent than those of Emmanuel de Witte, who emulated him. Saenredam is distinguished by pure colors and by a carefully premeditated equilibrium that foreshadows the De Stijl group and Neoplasticism.

Interior of the Church of Saint Bavo in Haarlem, c. 1649.
(96 x 57 cm.). Rijkmuseum, Amsterdam.
Saenredam, a painter, draftsman, and architect, who was the son of an engraver, created marvelous images of walls. He was fascinated with masonry and revealed admirable talent in recapturing its qualities.

INTERIORS

Each aristocrat or young woman whom Terborch chose as a model bears this imprint. In a singularly paradoxical way, however, each of his figures, including those who are most dissolute or unrefined, is a true-to-life inhabitant of its own milieu. Their linaments are profoundly and intensely expressive and the same qualities are evoked with equal precision by busy hands, foreheads revealed beneath masses of unkempt hair, the calm and joyful faces of mothers and the astonished or playful expressions of children. His illumination is never dazzling or overbearing, as light gently follows a comb moving through russet hair, enhances a wry grimace, glitters in the eye of a dog while its fleas are being removed, accentuates a jewel against moist flesh, or heightens the excitement permeating, animating, and preserving every event in the intimate and unending dramas conveyed by busy rooms, by the windows illuminating them, or by the banal occurrences transpiring there day by day. The painter created a transparent atmosphere which caresses pale necks exposed beneath carefully arranged hair. With dazzling pale golden tints, the distinctive radiance of a silver skirt, a scarlet bodice, steely gray breeches, fawn-colored boots, or a pearl dangling from a blue ribbon and brightening a fair complexion, mingles with the melodies of music boxes to cast benevolent shadows upon the velvety tranquility of lives unfolding amid security and comfort.

Elie Faure
Histoire de l'art

ITALIANATE AND MANNERIST ARTISTS

Among the Dutch painters, there were several Mannerists who merit recognition. All of them, beginning with Cornalis van Haarlem, whose nudes reflect a carefully developed eroticism, were influenced in various ways by Italian art. This category also includes Jan Van Scorel, Frans Floris, Joos van Winghe, and Abraham Bloemaert, along with the Flemish painter Bartholomeus Spranger, who lived in Holland around 1602 before he finally died in Prague.

Anthonis Mor

1517–1576

The imitators of Italian art included Anthonis Mor (Antonio Moro) (Utrecht, 1517–Antwerp, 1576), who was only a Dutch artist by birth. His paintings were significantly influenced by Italian portraiture. (This painter spent his career in Portugal and in Spain.)

Cornelis Cornelisz Van Haarlem

1562–1638

The style of Cornelis Cornelisz Van Haarlem (Haarlem, 1562–Haarlem, 1638) was significantly more interesting and original. He traveled to France when he was seventeen years old and returned to Holland in 1583, after having encountered the titillating paintings of Italian artists at Fontainebleau. He was a friend of Goltzius and of Carel Van Mander, who joined him in establishing an art academy in Haarlem. Cornelisz frequently created nudes, as in *The Banquet of the Gods, The Marriage of Thetis and Peleus,* and *Bathsheba Bathing.* His eroticism shocked some of his contemporaries, inducing Zeri to refer to "a sprawling array of buttocks and armpits, revealed with new and audacious perspectives," and "genitalia concealed by flimsy pieces of cloth that are just about to fall away."

Melchior Hondecoeter

1636–1695

The Mannerist current also emerged in landscapes created by the Flemish painters Gilles van Coninxloo and Joos de Momper or by the Dutch painters Philips Wouwerman from Haarlem and Melchior Hondecoeter (Utrecht, 1636–Amsterdam, 1695). Hondecoeter pursued the fanciful and pantheistic path that Roelant Savery had traveled and he became known as the "Raphael of birds" because he specialized in portraying fowl. Hondecoeter's *Peacocks* (Metropolitan Museum of Art, New York), which is characterized by dazzling colors and by the unexpected presence of a monkey alongside a squirrel, depicts a peacock unfolding its magnificent plumage.

Peacocks, late seventeenth century.
(190 x 135 cm.).
Metropolitan Museum of Art, New York.
Among the Dutch Mannerists, Melchior Hondecoeter excelled in depicting wildlife.

Bathsheba Bathing, 1594. (77 x 64 cm.). Rijksmuseum, Amsterdam.
Cornelisz's, *Bathsheba,* like his *Marriage of Thetis and Peleus,* is characterized by unrestrained sensuality.

MODERN MASTERS

It is not necessary to sacrifice time by describing the eighteenth century and the long "years of somnolence" that descended upon Dutch painting. Similarly, there is no need to describe the "Hague School," represented with varying degrees of merit by the works of Israels, the Maris brothers, and Weissenbruch around 1870. Because he sometimes attained excellence, Breitner is an exception among this group, which was partially influenced by Daubigny and the Barbizon School in France.

Jongkind and Van Gogh represented the rise of a new era in Dutch art, while Mondrian acquired a prominent role among the artists of subsequent generations.

Johan Barthold Jongkind

1819–1891

Jongkind, with his high and somewhat receding forehead, an elongated face framed by a long beard, and an amusingly lanky physique, displayed a deep attraction for the joys of Bacchus. In 1860, Claude Monet, in a letter to Boudin, described the hopelessness of Jongkind's situation, saying that the Dutch painter was "dead as an artist" and adding "he has completely lost his mind. Artists are collecting funds in order to help him with his expenses."

At this time, Jongkind was an impoverished drunkard whose creditors in Holland were in hot pursuit. Threatened by insanity, blindness, and delusions of persecution, he was painting moonlit nocturnal scenes in the style of Van der Neer.

Banks of the Isère, 1883.
Cabinet des Dessins, The Louvre, Paris. After 1873, Jongkind frequently visited the Isère region and, in 1878 he began to live at La Côte-Saint André. This painting where yellow and ochre hues predominate is typical of his work during the final years of his life.

He was soon rescued by Mme. Fesser, a stout-hearted woman with a somewhat hirsute upper lip. Her maternal watchfulness saved him from ruin. On March 14, 1862, Baudelaire visited Jongkind at 9 Rue de Chevreuse, near the Boulevard Montparnasse. Claude Monet was sufficiently reassured to refer to him as "the eminent Jongkind." Although the Salon rejected his paintings, he was not perturbed and continued to produce etchings.

But there were relapses, escapades, and bouts of madness mingled with drunkenness and painting. On May 4, 1871, Edmond de Goncourt, after having paid a visit to Jongkind with the art critic Burty, wrote in his *Journal:* "I was one of the first to admire his paintings, but I was unacquainted with the man. Try to imagine a blond giant with eyes as blue as pottery from Delft and with a mouth whose corners turn downward. He was wearing a cardigan and a Dutch sailor's cap... On the easel, there was a painting of the suburbs of Paris, where a loamy riverbank was depicted in a marvelously intriguing way... Meanwhile, he was followed everywhere by a short gray-haired woman with a noticeable mustache; her voice possessed the cajoling tone that mothers use with children. She was the epitome of loyalty and she somewhat resembled a butler from the former Imperial Guard." Concerning the painter himself, de Goncourt wrote: "Suddenly, his speech became slurred and *'Netherlandish.'* His words became bizarre and incoherent... He rose as if he were controlled by a spring: 'You see, some kind of electricity just went by me.' Then he uttered a sound imitating a whistling bullet."

After an inauspicious beginning, Jongkind studied art with Isabey, a painter of seascapes, who employed him at The Hague and in Le Havre. In Isabey's studio at 15 Rue Frochot in Montmartre, Jongkind began to complete paintings where he relied upon the subtle and pervasive white hues that distinguished his first "Paris" scenes depicting the banks of the Seine.

His paintings are uneven and vigorous. Deft brushstrokes and firm contours sometimes create striking intensity. Jongkind also created extremely expressive drawings and water-colors with unusually delicate tints. At times, his images of moonlit nights or skaters on the ice appear to have emerged from the collective unconscious. His most significant works are his evocations of Parisian streets, such as the Rue des Francs-Bourgeois, the Rue Mouffetard, and the Rue Saint-Jacques. Long before Utrillo, he depicted advertising posters appearing in large print on the walls of buildings. The *Rue Saint-Jacques* (Daber Collection) was painted in 1876, with admirable boldness and with densely applied and vibrant layers of paint.

Vincent Van Gogh

1853–1890

The need to consecrate oneself body and soul and by any possible means was never so compelling nor so fatal as in this man whose father was a clergyman in Nuenen. He was naturally in conflict with any form of established order, and from birth was marked as someone condemned to burn with the fire of the absolute, to such a point that he would lose his mind.

Wheat Field, 1889.
(46 x 56 cm.). National Gallery, Prague. This is a painting from Van Gogh's Saint-Rémy period. The straws of wheat appearing in the foreground were arranged in a precise pattern in order to emphasize the profuseness of the wheat field.

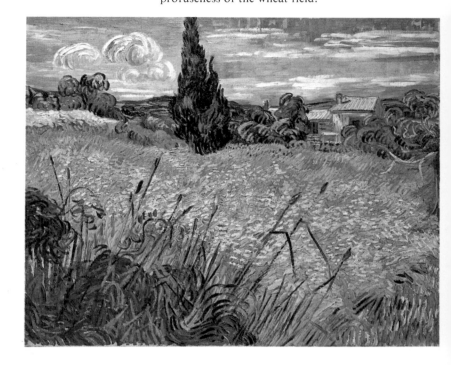

Cottages, 1890.
(60 x 73 cm.).
The Hermitage Museum, Leningrad. This painting, completed when Van Gogh was in Auvers in May, 1890 formerly belonged to the Morosov collection.

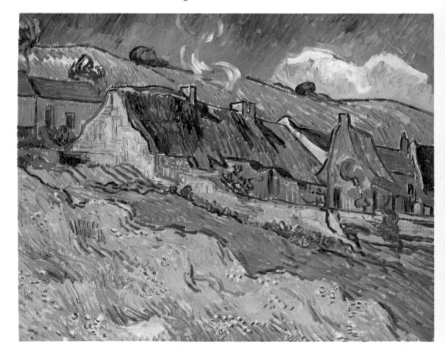

Survival was an impossibility for this man who, before he began to paint, had sold paintings in The Hague after being rejected by the family of Ursula, whose father was the owner of a London rooming house where he once resided. He had been an instructor in an Anglican boarding school at Ramsgate in Kent, a book dealer's clerk in Dordrecht, and an itinerant preacher in the coal fields near Mons, where he distributed Bibles to the miners and finally abandoned his lodgings in order to live in a hut that gave no protection from the wind and rain.

In 1883, in Nuenen, Van Gogh was obliged to renounce his love for a female cousin. Subsequently, he attempted to transfer his affections to Sin, a prostitute whom he had rescued from the gutters. This situation was intolerable for his uncles in Amsterdam, who were respectable Dutch burghers. Indeed, it was intolerable to have a nephew who was only attracted by difficult entanglements and who walked among the brambles beside the road, precisely because, in his words, it was more difficult to do so.

Then he scrambled for a solution and began to study painting with Cormon (he met Toulouse Lautrec through Cormon).

Until that time, his confusion of art and noble intentions inspired an interest in paintings depicting the lives of the downtrodden, although his mediocre results led him to abandon this path. Subsequently, as his tastes became more sophisticated, he

The Painter's Chair, c. 1888. (94 x 74 cm.). Tate Gallery, London. This is the famous chair from Van Gogh's room in Arles. It is painted in a boldly three-dimensional way and therefore has a monumental quality.

admired Mauve, Joseph Israels, Weissenbruch, the Maris brothers, and other members of the "Hague School." After he painted *The Potato Eaters* (1885), the phase of self-pity, misplaced emotions, introversion, and absinthe abruptly ended. Van Gogh painted flowers and *The Tavern,* while, from the heights of Montmartre, he absorbed the rhythms of Paris beneath his feet.

From then on, painting became a way of soothing his passions and Van Gogh filled his canvases with flurries of feverish brushstrokes as he recreated the soil, fields, and the tiniest blade of grass with awe-inspiring humility.

He received encouragement from his brother Theo, who provided him with a place to live, on the Rue Lepic. Until the end, Theo furnished a small allowance that enabled Vincent to survive each month. At a later point, he wrote to Theo, "You've created these paintings with me, in a certain way."

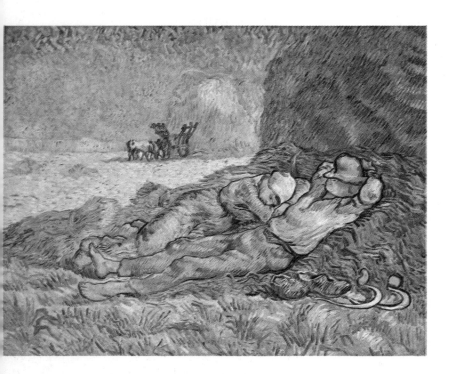

The Siesta, 1889–1890. (73 x 91 cm.). Musée du Jeu de Paume, Paris. This painting from Van Gogh's Saint-Rémy period (December 1889) was an adaptation of one of Lavieille's woodcuts of *Four Hours in the Day* by Jean-François Millet.

VINCENT VAN GOGH

Reddish hair (a small goat-like beard, an unkempt mustache, and a close-cropped skull), eyes like those of an eagle, and a finely hewn mouth, so to speak; an ordinary but robust stature without any excess flesh, lively gestures, and an abrupt gait: that was Van Gogh, always carrying his pipe, a painting, an engraving, or a sketch...

As the son of a Protestant clergyman in Holland, Van Gogh seemed destined for the clergy from birth but, after a brief effort, he abandoned it for painting. He was excessive in everything and undoubtedly collided with the strict doctrines of his preceptors! Fascinated with art, he discovered the works of Israels, who was his first model. Then he discovered Rembrandt. Subsequently, he visited Goupil in France but his brother, Theodore Van Gogh, ultimately aided him. Through his brother's help, he was now free to paint. He studied with Cormon but quickly became dissatisfied. He experimented with pointillistic techniques but lost his patience. Then he pursued his own course after scrutinizing Monticelli, Manet, Gauguin, and others. Indeed, he departed from all of them. Van Gogh is more personalized than any other artist. Admiring the art of Japan, India, and China, or anything which sings, laughs, and pulsates, he discovered within these domains the surprising techniques that led to his harmonies and to extraordinarily vigorous contours as he relentlessly thrust upon us the maddening nightmares of his innermost depths.

Emile Bernard
La Plume, 1891

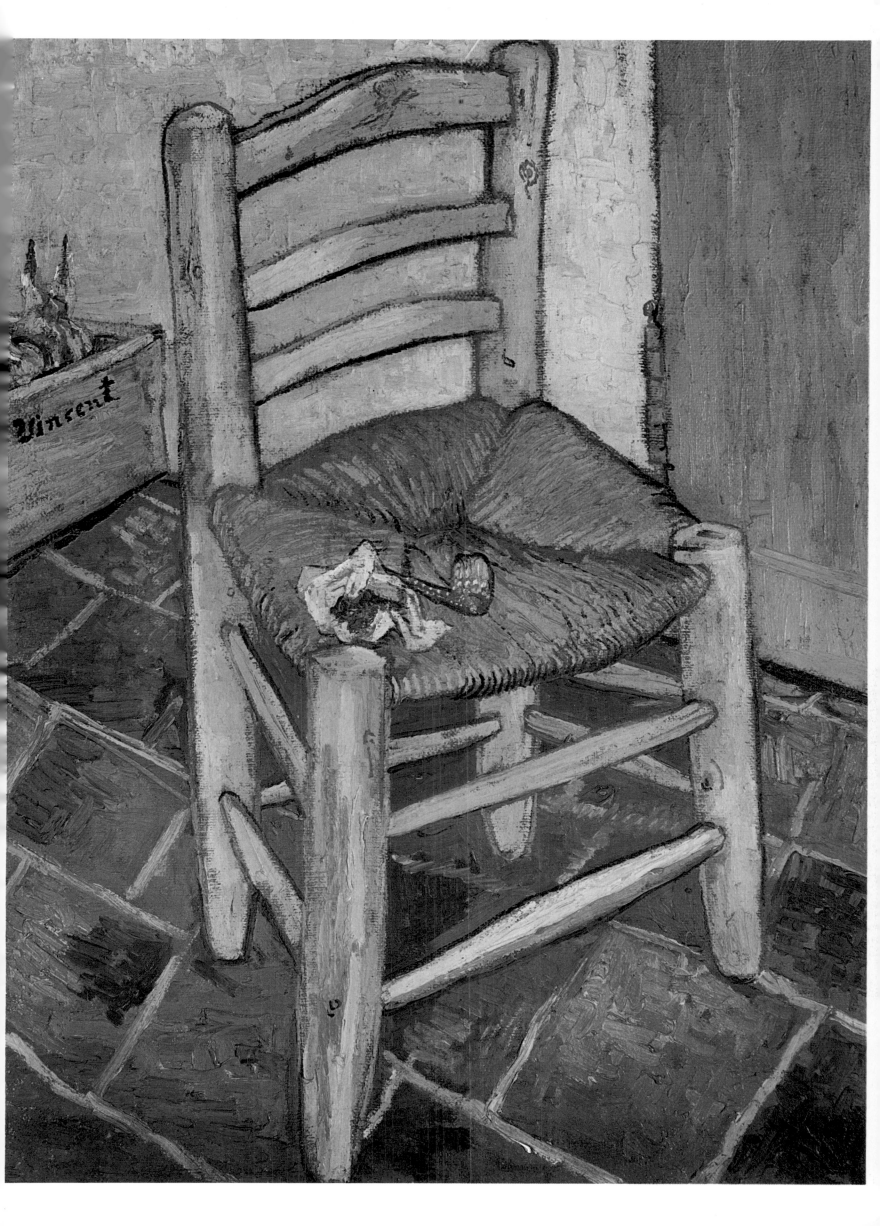

Inspired by the works of the Goncourt brothers and Zola, and with encouragement from Toulouse Lautrec, Van Gogh traveled to Provence. At the end of February, in 1888, he decided to live at 2 Place Lamartine in Arles. As he sought to mingle with nature, everything became dazzlingly tumultuous, unleasing a torrent of love that was too vast to be confined to a single human heart. In his own words, he fell prey to "the madness of sunflowers." Everything that he saw whirled around the sun. He became a man of fire but he did not lose hope, at least until the night of his self-mutilation.

Van Gogh invited Gauguin to visit him in Arles and live with him. One night, Gauguin departed for a solitary stroll. When he reached the Place Victor-Hugo, he heard rapid and abrupt footsteps behind him. In Gauguin's own words, "I turned at the very moment that Vincent was dashing toward me, with an open razor in his hand. My expression must have been extremely severe, because he stopped, lowered his head, and began to run back toward the house." To punish himself, Van Gogh cut a piece of flesh from his earlobe. Then he wrapped it in a piece of paper and took it to a prostitute.

Subsequently, he was sent to the asylum at Saint-Rémy, where he felt imprisoned by guards, nurses, and physicians. He lapsed from one crisis to another and later moved to a rest home, where he wrote to his brother: "It gives me some consolation that I have begun to regard madness as an illness like any other and to accept it for what it is... If it were not for your loyalty, I would be ready for suicide without any regrets, and, although I proceed somewhat slowly, that is how my days shall end." The sight of an aged tree caused his feelings to overflow, whereupon he compared himself to a family's dog that understands those who cannot understand him.

Finally, Van Gogh's brother was able to get help from Doctor Gachet, a resident of Auvers-sur-Oise, who had befriended Guillaumin, Pissarro, and Cézanne and who painted under the pseudonym "Van Ryssel." Van Gogh lived in Ravoux's inn on the

A Stroll at Dusk, 1889.
(49 x 45 cm.).
Art Museum, São Paulo.
In this painting, each element whirls beneath the large crescent of the moon, above the strollers. In the foreground, the yellow of the woman's dress echoes the crepuscular yellow of the moon.

← *Church in Auvers-sur-Oise,* 1890.
(94 x 75 cm.).
Musée du Jeu de Paume, Paris.
This painting was donated to the Louvre by the son of Doctor Gachet in 1951. It was completed in Auvers between June 4 and June 8 in 1890, shortly before Van Gogh committed suicide.

main road, while being treated by the doctor who lived elsewhere. His dementia caused increased suffering although there were intervals where he regained his sanity. In another form, he was experiencing the same affliction described by Gérard de Nerval in *Aurelia,* although Van Gogh possessed physical strength and a robust constitution.

One day, he painted a wheat field beneath an ominous sky filled with crows. This moment was a turning point. Upon returning to the inn, Van Gogh obtained a rifle and climbed to the top of a hill where he shot himself near the heart. He retained enough strength to return to the inn, drenched with blood. Theo immediately set out from Paris but only arrived soon enough to hear his brother's final words: "Don't weep. I did it for everyone's good."

This fiery man left behind one of the most terrifying artistic legacies known to us. His penetrating perceptions, accentuated by greens and blues, with brushstrokes that created forceful, energetic, and well defined contours, evoked landscapes and

fields beneath ominous skies or on the verge of being moistened by a brief shower while a coach is traveling along the road nearby. Then there are evenings beneath the sap-laden cypresses, where lovers walk hand in hand, representing a love that was not for him. Van Gogh, who died when he was thirty-seven, emulated Rembrandt by creating a large number of self-portraits (perhaps because he had no other model, but also because of a compulsion to record his moods and his despair on canvas). These self-portraits allow us to trace the stages of his illness, up to the last one that he painted in May, 1890. The haggard appearance of this face, seemingly surrounded by flames and radiating the urgency of a final outpouring of emotions, reveals the unmoving and penetrating gaze of a man who knows that he is condemned to die.

Composition with Black and Red, →
c. 1919–1926.
(102.2 x 104 cm.).
Museum of Modern Art, New York.
This large canvas embodies the strict constraints adopted by an artist who elevated painting to its most rigorously defined mode of expression.

Piet Mondrian

1872–1944

Among the partisans of the so-called "abstract" art that superseded Cubism, Mondrian is the painter who journeyed to the outermost limits of a style that dispensed with all seemingly superfluous elements. His compositions only retained colored surfaces and demarcation of planes.

For at least twenty years, Mondrian had been a figurative painter. He painted natural settings and *The Blue Tree* (Municipal Museum, The Hague), becoming spontaneously fascinated with an extremely free interpretation of Nature and of bright colors. Between 1911 and 1913, he lived in Montmartre where his predominant theme, the tree, became increasingly rarified until the painter felt the need for an absolute return to unity, subsequent to his investigation of theosophy. Mondrian and Theo Van Doesburg then established the "De Stijl" group in Holland, with the aim of developing a category of art that, without being decorative, would nevertheless be applicable to certain areas of architecture.

During a visit to the Van Nelle tobacco processing plant in Rotterdam, built by the architects Brinkmann and Van der Vlucht (1929), there was a recreation area consisting of a small enclosure where the floor had been created by Mondrian.

One relatively surprising aspect is the degree of intensity that Mondrian managed to incorporate into his art. Although his creations appear to have an exaggerated simplicity when one encounters them for the first time, this is a type of art that fills the soul if one returns to it several times. A sense of Mondrian's absolute sincerity emerges from his adoption of horizontal or vertical straight lines (before the final paintings completed in the United States). In his paintings, we only encounter patterns of bright and unvarying colors, arranged with an extremely fine sense of proportion into planes that separate relatively broad areas. We are astonished to find that such a restrictive art with

carefully calculated patterns is capable of awakening our emotions. Mondrian was able to transform ostensible rough drafts into a plastic poetry where we are compelled to experience the painter's perception of space. These are not merely brightly colored surfaces composed of reds, yellows, and blues intersected by white and divided by black lines. To the contrary, Mondrian's harmonies are carefully distributed, with a stunning equilibrium established for each dominant color, as in his *Composition* (1921) at the Municipal Museum in The Hague.

Fernand Léger has recounted how, during a breakfast with Mondrian at a convention, the Dutch artist confided that he had had a dreadful nightmare. "I dreamed," he said to his friend, "that curves were raining down upon me."

I met Mondrian in Paris around 1925, after he had published *Neo-plasticism*. He reminded me of the director of a surgery department, with his clear eyes concealed beneath rimless eyeglasses. Mondrian was a serious man who told me that he was gratified by the interest that the younger generation had expressed in his work (I was in my early twenties at the time). Later in his life, Mondrian moved to London (1938) but, after the wartime bombings (1940), he moved again to New York, where he died after having completed *Broadway Boogie Woogie*.

Brame Van Velde (1895–1981)

Geer Van Velde (1898–1977)

A final word concerning the Van Velde brothers is necessary. Brame Van Velde (Zonderwonde, 1895–Grimaud, 1981), who was initially a house-painter, learned how to produce beautiful tonalities, creating paintings with an unusual Baroque quality (although he sometimes relied excessively upon trickled paint). His brother Geer Van Velde (Lisse, 1898–Paris, 1977) developed a more structured style, with subtler coloring. He was a secretive artist who always maintained a cautious stance toward other persons.

Lastly, under the influence of Alechinski, Holland became the source of the "Cobra group," whose leading members were Karel Appel, Constant, and Corneille.

Index

Translated by Larry Lockwood
Typeset by Arts & Letters, Inc. Brookline, MA
Printed by H. Fournier, S.A. - Vitoria-Spain

BIBLIOGRAPHY

Bruegel l'Ancien, Robert Genaille; Tisné, Paris, 1953.

Constant Permeke, Roger Avermaete; L'Arcade, Brussels, 1970.

Corpus de la peinture des Pays-Bas méridionaux au XVᵉ siècle, De Sikkel, Antwerp.

Correspondance de Rubens (6 vol.); published by Charles Ruelens and Max Rooses, Antwerp, 1887-1909.

Deutsche Academie, Joachim von Sandrart; Nuremberg, 1675.

Die Altniederländische Malerei, Max Friedländer; Berlin-Leyden, 1924-1937.

Frans Hals, Trivas; Hyperion, Paris, 1950.

Histoire de la peinture moderne en Flandre, Paul Haesaerts (Preface by Pierre Courthion); L'Arcade, Brussels, 1960.

Hollande, Louis Hourticq; Ars Una, Paris, 1932.

Introduction à la peinture hollandaise, Paul Claudel; Paris, 1935.

Jacob van Ruysdaël, J. Rosenberg; Berlin, 1928.

Jérôme Bosch, Max Friedländer and Mia Cinotti; Flammarion, Paris, 1957.

Jongkind, Paul Signac; Paris, 1927.

Künstler Inventare (8 vol.), Bredius; The Hague, 1915-1929.

Le Livre de peinture, Carel van Mander, 1604; Hermenn, Paris, 1965.

Les Maîtres d'autrefois, Eugène Fromentin, 1876; Garnier, Paris, 1972.

Mondrian, J.-J. Sweeney; New York, 1948.

La peinture des anciens Pays-Bas (from Van Eyck to Bruegel), Robert Genaille; Tisné, Paris, 1954.

La Peinture flamande des origines à la fin du XVᵉ siècle (3 vol.), Fierens-Gevaert; Van Oest, Brussels, 1927-1929.

La Peinture flamande de Van Eyck à Bruegel, Pierre Courthion; Somogy, Paris, 1958.

La Peinture hollandaise, Robert Genaille; Tisné, Paris, 1956.

Pieter Bruegel der Ältere, M. Dvorak; Berlin, 1923 and 1928.

Les Primitifs flamands, Leo Van Puyvelde; Brussels, 1954.

Rembrandt, Otto Benesch; Skira, Geneva, 1957.

Rubens, Paul Jamot; Paris, 1935.

Saenredam, Swillens, 1935.

Van Gogh, Hammacher, 1948.

Vermeer, Van Zype; Brussels, 1908.

Vermeer, A.-B. de Vries and René Huyghe; Tisné, Paris, 1948.

Vermeer, André Malraux; Gallimard, Paris, 1952.

Vermeer und Karel Fabritius, Hofstede de Groot; Amsterdam, 1907-1930.

Von Van Eyck bis Bruegel, Max Friedländer; Berlin, 1921.

Photographic Acknowledgements

Artothek: Blauel, 89. Édimédia: coll. Colothèque, 9, 102; Giraudon: 32; Izobrazitelnoïe Iskousstvo; Moscow: 21, 34 bottom, 93 top, 95, 96 top, 99 top, 123, 127, 129, 149, 158, 160 bottom, 161, 167, 173 bottom; Musées nationaux: 41; Ziolo: Cercle d'Art, 47; Faillet, 172; Held, 128.